DIGITAL MAYHEM: 3D MACHINE TECHNIQUES

DIGITAL MAYHEM: 3D MACHINE TECHNIQUES

DIGITAL MAYHEM: 3D MACHINE TECHNIQUES

WHERE INSPIRATION, TECHNIQUES, AND DIGITAL ART MEET

EDITED BY DUNCAN EVANS

Routledge
Taylor & Francis Group

LONDON AND NEW YORK

First published 2015 by Focal Press

Published 2018 by Routledge
2 Park Square, Milton Park, Abingdon, Oxon OX14 4RN
711 Third Avenue, New York, NY 10017, USA

First issued in hardback 2018

Routledge is an imprint of the Taylor and Francis Group, an informa business

Library of Congress Cataloging in Publication Data

3D machine techniques : where inspiration, techniques, and digital
art meet / edited by Duncan Evans.

pages cm — (Digital mayhem)

1. Machinery—Pictorial works. 2. Computer-aided design. 3. Three-
dimensional display systems. 4. Commercial art. I. Evans, Duncan.

TJ211.15.A124 2014

006.6'93—dc23

2014014436

ISBN 13: 978-1-138-38088-2 (hbk)
ISBN 13: 978-0-240-52599-0 (pbk)

Typeset by Alex Lazarou

THIS BOOK IS DEDICATED TO ALL THOSE ARTISTS FACED WITH UNINTELLIGIBLE SOFTWARE INTERFACES, RANDOM BUGGY BEHAVIOUR, COMPUTERS THAT CRASH OR SPEND THE BEST PART OF A WEEK RENDERING, YET STILL MANAGE TO PRODUCE SOMETHING WONDERFUL, CREATIVE AND INSPIRATIONAL.

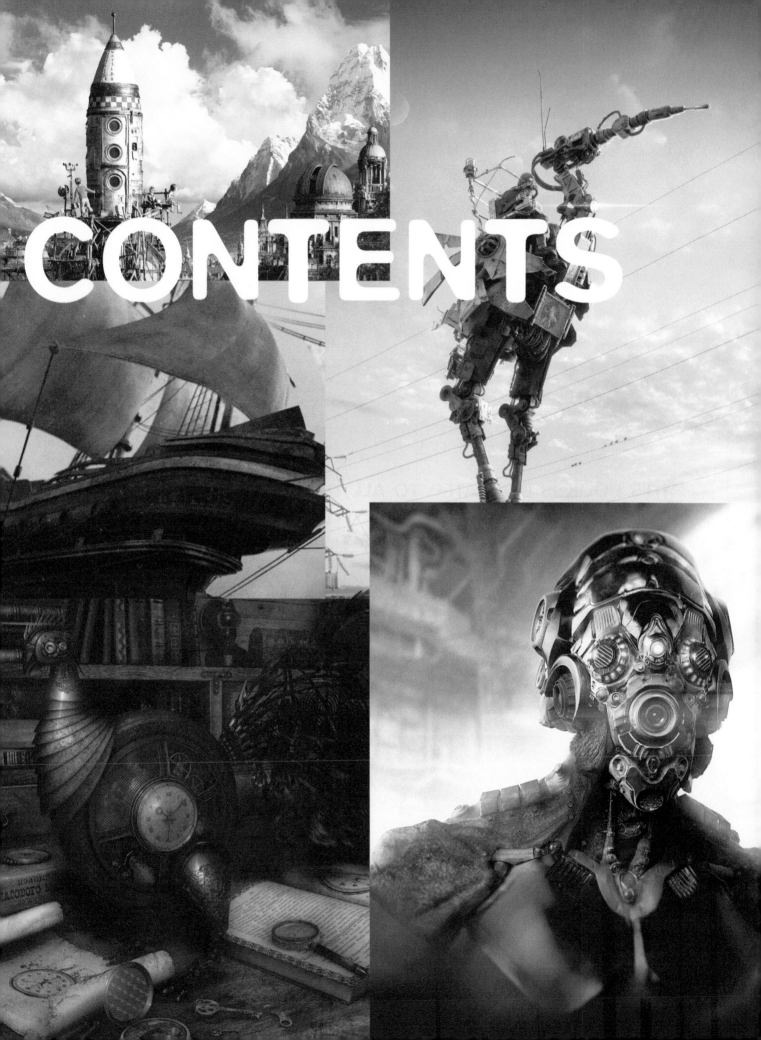

CONTENTS

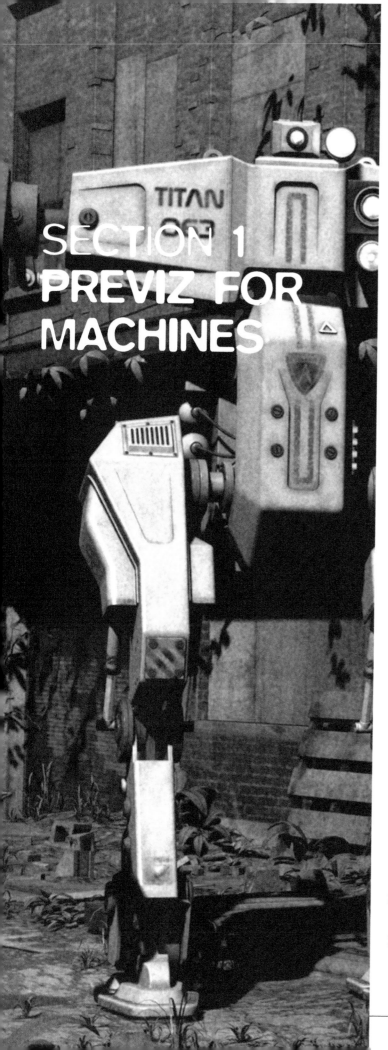

SECTION 1
PREVIZ FOR MACHINES

Get started with creating 3D machine images by considering what influence colour temperature has on an image, how to use depth-of-field creatively and the effect that different focal lengths have with render camera lenses. These are the things to know before you start.

Chapter 1

SECTION 2
MACHINE MASTERS AT WORK

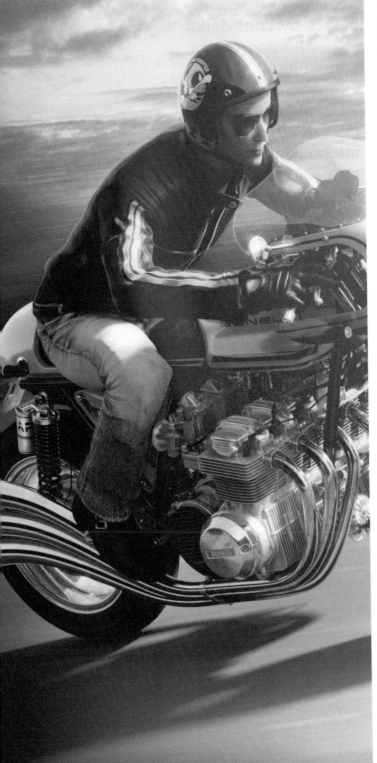

The main body of the book with showcase images to inspire and workflow tutorials to inform. Each chapter is dedicated to a different type of machine and has one or more tutorials related to that subject.

Chapter 2
CARS

Chapter 3
INDUSTRIAL AND AGRICULTURAL

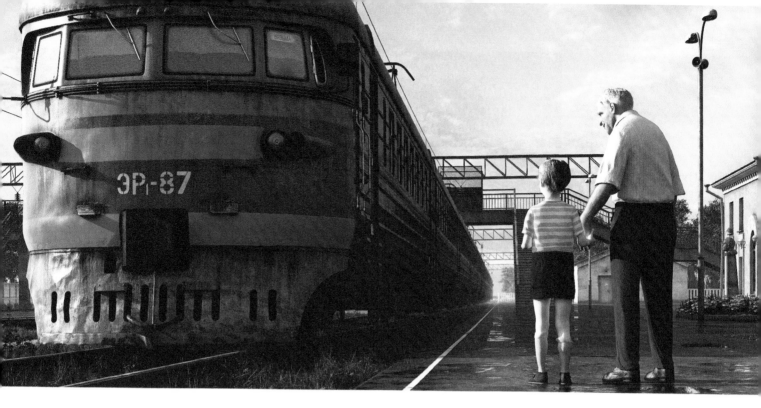

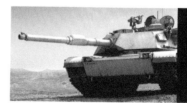

Chapter 8
NAUTICAL

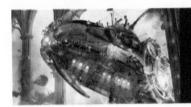

Chapter 11
SCI-FI
VEHICLES

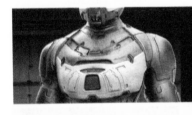

Chapter 9
STEAMPUNK

Chapter 12
SCI-FI
SPACESHIPS

Chapter 10
ROBOTS

SECTION 3
POST PRODUCTION EDITING

Those tweaks and enhancements or significant changes that you can make to improve your render or come up with a completely different version. Plus some practical advice relating to the target audience for your image.

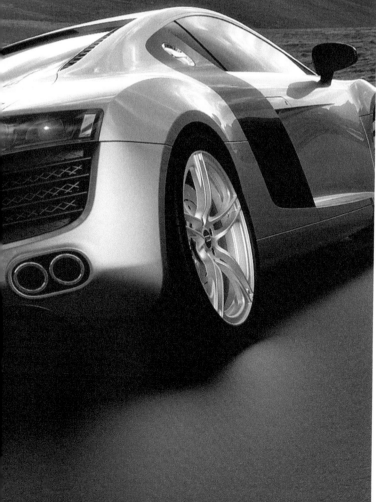

Chapter 13
POST PRODUCTION

Chapter 14
APPENDIX – RESOURCES

Hello and welcome to *3D Machines*, the second book from Focal Press in the Digital Mayhem range. As with the first book in the series, *3D Landscapes*, the format of the Digital Mayhem series brings you an unusual mixture of showcase images and tutorial workthroughs. The showcases are the best images from artists creating machinery, whether they are professionals working in the CG industry, or talented enthusiasts working by lamp light at home. The purpose of these is to inspire your own creativity and set the standard for what can be achieved. In each chapter there are one or more tutorials, detailing the workflow that the artists go through to create their incredible images. Pick up tips or get to know the process more intimately. What this book won't tell you, is how to model a wheel using 3ds Max – it's not a software guide, it's a guide to great images by the people who made them.

The book is split into three sections: pre-viz for machines, the machine masters at work, and post production editing. The first and last sections are beginner-orientated with advice on various aspects of 3D that are worth considering before and after you create your images. The bulk of the book is the showcases and the tutorials. Everything in *3D Machines* is arranged in a magazine-style format and all the content is entirely self-contained. This means that you don't have to read it in order, just dive right in and enjoy anything that takes your fancy. Alternatively, head for the contents pages and peruse the chapters and descriptions of the 3D goodness awaiting you.

With over 300 pages to enjoy we hope that you feel entertained, inspired and encouraged to tackle your own 3D machine projects. Stay tuned for further releases in this exciting new series.

Duncan Evans
Series Editor

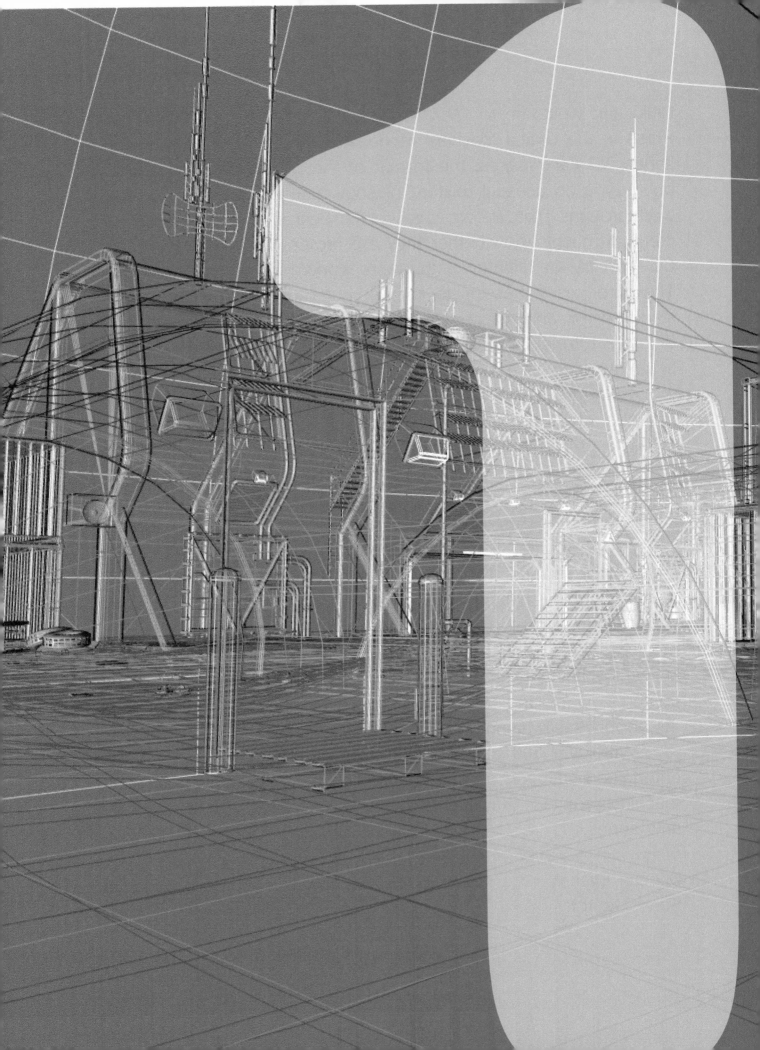

SECTION 1: PREVIZ FOR LANDSCAPES

Regardless of what kind of scene you are going to create and how prominent the machinery in it will appear there are some basic concepts to consider that will help improve the final render. These start with your choice of software. Some are better than others at hard surface modelling, while others excel at adding effects and the surrounding landscape. Get the package that is going to do the job that you want. Then take a look at the concepts of colour temperature, depth-of-field, the art of composition, the choice of focal length for the camera and finally, the burgeoning demand for stereoscopic 3D.

SELECTING THE RIGHT SOFTWARE

There's a handsome selection of packages you can use for creating 3D machines, each with their own strengths and weaknesses

When considering which software to buy for creating scenes featuring 3D machines there are numerous considerations. If you're going to work or train for a professional career in 3D then the Autodesk and Maxon packages are likely to be most suitable as they are most widely used in the industry. Then there's the consideration of whether you actually want to create the machines that feature in your scenes, or whether you're content to texture and light them only. On the creation side you're talking about hard surface modelling and some packages are better at this than others. For pure modelling needs, Modo from Luxology often comes up trumps, while Autodesk's 3ds Max has a better toolset than sibling Maya. A different route is to take pre-designed models and use them in scenes. For this, e-on's Vue has plenty to offer as it can not only create the landscape around the model, there are many options for texturing the surfaces and creating realistic lighting situations. Indeed, that brings us to the next question: how are the surroundings to be created? For anyone making models of cars the answer is usually that the background is a photographic plate and that means using After Effects, Photoshop or another 2D photo editing package to put the images together.

Autodesk 3ds Max

3ds Max is most often used in architectural visualisation, industrial design and advertising product markets as it has a robust modelling toolset and is easier to get on with than stablemate Maya. Max is a very complex, industry standard package and as such it's well used, but not really in animation or game environments. As such it carries a commercial price tag and, while there are trial versions and educational discounts, it's only worth learning if you are looking for a job in the core market areas.

Autodesk Maya

The role of Maya in TV and film is well documented – it's the software of choice for big budget visual effect studios. As such its primary role is in animation rather than static imagery, though it can be used for one-off scenes equally as well. The modelling toolset isn't as varied and the interface is harder to grasp than Max. As such, you wouldn't want to try to learn Maya just for modelling yourself, but if you were intending working in the entertainment and TV industry it is the number one package in that area and consequently has a studio-orientated price tag.

Luxology Modo

A couple of years ago Modo was recognised as a great modelling package but not for much else. The last couple of releases have seen that functionality expand significantly so that Modo now offers an all-round package with those modelling tools being backed up by painting, animation, dynamics, pipeline integration and a new procedural particle engine. Modo is useful for creating machine models as well as working in design, arch viz, advertising and game development. It's also much cheaper than the Autodesk products.

Maxon CINEMA 4D

With a decent modelling side and affordable price, this is a popular package in Europe, and popular with studios creating work for TV such as advertising logos as well as visual effects for programmes and animations. It uses an instancing system for landscape population and has scaled pricing according to the version – each is designed for the separate markets. It is also used extensively in architectural visualisation and is one of the easiest 3D packages to learn how to use.

NewTek Lightwave 3D

An all-in-one package that covers modelling, animation, rendering. It is most popular with studios creating work for American TV but is dated compared to rivals. It has contributed to plenty of big budget films, though it can't compete with Autodesk's Maya for film studios and CINEMA4D is more popular in Europe. Highlights are geometry instancing and fracturing animation. This isn't a package you would choose to learn for yourself, but because the studio you were joining used it.

DAZ3D Carrara

If you're looking for a package that offers integration with DAZ3D's range of figures, modelling, landscape design and animation yet doesn't break the bank then Carrara is probably your best bet. It isn't as sophisticated as the packages designed for studios, but for the hobbyist it adds a level of control over the modelling process that you don't get with DAZ3D's other offering, Studio. The Pro version is more expensive but adds support for 64-bit multi-core rendering.

INFO
Website: www.autodesk.com
Price: from $3675/£3795 or $195/£235.75 monthly, $575 quarterly, $1840/£1897.50 annually
Best for: Architectural visualisation, industrial product design
Format: Windows 7 or 8 (64-bit only)

INFO
Website: www.autodesk.com
Price: from $3495/£3795, $195/£235.75 monthly, $1840/£1897.50 annually
Best for: Big budget TV/Film, animation
Format: Linux, Windows 7/8 Pro, Mac OS X 10.7, Red Hat Linux

INFO
Website: www.luxology.com
Price: $1495
Best for: Modelling, arch viz, product design, rich hobbyists
Format: Windows XP, Vista, 7 and 8 (64-bit only), Mac OS X 10.6.8, Red Hat Linux

INFO
Website: www.maxon.net
Price: $995-$3695/£720-£3120
Best for: TV/Film, advertising, architecture, animation, rich hobbyists
Format: Windows XP/Vista/7, Mac OS X 10.6.8

INFO
Website: www.newtek.com
Price: $1495
Best for: TV/Film
Format: Windows Vista/7/8 (32-bit or 64-bit), Mac OS X 10.6+

INFO
Website: www.daz3d.com
Price: Standard $149.95, Pro - $285
Best for: Hobbyists
Format: Windows Vista/7/8, Mac OS X 10.6+

INFO
Website: www.e-onsoftware.com
Price: Free then $9.95 for themed packs, main versions $199-$1495/Free then $9.95 for themed packs, main versions £166-£1250+VAT
Best for: TV/film, animation, hobbyist
Format: Windows XP/Vista/7, Intel Mac

INFO
Website: www.daz3d.com
Price: Free
Best for: Hobbyists
Format: Windows, Mac

e-on Vue

While Vue is generally regarded as the number one landscape creation package, it also offers an easier route to creating scenes with machines by being able to import and texture those models. It starts with some simple, content-driven packs for just $9.95. The features then scale up to the pro-level xStream plug-in and Infinite versions that have been used in big budget films like Avatar. The best features of Vue are the terrain sculpting and the Eco system. It also features an online content buying system that links directly from the app itself.

DAZ3D Studio

Although the focus of DAZ Studio is posing and rendering people, it's easy to import models, and especially robotic human figures, tinker with the materials and poses and render those. The new Genesis models in particular are impressive. There's a massive amount of pre-made content in an online store so if you wanted a gentle introduction to the genre without having to do any modelling yourself, this is a good option for hobbyists.

COMPOSING THE IMAGE

How the various elements are arranged will determine the ultimate success or failure of an image.

There's no doubt that while great composition won't make a 3D model any better from a modelling point of view, or improve the lighting and textures, it does make the difference between something looking right, dynamic and engaging, or simply looking wrong, awkward and crowded. When talking about 3D machines, it's likely that the machine part is the focus of interest and that almost everything else is background. There are exceptions to this of course, where the view is so close and the machine so big, that it's all about details, or that the entire scene has machinery from top to bottom so it all has equal weight. But, for the most part, the machine, whether that's a car, truck, tank, plane or ship, will be centre stage. How you approach the composition differs slightly, depending on what environment the machine is set in. The most common is where it's on the ground so here we'll talk about cars and for that you can read anything else with wheels and tracks.

Mistakes to avoid

The worst composition of all is to put the vehicle dead centre, sideways on. It's an absolute scene killer. It makes the car look two dimensional, it cuts the image in half, there's no depth and no lead through for the eye. There are two ways to showcase a car and they are either from the front, or from the back. From the front, angle the car to show the bonnet and front grill and you immediately add depth to the subject. Put the back end close to the side of the image, leaving more space at the front end and you give the car room to breathe and move. It looks like it is moving into the scene, not leaving it. It's also the best view for simply showcasing a car that isn't moving. If you rotate the car all the way around so that it is facing the camera, you have many of the problems of the side shot, but you can mitigate these by angling the camera, adding blurred backgrounds, shining lights and so on, to make it seem like the car is hurtling towards the viewer. That way the image becomes dynamic and action-orientated.

When showing the car from the back, again, it should be angled so that you can see down the side as well. Also, the positioning needs to be carefully done so that there is enough scenery in the direction that the car is heading, so the viewer can see that the car is heading off in that direction at speed. You are sacrificing the detail and possible view of the driver that you get from a front view, for action and drama. A completely flat from the back shot doesn't really work at all because it is so limited.

Lead through is another important concept in composition. By this I mean having items of interest that lead the eye through the image, from the foreground, which is usually at the bottom, to the background, which is usually at the top of the image. That's why angled cars work so well, the shape of the car takes you through the image. It's also important to avoid dead space areas where the eye doesn't go and where nothing is happening. In detail shots, specifically close up ones, the idea isn't lead through, but content, and here you need to fill all the areas with things to look at. It's more of an exploration, a treasure hunt for details, so it's important that there are no empty areas.

Using the rule of thirds

The rule of thirds is a classic landscape compositional aid which works by dividing the screen into thirds both horizontally and vertically. The basic concept is to place the horizon on either the bottom third which is the best option for cars, or the top third, which is the better choice if the camera is angled downwards. In landscapes the aim is to put key interest points on the lines of the thirds and, if possible, on where the lines intersect. Now that isn't always possible, and in car shots especially so, but placing the horizon appropriately should always be a consideration.

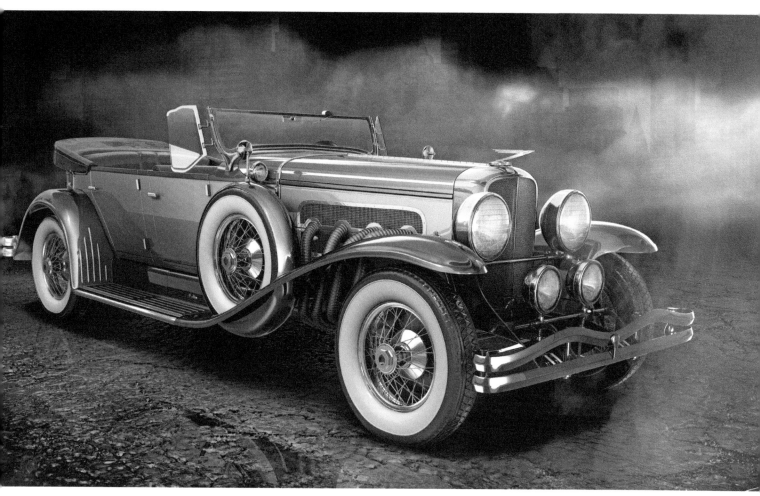

The 1929 Duesenberg Model J Dual Cowl Phaeton by
Alexandr Novitskiy shows a traditional front and side shot,
with space in front of the engine, showcasing the details of
this beautiful car.

IN THE AIR

Aeroplanes, spaceships or flying machines in general can
either be on the ground or in the air. When on the ground,
just treat them as you would a car in terms of positioning,
though a front view is going to work much better than
a rear view. Where you really want to make airborne
machines work though is when they are flying. Fighter
planes especially have sleek, sharp lines that work well
on angles, whether that's three dimensionally with the
plane coming towards the camera at an angle, or from
above. With this latter shot, you are reducing the plane
to a two dimensional object, much like the frontal shot of
a car, so you need to compensate by having the plane at
a diagonal angle and showing the landscape screaming
by underneath which gives the image depth. It's usually a
good idea to put some motion blur into the landscape to
give that impression of speed. The alternative to showing
the landscape is to picture the plane in the sky and
here jaunty angles, with the plane heading upwards, are
good as they infer a sense of speed, power and ripping
through the sky into space.

RENDER CAMERA LENSES

Use different camera focal lengths to change the view in your render scene

Whether your machine is the centre of attention in the scene or simply part of an overall landscape, the choice of focal length for the render camera plays an important part in how it looks. The standard focal length used to be 35mm, in 35mm film camera terms, and some software still defaults to that, but a wider angle of 28mm is more common. As the focal length of the camera reduces, so the field of view increases, so that 18mm focal length produces a much wider field of view than even 28mm. When you get down to 12mm you're talking about fish-eye lens effects because the lower the focal length, the more distortion is introduced. Whatever is in the centre becomes more highlighted and everything else bends away. It means for car renders, a wide angle lens is often very useful, because if the car is right at the front of the scene, at an angle, the point of focus can be the front corner, and you then get a great sweep of the bonnet towards the rear of the car and the rest of the scene becomes completely secondary.

At the other end of the spectrum, a telephoto lens uses higher focal lengths and brings everything in the scene closer. It also has the effect of narrowing the field of view. Now, telephoto lenses are used in reality to bring things closer because you can't physically get any closer to the subject. In 3D that isn't a problem, just move the camera to wherever you want. Unless the scene is specifically showing the viewpoint from a human point of view, you aren't restricted.

So that brings us to the effects of using long lenses or high numbered focal lengths. One common misconception is that longer focal lengths compress the perspective of the scene, which is to say, that the distance between objects in the foreground and background appear closer together than when using a wide angle lens. In actuality, it doesn't really happen at all, it's simply that if you increase the focal length, the field of view narrows and all the objects come closer to the camera. So, the practical use for telephoto focal lengths is simply to narrow the viewpoint. This works well if the scene is presented in portrait orientation because it focuses everything in the middle. Or if your machine is say an aircraft or spaceship, flying down a canyon, then a narrow field of view will encapsulate the scene better. There's also the issue of distortion as mentioned earlier. While a focal length of around 75mm produces very little distortion, there's also an old trick in portrait photography which is to use a 200mm telephoto lens and stand further back. It narrows the field of view, has no distortion and produces a shallow depth-of-field. For your machine image, move the render camera back so that the subject appears as close as it was before, rather than right on top of it, but now you will find the scene much narrower.

However you use the render camera focal length is down to what you want to do with the subject, how it appears in the scene and how you want the background to be represented. Experiment with different settings and move the position accordingly to see the different effects it can create.

DIFFERENT FOCAL LENGTHS

The camera focal length changes from wide angle to telephoto with each image.

24MM The wide angle view encompasses the entire scene but pushes most elements into the background.

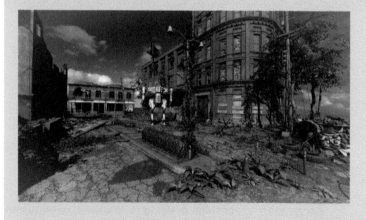

35MM A standard viewpoint now bringing the background closer but immediately losing the ruined car in the foreground.

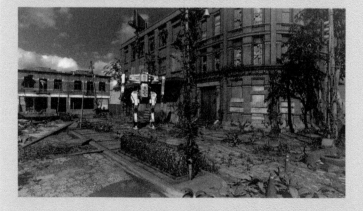

50MM

A modest telephoto, often used for portraits. It excludes most of the foreground and shows the machine in the mid-ground.

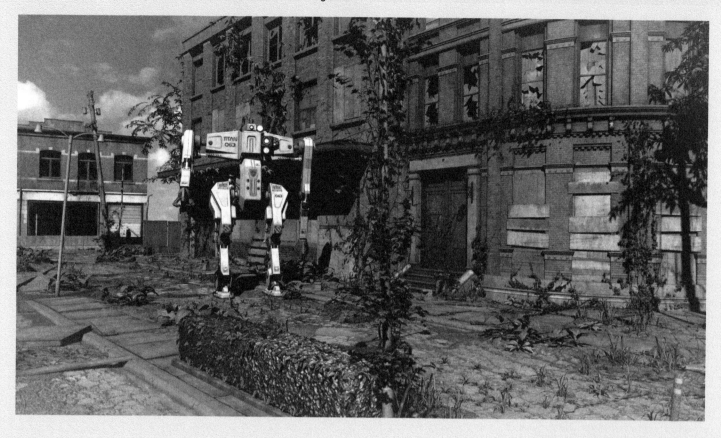

80MM

Telephoto lens view removes the foreground detail completely and focuses directly on the robot machine.

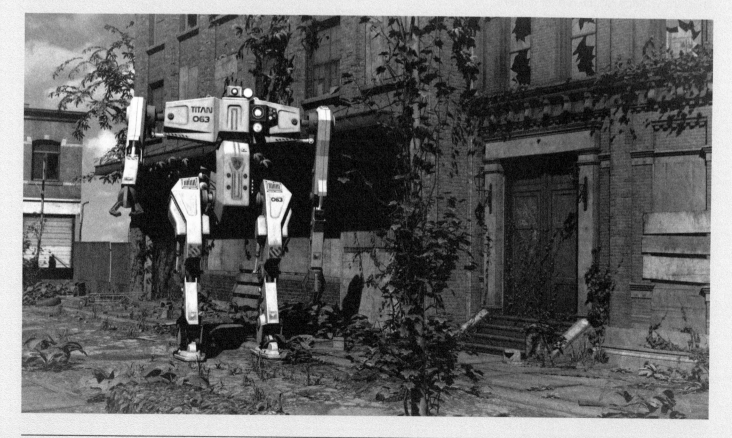

USING DEPTH-OF-FIELD

Select lens types and apertures to create customised depth effects

One of the effects of using different focal lengths is that it changes the amount of depth-of-field generated in the scene. D-o-f is, of course, the amount of the scene that is in sharp focus, from front to back. With actual camera lenses, wide angle lenses produce lots of d-o-f at all aperture settings while telephoto lenses, or high focal lengths, say 200mm, produce very little. The aperture determines how much light comes into the camera, with a wide aperture letting in a lot but producing a very shallow d-o-f and a narrow aperture letting in very little, but producing a lot of d-o-f. Now, on some software, the amount of light let in by the aperture is irrelevant because this is tied to the shutter speed to produce an exposure. In 3D it tends not to matter because the exposure time is an artificial construct so that the image is produced with a set lighting level. On more sophisticated software, you can tie the two together, but equally, they can be separated and you just have to concern yourself with the aperture.

Where this all comes into play when creating a scene with a 3D machine in the mix is deciding how much you want the background to be visible. For cars or single objects in a pure CG scene, except for perhaps the sky, then including all the background means a narrower aperture setting, or using a wide angle lens, to ensure that there is plenty of d-o-f and you can see what's going on all the way through the scene. With a photographic backplate, the d-o-f in the CG part needs to be consistent with how sharp the background is. The alternative to these is to use a medium d-o-f so that the immediate surroundings are all nice and sharp but the background is slightly blurred, or really just emphasise the subject by using a shallow d-o-f so the entire background is blurred. Obviously you need to be careful when setting the focal point so that the subject is in the sharp area of focus.

APERTURE EFFECTS IN PRACTICE

Here are two versions of the same scene using very different aperture settings for the render camera.

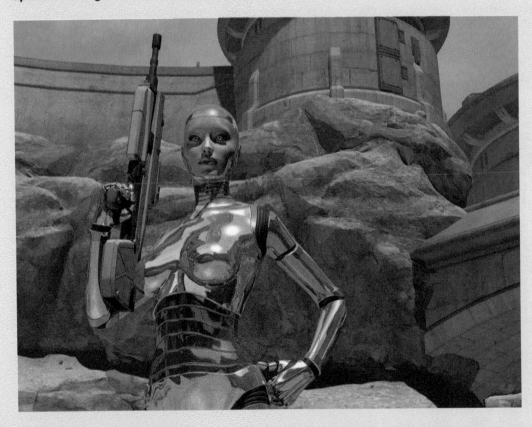

The figure competes with the background thanks to the copious depth-of-field.

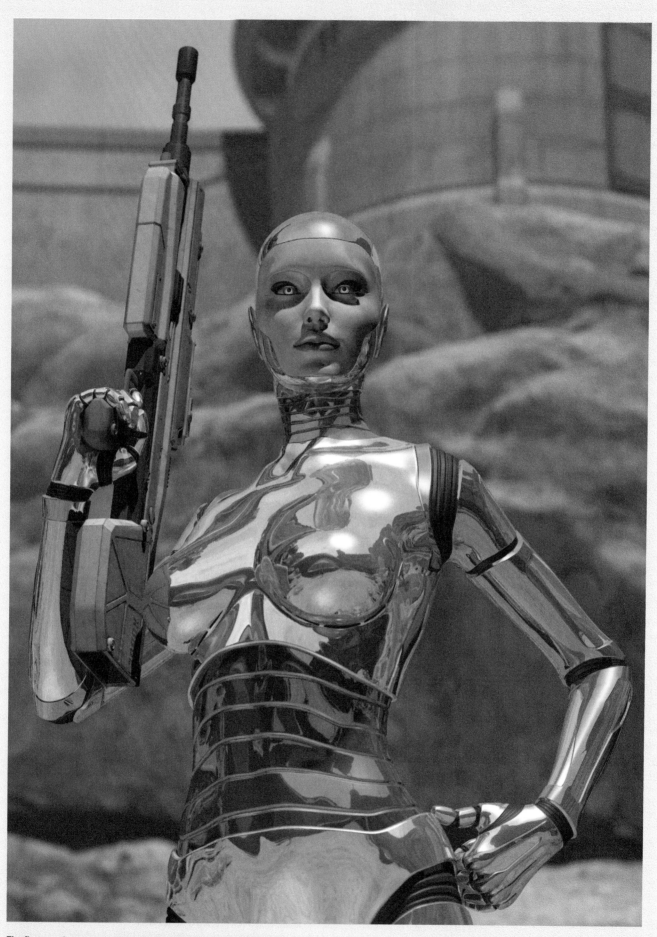

The figure no longer competes with the background thanks to
using a wide aperture setting for a shallow depth-of-field.

SETTING THE COLOUR TEMPERATURE

How to use temperature to set the scene and enhance the environment for your machine subject

All light has a colour temperature, measured in degrees Kelvin, with lower numbers for very low levels of reddish light and high numbers for cold, blue light. The colour temperature of natural light changes throughout the day and is also modified by weather conditions. At mid-day it is said to have a temperature of around 5500K–5600K which gives white light. Shade in the morning produces blue light as does high cloud cover. At sunset and sunrise the light is much more red and is more like 2000–3000K. Artificial lights tend to be lower, with fluorescent lights at 3300K, giving a yellow/greenish light, tungsten at 2500K and candle light at 1800–1900K.

So where does this come into play for your 3D scene? Well the first thing is that since you have control of the scene, you don't have to struggle with difficult colour lighting, it can be whatever you want it to be. The second is that sunset and sunrise are automatically associated with red and orange colours with the viewer, so giving a scene a blue tinge would look wrong. The other point to note is that metallic surfaces work well with blue tones, so setting the scene under cloud, in the shade, or with a high mid-afternoon sun with deep shadows, will look authentic. Of course, car images do like a sunset, which suits a dramatic or a passive image, but it's something to consider.

For indoor lighting, you need to be more considerate of what is going on in the scene. If there are mixed lighting sources, you should consider mixing up the colour temperatures as well. For example, a scene lit by fire or tungsten lighting, that you create as white light would, in nature, make any natural light coming in from outside look blue. The opposite applies – if you balance the scene so that the natural light from outside looks white, then any artificial light inside should have a distinctive low colour temperature.

THE TEMPERATURE CHART

Here's a simple guide to the colour and temperatures involved at different times of the day.

10,000K	Clear blue sky
	Shade on clear day
	Cloudy sky
5,500K	Average noon
	Mid-morning, mid-afternoon
	Late afternoon
	Fluorescent
	Household tungsten
	Sunrise, sunset
	Match flame
1,000K	

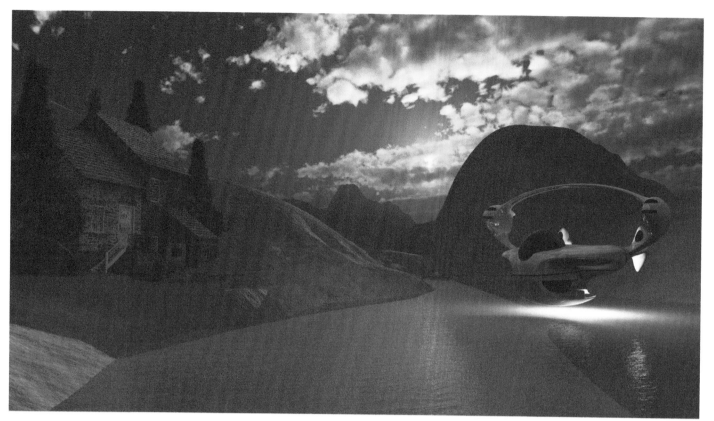

This is the standard view of this image where the spaceship light is white, the house lights are yellow from tungsten but the sunlight doesn't exert a significant influence on the scene.

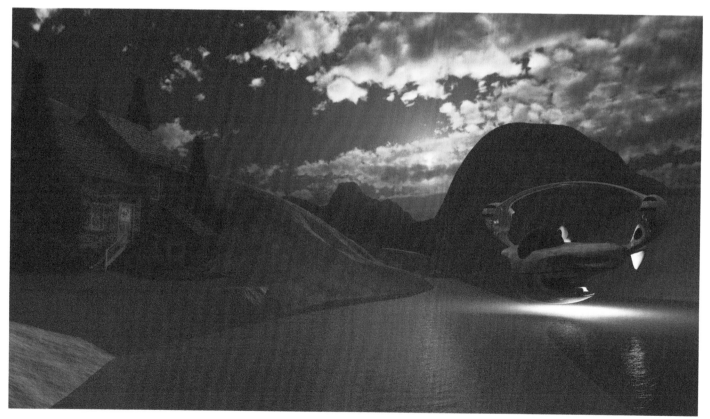

Here's an edited version where the rest of the scene has had the colour temperature lowered to make more of the sunset effect, while retaining the white light from the ship.

Osprey ship courtesy and © Terry Allitt

STEREOSCOPIC IMAGERY

Take your CG images into the next dimension by creating a 3D version

With actual 3D, rather than referring to all CGI as 3D which everyone in the industry tends to do, there has been a resurgence of interest from the brief hey-day in the 1950s. This has been driven by cinema, which has profited by being able to charge a premium for a 3D showing against a 2D one. One of the unfortunate side effects of this seeming bonanza is that studios have rapidly retro-converted ordinary films into 3D in order to cash in. Clash of the Titans was one of the earliest attempts at this, being rushed through in only around eight weeks once the actual feature had been finished. At the other end of the spectrum was Avatar, which was filmed with stereoscopic cameras to create a more natural 3D result. Many 3D visual effects were added in post production but even then they were in consistent because lead studio Weta didn't have enough time. ILM, Framestore, Prime Focus, Giant Studios and Hydraulx all chipped in and this meant that some scenes featured things in 3D that stood out a lot more than others. All of which brings us to presenting your work with a 3D effect, rather than a flat 2D representation of a 3D scene. There's no doubt about it, if you want to add the wow factor to a presentation, visualisation or effect, showing in 3D immediately engages the viewers a whole lot more. As you might have gathered from the introduction though, there's a lot of different ways of going about it.

The simplest thing to do is to render your machines as you would normally, but then use a 3D monitor to turn the 2D display into 3D. There are a number of monitors that can do this at very affordable prices these days. An LG D2343P, 23", IPS LED monitor with 3D function is under $200/£150 for example. The depth effect created is graduated and goes backwards from the monitor front into the distance. The rest of the time it can simply be used to display 2D images.

For actual image creation there are two main types: anaglyph and stereogram. Both CINEMA4D and Maya use the anaglyph method which basically separates the channels of an image and spaces them slightly apart. Coloured glasses are then used to block out a channel for each eye, leaving the brain to recombine the two channels left into one, 3D image. Needless to say there's a small problem with this. Monitors use an RGB process (CMYK is used for print) which is, of course, three channels. So, two of the channels have to be combined into one which is why the glasses used to view anaglyph images are either red and cyan – not blue, the cyan is actually green and blue, or green and magenta – not red, the magenta is blue and red. Of these, traditionally, red and cyan have been used, but in practice, green and magenta actually gives better results, particularly for landscape-based scenes. The point though is that the software has a 3D mode and can display the scene you model and create in 3D at the end. The advantages of anaglyph are that the images can

be viewed easily on screen or in print with very cheap cardboard and plastic glasses.

The alternative to anaglyph is the stereogram. This is where the same scene is displayed twice, but the camera has been moved slightly to the left or right of the original image giving a slightly different perspective. The two images are then viewed through polarized glasses where each lens blocks out one of the two images. The eyes see one slightly different image each and the brain then combines these into a 3D result.

In the cinema and on TV, it isn't practical to try to shove two letterbox sized images next to each on the same size screen, so instead one frame is displayed first, then the alternative frame is displayed next. As the format is a motion-based one at 25fps or 30fps the images can be displayed quickly for each individual frame to be seen. Again, the glasses filter out the other image, allowing the brain to recombine what it sees through each lens into one, 3D image. On paper, this was the original method of creating 3D and it is very effective. It doesn't suffer from colour fringing effects that can plague the anaglyph method, but the disadvantage is that it takes up twice the space. On monitor screens, putting a static image twice across it essentially reduces the size by half as well which is why it generally isn't used. For animation though, actual stereoscopic film delivers better results than anaglyph but requires more dedicated hardware and more expensive eyewear.

A post-script to creating 3D with your CGI images is to create some effects in post production with Photoshop. It's easy to simply move one of the channels to one side to create an anaglyph image that, when viewed with the right glasses, then appears to sit behind the monitor screen. It won't appear to have any actual depth though. For that you can cut up parts of the image to increase the channel separation for a foreground, midground and background effect. This then starts to be more trouble than it is actually worth but it means you can retro-fit existing images into 3D long after the source files have gone. If you are starting out, while you could do separate render passes for each area then tweak the channels in Photoshop, it's a whole lot easier to just use software that supports the 3D process in the first place.

Software like Autodesk Maya now comes with stereoscopic modes that use twin cameras to create a true 3D image.

It's easy in Photoshop to make an existing image into a basic anaglyph 3D version, but this will still look quite flat.

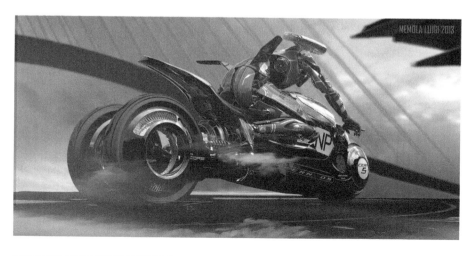

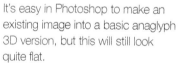

This is another view of Luigi Memola's AEG27-CERN05 image, turned into a two-part 3D image so the background appears further away from the rider. View it with red–cyan glasses for the effect. Go to page 232 to read more about the original image.

SECTION 2: MACHINE MASTERS – SHOWCASES AND TUTORIALS

Get ready for awesome 3D machines as we welcome you to the main section of the book. Here you can admire the work of machine masters through a range of showcase images and discover interesting and valuable insights and tips from the workflow of the tutorials. Each chapter in this section covers a different style of image making, from cars and trains to tanks, steampunk machines and spaceships, with a selection of the best artwork out there and one or more tutorials. Read on to see what is covered.

CREATING THE LAMBORGHINI AVENTADOR

Michael Hirsch reveals how he modelled, textured and lit the ultimate, luxury sports-car from Italy in 3ds Max, using the Madcar plug-in.

CONCEPT BACKGROUND

There was a fantastic, expensive car, built in Italy, called the Lamborghini Aventador that featured a V12 engine, capable of 0–100 km/h in 2.9 sec and with a top speed of 350 km/h. With futuristic styling for the carbon fibre body, I was really impressed by the car and decided my next CGI project in Maya would be to create one.

To start with, I had the idea of an old factory building in combination with a new piece of architecture which should symbolize the temporal change, and somewhere in the middle would be the Aventador.

It was time to think about the car paint colour. I knew it should be a bright colour, maybe metallic white. I love white cars and in my opinion, a white paintwork fits perfectly into a sunset situation. I used this creative decision as a starting point for my new project which was to be called, "Dream Factory".

The Lamborghini Aventador being unveiled at the Geneva Motorshow in 2013.

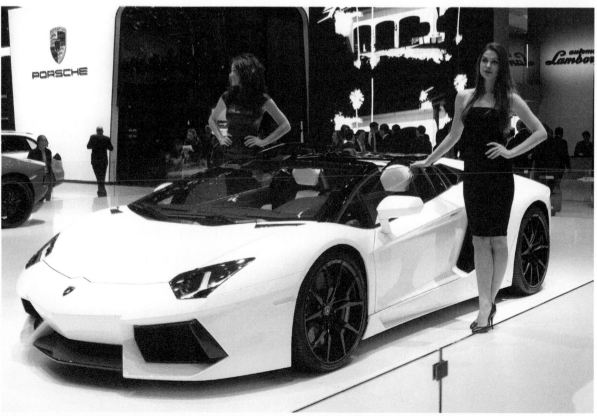

STEP 1
MODELLING THE FACTORY

First of all, I went on the web to search for some photo reference materials. By looking at the actual car from various angles you get a good idea of how it should look. The alternative is to get hold of blueprints of a vehicle, if you want to make a perfectly accurate version. For modelling the assets, I used the poly modelling technique. I just added details at the points of interest. The first stage was to build the factory itself.

STEP 2
ADDING DETAILS

The key point was to have a roof overhead, but that the side would be wide open to let the light in. I added basic circular tubes as supports and created the fence and doors to the factory area.

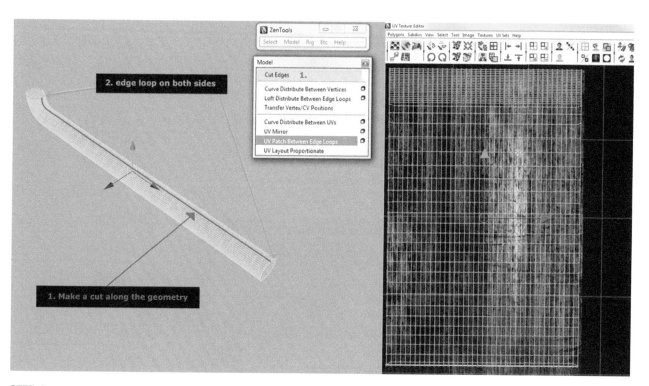

STEP 3
UNWRAPPING THE UVS

For the UV setup I used standard mapping techniques like planar, cylindrical and automatic mapping. Furthermore I used a very nice tool called "ZenTools". This tool makes unwrapping of complex geometries very easy. You just have to select the first and the last edge of an object and the tool does the rest – very clean and fast.

PROJECT	DREAM FACTORY – LAMBORGHINI AVENTADOR
SOFTWARE USED	AUTODESK MAYA, V-RAY FOR MAYA, ADOBE PHOTOSHOP
RENDERING TIME	APPROXIMATELY 3 HOURS FOR THE CAR PASSES AND 8 HOURS FOR THE ENVIRONMENT
ARTIST	MICHAEL HIRSCH
COUNTRY	GERMANY (MUNICH)

STEP 4
CREATING TEXTURES

For texturing the buildings and the floor, I used Photoshop and my DSLR camera. I shot all images in RAW format to achieve more flexibility and higher quality textures. For the floor I created three different high resolution displacement maps. For a better result and more flexibility, I split the ground plane in smaller pieces by the same proportions.

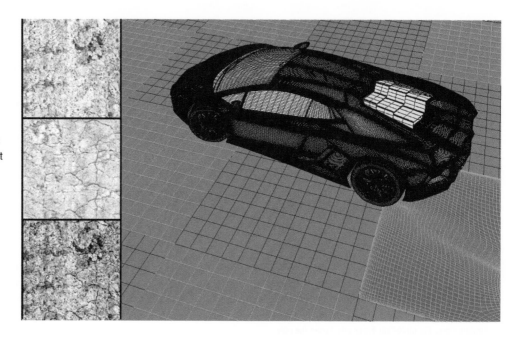

STEP 5
ANGLE HUNTING

Almost every time, when I start modelling an environment, I know pretty well how the scene should look before I am finished. It's exciting for me in a still project to find a nice camera perspective. In this image, there were a lot of things I had to pay attention to. The first was the car's position. The second was the final alignment of the buildings. The third was to find a good looking camera angle which is equally suited for architectural photography and also car photography. For the maximum amount of realism in architectural photography it's best to keep vertical lines actually vertical. In this case the camera has to be at a 90 degree angle, horizontal to the floor. To get the result I wanted I took advantage of a technique called "lens shift" so that the car was standing in the position I wanted with the vertical lines of the architecture still in their vertical position.

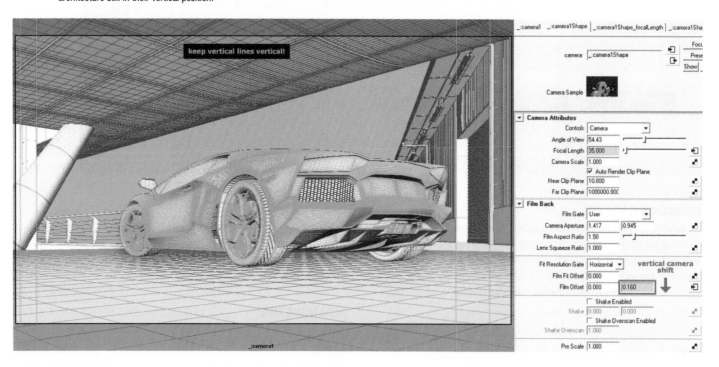

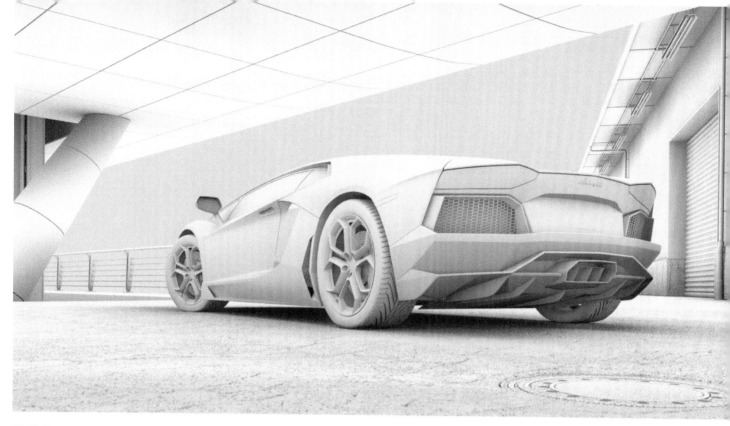

STEP 6
SHADING AND LIGHTING

After modelling the scene and creating the UVs and the textures, it was
time for a render preview in an Ambient Occlusion look, to prove whether
all the geometrical parts and the displacement textures were working.

STEP 7
LIGHTING POSITIONS

For lighting the scene I used three different types of lighting. You can see
in this screenshot all the various sources, designed to shine onto the car
to make sure it was bright, even with the bright sunlight outside.

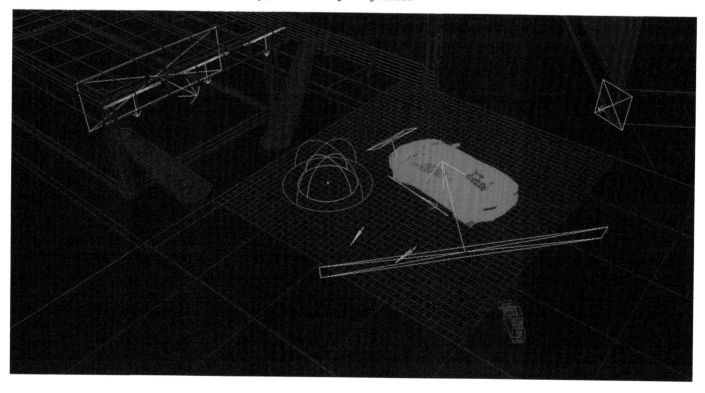

STEP 8
NATURAL LIGHT

For the natural lighting I used a V-Ray Domelight with an integrated sunset HDR. Furthermore, some area lights for the building were used to simulate artificial light sources. The car itself interacts with all the light sources in the scene. For accentuating the car body form, I used specular lights in the form of area lights. The wheels got a brightener in the form of two spot lights. On the opposite side I used a rim light for the trunk to get the feeling of more depth.

STEP 10
RENDERING THE SCENE

For rendering the whole scene I used V-Ray. I rendered the complete scene with render elements to get maintain flexibility in the post process later. I rendered eight different layers plus some RGB masks for the car and environment. These included diffuse lighting, normals, reflection, refraction, shadow, specular layer and Z-depth layer. For the linear workflow I used the method with a gamma correction node in all shaders and not the method over the linear workflow button in the Vray Render settings, because this button is for testing purposes only. For better handling in Photoshop I rendered the car and the environment separately.

STEP 9
PAINT SHADING

For the car paint I used a V-Ray blend material to control diffuse colour, specular highlights and reflection values separately. In realistic environments, the car paint consists of more paint layers. For example, the base colour layer, metallic effect layer and a clear coat layer.

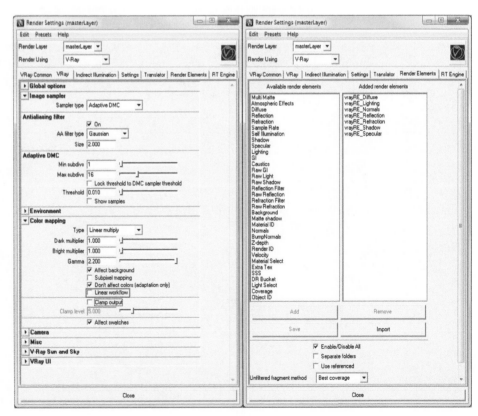

STEP 11
COMPOSITING AND ADDING THE FINAL TOUCHES

The time had finally arrived to add the final touches in Photoshop, to bring more drama into play, with sun rays, haze effects, a little bit of photographic grain, depth-of-field and so on, but with as little manual retouching as possible.

STEP 12
REFLECTION LAYERS

I try to squeeze as much as possible out of the 3D part so that I have as little as possible to add in Photoshop other than final colour corrections and some reflection improvements. For the reflection improvements of the car I rendered four different reflection layers – one each for the side, the trunk, the front and the top part. This is nothing different to what a professional automobile photographer does when shooting on location to get the most out of the car.

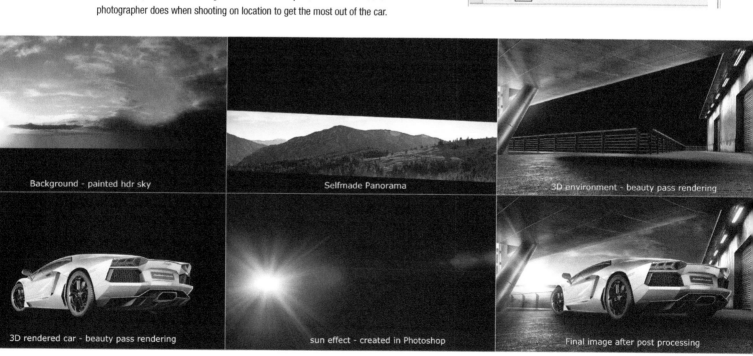

Background - painted hdr sky

Selfmade Panorama

3D environment - beauty pass rendering

3D rendered car - beauty pass rendering

sun effect - created in Photoshop

Final image after post processing

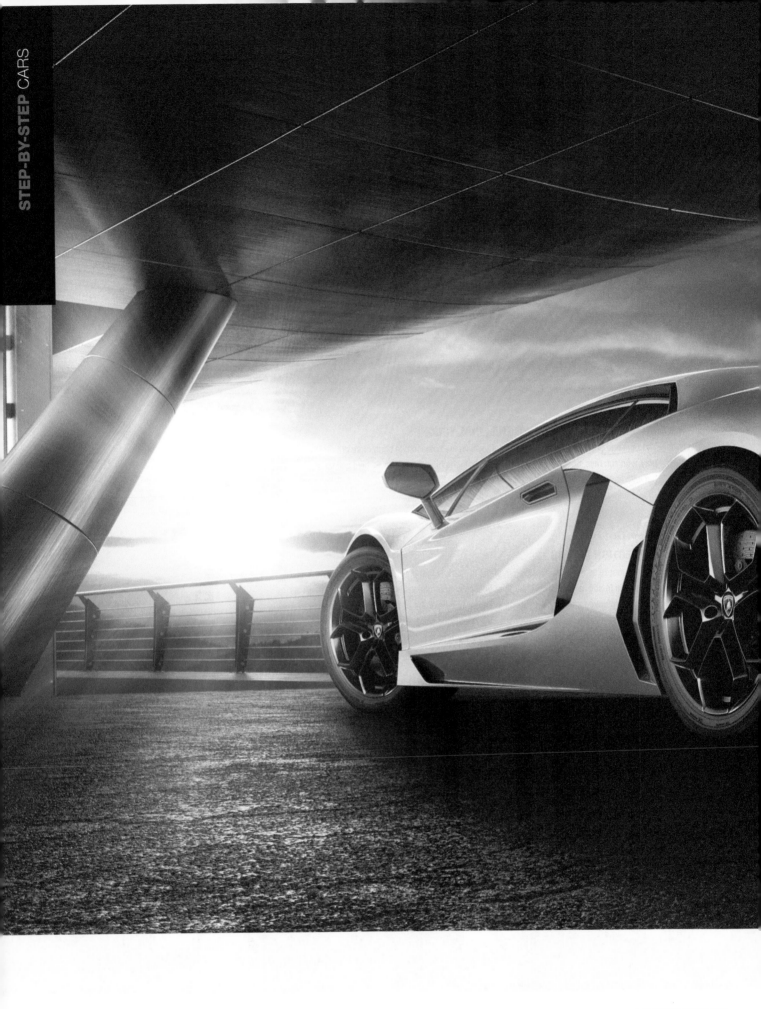

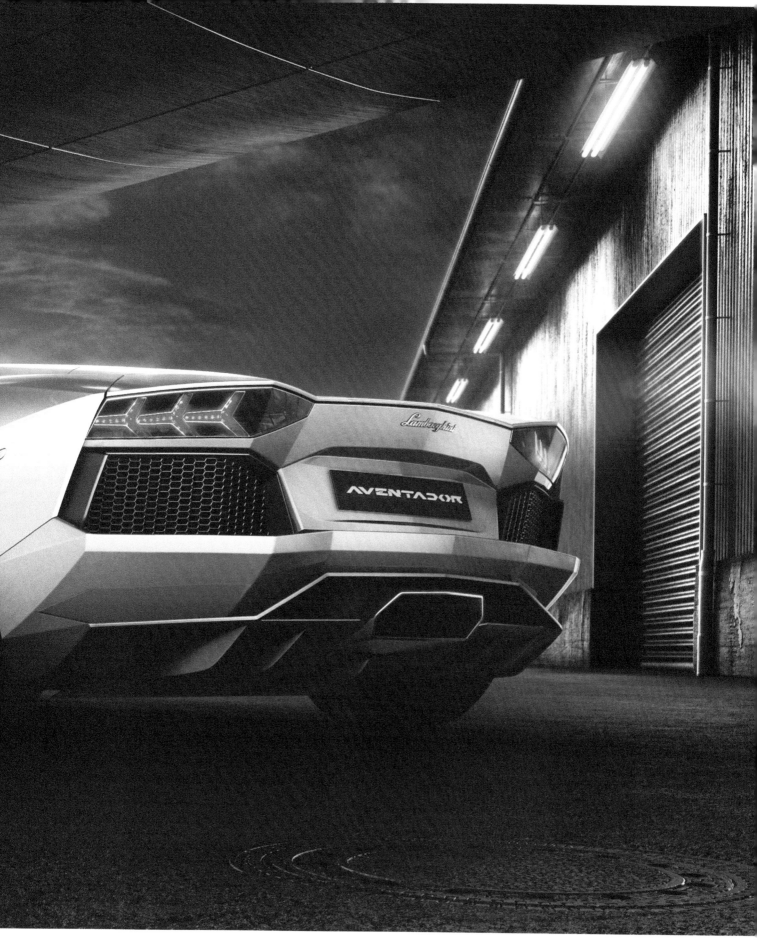

LAMBORGHINI AVENTADOR
BY MICHAEL HIRSCH

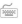 AUTODESK MAYA, V-RAY FOR MAYA, ADOBE PHOTOSHOP

3 HOURS FOR CAR PASSES, 8 HOURS FOR ENVIRONMENT

" Personal project together with my former colleague, car photographer Karl-Fredrik von Hausswolff. The car model was originally purchased, but we edited some topology for better rendering, modelled the kayak, some props and new alloys. We shot the backplate and an HDR image at Torö beach near Stockholm. This was later used for most of the lighting and reflections, but I also added some CG fill lights to give the front of the car some gradients. The final render was later composed and retouched together with the backplate in Photoshop, where I also added the final colours and effects. **"**

PROJECT	MORNING GLORY
SOFTWARE USED	CINEMA 4D, MAXWELL RENDER
RENDERING TIME	4–5 HOURS
ARTIST	FREDERIK TENNHOLT
COUNTRY	SWEDEN

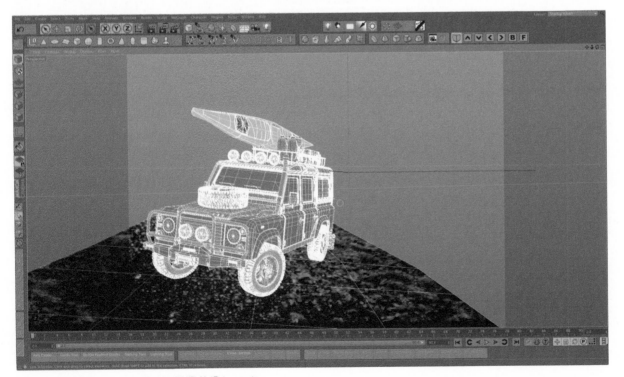

The topology of the car was edited in CINEMA4D to create better surface definition for rendering.

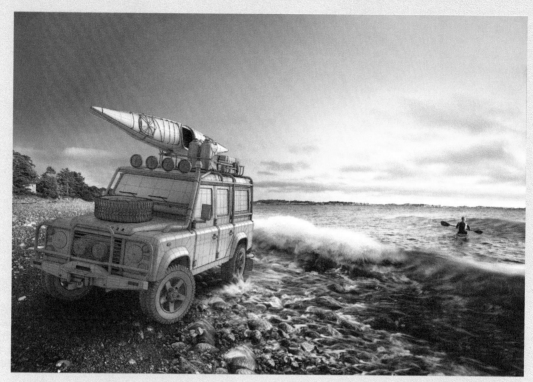

Wireframe model positioned on the beach which was specifically photographed from this perspective.

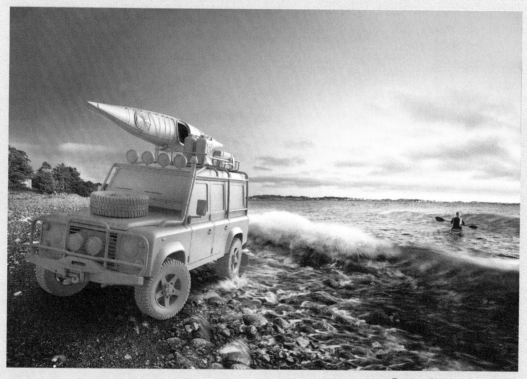

Render without textures to see where the light worked and where it needed extra spots.

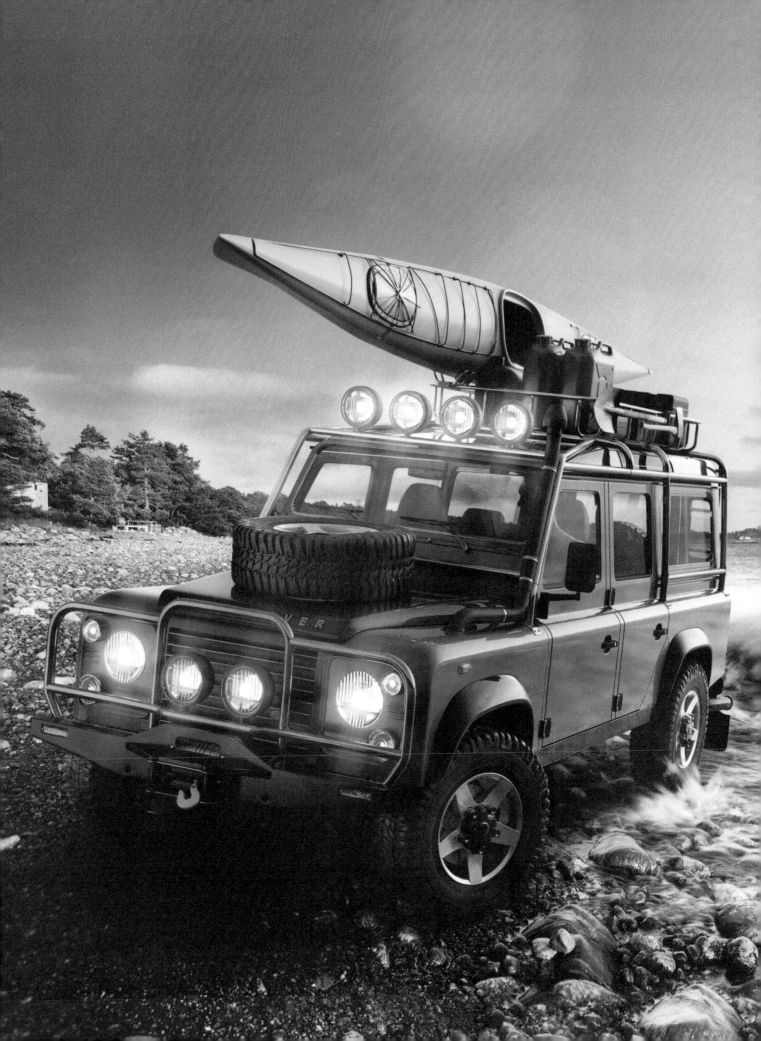

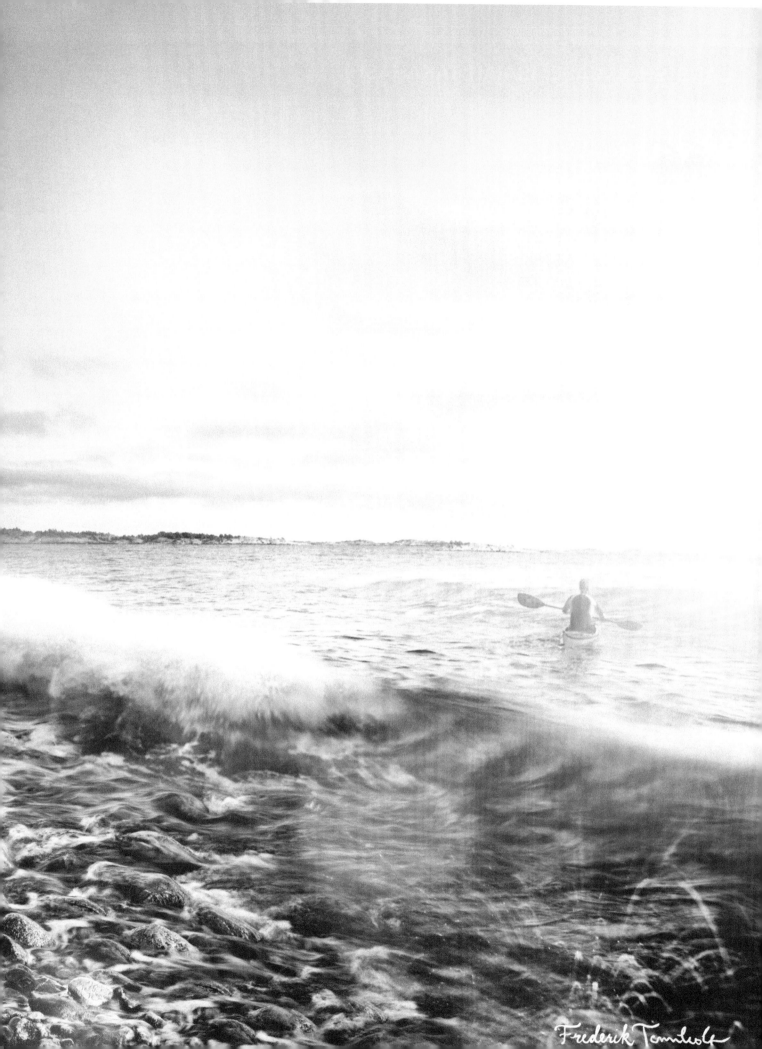

Frederik Tornholt

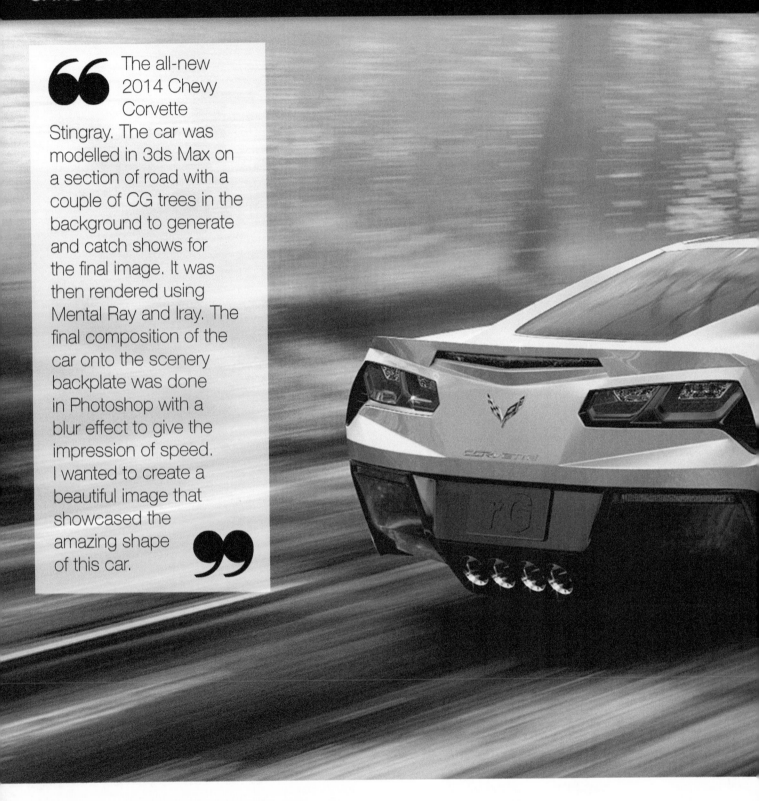

> The all-new 2014 Chevy Corvette Stingray. The car was modelled in 3ds Max on a section of road with a couple of CG trees in the background to generate and catch shows for the final image. It was then rendered using Mental Ray and Iray. The final composition of the car onto the scenery backplate was done in Photoshop with a blur effect to give the impression of speed. I wanted to create a beautiful image that showcased the amazing shape of this car.

PROJECT	2014 CHEVROLET CORVETTE STINGRAY
SOFTWARE USED	3DS MAX, MENTAL RAY, IRAY, PHOTOSHOP
RENDERING TIME	APPROXIMATELY 4 HOURS
ARTIST	ISAIAH TAKAHASHI
COUNTRY	USA

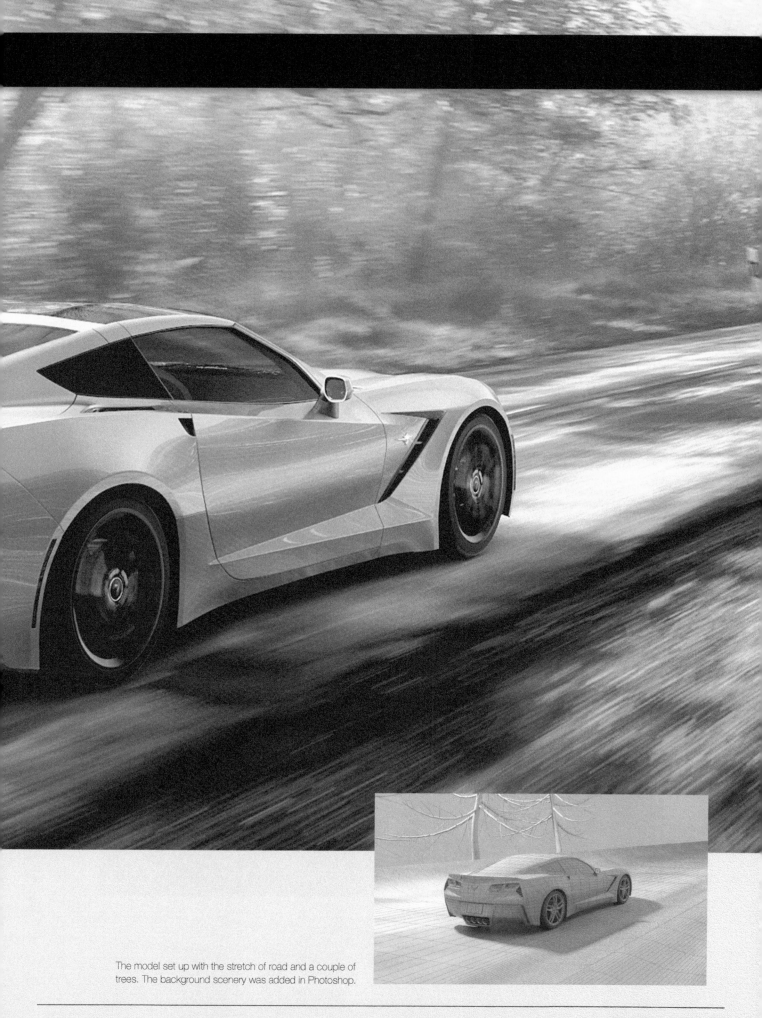

The model set up with the stretch of road and a couple of trees. The background scenery was added in Photoshop.

66 The model of the Duesenberg was created and lit in Maya. The backgrounds are basic building shapes with textures to show windows and other background detail. Photoshop was used to create the atmosphere and colour styling. There was a lot of detail in the model to really show how intricate the car actually was. Rendering was done in V-Ray. It's one of my favourite cars because of the gorgeous design and sleek, clean lines. 99

PROJECT	1929 DUESENBERG MODEL J DUAL COWL PHAETON
SOFTWARE USED	MAYA, 3DS MAX, V-RAY, PHOTOSHOP
RENDERING TIME	APPROX 4 HOURS
ARTIST	ALEXANDR NOVITSKIY
COUNTRY	UKRAINE

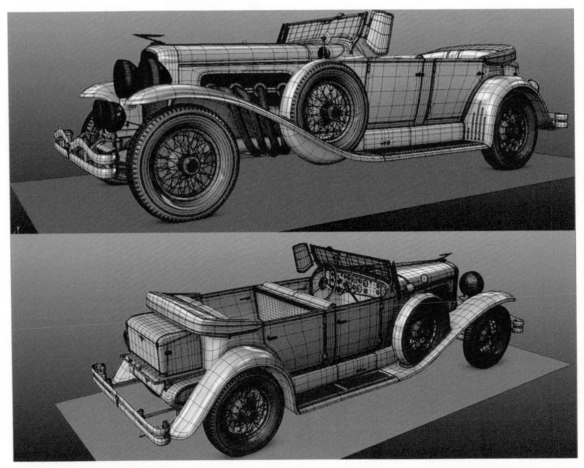

The wireframe model completed in Maya to show all the tiny details.

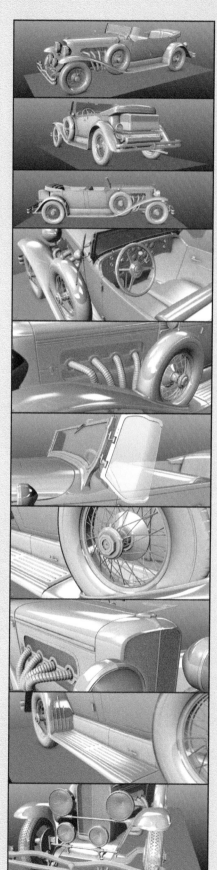

Adding lighting effects to bring the car
to life prior to rendering.

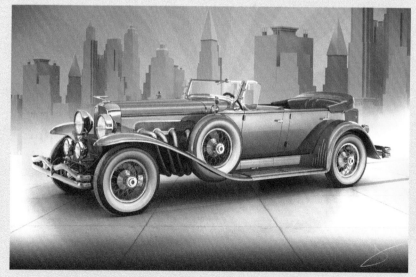

Ready in the scene with the box-building backgrounds
that would just be visible in the scene.

Some of the details in close
up with the solid model.

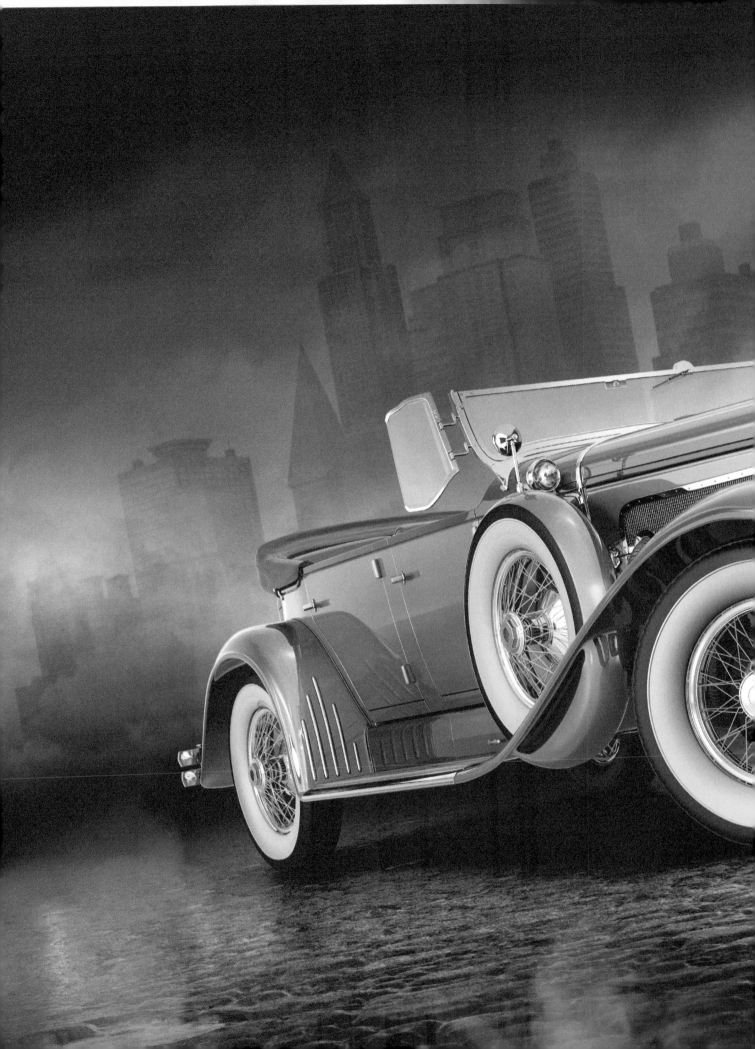

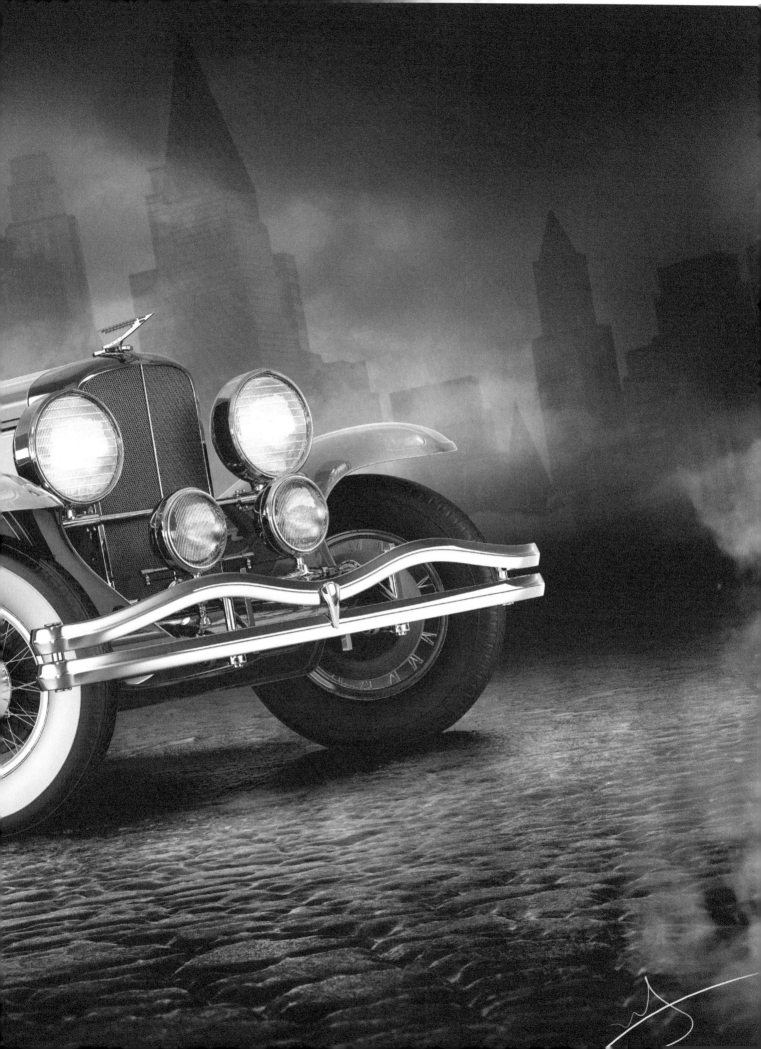

Modelling Bob Burman's head in ZBrush to ensure as accurate a resemblance as possible.

The intricate engineering was modelled while referring to original drawing and plans of the car.

> **"** In 1911, Bob Burman ripped across the immensity of Daytona Beach at a record speed of 228.1kmph. The sound and speed of his Blitzen Benz as it carved through the sand changed man's perception of what was possible. Now, for the first time ever and in stunning detail, Bob Burman's reminder of what we can achieve with technology can be seen in a new light. In full CGI and astonishing 15.000px resolution, Playground have brought this extraordinary shot forward in time so that once again, it shifts our view on how quickly we're moving towards the possible. **"**

PROJECT	BOB BURMAN'S BLITZEN BENZ
SOFTWARE USED	3DS MAX, ZBRUSH, PHOTOSHOP
RENDERING TIME	16 HOURS, FOR THREE SEPARATE LAYERS
ARTIST	PLAYGROUND PRAGUE
COUNTRY	CZECH REPUBLIC

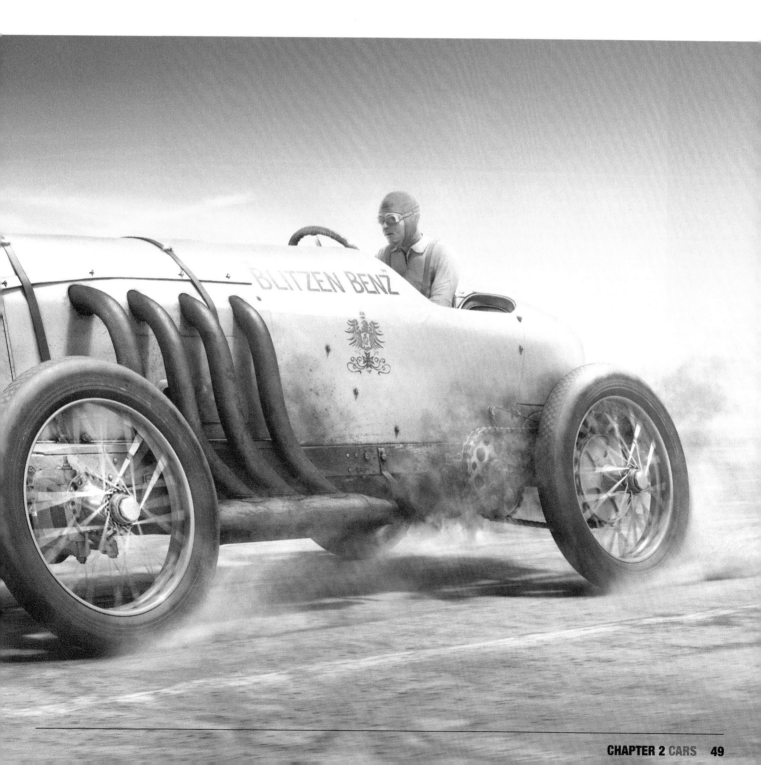

HOW TO ANIMATE AN AUDI A8

André Kutscherauer explains how to rig and animate a car inside 3ds Max, using the Madcar plug-in.

ANIMATING A CAR

The purpose of this tutorial it to show how easy and fun it is to animate a car with the Madcar plug-in within 3ds Max. You will learn how to prepare a finished modelled car for animating with Madcar, how to rig it and how to set up and fine tune Madcar. There are some essential tips on how to realise a whole car animation sequence with different camera views. Discover how to set up the whole car rig and how to fine tune the physics settings of the plug-in. Finally you simply need to plug in your game controller and start driving your car like in a video game, even with analog input! Madcar will calculate every car movement in realtime. There is a finished animation that can be viewed on www.ak3d.de.

PROJECT	AUDI A8
SOFTWARE USED	3DS MAX, RHINOCEROS, MADCAR, IRAY
RENDERING TIME	ABOUT 2 HOURS
ARTIST	ANDRÉ KUTSCHERAUER
COUNTRY	GERMANY

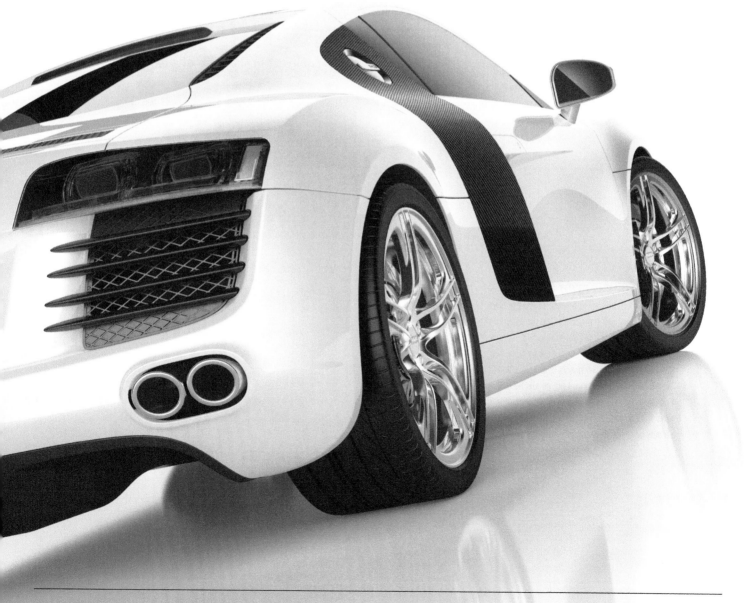

STEP 1
MODELLING THE CAR

The first step is to model a car. I have written a 650-page tutorial on how to model an Audi R8 in high quality with Rhinoceros. It is available as a real book or as direct PDF download on www.ak3d.de. You will learn how to construct the whole model from scratch up to the quality as seen on these renderings and in the animation. Each working step is illustrated with a screenshot, the tool used with an icon and a description what to do. For this MadCar tutorial you can then use your own car model or one downloaded from a resource site.

STEP 2
GROUPING THE OBJECTS

Once you have a finished 3D car model, the next step is to arrange the objects into nine groups that are relevant for animation. There are four groups for the wheels, four groups for the brake system and one group for the chassis. The four extra groups for the brake system are important, because the braking system is attached to the suspension, but of course not to the rotation of the wheels.

STEP 3
SETTING UP THE PIVOT POINTS

For these nine groups we have to set up the pivot points of every group precisely. The pivot points of the wheels should be exactly in the middle of each wheel as otherwise they will not rotate smoothly. The pivot points of the chassis and the braking system are not so important but should be in the middle, too. This step is also very important for the next rigging steps as we will match all the helper objects on those pivot points.

STEP 4
FIRST WHEEL RIG

The next step is to create the helper objects in Madcar. The first task is to isolate one wheel of the car and open the group, so that the bounding of the group box becomes selectable. Then object snap has to be activated and set to "Pivot Point". Now you can create a Madcar "Wheel" Helper object. It can be found within the "Helper" Tab on the "Create" palette. This helper object should be created exactly on the Pivot position of the Wheel Group. Then modify the width and height to match the wheel object. Finally close the Wheel Group.

STEP 5
SECOND WHEEL RIG

Unhide the other Wheel groups and then just copy this Madcar "Wheel" helper object to the other three Pivot positions. Then, turn the wheels on the right side around 180 degrees, so that the arrow also points to the outside. This is important as the plug-in will calculate the horizontal wheel forces too. Finally, connect all the four object groups to the helper object, to connect the motion of the Madcar System to the motion of the real 3D model.

STEP 6
FIRST SUSPENSION RIG

Now to create the suspension helper objects on the front wheels. They can be created on the pivot position of the wheels as well. The length depends on your car model. In the case of the R8, I chose 25cm. The top stop and the bottom stop are also car-dependent. In the settings select "Wheel drive" and for the "damper" preset select "Sports car". That suspension helper Object can be instanced to the left side. Snap it on the pivot point and turn it around 180 degrees.

STEP 7
SECOND SUSPENSION RIG

Now copy one suspension object to the back of the car. It is important to copy it, as there need to be different settings on the back of the car suspension. Again snap onto the pivot points of the back wheels, instance it to the other side and again turn it around about 180 degrees. Then select "Handbrake" in the Parameters and deselect "Wheel drive" for the back wheels of the car. Now the brake system can be connected to these suspension objects.

PROBLEMS AND SOLUTIONS

3D car modeling with Rhinoceros is a 624-page, complete, step-by-step guide on how to model an R8 in high quality with mainly A-class surfaces with Rhinoceros. It is the perfect addition to this rendering tutorial as you will learn how to create a photo-realistic 3D model of a complex shaped car from just the blueprint. You will learn how to construct the whole model from scratch, up to the quality of the renderings in this tutorial. Each working step is illustrated with a screenshot, the tool used with an icon and a description of what to do. It's available at ak3d.de as a hardcover book or as pdf file for download.

This book describes the complete modelling process for creating the R8 model with Rhinoceros. Alternatively, you can use any other car model.

STEP 8
CHASSIS WORK

Now to create a new Madcar chassis helper object. Create it on the pivot position of the 3D model's chassis. For this object it is important to have the same width and depth as the real chassis. The Z-position is also important, as this is the position of the centre of gravity of the car. As the R8 is a sports car this point is relatively flat. For any off-road cars this position can be higher. This has a great influence on the car dynamic calculations and finally the car behaviour later on.

STEP 9
LOCK THE COMPONENTS

Create a "Madcar" Helper object on the Pivot position of the chassis. The size is not important this time, it is just an object where most MadCar Dynamic Settings are reachable. In the options of that object, ensure the "Gravity" setting is 9.81 m/s². Then click on "Lock components" to connect all structural part together and to check and finalise the helper setup.

STEP 10
FIRST TEST DRIVE

Now comes the fun part of creating a car animation: the driving. Create a plane first, maybe with some small noise 3D displacement added. This surface should be put under the car's ground position. Then, on the Madcar settings, click on "Surface" and select this plane. A second click on "Update Surface" refreshes the model. Now create a camera in the back of the car and connect it to the Chassis Helper object. Finally connect your game controller, switch to the camera viewport and just click on "Drive".

STEP 11
FINE TUNING

After the first test drive it may be necessary to optimise the physical behaviour of the car. This can easily be done with the "Damper" Settings Tools. It's a really cool feature as it even visualises the changes of the settings. You can clearly see what happens if you change any of the damper settings. This setting alters the whole behaviour of the car as every behaviour while braking, turning, etc. depends on how the suspension works.

STEP 12
SECOND TEST DRIVE

After tuning the damper and Madcar settings, you should make some more test drives to check the behaviour of the car under different conditions – on flat ground, on bumpy ground under speed and under slow conditions. Also, make some handbrake turns to check the grip of the wheels. At this point you should clearly have the whole animation in mind. If all the required scenes are possible with the setup, you can go to the next step.

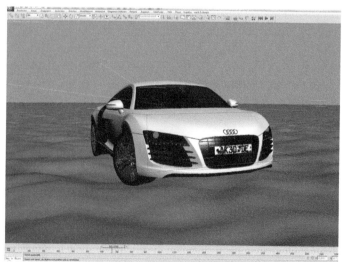

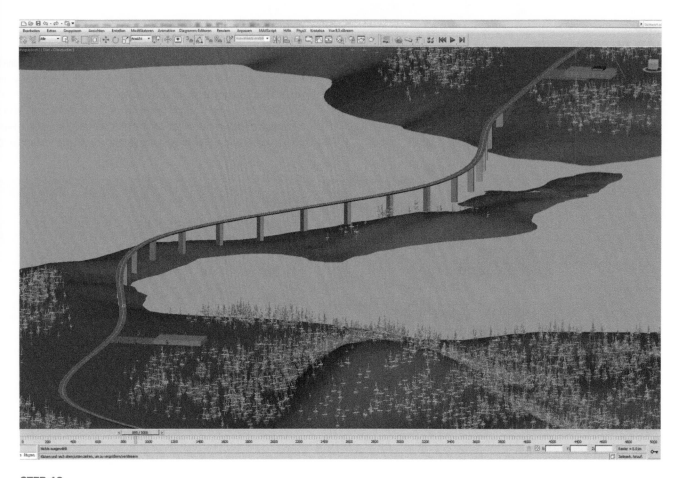

STEP 13
BUILDING THE TRACK

At this point you need to decide between building a track to drive on or simply drive on a plane and then build the track afterwards. For the animation on my website I chose the second option, as it was quite difficult to drive a 3 minute sequence at once and keep on the track without any cuts. So, with specific manoeuvres in mind, I drove on a rough plane and created the track afterwards. After making that trip on the plane, the drive was fixed and it was easy to style the track with interesting objects.

STEP 14
CREATING THE LANDSCAPE

After finalising the track it's time to add interesting elements to the drive. In my case I modelled a bridge, a sea and a landscape with more than 80 million polygons of trees with e-on Vue xStream which works as a plug-in to 3ds Max. For the start I wanted to have a kind of construction hall that opened the door and the car drove out. Then I wanted to have some good views over a seaside with some sunny effects on it and finally I wanted to have the car come to rest in a parking garage. Some of those objectives were in mind while making the drive animation, making it easy to synchronise them after the animation was done.

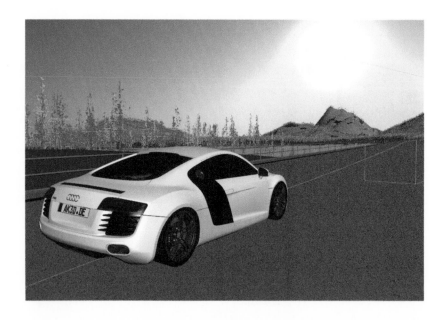

STEP 15
CAMERA SETUP

To get really good camera movements usually requires a camera rig. There are a lot of possibilities within 3ds Max to create an action-ready camera rig. There were some fixed cameras on the track as well as nearly 15 cameras linked to the car chassis itself. If the camera movements are set to be sticky to the chassis, you can deal with positional feather constraints within Max. Then the camera is linked, like on a flexible rig that makes all movements of the linked objects just some seconds later. In this way sequences become more natural and dynamic.

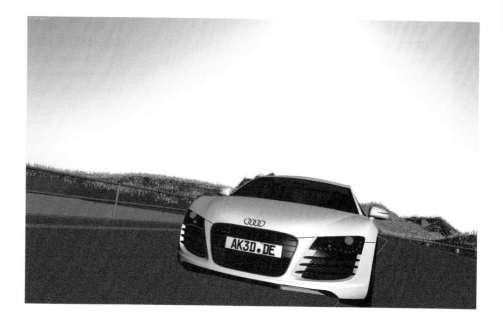

STEP 16
SWITCHING DIFFERENT VIEWS

A difficult part of the animation is to evaluate the whole sequence with cuts before any material is rendered. Normally a real camera team would take a lot of film material. Then afterwards, while cutting, that really huge amount of film material will be edited down to the 3 minute sequence. Some 90 per cent of the filmed material will usually be thrown away. With rendering you don't have this luxury. Every frame rendered should be used later on. So, cutting and filming have to happen at the same time. A very handy script for that purpose is the Camera Manager of Michael Coment.

STEP 17
RENDERING THE SEQUENCE

Finally it's time to render the entire sequence. For a fast moving object like a car it is essential to render the scene with motion blur. It's important to get spinning wheels to create a believable scene. A typical video camera has a shutter speed of 1/50th second. It is possible to calculate how often a wheel turns when filming a car driving at around 160 km/h. The spokes of the rims will nearly become invisible and it is necessary to calculate a lot of frames just to get a believable wheel rotation rendered.

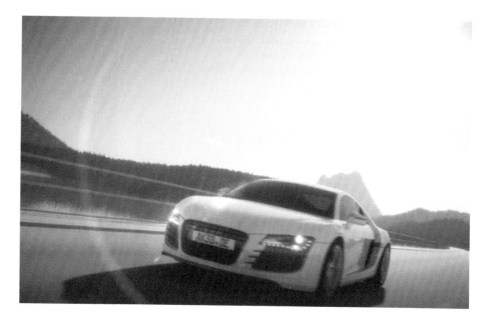

STEP 18
DOWNLOADING THE TOOLS

In this step two helper tools need to be downloaded and installed. The first is the iRay Manager script that can be downloaded here: http://www.youcandoitvfx.com/?page_id=12. With this tool installed it's easy to set up whether to render using the CPU, GPU or both. There's also access to a special HDRI projection mode that is not accessible inside Max at the moment. The second tool required for good car renders is the iRay Material 1.3 from here: ftp://ftp.nvidia-arc.com/pub/iray_material_plugin_1.3_Max2014.zip. This is a material plug-in special for iRay that makes layered materials available. It provides a huge bunch of material presets and also presets for car paints!

STEP 19
BASE SCENE SETUP

First of all, we import or open the car model. In my case I used the final 3D model from my tutorial Book *3D car modeling with Rhinoceros* (http://www.ak3d.de/all/3d_car_tutorial_book_animation). The finished 3D model is also available there. Alternatively you can use any other car model as well. Group the model into five groups consisting of the chassis and the four wheels. After placing the pivot point of the front wheels correctly, turn the wheels for a perfect pose for rendering. Finally, create an omni light that is switched off. This turns the standard light function from 3ds Max off.

STEP 20
IRAY MATERIAL SETUP

For faster material placement put the different car parts on different layers with their material name as layername (paint, metal, alu, black plastic and so on). Then open the Material editor and open the map/material browser and search for the iRay Material. Then choose a preset that comes next to the material layer and fine tune the parameters. For example, select the preset "red car paint" and change the colour to grey. Then select the objects on the layer and assign the material to that layer. We repeat this step for every single material layer.

PIMP MY RIDE

The physical setup of a car is not easy at all. For an animation project like the one I did for the R8 animation (www.ak3d.de), you have to find a setup with all scenes possible that you have in mind. This can be really time consuming. In my case I wanted to have this u-turn at the beginning of the animation. So, I had to deal with the weight of the car and all other parameters of the car until this scene was possible. I made the animation without any landscape first, and then created the world around this trip. For me this was the most straightforward method of creating the whole animation. R&D will release the iCars Vol.1 collection. These are finished modelled, rigged and tuned models, ready to use with Madcar without any setup. With that, a lot of time for test drives and fine tuning can be saved.

STEP 21
HDRI SETUP AND EXPOSURE CONTROL

Open the Environment Dialog, choose Use map and select a bitmap slot. Drag this Bitmap slot to a Material editor field and select a HDRI in the browser field. For the colour, choose Real pixel 32-bit and leave the values as they are. Then switch the projection mode to Hemisphere and close the Material editor. In the exposure settings choose the Mental Ray photographic exposure tool and click on checkbox for "Affect maps and environment". Then click into a viewport and press Alt-B to open the viewport background menu to see the environment map.

STEP 22
RENDERING AND FINE TUNING

Now to finally start rendering the scene. For this, open up the environment dialog and the Material editor and start to fine tune all settings. First look at the HDRI background and set up the exposure level to a nice value so that the details of the background picture stay visible. Then set up the white point and contrast settings until the picture looks right. You can even add a vignette effect at this stage. As soon as the background is correct, start to fine tune the iRay material settings. Just change the settings and re-render the scene until each material looks as good as possible.

STEP 23
FINAL RENDERING SETTINGS

Finally, time for a very handy trick. Start the iRay Manager script and switch the projection mode to Hemisphere. Tick on the boxes for "shadow ground" and "glossy ground". This finally transforms the HDRI image so that the car stands on the ground with a correct shadow and even reflection on the street! Then fine tune the values for Ground scale, Environment scale and the Reflection glossiness and render the scene constantly until the picture looks perfect. Lastly, render the scene as a HDR file and chose a good sampling value like 2000. From that point on, the next steps can be done in Photoshop or After Effects.

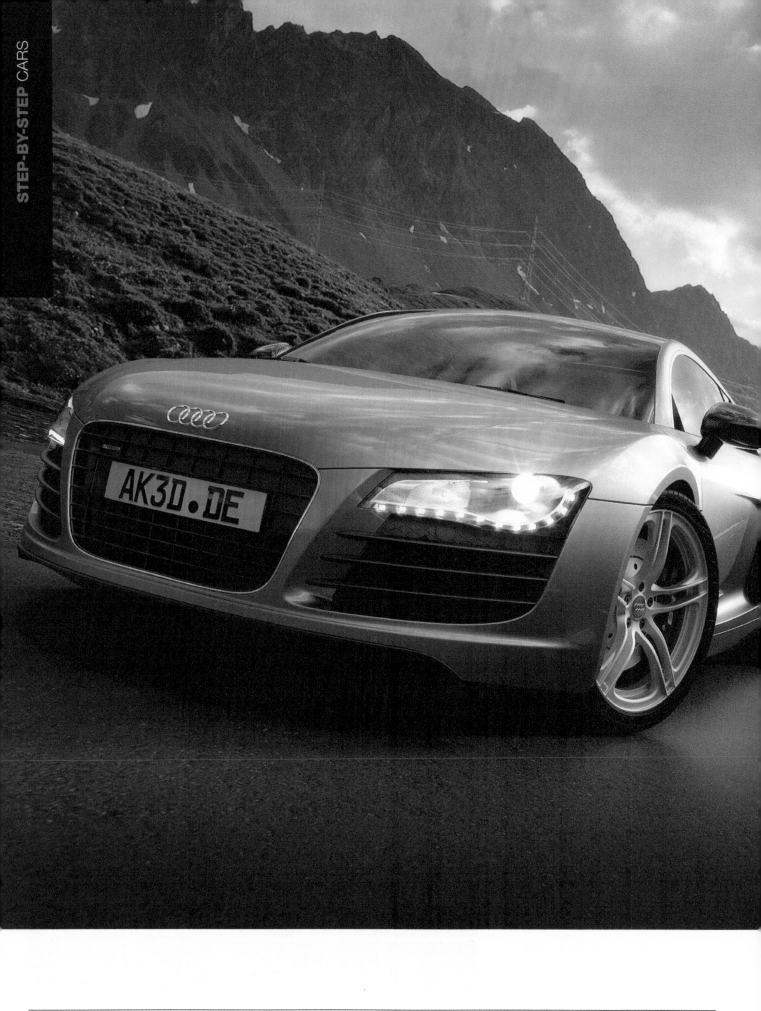

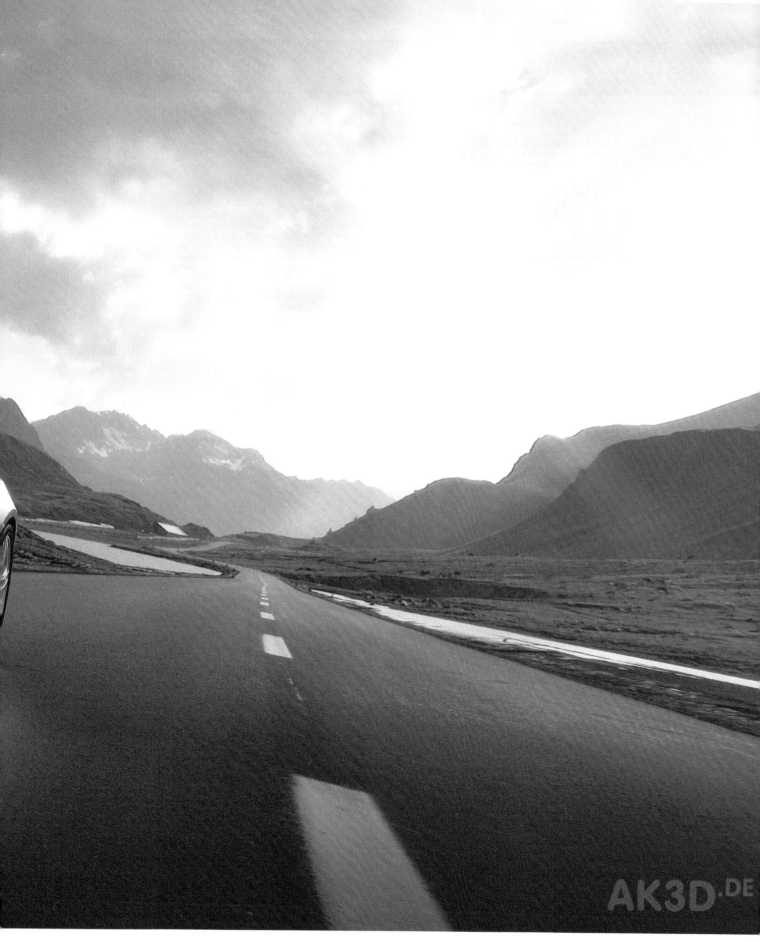

AUDI A8 BY ANDRÉ KUTSCHERAUER

 3DS MAX, RHINOCEROS, MADCAR, IRAY

 2 HOURS

> " I like to create industrial style machines so decided to make this diesel generator. It was also good practice for my modelling skills to add all the fine detail and pipes. "

PROJECT	DIESEL GENERATOR CAT
SOFTWARE USED	3DS MAX 2013, V-RAY, PHOTOSHOP
RENDERING TIME	1 HOUR
ARTIST	IGOR KULKOV
COUNTRY	RUSSIA

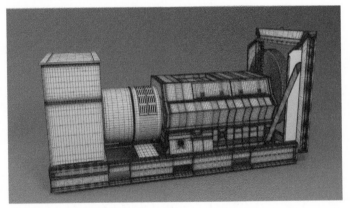

The model under construction. Here the basic tube shape is ready for the details.

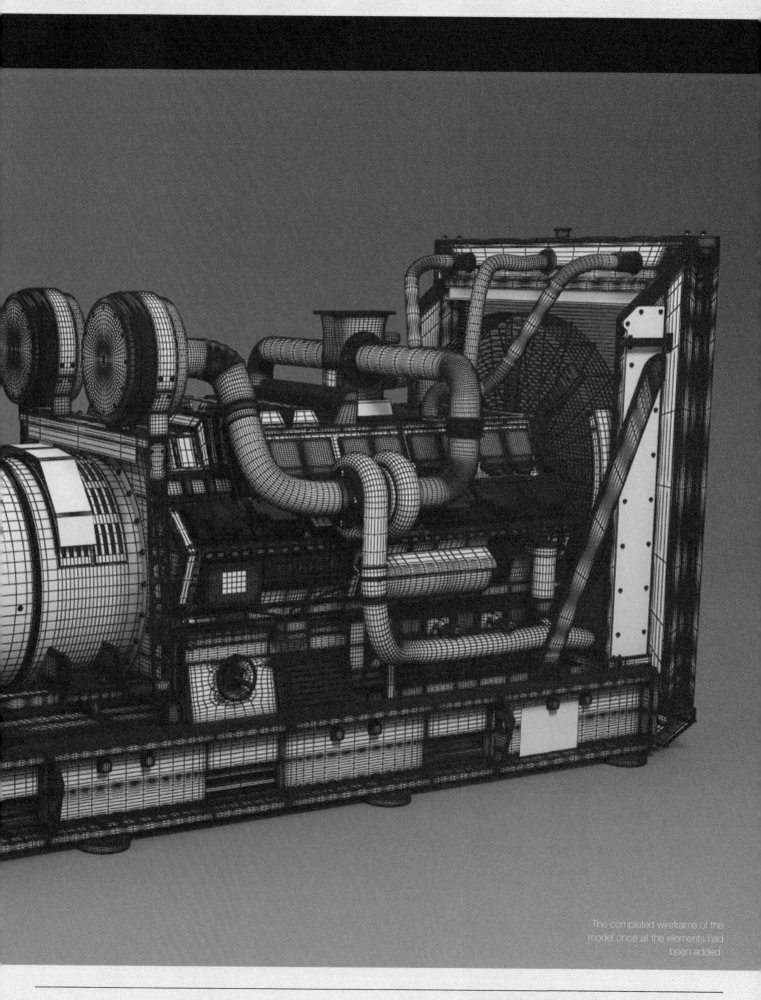

The completed wireframe of the model once all the elements had been added.

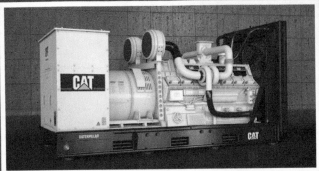

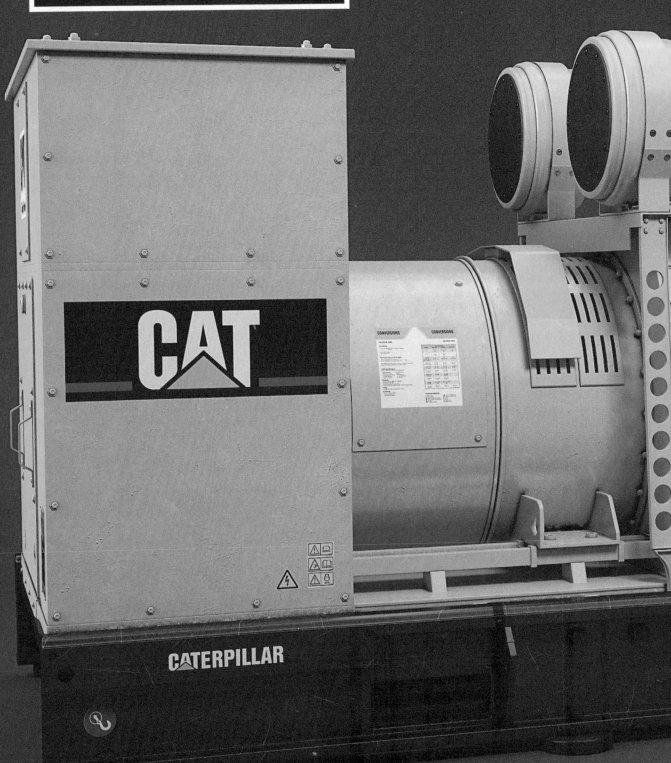

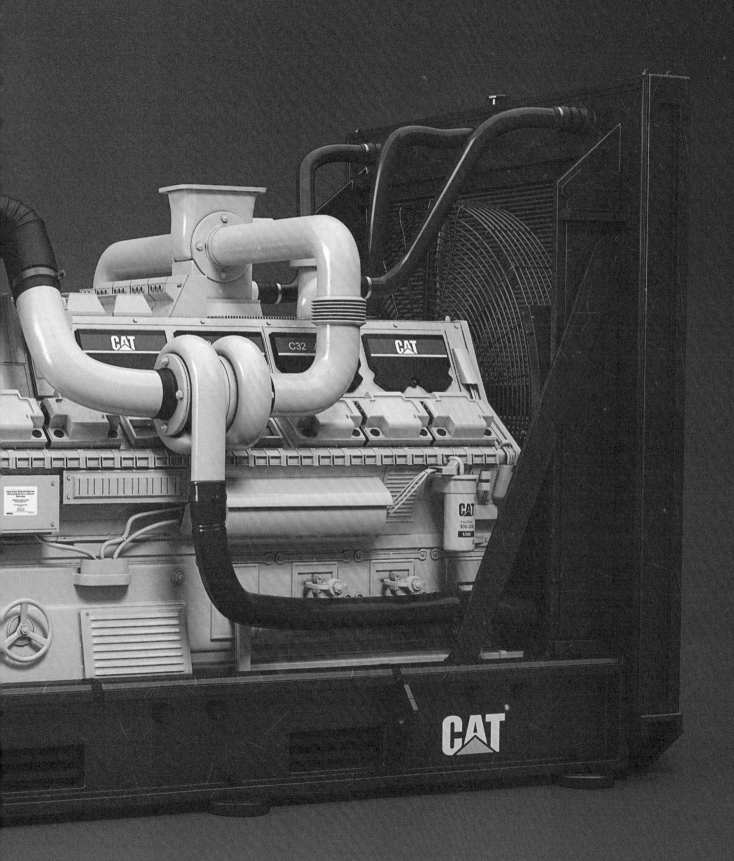

" This is another project for my idea of a robot-animal hybrid heavy duty machine. The initial idea was to create a bird-like robot. Then I developed the idea further into the welding machine. The overall concept is the walking machine which is handmade by survived humans in a post-apocalyptic future. The robot is completely peaceful and made to be a helper in construction works. The biggest amount of time was spent on developing the model itself. First I drew it as a sketch. Then I was searching for photos of parts of existing machines and was putting them on top of the sketch to fit the shape. The next stage was developing the idea further in Maya. I was modelling and designing it simultaneously. What you can see on the final image is the third or fourth version of the model as I remodelled most of the parts several times. "

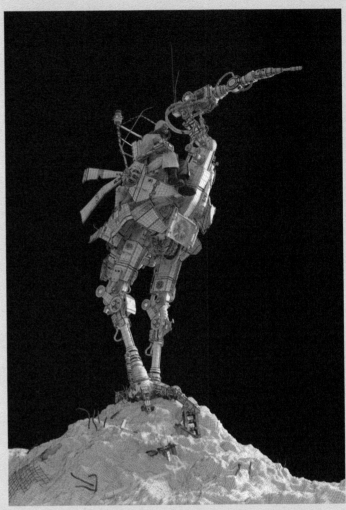

The model was developed from a combination of the bird form and heavy duty engineering parts.

PROJECT	EGR-8 MOBILE WELDING MACHINE
SOFTWARE USED	MAYA, ZBRUSH, MUDBOX, V-RAY, PHOTOSHOP, NUKE
RENDERING TIME	10 HOURS
ARTIST	DANIIL ALIKOV
COUNTRY	RUSSIA

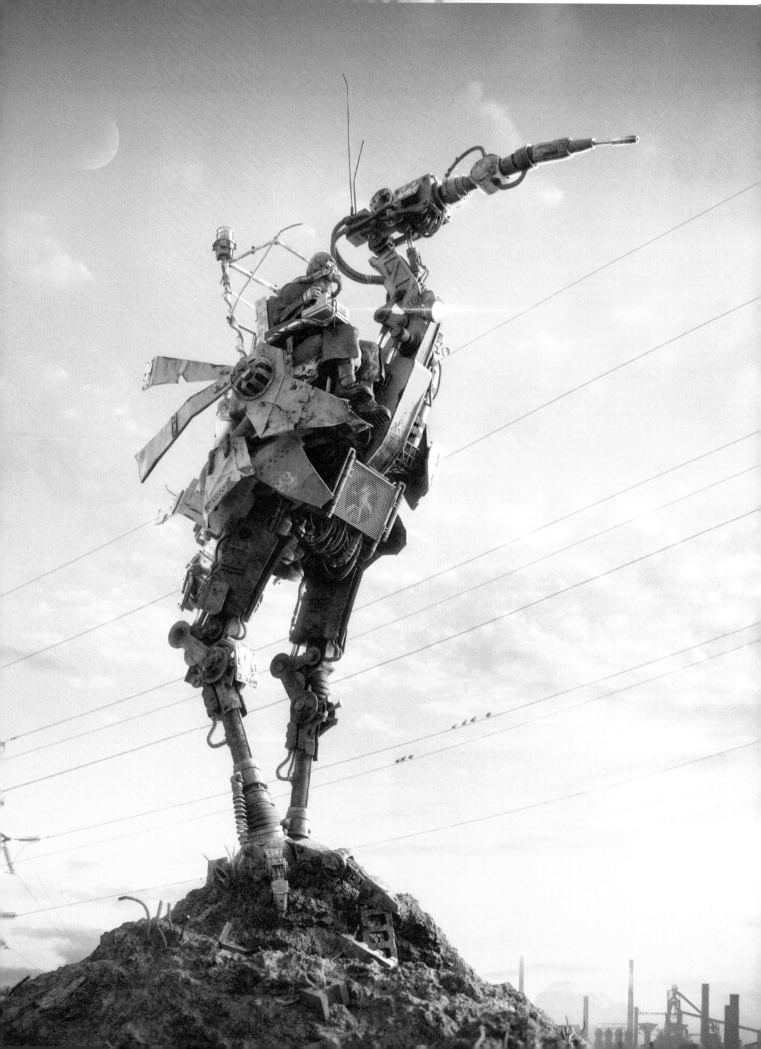

"Spider Crane was a project loosely based on a lot of Japanese Mech artworks. I had wanted to do a construction mech project for a long time and finally got the nerve to take it on. The biggest feat in this piece was making something that looked cool but could also function properly in the real world. The end result has hydraulic legs and a typical industrial paint scheme."

PROJECT	SPIDER CRANE
SOFTWARE USED	3DS MAX 2013, KEYSHOT 4, PHOTOSHOP CS6
RENDERING TIME	1 HOUR
ARTIST	TIMOTHY DIAZ
COUNTRY	UNITED STATES

Taking inspiration from Japanese art, the Spider Crane married functionality with imagination.

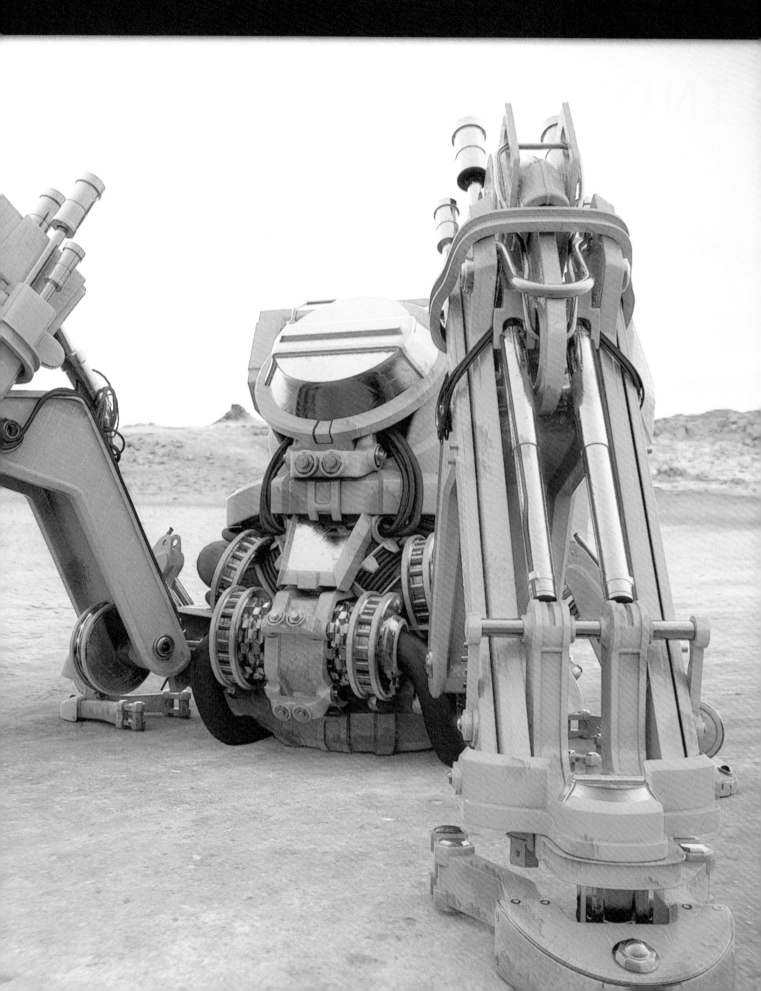

INDUSTRIAL POWER

Marcel Haladej reveals how he created a heavy lifting vehicle in the midst of urban renewal.

DEVELOPING THE STORY

I have always been interested in various old, often timeworn, industrial or agricultural vehicles. Machines which are way past their expiration date, but they still work and remain useful. The story of this picture did not begin in a town under construction, but one morning, on a journey to visit my girlfriend. It was then that I noticed, out of the corner of my eye, an old crane in an agricultural society facility. The morning sun battling through the haze left over by the night rain was setting the tone. At first sight I just went by, but after a while I turned around and came back to take a picture of this machine, knowing that it would make a good base for a new piece of work.

Another source of inspiration were photos from one borough of my hometown. This borough used to be a small village, but the political forces of the recent past had decided that this peaceful village had to change within a few years into one huge public housing area. So that's where the inspiration came from. All that was left was to choose the right composition and place the picture into the time of year and time of day.

My favourite season is autumn – full of colours and morning fog. Mornings when the sun rays are peeping through the tree branches and the world reflects in the puddles of rainwater. I wanted to train my skills while working on this project, to play with the materials, especially misted glass, ground covered by mud and also try to simulate the depth-of-field effect of a real camera, which divides the scene nicely into layers of foreground, middle, background. I would like to take this opportunity to thank my girlfriend for supporting me and putting up with my night shifts at the computer.

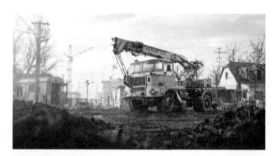

IFA – finished image

PROJECT	IFA
SOFTWARE USED	3DS MAX, V-RAY, PHOTOSHOP, MARI
RENDERING TIME	1 YEAR WITH A LOT OF BREAKS
ARTIST	MARCEL HALADEJ
COUNTRY	SLOVAKIA

It was an ugly rainy day, but I knew that even a random picture full of mud like this one could come in handy at some point

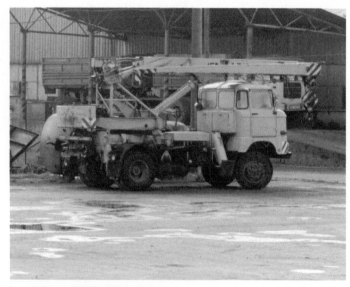

I wanted to model this weird old machine and create a CG version of it.

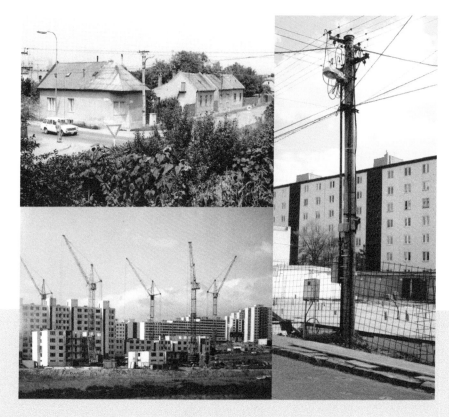

These pictures have become the base for background modelling where the housing project construction is going on.

**TOP TIP –
FLIP IMAGE**

When you get to a stage that you don't know what to do next with the image or you are beginning to miss some things, just flip the image horizontally and you will get a whole new perspective.

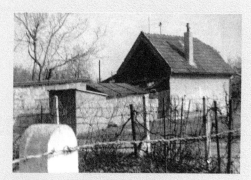

A picture taken long ago by my father, the house represented the contrast between the old housing and the communist-built tower blocks which were slowly taking over.

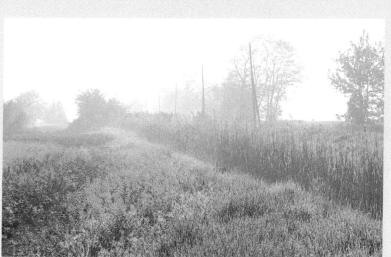

I was trying to achieve a hazy morning atmosphere in the new project.

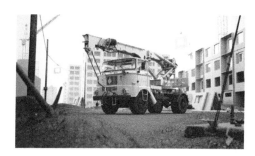

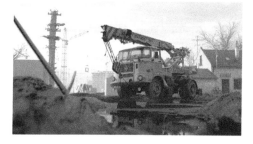

TOP TIP – COMPOSITION

Try to create a nice composition in the image even if there are a lot of objects in the scene. It should always be clear which object is dominant and which objects are supporting. You can highlight the dominant object using a suitable composition, perspective or by more vivid colors at the expense of the other objects.

This is how the original composition looked like before the final image was put together.

MODELLING THE SCENE

All the objects in the scene have been modelled by myself, so there are no purchased models and that's why the production took so long. The only object which was not modelled in the scene is the last plane with a picture of hills and clouds.

Modelling is not any kind of special activity, it is just a relaxing routine. The biggest problem is always with blueprints, because they are pretty hard to find for some specific models. Some models from my older projects have been used, for example my favourite old bicycle or the never completed model of a Trabant.

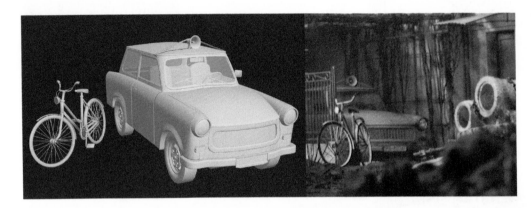

Models from older projects, including this unfinished one of a Trabant car, were used.

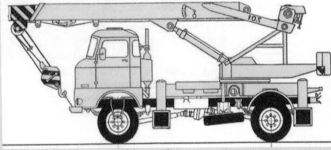

I used the basic modelling tools offered by 3ds Max. The first step when modelling real objects is the incorporation of blueprints into the scene. I almost always start from the most basic geometric primitives, usually from one plane, from which the edges are pulled out, thus creating new polygons and a more complex geometry. I always try not to go too far with the complexity of base geometry and only add details where necessary.

The Turbosmooth modifier was applied to the base model, which made the geometry smoother, but the disadvantage was the necessity to create support loops around the edges which needed to be kept sharp. The option was then to either apply a Chamfer modifier to these edges or better yet use the Extrude Edges option in Edit Poly Modifier with zero Extrusion Height value and various Extrusion base widths. The advantage of this method was that it didn't totally destroy the original edge. I planned to texture the mobile crane in Mari, so mapping was superfast. I divided the model into four parts and then I applied Auto-unwrap on them while each of the four parts was in its own mapping square.

The blueprints of the crane which were the basis for the modelling construction.

Creating planes and then pulling out the edges to add new polygons and build up the model.

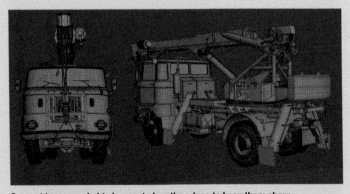

Support loops needed to be created on the edges to keep them sharp.

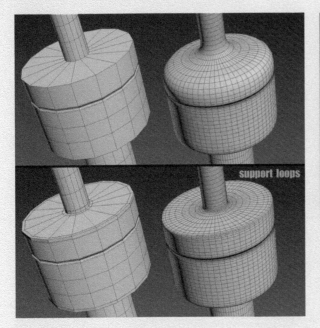

support loops

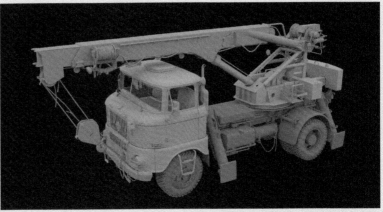

The model was divided into four parts for unwrapping prior to texture work in Mari.

Using the Extrude Edges option in order to retain the shape of the original edge.

The wheels were modelled by a classic and very popular method. One part of the tyre was modelled and it was copied around the Y axis via radial symmetry. Finally, the parts were welded together into one piece.

The upper part of the concrete mixer was modelled by a method which is most often used to model glasses. I created a profile line and then extruded it into a deformed cylinder model using the Lathe modifier. The bottom part was made up of simple boxes and circles. Small screws were placed on the model which added nice extra detail after the lighting of the scene.

The construction of the crane was made up of a vast number of lines. One sector of the crane was created, which was then copied, one on top of another. The sweep modifier was used with various profiles for lines. Some small details such as a lightning rod at the top, different wheels on the construction and headlights were added to create variety. The base of the crane wasn't modelled because I didn't expect that it would be visible in the end result.

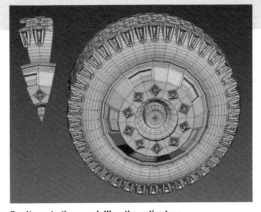

Don't waste time modelling the entire tyre, create part of it then duplicate it radially.

The concrete mixer was created using traditional glass modelling techniques.

The cranes consisted of large numbers of lines that were initially duplicated.

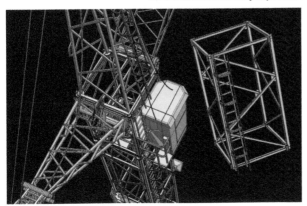

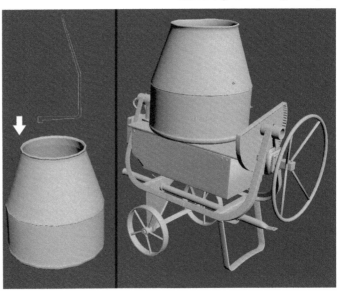

The family house was created by a method of extruding edges from one plane, because I knew the house would only be part of the scenery in the background. Only the visible parts have been modelled. The shelter for the car was built from scaffolding pipes, which were covered by the awesome ivy generator free plug-in.

The ground model was nothing remarkable. A Displace modifier was applied to the dense plane with a modified smoke map which created the basic puddles. The geometry was then modified by simple sculpting using the 3ds Max sculpt tools. The V-Ray Displacement mod was used on top of the modifier stack with tileable textures. Small pieces of the ground were scattered on the surface.

MODELLING RULES

I have one simple rule when modelling. The objects closer to the camera are modelled in greater detail. The more distant objects are simple models, but I like to add small random details on them such as TV antennas, lightning rods, railings, small lumps, etc. A quick way to make the object more detailed is application of the displacement modifier where I placed various textures or modified procedural maps. The model mesh must, of course, have dense meshes, either by Tesselate modifier or the Turbosmooth modifier. The high level of the Turbosmooth comes only during rendering. I have used this method on many objects because it allowed me to quickly and procedurally distort the perfection of the models. Of course, the disadvantage is high memory usage. The relatively large scene begs the question of how to manage it wisely. The easiest method was by using layers and nested layers via an older but excellent free script, the Onion.

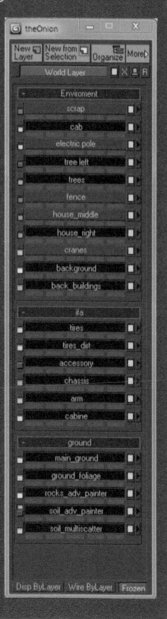

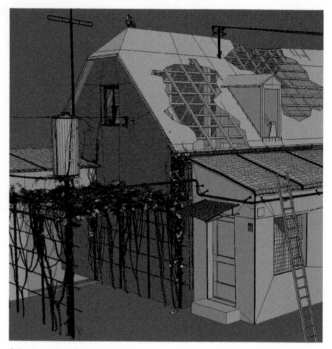

Only the parts of the house that were going to be visible in the scene were actually modelled.

A modified smoke map with a Displace modifier was used to create the ground plane.

Extra chunks of rock were scattered around the ground plane to break it up.

TEXTURING THE CRANE

Mari from The Foundry was used to texture the crane model. This software excels in the texturing of complex organic/mechanic models when you need to work with a lot of layers, masks and large textures. As mentioned before, the model was divided into four parts, each with its face ID. The individual parts had a texture resolution of 4096 x 4096 px. This method was much more flexible than working with one large 16384 x 16384 px texture for all the objects.

It is possible to create a preview shader in Mari, in this case made up of layers of metal, rust and mud. The masks of rust and mud were drawn manually using various pre-sets and my own brushes. Work in Mari is quick and user friendly, after one gets used to it. A bit like Photoshop, but you can see painted textures on the model on the fly.

The individual textures and masks were exported from Mari and then used in VRayBlendMtl.

Unwrapping the crane into four areas for texturing using Mari rather than one large texture.

Creating a preview Shader in Mari using layers of metal, rust and mud.

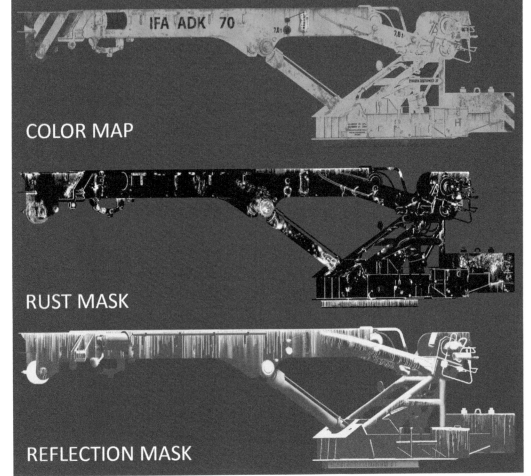

COLOR MAP

RUST MASK

REFLECTION MASK

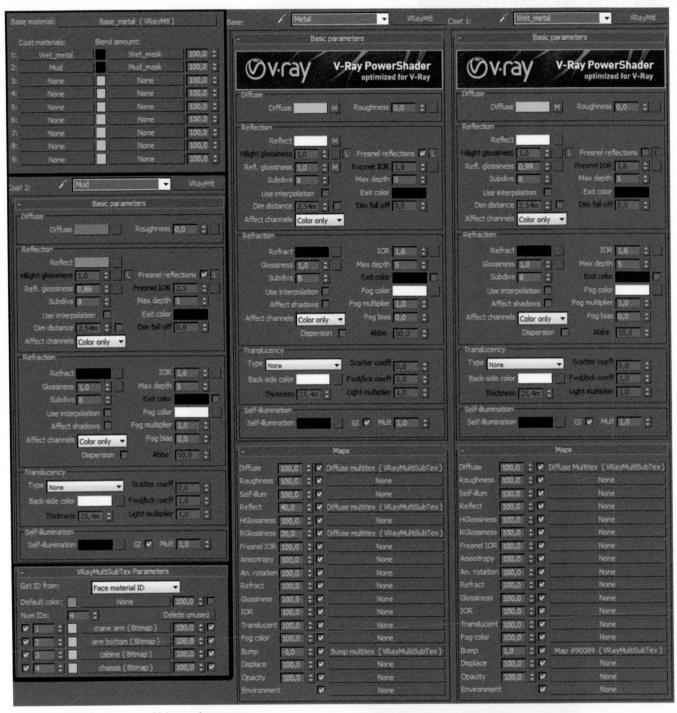

The Base material for the crane with layers of grunge on top to make it look realistic.

The main material of the crane consisted of the Base material of metal covered by Coat materials of rust, mud and water streams. There were four textures for each material of Blendmaterial from Mari which needed to be included into the final material. That's exactly the reason why there was VRayMultiSubTex in Vray, which assigns the texture according to the face ID. The only disadvantage is that you can only see one texture applied in viewport, so it looks kind of funny.

The VRayMulitSubTex in Vray was used to assign textures according to the face ID.

The base of the wheel material was VRayBlendMtl, where the Base layer was made up of the wet tyre with a layer of mud applied using a manually drawn map. VRayDisplacement modifier was applied to the wheel with a drawn displace map.

The ground material was a simple Vray material with ground texture and reflections. The diffusion channel was copied to the Reflect, Rglossiness slot with 30 per cent opacity.

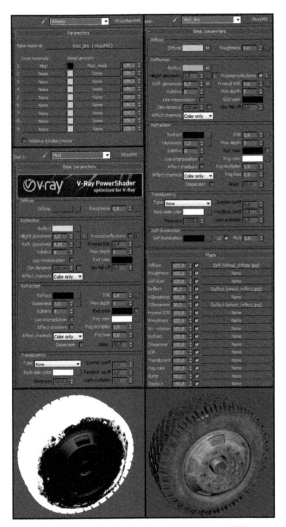

The Base layer of the wheel material was a wet tyre with a layer of mud over the top.

DISPLACE MAP

COLOR MAP

The ground material used a ground texture with reflections and a simple material.

CREATING REALISTIC LIGHTING

When creating the scene I experimented with various types of lightings. Whether it was the classic direct light with Global Illumination or Image Based Lighting with various HDRI maps. In the end I used the proven V-Ray physical system with VRaySun, VRaySky and VRayPhysicalCamera. This setting allows you to achieve realistic lighting in a simple way. It also allows you to control the exposure of the whole scene using camera parameters as if it were a real-life environment.

The value of Turbidity was changed in the V-Ray sun, which added a yellow-orange tint to the main light. The size parameter was tweaked which softened the shadows. The sun was placed outside the picture on the left, a little above the horizon to replicate the traditional lighting effect known as the golden hour, when the sun is relatively dim, the objects throw long shadows and the scene has a golden tint. Additional lights weren't used to fill the shadows, which 3D artists often do. Here I wanted it to look as natural as possible.

When creating a V-Ray sun system, 3ds Max automatically assigns a V-Ray sky map into the environment slot. If you want to modify it, just drag it to the Material editor and set the necessary parameters. For this scene the value of indirect horizontal illumination was modified, which had a decisive influence on the exposure of the sky.

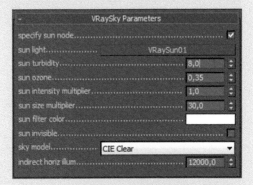

The exposure of the sky was influenced using the indirect horizontal illumination.

TOP TIP – RULE THE LIGHT

It might be a good idea to experiment with light before each render. You can move it by a bit, play with the colour temperature, intensity or adjust the size of shadow. When you work with the same light for a long time, even such small changes can improve the render.

To add a touch of reality to the picture, a caustics pass was used. The pass was rendered with grey materials and only materials which had a decisive influence on the caustics were used, namely transparent materials and metals. This effect was most visible on the front part of the crane cabin lit up by reflected rays from the puddles in front of it and on the doorframe of the yellow caravan.

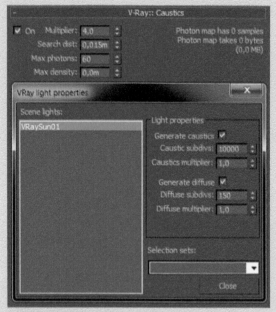

A caustics pass was used to create extra detail in the cabin and puddles.

To get the most out of the V-Ray physical lighting method, it is important to use the proper setting for the Linear workflow. In the 3ds Max settings, under Preference Settings, Enable Gamma needs to be selected and set to 2.2. The options to Affect Material editor and Color Selectors also need ticking. The Input Gamma should be set to 2.2 and Output gamma to 1.0, because the renders were going to be saved in 32-bit exr format. In VRay>Color Mapping the Gamma was set to 2.2, Linear Multiply and Affect Background was selected. To display the render the V-Ray frame buffer was used where the render can be previewed with applied LWF by activating the small sRGB button.

TOP TIP – WORLD AROUND US

Observe the world around you, observe what materials, light and quality of light can do. It is best to take a reference photo, even if it is just with a cell phone. You never know when you're going to use it. If you have good references, especially when it comes to materials, their creation in 3D is much easier.

RENDERING THE SCENE

The V-Ray renderer was used for rendering with some fairly standard settings. Set image sampler to adaptive DMC, Max. Subdivs to 100 and Min. Subdivs to 1, Primary and secondary GI engine to Brute Force. With these settings it is possible to get an excellent quality render, without artefacts in the GI calculation and with clean reflections. The qualities of the whole render can be changed thanks to one single parameter: Noise threshold in DMC sampler.

The Dynamic memory limit in the V-Ray System was set to 0, which means that V-Ray takes as much RAM as it needs. But only use this setting if you have sufficient amount of RAM, because in large scenes the render time could increase significantly.

The whole scene was submerged into the morning haze, which was achieved thanks to VRayEnvironmentFog. The results offered by this atmospheric effect are really awesome so it is worth using despite the incredible computing demands. In the VRay>System the Optimized atmospheric evaluation option was selected, which reduced the render time a little bit.

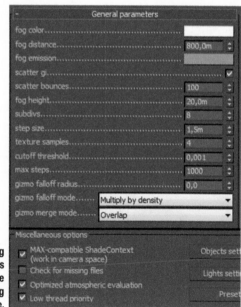

The environment fog option in V-Ray was used to help create the early morning atmosphere.

The environment fog option in V-Ray was used to help create the early morning atmosphere.

More render time was required by the rendered depth-of-field. The settings were left on default values. This depth-of-field divided the scene into foreground made up of mud heaps, middle with the mobile crane and background with the blocks of flats. The whole render time in the 5000 px resolution was 17 hours. The RAM usage was approaching 50 GB, mainly thanks to detailed displacement on the ground.

An important part of rendering was exporting the black and white masks of objects which were going to be worked on during post production. One of the methods is the application of white material on the object which we want to have in the mask, while the other objects get a black material. However, this means the rendering has to be run several times. A much more flexible method was using the V-Ray render element VRayExtraTex, where objects that will be included in the mask could be marked with the include button, while a clear white colour was assigned to the texture slot. This way multiple masks could be exported with a single render. For this image a Beauty pass and Render Elements and masks were rendered into 32-bit exr format.

The renders were stored in 32-bit exr format, which allows better work with the light and dark areas for a larger dynamic range than the standard 8-bit images. For example, it allows you to reduce the overexposure of some places without the loss of quality.

The final image was completely composed of render elements – render passes. The base layer was a Diffuse pass, then I applied Global Illumination pass above it, Reflect pass, and so on until I achieved a picture that matched the Beauty pass. This method of assembling the elements gives you the option to locally modify individual components of the image. For example, lowering the intensity of reflections on the ground only, completely removes specular on the building. This 32-bit project was saved as a Photoshop Smart object, which enables editing later, in a new 16-bit project, where the colour grading could be fine tuned. Small details in the image were retouched, such as adding some rust on the crane.

Colour grading was handled with the usual PS tools of Hue, Saturation, Color Balance. This included duplicating a layer, desaturating it and then setting the blend mode to Overlay. Rendered masks were applied on the individual groups of adjustments. That way the grading was linked to only certain objects in the scene. In the end a bit of lens flare and dirt on the lens were added.

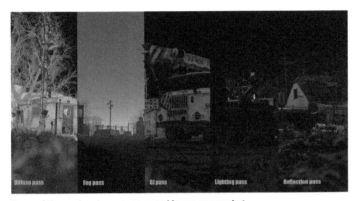

Some of the render elements arranged in one screenshot to show what they were for.

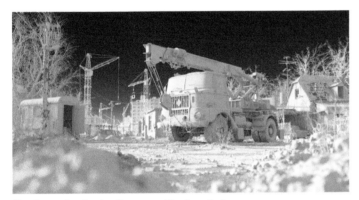

The clay render showing the scene without any textures.

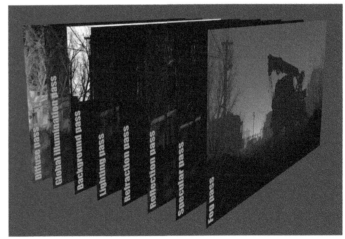

The different passes were combined in Photoshop to enable specific elements to be tweaked.

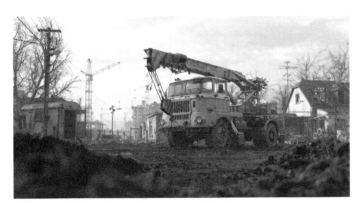

The final image out of the render engine, but without any post production work.

Individual objects could be identified and treated separately from the others in the scene.

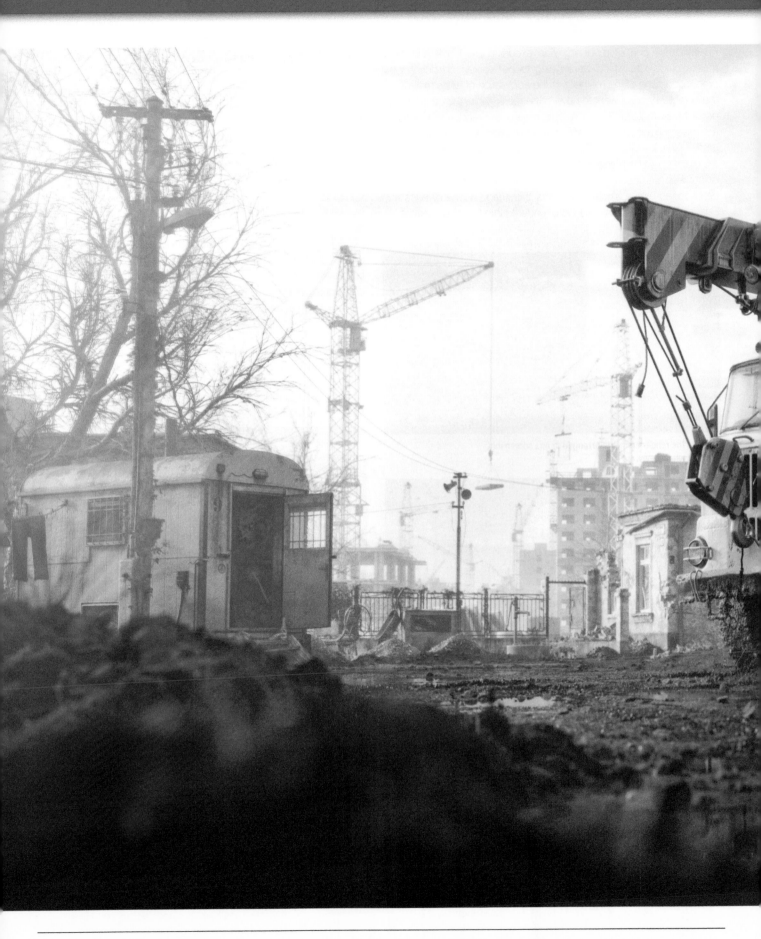

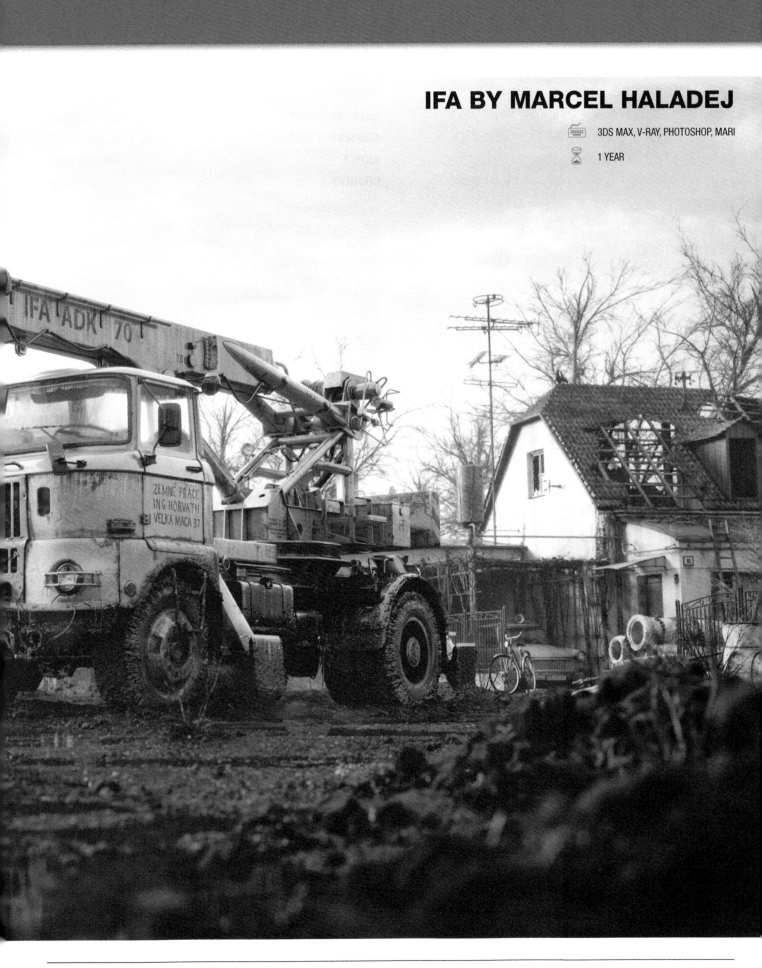

IFA BY MARCEL HALADEJ

3DS MAX, V-RAY, PHOTOSHOP, MARI

1 YEAR

> Inspired by the many TV adverts for airlines, I wanted to create a classic over-the-clouds shot on an airplane. I used the name Guru Air, based on my website (blenderguru.com). It was my first serious attempt to create an airplane, and it took around four days in total.

PROJECT	BOEING 747-400
SOFTWARE USED	BLENDER, PHOTOSHOP
RENDERING TIME	8 MINS. 4 DAYS TO CREATE
ARTIST	ANDREW PRICE
COUNTRY	AUSTRALIA

The engine was surprisingly easy to model – just a solid cylinder. I didn't bother with the inside motor as it isn't viewable from the camera.

This was the final node layout in Blender for the exterior material. Lots of custom textures were overlayed on top of each other.

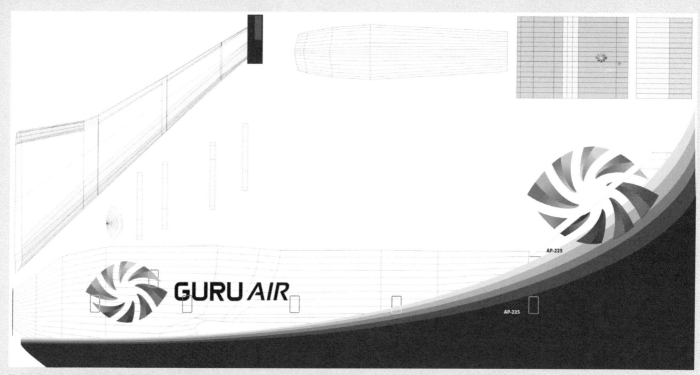

The unwrapped texture in Photoshop. The decal placements and colour swirl were inspired by other airlines. I later added subtle dirt and grunge to make it look used.

User Ortho
Meters x 5

The finished wireframe. The entire plane was mirrored to save on modelling so only half had to be created.

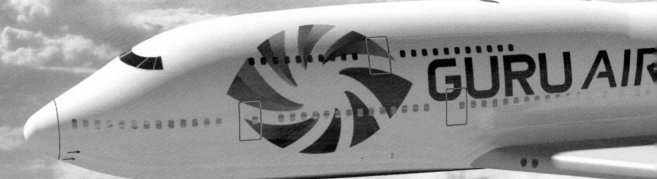

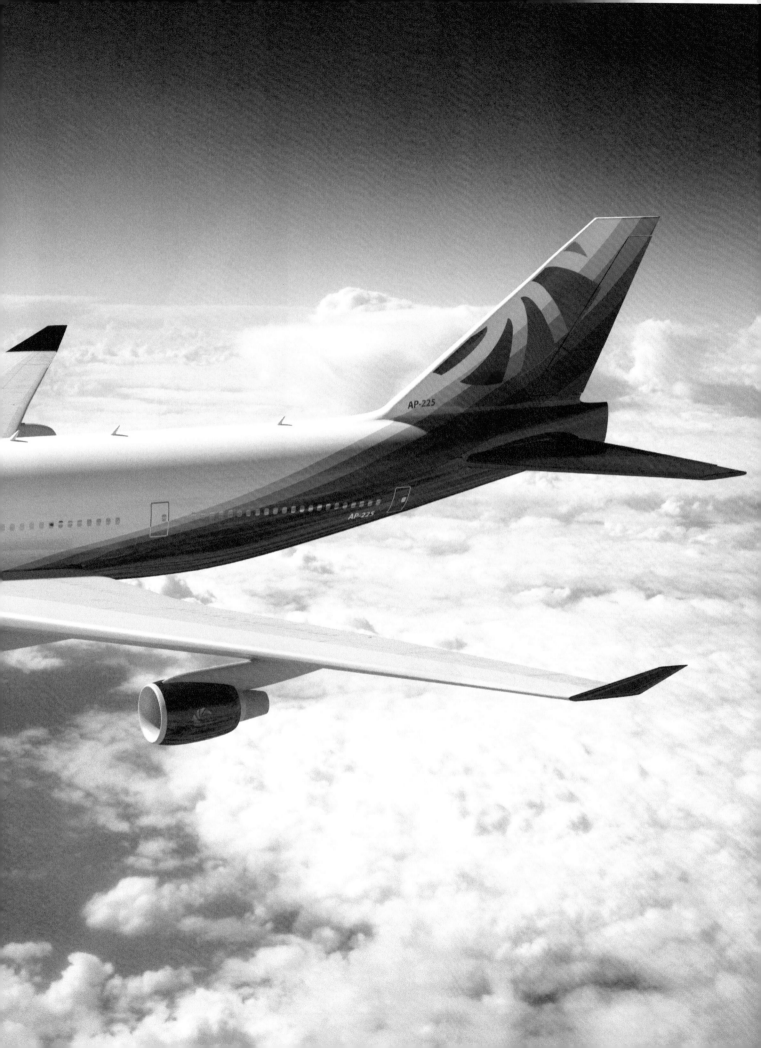

PROJECT	NORTH HUNTER
SOFTWARE USED	BLENDER 2.65
RENDERING TIME	2 HOURS
ARTIST	ANTOINE MOREAU
COUNTRY	FRANCE

" A Vietnamese Mikoyan-Gourevitch Mig-21 is finishing its manoeuver in the north sky. When I was a young boy, I dreamed about fighters. I tried to draw some of them but I was finally able to get what I wanted using 3D software. I modelled this one in Blender using very classical polygonal modelling. It is composed of distinct objects: fuselage, cockpit, seat, pilot, missile, etc. Each object has its own UV mapped textures drawn using Photoshop which include a colour map, one or two bump maps mixed in Blender nodes and a reflective map. I painted the clouds using a photo reference over a ground and painted the top part of the blue sky. "

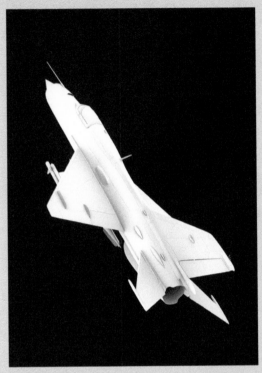

Constructing the MiG-21 using distinct objects to make up the shape and the surface features.

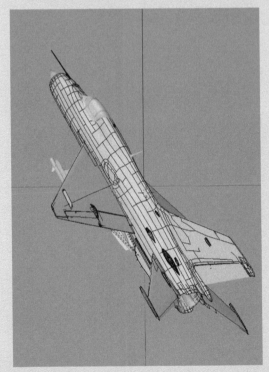

The ambient occlusion pass. Used when compositing the image with the background in Photoshop.

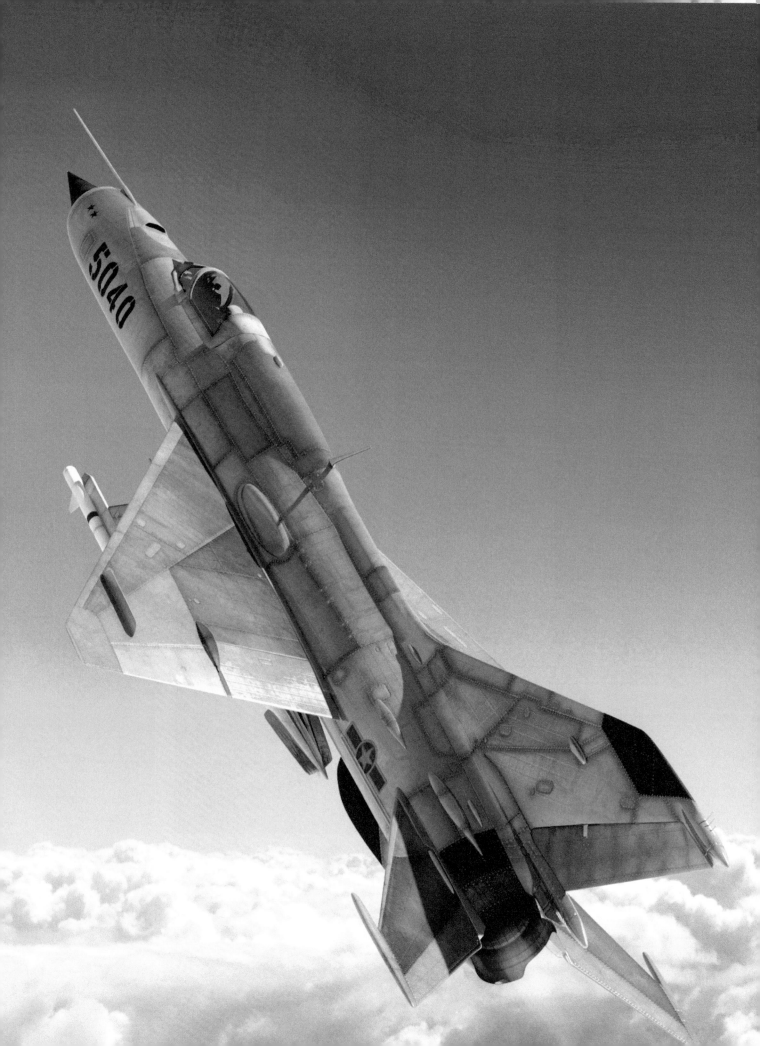

" The Antoinette was one of the most graceful pioneer aircrafts. Powered by a V8 engine, one almost crossed the English Channel a few days before Bleriot flew into the history books. I wanted to depict an aviator waving to people who may never have seen a flying machine before, and the impact it would have made on them. Early planes often navigated by following roads or railway tracks, and rarely flew very high – in 1910 it was an Antoinette that set a new world altitude record of 510 ft. "

I started with a generic terrain, and flattened a strip down one edge.

The narrowboat is a collection of blocks and simple shapes, the canal is another block with a suitable water texture applied.

When all the pieces were assembled, it was like making a virtual train set.

PROJECT	THE EARLY BIRD
SOFTWARE USED	3DS MAX, VUE 9
RENDERING TIME	14 HOURS
ARTIST	STEVE KERRY
COUNTRY	ENGLAND

All that remained was to
position the camera for the
best angle, then arrange
everything around it.

1910 Antoinette by Steve Kerry

I made the Antoinette model
a while ago, as an exercise in
modelling and texturing.

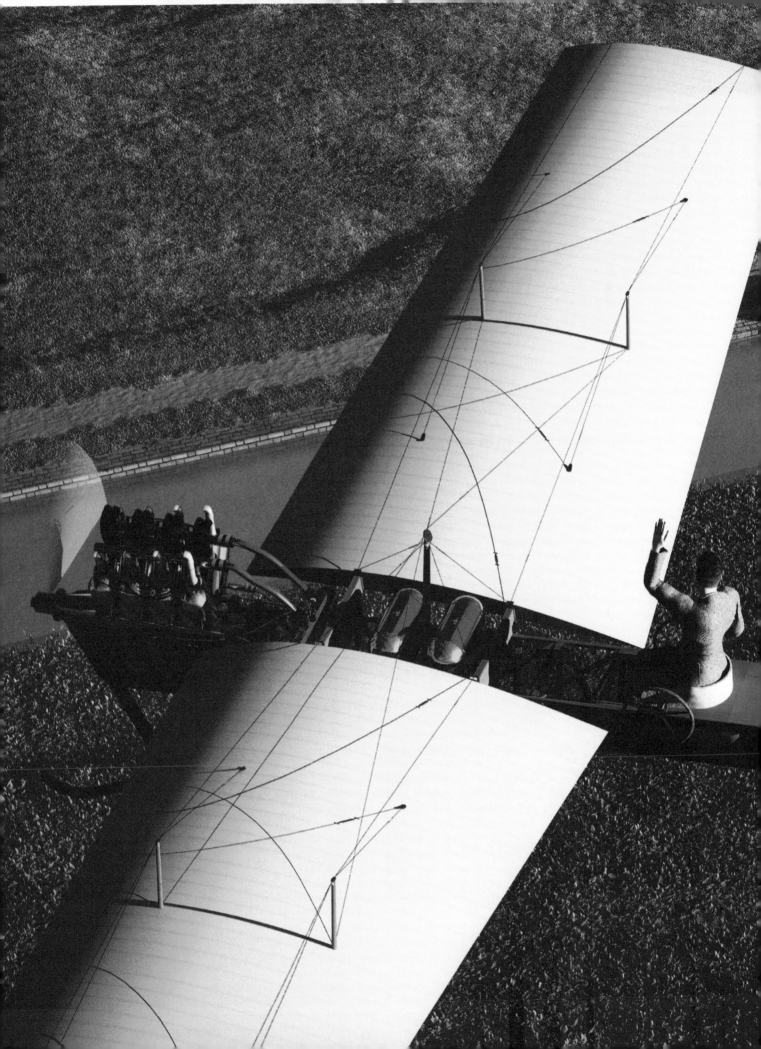

MODEL AND TEXTURE THE SPACE SHUTTLE

Nicholas McElmury explains the process of creating the icon space vehicle

BEHIND THE SHUTTLE

I built this for a mini-challenge at CGSociety. I've always been a bit of a space geek, so when I saw they were doing a NASA challenge, I couldn't resist. I was fortunate enough to see a couple of shuttle launches and tour the Kennedy Space Center a while back. I can remember being so impressed by the scale and precision of everything that went into launching a vehicle into space. Since the program is grounded now, I thought it would be a good homage to the end of such a great era in space travel.

For the final image, I wanted something realistic, but a little more pleasing to the eye than a typical launch photograph. I took great care to make everything as true to the actual shuttle as I could, including all the small panels, heat shielding, engine details, escape hatches and even the dirt patterns on portions of the body.

I wanted to capture the power of a launch, from the actual size of the shuttle, the distance it's travelling and the massive amount of heat given off by the boosters as they burn through their fuel on the way up.

PROJECT	SPACE SHUTTLE ATLANTIS
SOFTWARE USED	3DS MAX, V-RAY, PHOTOSHOP
RENDERING TIME	20 MINUTES
ARTIST	NICHOLAS MCELMURY
COUNTRY	UNITED STATES

Space Shuttle Atlantis – final image

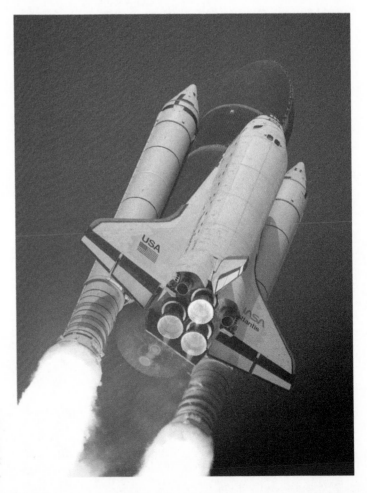

This photo is a good representation of the heat the rockets give off when they are at full power.

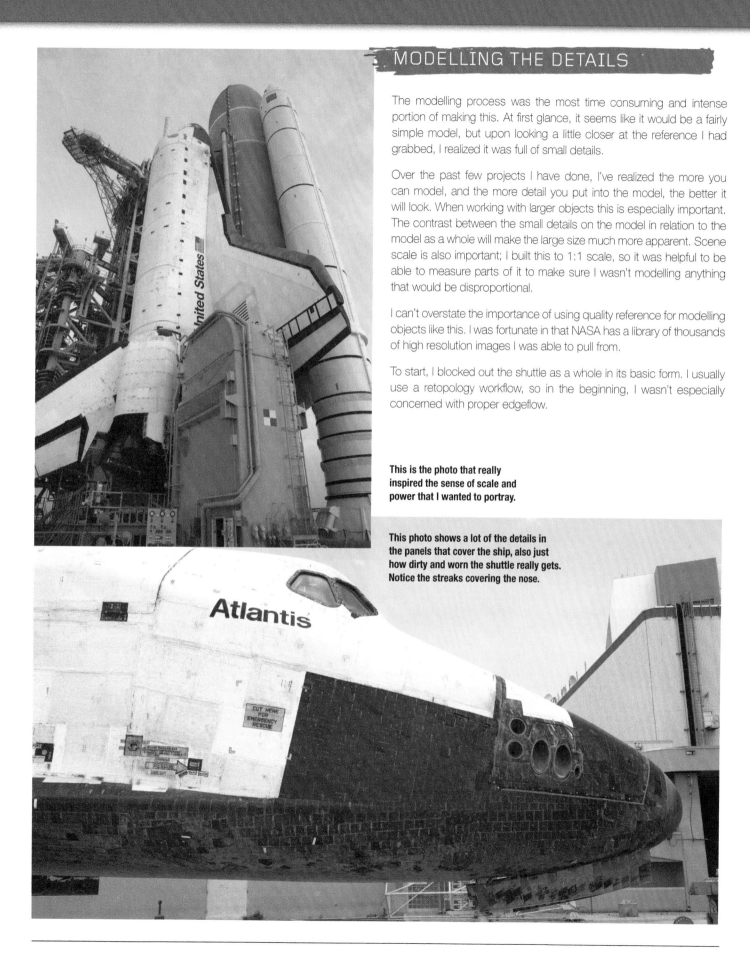

MODELLING THE DETAILS

The modelling process was the most time consuming and intense portion of making this. At first glance, it seems like it would be a fairly simple model, but upon looking a little closer at the reference I had grabbed, I realized it was full of small details.

Over the past few projects I have done, I've realized the more you can model, and the more detail you put into the model, the better it will look. When working with larger objects this is especially important. The contrast between the small details on the model in relation to the model as a whole will make the large size much more apparent. Scene scale is also important; I built this to 1:1 scale, so it was helpful to be able to measure parts of it to make sure I wasn't modelling anything that would be disproportional.

I can't overstate the importance of using quality reference for modelling objects like this. I was fortunate in that NASA has a library of thousands of high resolution images I was able to pull from.

To start, I blocked out the shuttle as a whole in its basic form. I usually use a retopology workflow, so in the beginning, I wasn't especially concerned with proper edgeflow.

This is the photo that really inspired the sense of scale and power that I wanted to portray.

This photo shows a lot of the details in the panels that cover the ship, also just how dirty and worn the shuttle really gets. Notice the streaks covering the nose.

This shuttle is covered in small panels, so I used 3ds Max's graphite tools, namely the Freeform PolyDraw tools, to map out most of them. It took some serious time, but I wanted to make it as accurate as possible. I placed them directly on the base mesh I had made and built them in blocks.

For the white panels, I cut directly into the base mesh and bevelled accordingly since they had a tendency to wrap and conform to the curves of the shuttle. Some of the stickers were modelled as well, more for the sake of making the texturing process easier than anything else.

Certain portions of the shuttle are covered in rivets and bolts, though they are basic, I decided it would look best to place them in the proper spots to give it the amount of small detail I was aiming for.

One important thing to note when making vehicles that have windows – it is always a good idea to build an interior, even if you won't be able to see much of it. I found some references of the flight deck and built a basic shadow interior. When viewing it from certain angles it's nice to see some shapes refracted in the glass and gives it that much more believability, even if it's just low poly filler objects.

Nearly everything on this model was bevelled so the light would have a nice edge to reflect from. For certain larger, more visible edges, the triple edge technique was used which is great for rounding corners with minimal effort and polygons. This technique will usually hold up with a smooth applied to it as well, though sometimes it's not necessary.

The boosters and rockets were made from basic shapes, cylinders and capsules with the proper faces extruded and details cut in.

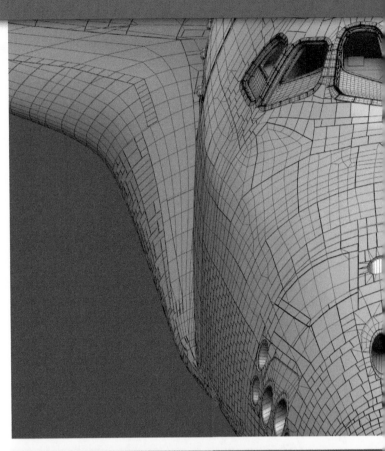

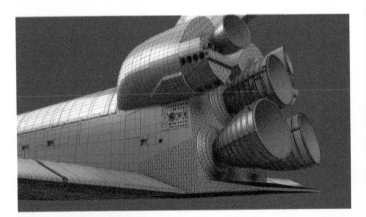

Here's an example of all of the panels that were modelled. Since I wasn't smoothing the main fuselage, I wasn't too worried about having long triangles.

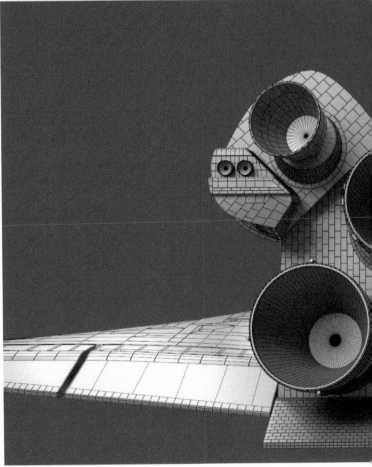

The front end where the flight deck resides. Most of the large panelling was built to smooth. You can see the basic interior that was created.

Here is a top view, you can see the panelling details also cut in to the wings.

The back of the spacecraft. I knew the engines were going to be spitting out fire, so I didn't spend much time modelling the interiors of the rockets.

Wireframes for the fuel tank, rocket boosters and supports. The basic shapes were easy, the devil was in the detail.

GETTING DIRTY MATERIALS

Texturing and shading has always been one of my favourite parts of the process. The space shuttles actually get quite dirty and have lots of small scuffs and wear marks on them, so I wanted to make sure they were represented properly and where they would naturally form.

A combination of file textures, procedural textures, composite maps and shader effects were used to get the final look of each piece.

The hard panels were textured with two painted textures, a V-Ray dirt map, and a noise map all built into one composite texture. All the panels had a lighter colour at the points where they meet, so I used the V-Ray dirt map to achieve this effect easily and relatively cheaply. A faint noise map was added on top of everything to show some wear and tear. Around the nose, streak maps were painted that were overlaid as well using a separate UV channel to precisely place them.

The soft white panelling was textured with two image textures. I cropped a few different-looking cloth panels onto the same texture sheet, and was able to unwrap the portions and place them on the texture wherever they looked best. This sped up the process quite a bit, allowed me to keep the resolution high on smaller pieces, and was topped off with a painted dirt map that encompassed all of the white panels on a separate UV channel to give them the needed variation.

For the white cloth panels, a falloff map in the diffuse slot was used with two versions of the diffuse texture; a darker one for faces pointed towards the camera, and a slightly lighter version of it that appears as the faces wrap away from the camera. This gave it a nice, soft, cloth-like effect.

The V-Ray Material was used for all of the materials as it gave the most control over reflections and refractions across the model.

I generally work with composite textures a lot. They work well in conjunction with multiple UV sets and this way you can layer anything you want across multiple resolutions.

FACING PAGE

(top) Some procedural and painted textures were used to make some scuffs to the front. The painted-on details (emblems, stickers, etc.) were all done with composite textures and UV sets.

(bottom) Here is a shot of the back. The shuttles actually have a lot of grime on them.

Below are a few of the maps that were used. On hard surfaces, I made sure to make colour, spec and bump textures for nearly everything.

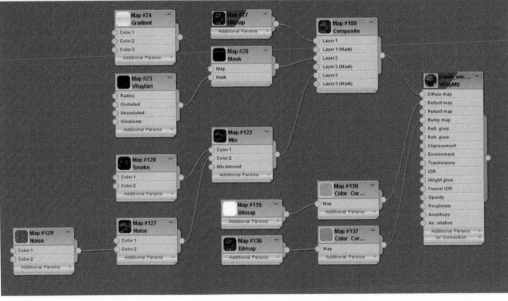

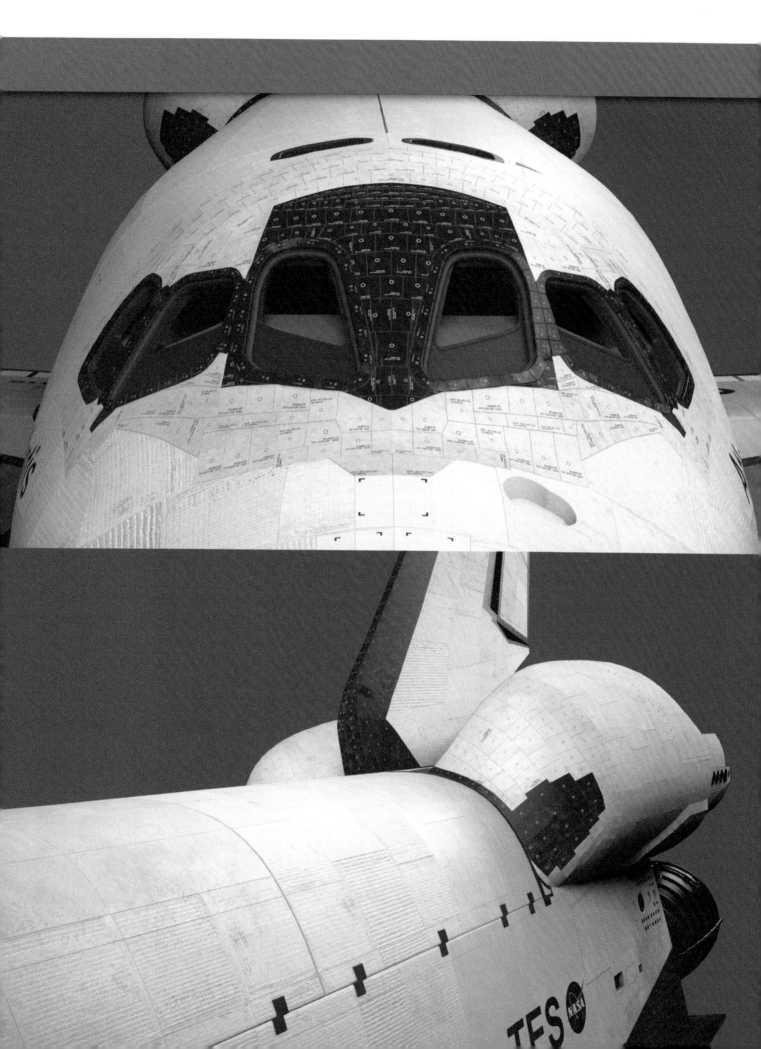

LIGHTING THE SKY AND FIRE

The lighting for this was probably the fastest, simplest part of the whole process. I wanted a nice daylight along with some light to show the heat from the rocket fire.

A standard directional light with V-Ray shadows for the sunlight illumination was used, coupled with a V-Ray dome light to simulate the bounce light.

For the rocket fire illumination, a series of omni lights with a hot orange and red colour were used to light up the shuttle where it would be receiving light from the fire. These all had attenuation set so the light would fall off nicely across the model as it got further and further away from the heat source. They also were all using V-Ray shadows.

One important thing I always try to do is to work with gamma correction turned on and set to 2.2. You could spend hours dropping in lights and trying to place them to get an even look of illumination across your entire model, but setting your gamma properly makes this much easier to achieve, saving you loads of render time.

Along with setting your gamma to the proper settings, using proper exposure control and camera settings will also make your lighting process a little easier.

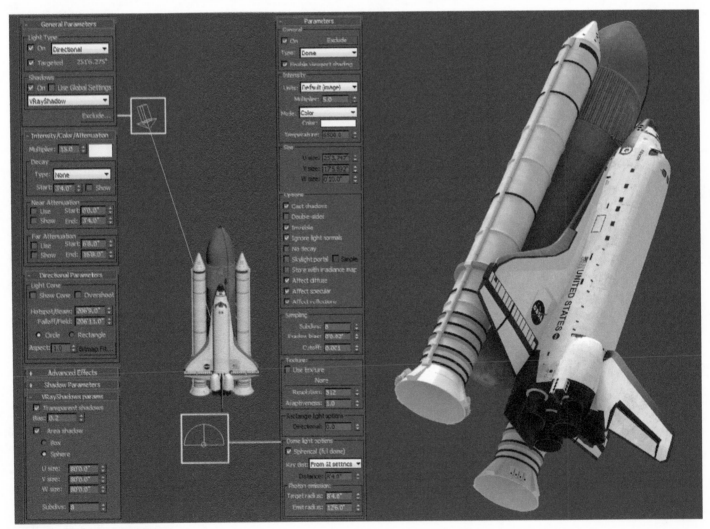

Here is the placement and the settings for the daylight and sunlight in the viewport and the resulting render.

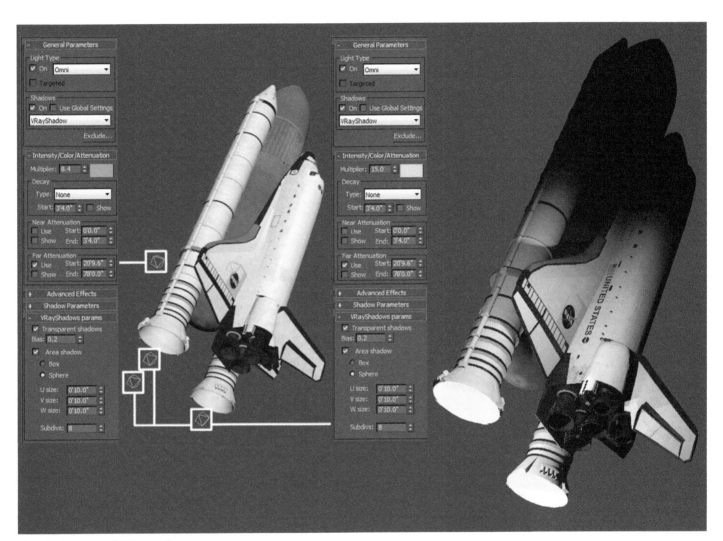

The main three engine lights were all set at a pretty strong intensity, the other engine light has a more saturated red colour and is a bit less intense.

TOP TIP –
TRIPLE EDGE TECHNIQUE

For hard angled edges, instead of using a chamfer, use a triple edge. These are supporting edges that don't deform the model and lie close to the angled edge. In 3ds Max, select an edge, and hit extrude, keep the height at 0, and adjust the width. Use smoothing groups (soft edges) to blend over them. They will also hold up better than a standard chamfer when you apply a smooth.

USING V-RAY TO RENDER

V-Ray was used for the rendering and took about 20 minutes to render out the complete image fully. For the daylight pass, I kept GI off for this render, as all it would do was increase the render time.

When you're rendering with V-Ray, it's important to understand how the sampling engine works. Fine tuning the adaptive image sampler and the DMC sampler along with a sample rate render pass can really help your render times.

As far as render passes, the main daylight pass, a pass for the glow from the rocket fire, a V-Ray dirt pass (ambient occlusion), a sample rate pass (for testing) and an object ID pass were rendered to create separate elements making it easier to combine them later on in Photoshop.

A V-Ray camera was used to render from and it's settings were adjusted to the exposure that I wanted. Since images of the shuttle at high altitude require a long lens, I set my focal length to 280mm, and my film gate to 24mm to get a nice look. For the exposure, I kept the f-number at 8, set the white balance to pure white, and set the film speed (ISO) to 100.

When I render out of 3ds Max, I try to get everything as close as is possible to the final look I want, instead of relying on extensive post processing. I find it easier to achieve the look I want this way, instead of layer upon layer of colour correction operations.

Here are my render settings. Everything is mostly default, with the exception of 2.2 gamma and tuning the samples along with the noise threshold.

Basic parameters	
type	Movie cam
targeted	☐
film gate (mm)	24.0
focal length (mm)	280.0
fov	4.831
zoom factor	1.0
horizontal offset	0.0
vertical offset	0.0
f-number	8.0
target distance	58'3.62"
vertical shift	0.0
horizontal shift	0.0
Guess vert.	Guess horiz.
specify focus	☐
focus distance	16'8.0"
exposure	✓
vignetting	✓ 1.0
white balance	Custom
custom balance	
temperature	6500.0
shutter speed (s^-1	200.0
shutter angle (deg)	180.0
shutter offset (deg)	0.0
latency (s)	0.0
film speed (ISO)	100.0

Here are the camera settings, with the focal length set to give a nice zoomed in look.

TOP TIP – CAMERA SETTINGS

Try to keep your camera and exposure settings close to real world values – this will help ground your scenes in reality (if that's what you're going for). This will also help with lighting your scenes, since you can light based on values set by your camera.

These are the separate light passes, left to right, sunlight, bounce light, rocket lights.

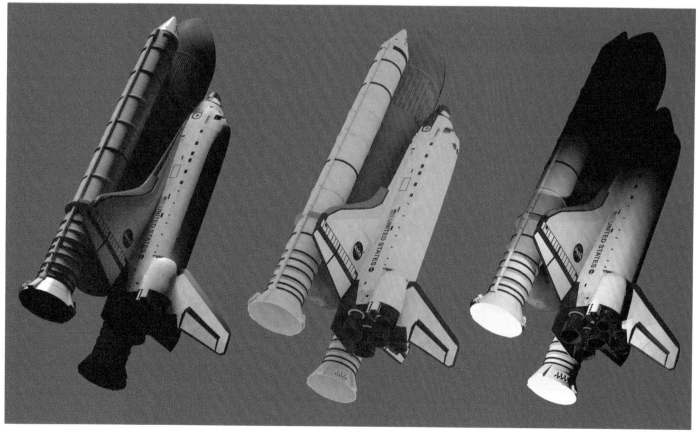

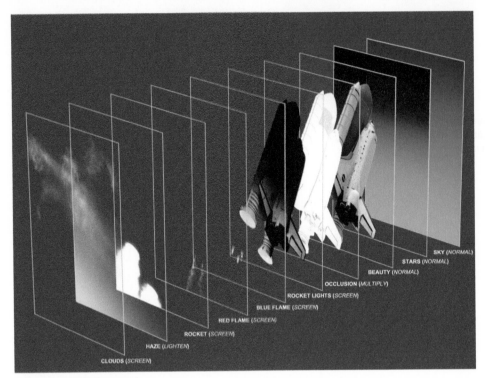

These are the main layers and
blending modes that were used
to create the image.

COMPOSITING IN PHOTOSHOP

All the compositing was done in Photoshop. After I've rendered out all
of my elements, I bring them all into one document in Photoshop and
order and name them properly. Keeping clean, properly named layers
always helps me work a little faster since I don't have to guess which
layer is which.

Using the multi-matte element also gives you a great advantage as you
can isolate certain areas of your image by selecting colour channels
and using them as masks.

The main shuttle and engines were all built in 3D, whereas the
background is just a simple gradient with a painted star map laid over
the top of it. A couple of adjustment layers were used to do minor
colour corrections on certain areas of the shuttle, and brightened up
some small areas that I wanted to stand out a little more.

The fire and smoke effects were painted using standard brushes
within Photoshop with some basic scattering and brush stroke effects
applied.

This is the layer stack.
You can see the multi-
matte element sitting on
top which I used to create
some of the layer masks.

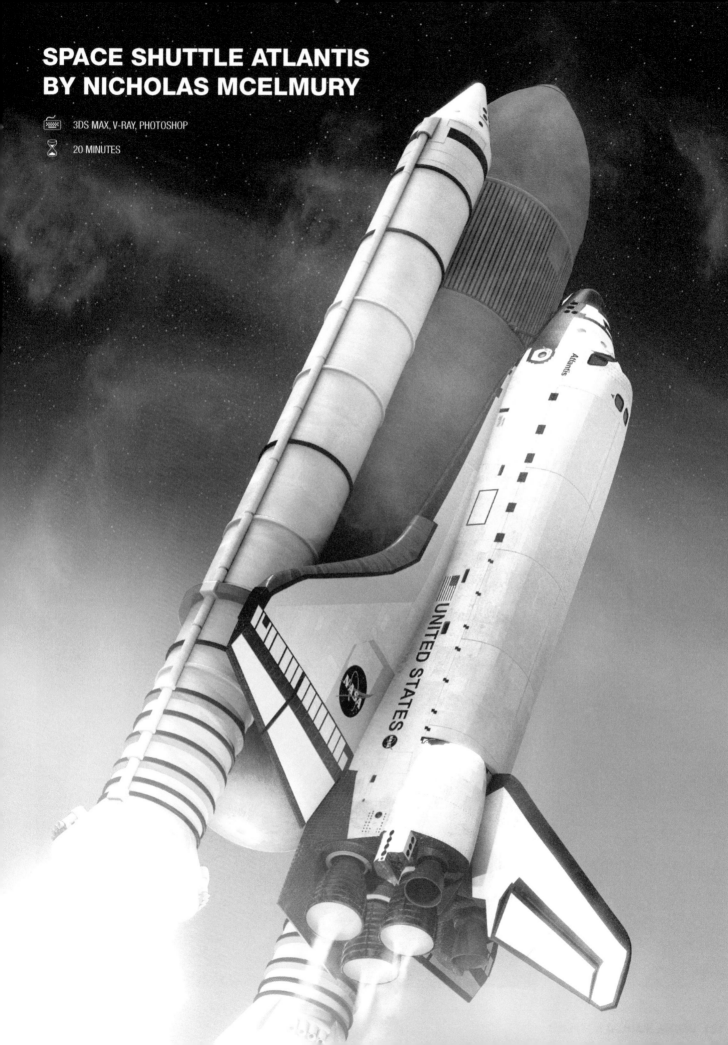

SPACE SHUTTLE ATLANTIS
BY NICHOLAS MCELMURY

3DS MAX, V-RAY, PHOTOSHOP

20 MINUTES

66 I love technical modelling and dirt bikes. That is the reason why I wanted to make a motocross bike model. I started this project back in 2010, originally for a game. Later I decided to do a detailed high-poly model that would look good on renders. I worked on it in my spare time for a few years until 2013 when I finally manage to finish the model. With help from John we textured the bike with his decals and seat cover. Now I use it to preview bike graphic decals from different companies and people interested in bike graphics. 99

PROJECT	2012 SUZUKI RM-Z450 WITH JVDL V2 DECALS
SOFTWARE USED	AUTODESK 3DS MAX, V-RAY, PHOTOSHOP
RENDERING TIME	6 HOURS
ARTIST	ZBYNĚK HLAVA (IN COLLABORATION WITH JOHN VAN DE LEST)
COUNTRY	CZECH REPUBLIC

You can see two things in this picture. The lighting is done with an HDRI map in a domelight and the grass is made with MultiScatter.

Here's a wireframe of the front wheel with the patterns on the tyres.

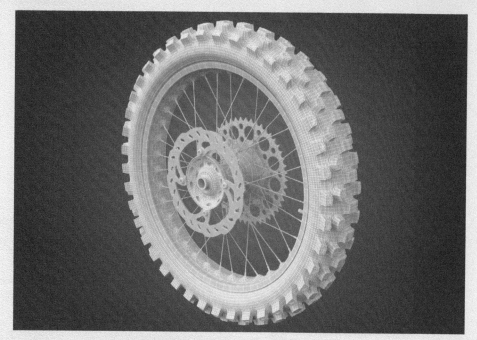

There are lots of materials on the bike. Here are nodes and the settings of the exhaust muffler which uses carbon fibre with clearcoat reflections and metal parts.

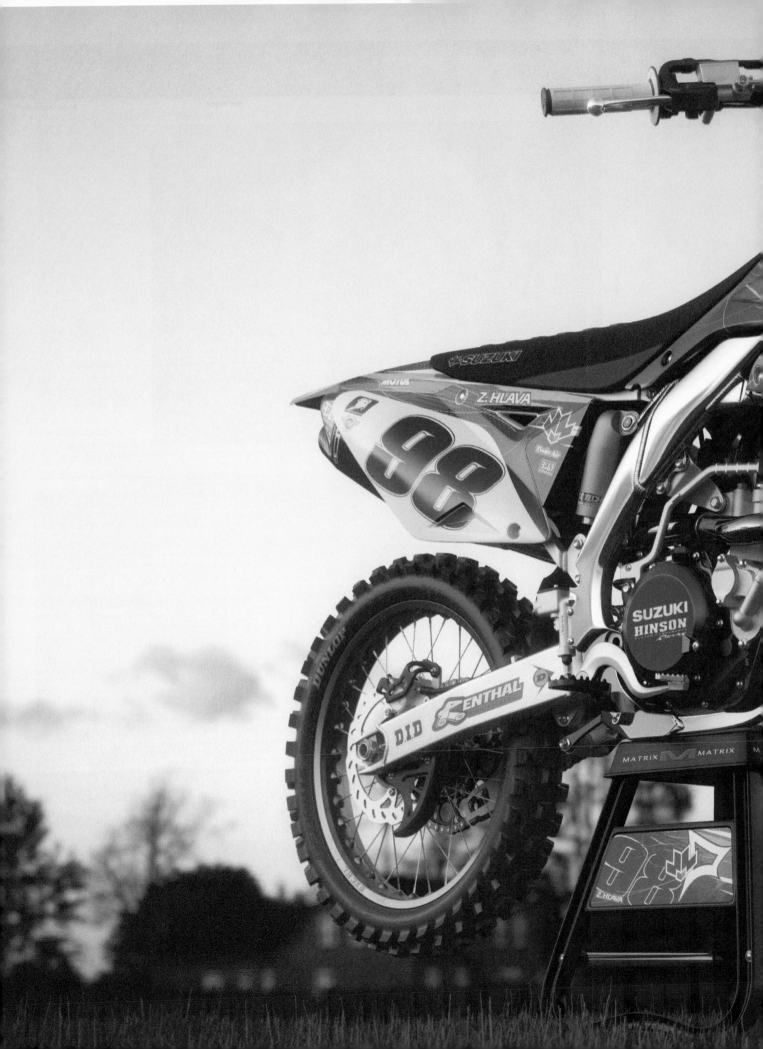

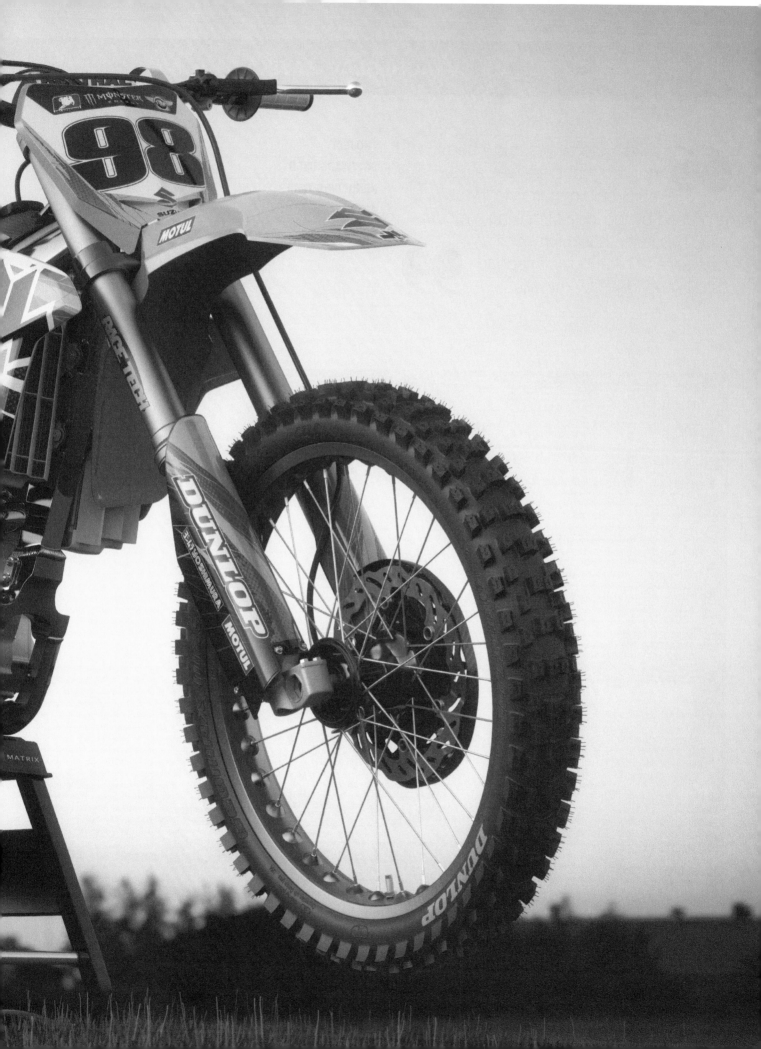

> 66 I like motorcycles and when I noticed that there was a new electronic motorcycle, I was enthused by the idea of making a model of it. This is the basic form of the new style of bike, but with added details and ideas by myself. 99

PROJECT	MOTORCYCLE LITO SORA
SOFTWARE USED	AUTODESK MAYA 2012, V-RAY 2.0
RENDERING TIME	2H 34 MIN
ARTIST	VYACHESLAV ZAYIKA
COUNTRY	UKRAINE

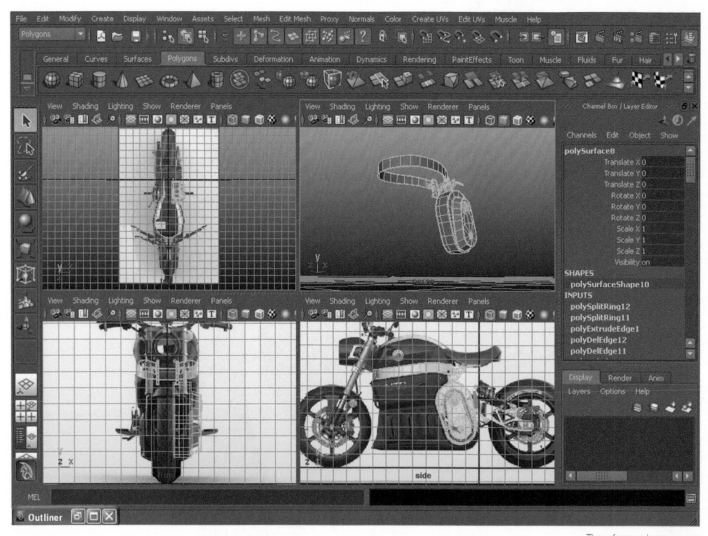

The reference images were loaded and the base forms were modelled using the CV curve tool, Loft, Extrude face and Split polygon tools.

Making the large but basic parts such as the tank, frame and wheels.

Small details being added to increase the realism of the model.

Creating V-Ray materials to give the bike the right kind of finish.

Finally the camera has been set up to create the shot for rendering.

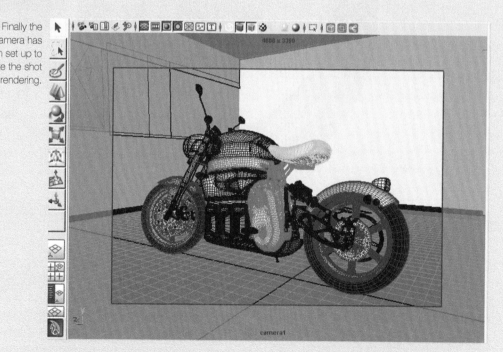

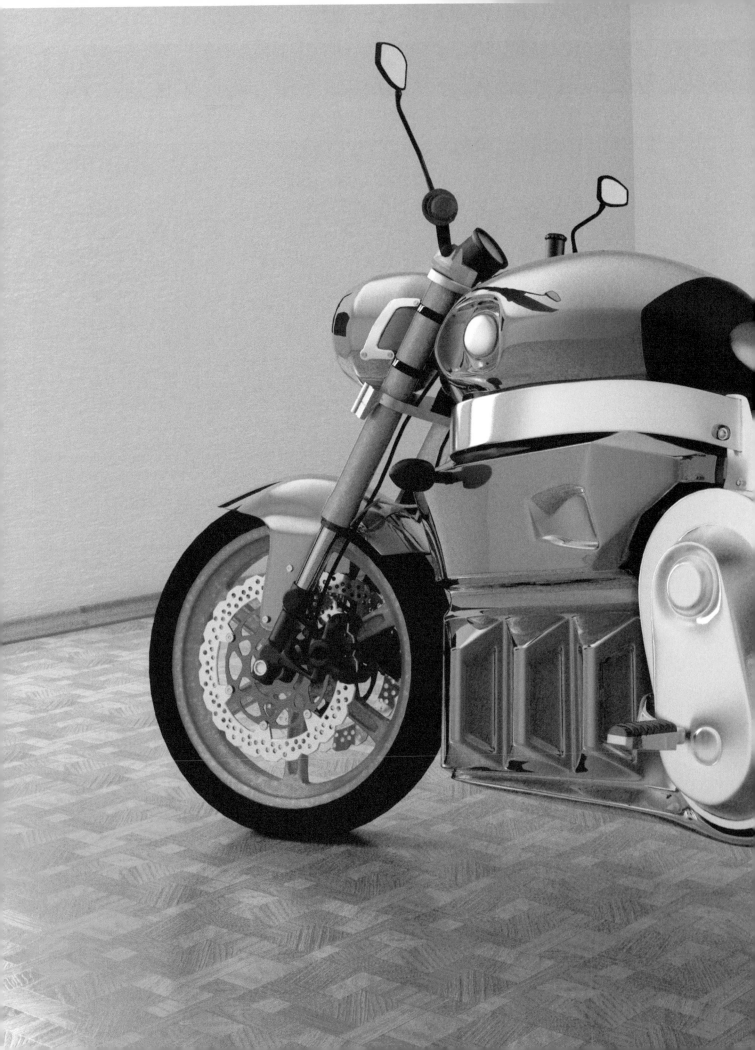

CREATING A CAFÉ RACER

As the old school style of motorbikes has come back into fashion,
Andrea Lazzarotti decided to recreate a classic model from Benelli

THE HISTORY

The Benelli 900cc six-cylinder, 4-stroke motorcycle was once a symbol of the Made in Italy industry. It was also the first six-cylinder motorcycle in history, a significant challenge for the engineers of the past. Although it was never a commercial success it is, and remains, a piece of motorcycling history.

PROJECT	BENELLI CAFÉ RACER
SOFTWARE USED	3DS MAX 2012, COLORISTA 2, ZBRUSH, RHINOCEROS
RENDERING TIME	ABOUT 2 HOURS
ARTIST	ANDREA LAZZAROTTI
COUNTRY	ITALY

Source images of the actual bike and a stripped down frame on a street corner.

On this model I wanted to create a custom template style café racer that I could make various versions from. This style of bike is back in fashion in recent years to the point that nearly every motorcycle manufacturer has put into production some vintage models from several decades ago, with the necessary improvements required today, insofar as possible, without changing the spirit too.

Initially I had to make a thorough search on the net to find decent pictures to have accurate reference material so that I would be able to model each element without having to invent items. Although there were many photos of the bike in action, I was lucky that some customisers and restorers took detailed photos of their work, and this gave me the opportunity to understand and visualise the various dimensions and aspects of the components, especially the recesses of complex parts such as the engine and carburettors.

The original Benelli was equipped with three carbs, two per cylinder, but I opted to mount six carburettors as it definitely gave it a more impressive and muscular look.

The drum brake mechanism on the front wheel of the bike.

The blueprints of the original design for the bike.

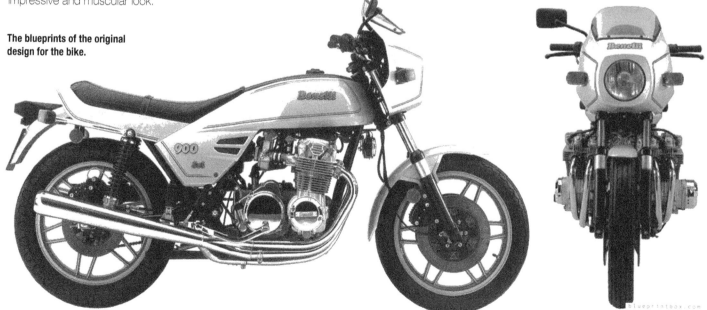

ENGINEERING THE FRAME

After laying out the blueprint that I had found on the net I started to draw the frame tubes. As I didn't have a view from above, it helped a lot to look at pictures from different angles, all the while maintaining the actual measurements of the bike.

Once the frame was created in the right scale, I created the welding seam between them with a convenient and useful free script called Welder. You can find it here: http://jokermartini.com/2011/08/10/welder.

Then I started to create the spoked wheels and in this case I preferred to exclude the original version and the drum brakes brand of Fontana, which was very common in motorcycle racing at that time. It's easy enough to change them back by looking on the net for photographic material for this brand. I used splines for the spokes and a circular array for positioning them around the rim.

When the wheels were finished, I started on the engine. It might have been a better idea to have modelled this in Rhinoceros using NURBS, but as I didn't have much experience with the package I decided to use good old polygons in 3ds Max. I also then would have total control on the final topology. Every corner was filleted and there were geometries fused in others. In addition, each piece was modelled as a separate component, like in the real world. These included the head, cylinders, manifolds, carburettors, coils, side covers, cover lifters, etc. To vary the nuts and bolts I modelled different sets of screws, bolts, allen keys, springs, etc.

Initially I had thought about creating a set of screws and converting them by proxy in order to make the scene more streamlined but in the end I abandoned this idea in light of the fact that several bolts and screws were unique anyway and therefore different from the others.

Creating the frame is always the first step for something like a motorcycle.

The front wheel and drum brake is quite accurate but varies slightly in design.

Some of the screws and bolts that were unique in places provided plenty of variety.

Getting the correct curvature and scale of the engine was not a quick or easy thing to do, especially for the lower parts where I did not have many photographic references. This was really a work of patience. Once the body of the engine had been created, it was time to add all the little details where the engine was mounted in the frame with coils, spark plugs and the electrical system. The exhaust system was created, starting with a simple spline with bezier handles positioned and curved, then converted to polygons.

Being the owner of a Kawasaki from that period (1970–80) it was not difficult to wire the motorcycle as it should be in reality, both in regards to the electronics and the cables, clutch, brake and accelerator. Obviously I decided not to model the complete electrical system when most of it would not have been visible under the fairing and engine, but a good 60 per cent of it had been done by now. Every bulb and headlight had its own wiring.

Once the engine had been built I had to think about how to continue the design of this special bike. I had taken the time to look at various models of authentic fuel tanks from the time, but also the various approaches taken by other designs were helpful in creating a rough starting point from which to begin to model my fuel tank.

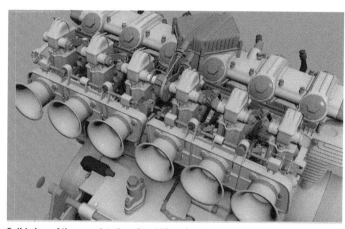

Solid view of the completed engine. Although some duplication sped things up, it was still a painstaking process.

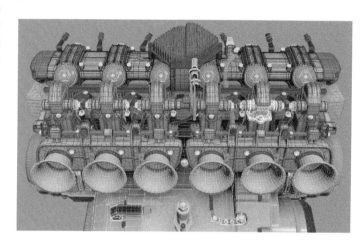

The wireframe of the engine. Most of the engine connections are present, just those out of sight weren't modelled.

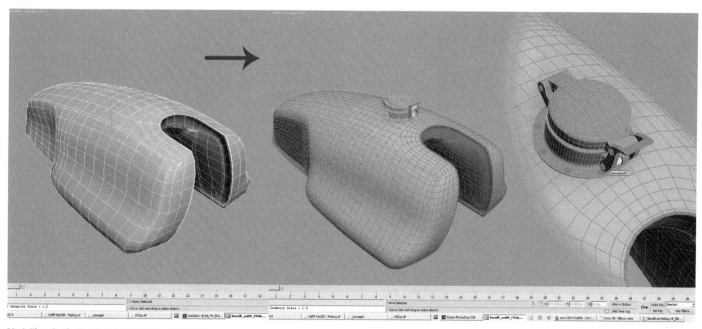

Modelling the fuel tank was relatively easy, it was more a case of deciding which shape to use.

I wanted to give a touch of originality to the design by arranging double headlights, moved to the right side of the windshield. The other reason for doing this was so that people didn't look at the windshield and think it was something they were already familiar with.

The fuel tank cap was perhaps the only thing actually existing and commercially available at the time. The instrumentation tachometer and speedometer were done taking inspiration from the Kawasaki W800 while the LED plate is steel, bent, drilled and brushed as is often seen in various preparations. For the body fairing near the knees

I made one of my many Cafe Racer logos and custom embossed it using a displacement map.

Other features included the bullet-style turn indicators which were much more elongated than those that were on the market for this bike. To give a realistic lighting effect the inside of the light casings (for stop, turn signals and lights) was modelled as they were in reality to simulate the same effect reflections. You simply don't get the same effect by just using a bump map. I went as far as modelling the light bulb filament present inside.

Wireframe showing how all the leads connected the various control systems together.

Solid view showing some of the engine detail with it in the frame.

Here's a wire showing the entire model. It was built from individual components where possible.

The engine had to be built to an accurate scale to then fit into the frame properly.

The wiring for the plugs and all the leads for the electrical system.

The knee-pad area
of the body with a
custom-designed logo
added.

Here's the logo as a displacement map which was
added to the body.

The texture for the speedo was designed
to have a more retro feel to it.

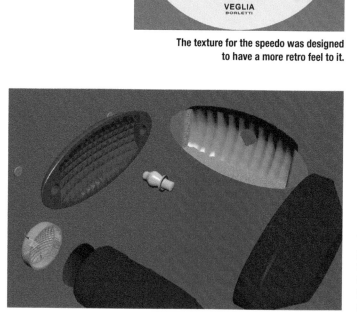

The twin gauges
for speed and
revs were inspired
by the Kawasaki
W800.

The component
parts for the light
fittings featured
actual elements
for a more realistic
effect.

THE PAINT SCHEME

For the livery I spent some time in deciding what to do. There were many styles and colour combinations that fit well, but in the end I had to force myself into a final decision and opted for a classic yellow with black stripes. This gave it a Camaro feel that said the bike was built for racing.

Thanks also to my colleague, as well as motorcycle enthusiast, Federico Tosi, I created the livery of the helmet. You can see his other creations on Facebook by going to: https://www.facebook.com/tworight.hands?fref=ts

More decals and paint effects that were added to the bodywork.

The classic yellow and black livery that was used to give the bike a racer feel.

BACKPLATES AND LIGHTING DESIGNS

Once the bike modelling was finished it was time to find the ideal real-world location to place it for rendering. For the first location I chose Passo del Vestito, Italy, Massa Carrara (Latitude 44 ° 3'55 .97 "N Longitude 10 ° 13'28 .86" E), where I made several shots in RAW format. I then created an HDRI at 360 degrees, shooting different exposures in RAW with my decrepit old Canon 400D. This used a Sigma 8 mm fisheye lens mounted on a Nodal Ninja for precise and easy 360 degree rotation. I also took lots of pictures from different points of view to create a stock of backplate pictures. Once the shooting was done I used a programme to create a spherical environment that could be used in 3ds Max.

I used a dome with the HDRI image created earlier to illuminate the scene with IBL using V-Ray as the render engine. This ensured a good level of photorealism and an exact fit. For each shot a map rotation was made that fills the photo of the backplate. I used a low-res and blurry version of the HDRI to illuminate the scene using environment skylight, and the full resolution HDRI in the slot for reflection. One direct light was used to improve the sun light direction. After setting the lighting, backplate and the HDRI I turned on Global Illumination using irradiance maps.

Also in this case, as often happens in my personal work, I wanted to change and create another style. In fact, I wanted to create a model with the engine painted black, red frame, no fairing, race number in place of the side panels and a classic tank with unpainted, bare metal.

Each piece of the body underwent several changes before becoming what it is, because I hardly ever have an overall view of the work I'm doing. I love to change direction, leaving me to implement ideas at the last minute.

Here's the scene being set up to render with the HDRI lighting.

These are the alternative textures for some of the other scenes.

The photo backplate for the road scene before adding the CG elements.

Here's the classic yellow version and the character walking away from the bike.

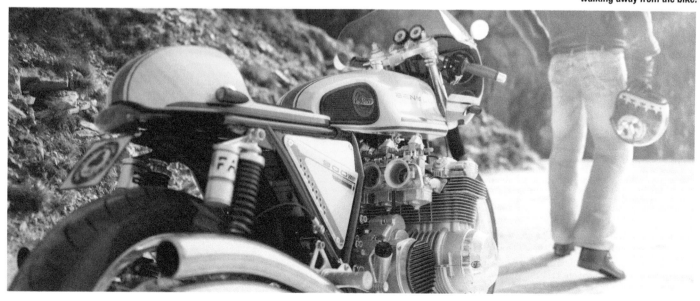
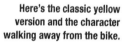

An alternative livery with new kit,
lateral number, handlebar mirrors
and iron cover for back rim.

A close up of the engine
with the photo backdrop of
the road behind.

A 360 degree view of the location
used to create an HDRI lighting
scheme.

PARK AND RIDER

For the version of the bike at the park instead I tried to use my old Light Probe, the famous giant ball reflecting on a tripod. This technique is very fast but obsolete because it returns a small image size, which then needs to be cropped into, reducing the image size further. Also, let's not forget that photographing a subject that reflects the environment, and not directly the environment itself as it does with a fisheye, makes everything appear in reverse. I used the ball technique when I needed to quickly grab an environment.

For the bike rider, I took a pre-existing model of a man at low detail and I sculpted it in Zbrush, refining the face and projecting the various textures on the face with the cool tool called Spotlight. From the body I then created a model in 3ds Max with very rough garments which were then refined, modelled and textured in ZBrush. Also the mapping coordinates were generated in ZBrush with the projection master tool.

Once sculpted I saved displacement maps in 16-bit TIFF image formats and put them in V-Ray, with the displacement mode, over the figure. For the material of the skin I used SSS2 in V-Ray. The settings were very standard and I limited myself to mixing a diffuse map created in ZBrush with a subdermal map (a colour edited map of the diffuse) below one of the many tests for the skin.

This created the elements for the third location, at the central park in Parma called the Parco Ducale.

The last image was created without the use of dedicated and photo HDRI backplate, but rendered using only a sun and sky in V-Ray, sky in the environment and GI lighting. The whole image was then composited in AfterEffect adding backgrounds, lighting, camera blur and the bike itself. Finally, Colorista 2 was used for colour correction.

The old reflecting ball on a tripod technique used to quickly generate an environment.

An alternative version of the image set in the central park in Parma.

The basic wireframe of the rider was
then sculpted in ZBrush.

You can't have a motorbike
rider without a cool pair of
boots.

Rough garments were
created in 3ds Max and
refined again in ZBrush.

TEST_008

Modelling the face of
the rider then projecting
textures onto it.

Here are the face textures being
unwrapped for UV mapping.

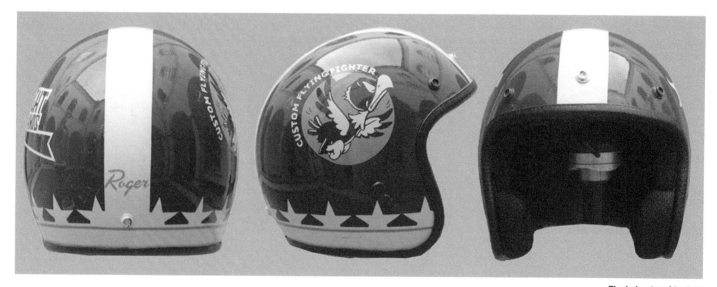

The helmet and texture
were specifically
designed to cultivate
the retro racer feel.

COMPOSITING THE FINAL IMAGE

Here are the final steps used in After Effects to put the render passes and the background and lighting together to create the final image.

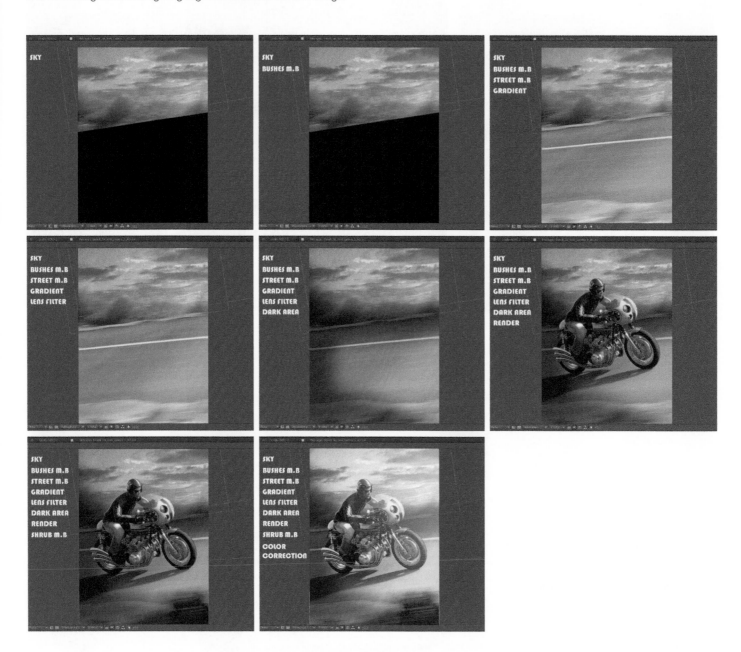

BENELLI CAFÉ RACER
BY ANDREA LAZZAROTTI

 3DS MAX 2012, COLORISTA 2, ZBRUSH, RHINOCEROS

 2 HOURS

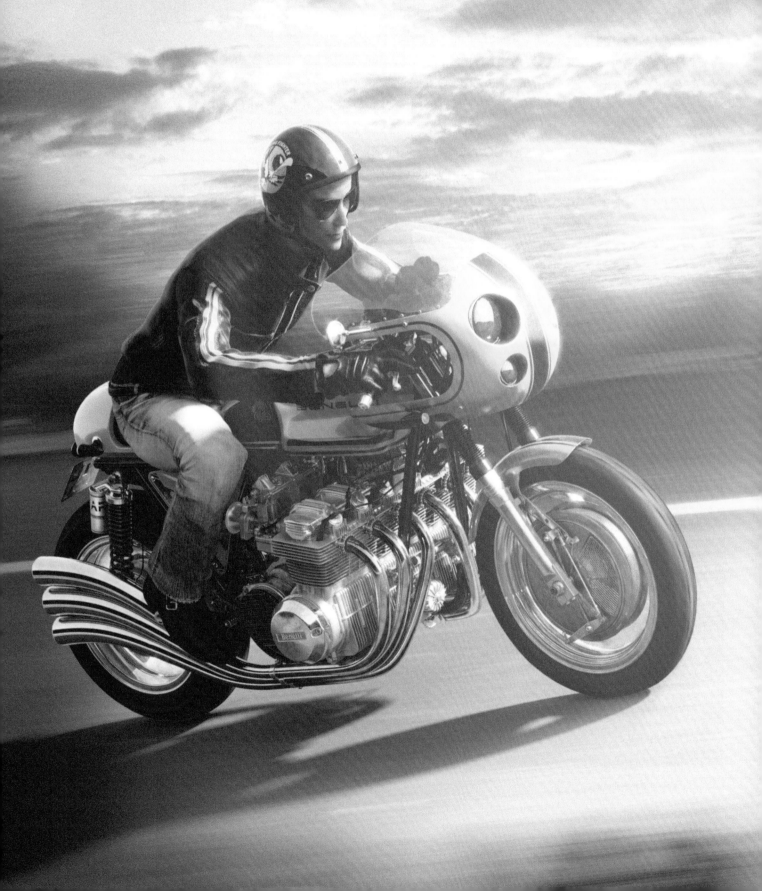

" This picture is about clock-making masterpieces. On the one hand it was inspired by a picture of a rooster-formed clock which I saw in a book 10–15 years ago. On the other hand it was inspired by English and Swiss automations of the eighteenth–nineteenth centuries and especially by the mechanisms of a great Russian inventor, Ivan Kulibin. I tried to make it look like a true fully movable mechanical bird. Imagine an alarm clock which can suddenly wake you, and possibly your neighbours, in the morning with loud crowing and then quickly run away from you if you try to hit it, catch it or try to throw a pillow into it. "

Adding various spotlights to highlight the metal form of the alarm clock construction.

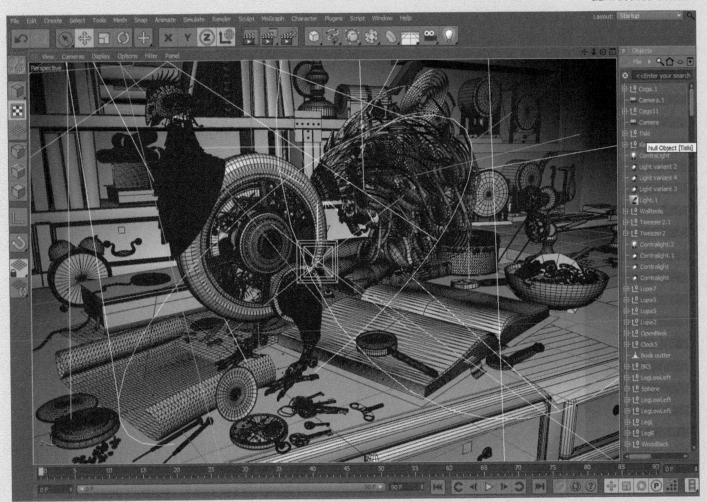

PROJECT	ALARM CLOCK
SOFTWARE USED	MAXON CINEMA 4D R13, ADOBE PHOTOSHOP CS3
RENDERING TIME	APPROX. 3 DAYS
ARTIST	ALEXANDER VANIEV
COUNTRY	RUSSIAN FEDERATION

Solid, smoothed surface viewport look at the scene and all the elements to check the composition.

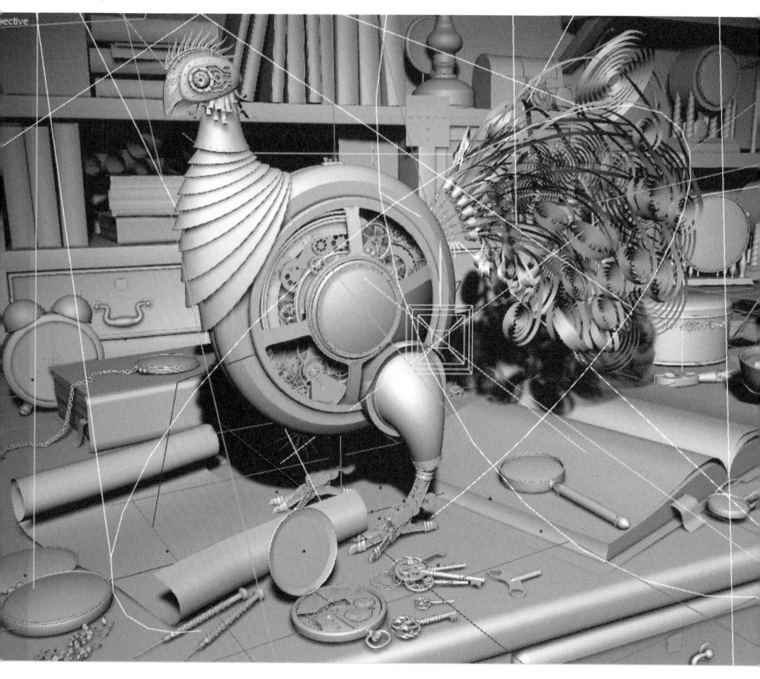

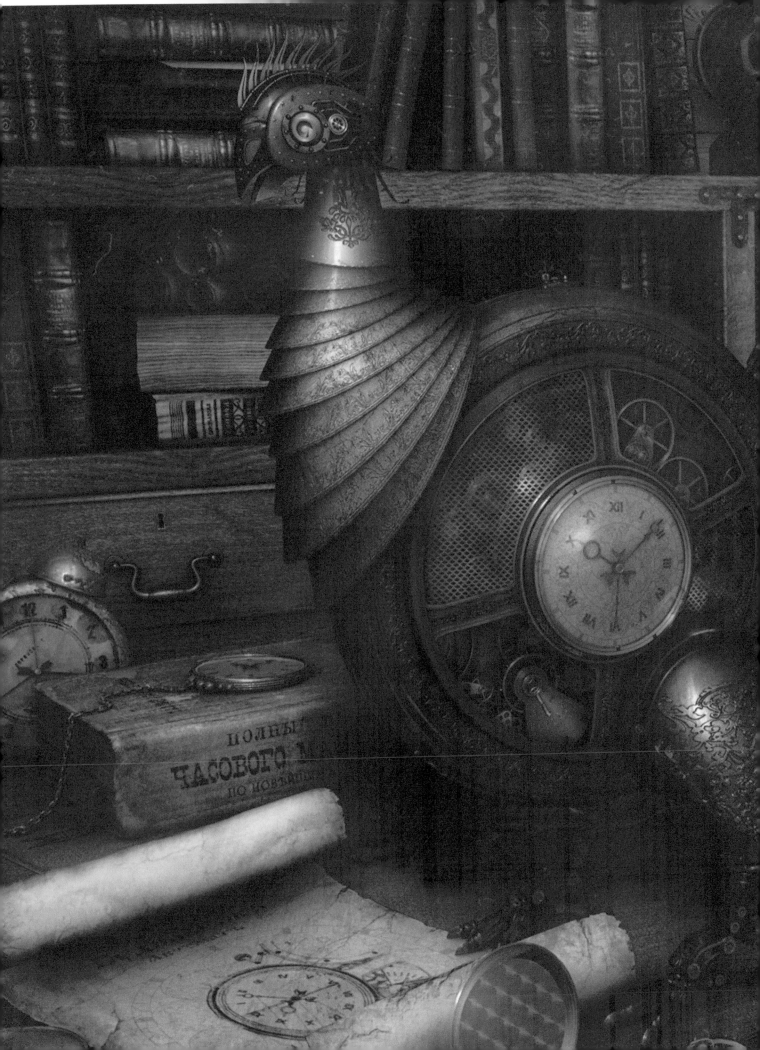

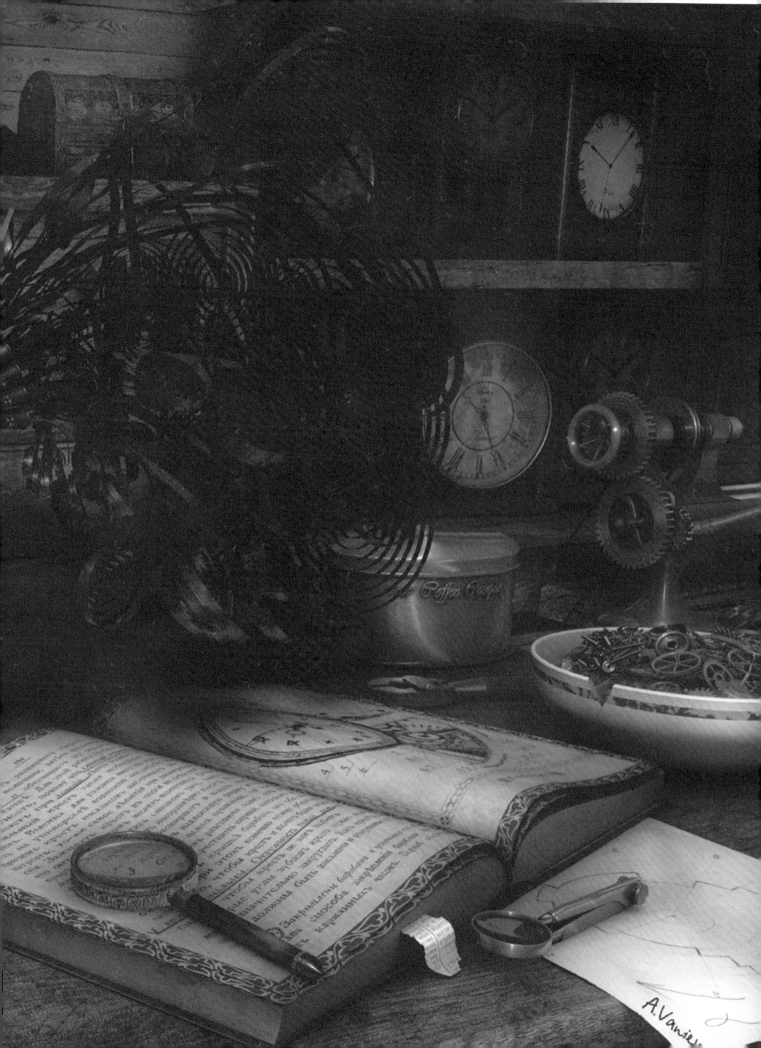

> The idea was to create a modern street tram in a busy city with very steep hills in the background. Because I had a basic PC I only modelled the fronts of the buildings and the visible sides of the tram and cars to cut the polygon count down. The image was rendered with V-Ray and post production in Photoshop added colour and styling plus the light effects and reflections.

V-Ray Materials were used to add textures to the road surfaces.

Multiply
alpha 71

Photoshop was used to add lens correction and lighting effects.

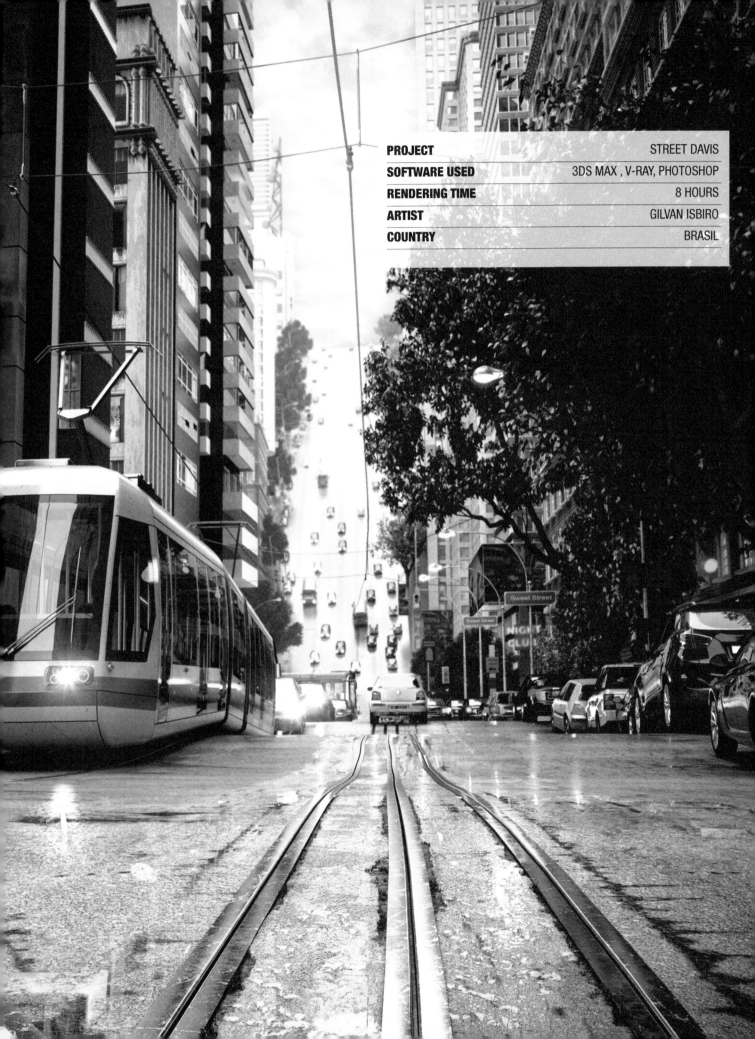

PROJECT	STREET DAVIS
SOFTWARE USED	3DS MAX , V-RAY, PHOTOSHOP
RENDERING TIME	8 HOURS
ARTIST	GILVAN ISBIRO
COUNTRY	BRASIL

" This picture is from my memories. In my childhood I spent my holidays in the countryside. My granddad and I took a train and went out to explore the countryside. I loved those days and always wanted some way to recreate them. At the time we did not have a camera to photograph those moments so creating the image with CG software helped me to bring to life all those memories in my mind. "

PROJECT	GAGARIN
SOFTWARE USED	3DS MAX 2012, VRAY, PHOTOSHOP
RENDERING TIME	8 HOURS
ARTIST	ANTON TURKIN
COUNTRY	RUSSIA

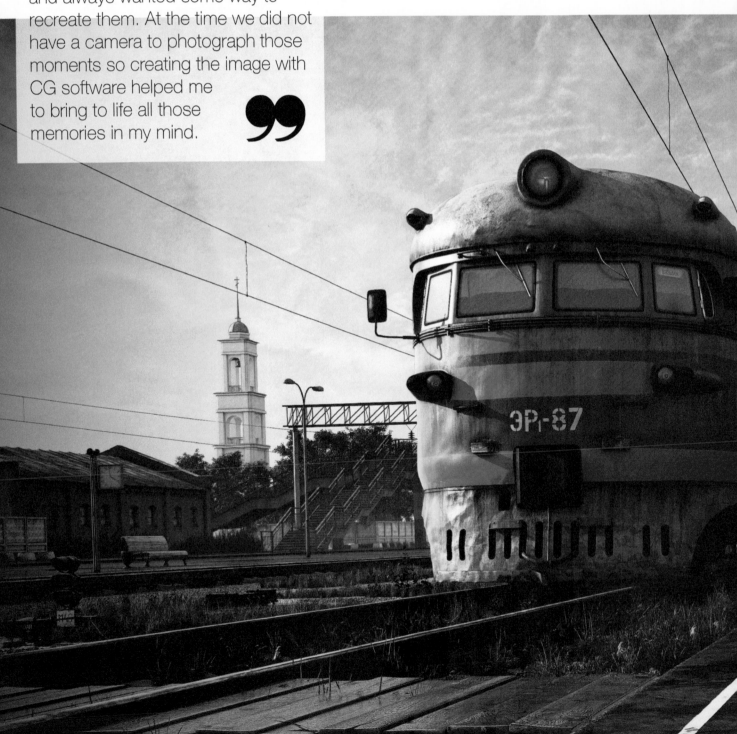

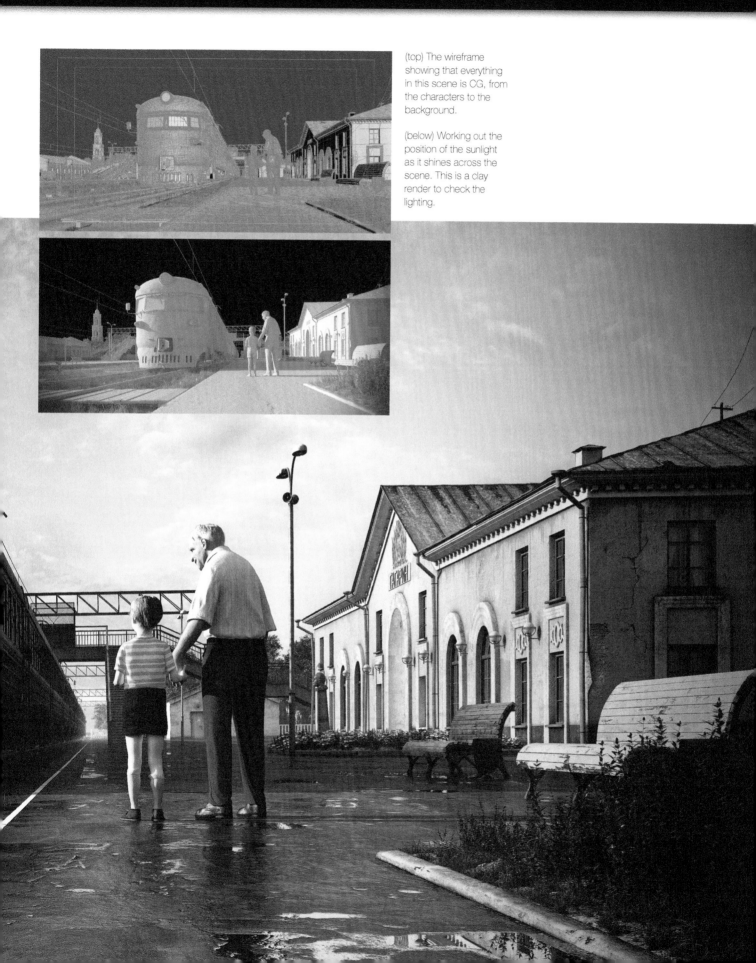

(top) The wireframe showing that everything in this scene is CG, from the characters to the background.

(below) Working out the position of the sunlight as it shines across the scene. This is a clay render to check the lighting.

> The train was modelled, textured and lit in CINEMA4D. Originally I wanted to photograph several trains and mount them using Photoshop, but there were just way too many reflections on the surface. When I rendered it I used multi-pass rendering, so it was possible to work on the reflection and shadow maps in Photoshop after rendering. The backdrop was a mixture of Argentina (foreground) and Austria (mountains). Most important additions were the lights on the train, as well as the smoke. Both were painted in afterwards using Photoshop.

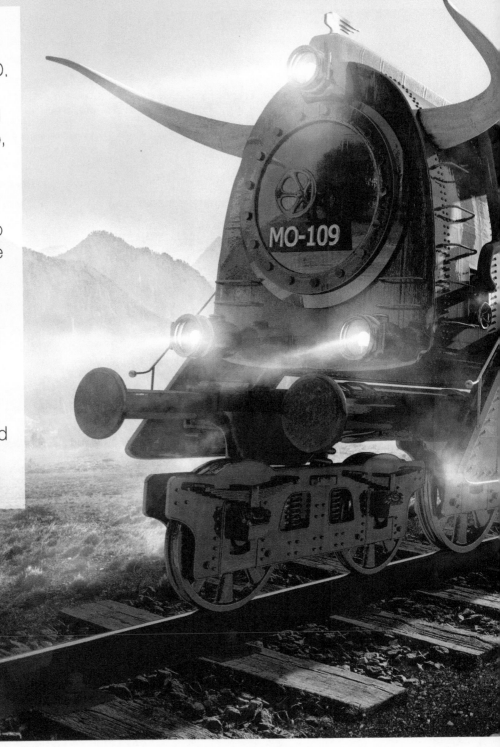

PROJECT	MONORAIL
SOFTWARE USED	CINEMA4D R14, ADOBE PHOTOSHOP CS6
RENDERING TIME	ABOUT 10 HOURS
ARTIST	ULI STAIGER
COUNTRY	GERMANY

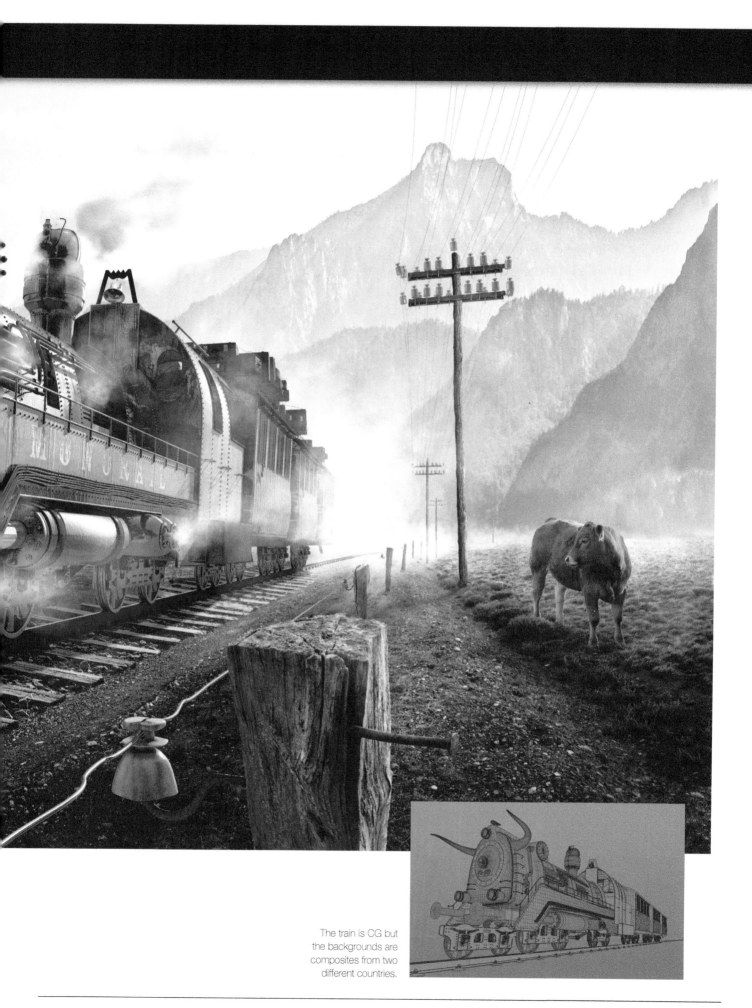

The train is CG but the backgrounds are composites from two different countries.

" I really wanted to make a beautiful old-time steam train. I found my inspiration on Google when I saw a picture of Baldwin, an old steam train from the company Burnham, Parry, Williams & Co. made in 1876. I modelled and rendered it using Autodesk Maya. The final image featured textures that I made from batch rendering many different layers and using Autodesk Composite to mix them together. "

PROJECT	THE BALDWIN STEAM TRAIN
SOFTWARE USED	AUTODESK MAYA 2014
RENDERING TIME	AROUND 30 MINUTES
ARTIST	KRISTÍN SNORRADÓTTIR
COUNTRY	ICELAND

An ambient occlusion render to show the lighting on the model.

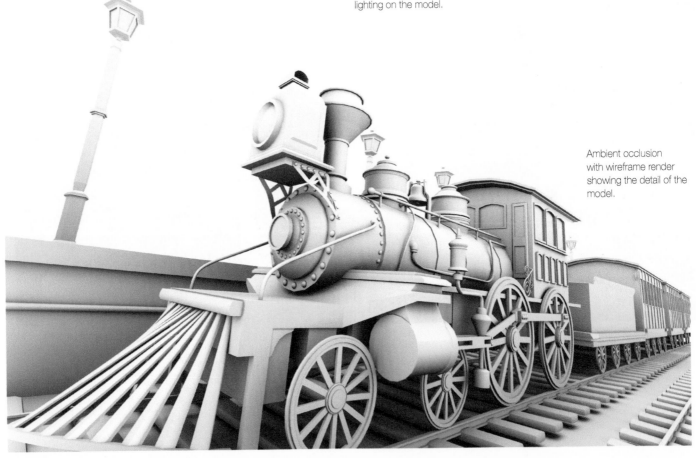

Ambient occlusion with wireframe render showing the detail of the model.

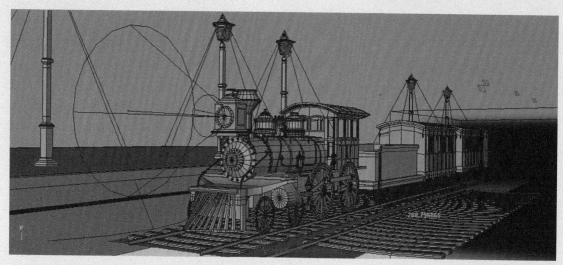

A front-view screenshot of the train from the scene file in Autodesk Maya 2014.

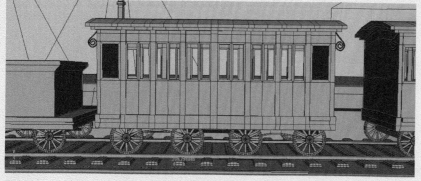

The side view of one of the wagons. Once small elements were built they were duplicated to make up the whole.

The engine itself was the most complex part of the model.

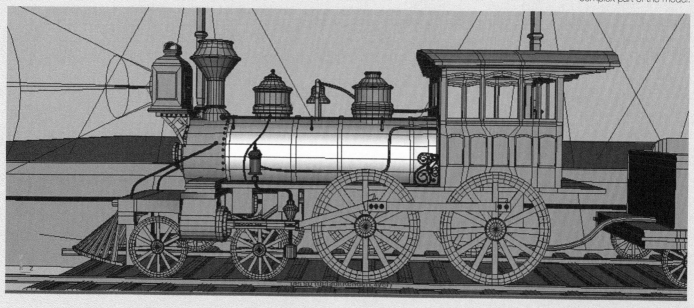

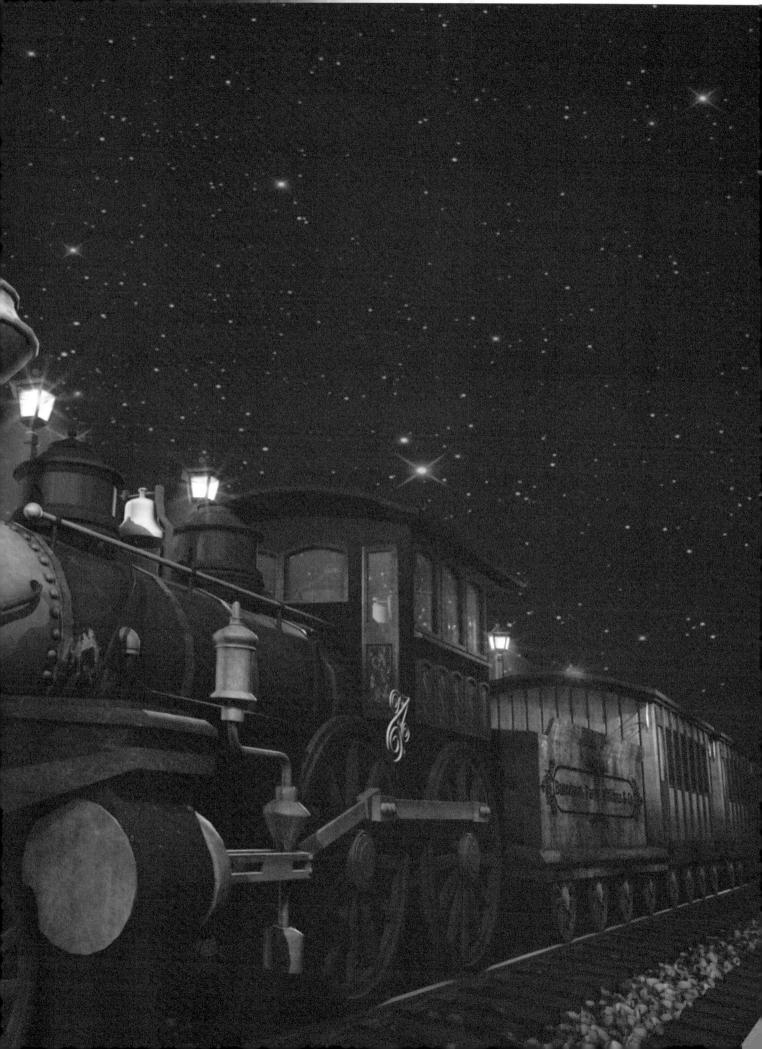

BUILDING THE LISBON TRAM

Discover how Omer Messler created an old-fashioned-style tram on the streets of Lisbon, Portugal

DIRTY URBAN CITIES

The main reason for creating this image originally was for my portfolio and then uploading to my website. Before I started working on the project I needed to feel inspired to create it. For me this is one of the most important steps! I spend plenty of time here, thinking and looking at references. These can be almost anything like a photo, painting, movie, or simple everyday things that inspire me to form my main idea for the project. For this one I wanted to create something old, dirty and urban. This led me to Lisbon City in Portugal. I immediately fell in love with the street style, buildings and the amount of detail.

I had in mind to create a scene which was both simple and beautiful so I decided to make an old tram. After searching the Internet for reference images of trams, I found this very charming tram and decided to put it as a main object in my street scene. The street itself was totally made up in my head, inspired by reference images I found on the Internet.

The whole image took about three weeks to make during the evening hours between my daytime work in the studio and was created using 3ds Max 2012 and rendered using V-Ray. Textures and post work were done using Photoshop CS5.

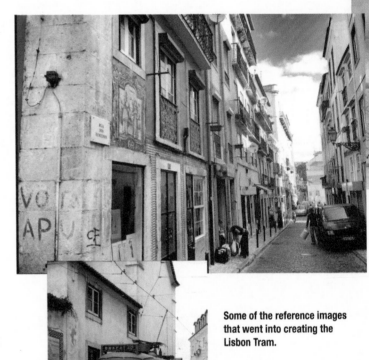

Some of the reference images that went into creating the Lisbon Tram.

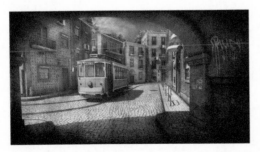

The Lisbon Tram – final image

PROJECT	LISBON TRAM
SOFTWARE USED	3DS MAX, V-RAY, PHOTOSHOP
RENDERING TIME	50–60 MIN
ARTIST	OMER MESSLER
COUNTRY	ISRAEL

SKETCHING AND MODELLING

First, I started by searching for all possible references of the tram and street scene due to the fact that I was unable to find an accurate blueprint for the tram itself. I ended up with around 200 images, some of which are featured in this tutorial. The process of searching for references was important because it helped to give me information that was essential for accurately recreating the environment I was imagining. On this occasion what helped me a lot was the technique of keeping things to scale. Finding references was quite easy. When all the research was done, it was time to start the project.

After I got my first idea I made one quick sketch that served as a base for things to come. It doesn't matter if you are good or bad at sketching, it's just that it's the fastest way of making a draft version of the ideas that you have.

The tram became the object I gave more attention to so I started modelling the tram from several references to have the most accurate representation. This included all the small parts like nuts and bolts. By the end, the modelling of the tram came to 794 pieces.

I used symmetry for most of the elements of the tram. A good tip for modelling this kind of work is to model all parts separately. This really helps not only for the modelling, but also for the texturing, and in general it leaves the model really light.

I built a few basic shapes in 3ds Max and staged the camera. I believe that the most important thing at this stage of an image is to define the main shapes in the composition, because the whole scene is going to be built around those shapes. The camera is another important consideration because the scene is created from the camera's point of view and so you only need to create what the camera sees. If you don't do this part right then, it's going to be a waste of time changing the main shapes later on, when you get into the detailing. It's also good to place some basic lights and define some materials. After the 3D scene blocking was finished, it was time to start with the modelling. When I create a scene with lots of details, it can take up to a couple of weeks to complete, depending on the time I have.

The modelling process for the street elements was extremely simple. The low-res buildings were very easy. To begin with they were just a plane or a box, and then I made the windows and doors and finished with fine details. I paid special attention to give extra quality while modelling.

I found this mosaic texture on the walls of a building so decided to use it in this scene.

GETTING THE BASICS

The scene was built from basic blocks once the camera position had been set. Each element was added until the entire scene was mapped out.

Without any blueprints to refer to, the reference images were essential for getting everything to scale.

Most parts of the scene were not difficult at all to model, since there were a lot of quite easy objects. These included boxes converted to Edit Poly and then manipulated, splines with thickness or extruded, etc. Usually when I finish with modelling, at the end the day, I do one quick render, bringing it to Photoshop and do a quick draft paint-over of that image, to make a plan for the next day. These over-paints look really simple but it gives me a better visual reference of the details which I need to do in some areas. Sometimes I end up doing only 40 per cent of what I sketched, sometimes it's more, it all depends on how much time it will take and if the new details will fit into the final model.

A good trick to check if you are producing an accurate piece of work is to assign a material with a high specular and low glossiness to check the behaviour of the mesh. If the brightness is constant and without strange artifacts, you're doing great!

A shaded view gave a basic idea of whether the model had any obvious shortcomings.

Now there's a wireframe of the tram in
the street with all the details added.

Again, the shaded view showed roughly how
the final image was going to appear.

The texture from
earlier on was
applied to the
outside of the
street walls.

Don't forget the small details that
make an image seem more real like
plants and wires.

Here's the entire scene after modelling the train and street.

A clay render without the texture shows the lighting and where it will fall in the final image.

CREATING THE MATERIALS

Once I was satisfied with the modelling I went into the texturing and materials stage. In 3ds Max, I always set Space Gamma to 2.2, which allows you to work in a linear workflow. I used V-Ray materials for every object in the scene, some of them with their Bump and Specular. I used also the ColorCorrect plug-in in order to have more control over the colour, brightness and contrast of the textures, without externally modifying the bitmap itself. After defining the base materials I textured the image based on a combination of those materials. For the UV coordinates, 80 per cent of the time I was using Box UV mapping from the UVW Map modifier. I tried to keep the scale of the Box UV mapping the same for all the objects I textured so I could have similar texture scales and a more realistic look.

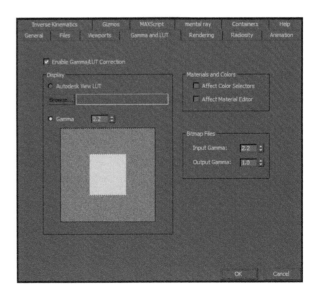

Setting the input gamma to 2.2 for a linear workflow.

SETTING UP THE LIGHTING

When I finished the modelling, texturing and materials processes, I started to set up the lighting. I always start with a grayscale render as it helps to get the right lighting setup. The light setup was also very simple to do. You won't believe it but I only used one light. When positioning light it's good to switch to Light View so you can be more precise. You can then get the feeling of where your shadows will be cast.

The image was illuminated with a V-Ray Sun working together with the V-Ray Physical Camera, which offers real control of exposure, shutter speed and ISO. My goal was to give the impression of mid-day lighting. The main idea was to achieve a warm mood in the picture. I created the V-Ray sun which was placed a bit outside of the scene in order to get the sunlight falling on the street. The sun was the only light to illuminate the scene.

The volumetric light was simulated in Photoshop later so that it could be more accurately controlled.

Just one light was used in the scene and that was the overhead mid-day sun.

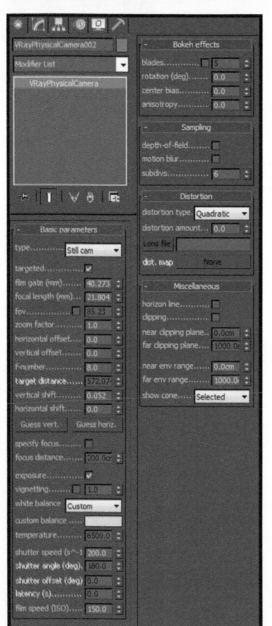

The V-Ray physical camera was used so that there was complete control over the effects created

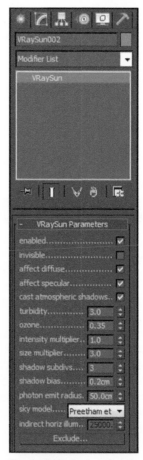

The physical sun characteristics set up in V-Ray. The volumetric effect was added later.

FINAL RENDERING AND COMPOSITION

The final rendering was done at 3k resolution, but all the previous test renderings were done at 2k resolution for the sake of speed. The image was rendered in two passes with a resolution of 3150 x 1699. The final rendering process took about 60 minutes on an Intel Core i7 2.93GHz, 8GB RAM, Geforce GTX 650 computer, which was pretty fast when you look at the complexity of the scene. I also rendered some RGB masks for compositing with the 3ds Max free plug-in, RenderMask. After an hour of rendering, I had the beauty render, ready for me to start the post production.

Compositing is the final process, and probably the most important as the final result depends on my ability to create a good artistic look in post editing.

I consider the render out of Max to be just the start of the final stage. It would be very difficult and time-consuming to get a good result directly from the Max renderer, so I used Photoshop to do colour correction, brightness and contrast. I started to bring out the colours individually using the render masks. All these corrections can be done in Max, but like I said, it would take a lot of time and test renders to get a decent result and sometimes it is just not worth the effort. Photoshop gives much more freedom and control over your image. I added the Ambient Occlusion render in Photoshop as a layer by setting the blending mode to Multiply. Next, I retouched the image using the Burn and Dodge tool to add more shadows and give it more life and then I added some extra dirt textures and lens flares.

After I finished the whole image, it was time to promote it on the Internet. What's the reason of doing something if you don't share it with other people? There are a lot of great galleries on the Internet where I usually send my latest illustrations. Sometimes I get useful critiques and ideas that make me think a little bit about what I did and how it could be better. When working on something personal for more than a couple of weeks, you may lose an objective perspective of your work. I know I do. So, it really helps to see how other people will react to the image. If you liked this tutorial and have any questions about it feel free to visit my site: http://www.omermessler.com or to drop me a line.

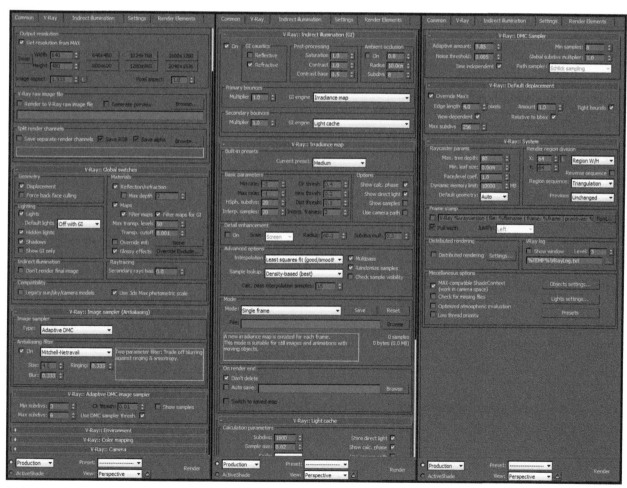

Setting up the render parameters in V-Ray then heading for post production.

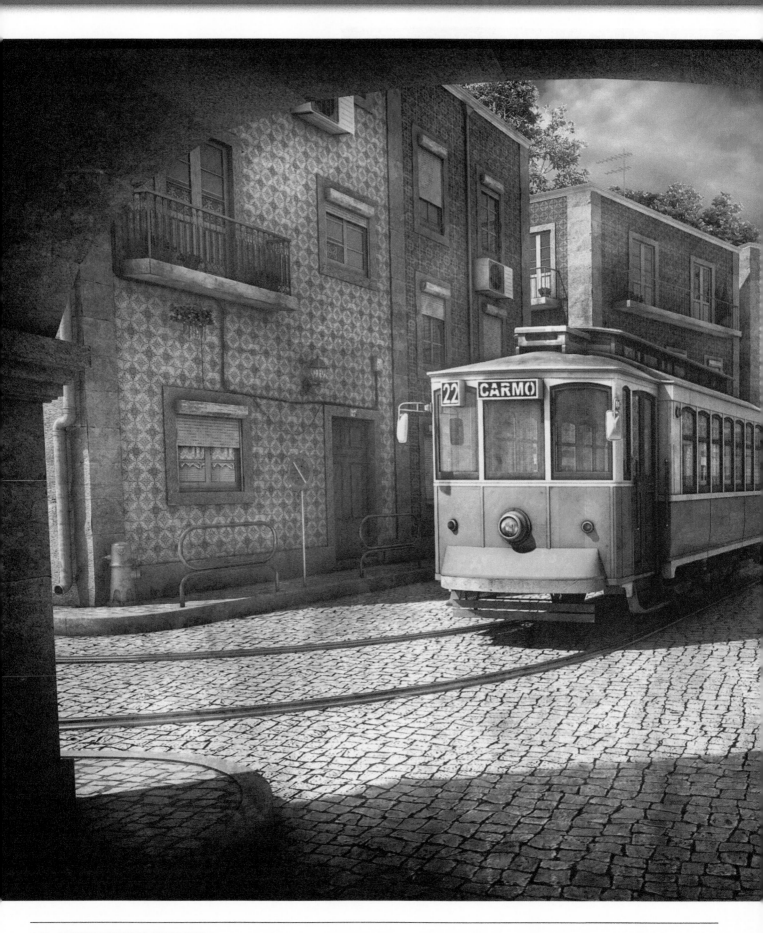

LISBON TRAM BY OMER MESSLER

3DS MAX, V-RAY, PHOTOSHOP

50–60 MIN

BUILDING THE MILITARY MACHINE

Gianpietro Fabre explains how he came up with the design for a military APC vehicle.

DESIGN INFLUENCES

The idea came about when a friend and colleague asked me to model a high resolution model of the Combine APC from Half Life 2 to be used in a short film he wanted to shoot. Since it was supposed to be a live action, the vehicle had to look realistic and be believable as a real asset. It also needed to have very high details, as it was going to be used for close shots as well.

He asked me to maintain the overall shape of the original APC game model. For the rest, I've been free to experiment and come up with my own ideas. The look of the original vehicle is very peculiar, and has a very well-balanced mix of World War II and sci-fi elements in it.

Fictional sci-fi vehicles usually have a great design and look very dramatic, but can lack functionality and logic, while in real military vehicles all the details like doors and handles, antennas, hatches, nuts, bolts, etc., are built in a proper way and serve a real purpose.

So, I gathered lots of images of real APC trucks and tanks from past and present times, as well as stills of famous armoured vehicles from legendary sci-fi films or games like Aliens, Batman's Tumbler, District 9 and Half Life 2 itself.

PROJECT	COMBINE APC
SOFTWARE USED	3DS MAX, V-RAY, PHOTOSHOP
RENDERING TIME	3.5 HOURS FOR A 4800 x 3300 IMAGE
ARTIST	GIANPIETRO FABRE
COUNTRY	ITALY

**Combine APC
– final image**

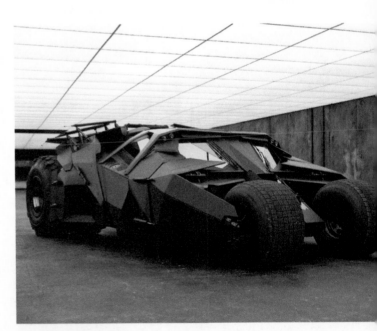

**The APC from the film Aliens
helped inspire the angular
shapes of the armour.**

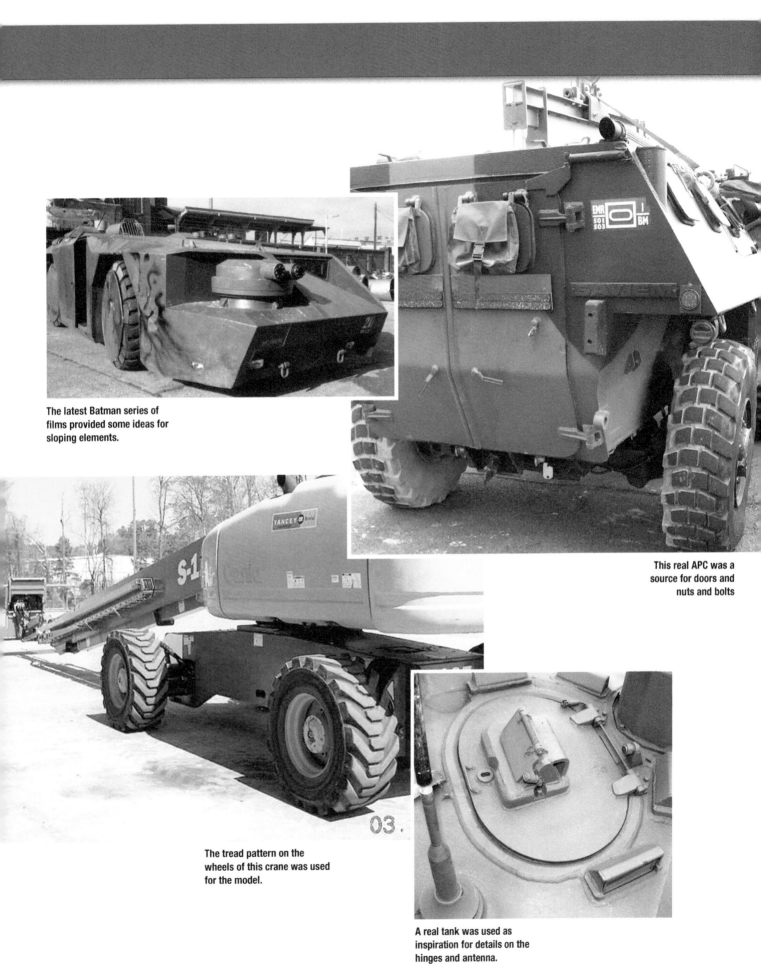

The latest Batman series of films provided some ideas for sloping elements.

This real APC was a source for doors and nuts and bolts

The tread pattern on the wheels of this crane was used for the model.

A real tank was used as inspiration for details on the hinges and antenna.

CONSTRUCTING THE MODEL

I took some reference shots of the original low-poly model from Half Life 2 and I modelled the main volumes and the wheels. Just using the basic modelling tools, piece after piece, I assembled a replica of the main volumes of the APC. Then, for the smaller realistic details I simply had to model them as they were in the reference photos I chose.

I focused on each area – mudguards, bonnet, main cabin, roof and so on, one by one – trying to add details in a logical and realistic way and being consistent between the different areas. For certain elements such as the rims, the headlights and the rifle mounted on the roof, I tried different designs. It was a trial and error method, and I discarded and remodelled them until I was happy with the result. In cases like this I use any method that will allow me to save time. Usually I take a screen-shot of my viewport in a perspective or orthographic view and do some quick paint-over in Photoshop, so I can understand whether what I have in mind worked or not.

Another method I use that may not be obvious: I have created over the years a small personal database of nuts, bolts, and common simple objects, with proper UVs. For this vehicle I selected some and used them all around the model. This saved me a lot of time during UV and texturing work.

When I was happy with the look of the model, and got it approved by my friend too, I moved on to the UVs. At this point I had a reasonably good idea of how much detail I needed, and which areas required more care.

I split the vehicle into six areas of roughly similar volume: front, main, rear, framework, wheel and another one for all the small details. I kept the rifle separate as well, since it was going to also be used as an independent asset. Each became a UV tile, and had a 4096 x 4096 texture.

It is very important to maintain a similar scale all across the model when doing the UV. Often, during the process, I shifted some geo from one tile to another when I couldn't get enough space. I kept a checker shader handy to constantly see if the scale between objects matched. Similar scale means the same level of detail across different objects, but in that way I could also share the same maps during the texture work.

I tried to avoid any kind of overlap as well, even with all the small bolts and nuts that could share the same UV. That gave me full control during my texturing work, and I avoided possible nasty results when I was going to bake the maps.

The front of the model with the main volumes completed.

The side view after the basic structure was put together.

The basic box shapes, seen from above, showing the layout.

Struts and chains being added to the front of the vehicle.

Door handles, bolts and steps now added to the sides.

Antenna, handles, vents and rails created on the top side.

Some of the many small elements that I already had in store and could re-use.

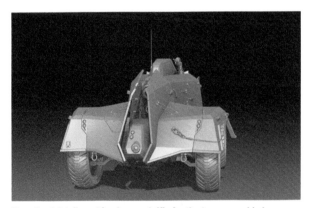

The wheel details, cabin glass and rifle for the top were added.

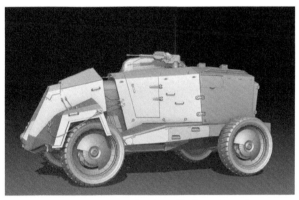

You get a better view of the details of the rifle from this angle.

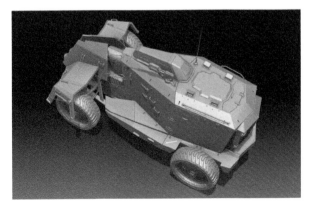

The entrance hatches for the occupants were then modelled on the top.

CREATING TEXTURES AND COLOUR SCHEME

First of all I decided the overall colour for the entire vehicle. It had to look like a police force vehicle, so I did some research for those types of vehicles. Dark blue with red stripes is the typical colour scheme for the Carabinieri, the Italian police force. I tried different palettes, grey/orange, black/red but eventually I chose this one.

Then I started to play with screengrabs in 3ds Max or directly on the textures in Photoshop, quickly trying different kind of stripes, writings and decals. I got most of the ideas from military airplanes or tanks and I used scale model decals as texture references.

Any metal, plastic or rubber surface of a vehicle will have some common elements that will determine how old, worn and ruined that surface will look. Those elements are mud, dirt, dust, rust, scratches and so on. I wanted to generate a map for each of those, and then work to correct and improve those maps in Photoshop. So I made extensive use of V-RayDirt map. I created a V-Ray material, and in the diffuse I added a V-RayDirt map. Playing with the values and adding different maps, I created and then baked four different maps:

1. Ambient occlusion – to be used as is and as mask for small dirt.
2. Convexity map – to give a subtle highlight to the edges of metal surfaces.
3. Scratches – very basic map to start with when painting scratches.
4. Mud – for the rubber of the tyres.

Once I baked all those maps they were masked in Photoshop and then all the areas I didn't want were removed. The results were used as masks for the scratched metal texture or the mud texture. After working on those layers, another level of hand painted scratches, stains and oil leaks were added. On top of all that was the convexity map, masking out all the surfaces but the metal. Convexity map simulates the Fresnel reflections. Then over all of those items a 50 per cent ambient occlusion was applied. Adding ambient occlusion or fake reflections and specular directly in the textures is a little bit unorthodox, but improves the final look of the models considerably.

A database of the photos and decals to be used in the textures.

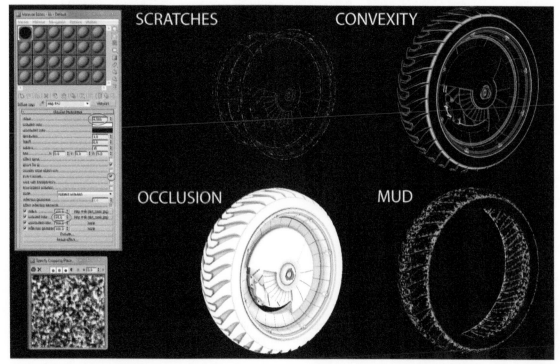

Generated maps with V-RayDirt to be used as masks for texturing effects.

Keeping all the layers and masks separate paid off when I finished my diffuse texture, because I could create the specular, glossiness, bump map and a specific paint mask on the fly.

All the shaders were pretty simple. I tried to obtain every aspect of the shaders just with masks and textures, so I didn't have to achieve complex effects with them. The V-Ray's car paint shader was used as it already has a matte base layer and a coat layer for reflections.

I plugged all my maps and masks into the shader, tweaking the maps in Photoshop rather than the values in 3ds Max. That method gave me full control over all the aspects of each shader of the shader.

The front of the APC with constant shading and colour palette only.

Sample texture with Diffuse, Specular, Glossiness and Bump passes.

Same thing as the last screenshot but seen from the side.

View from the front with constant shadow but now the complete texture applied.

TOP TIP – TEXTURING CONCEPTS

Even with an extremely powerful render engine like V-Ray, I don't expect it to do all the work, so I try to make my diffuse textures appealing and the shapes of my models recognisable even without any lighting. So while working, I kept 3ds Max's viewport in constant colour, so I could see exactly what I'm doing in Photoshop, without any distraction from the shading.

Same thing again but showing the textures on the side of the APC.

ADDING CAMERAS AND LIGHTING

As I was testing the shaders I started to set up the final scene with proper lighting, cameras and environment. I wanted to place the vehicle in a real urban environment, modified to resemble the original City 17 of Half Life 2, which looked like a huge prison camp. I found a free set of photos I liked and an HDR image on www.smcars.net that I could use to create the image-based lighting. A selection of three shots were made with good lighting and camera angles and then they were matched with the cameras in the 3ds Max scene. In my case I didn't have a reference cube in the photos so I assumed that the shots were taken on a tripod at 1.50 meters (except the one of the main image). Three different V-Ray cameras were created, and the photos were used as backgrounds. I tried to match the photos' focus points with a grid placed in 0,0,0. It's trial and error here, but every image had a quite recognizable grid on the ground, so this time it wasn't very difficult. The scale of the vehicle was another guess, but the parking lot lines helped.

The light setup was very basic, as I just had to match the existing lighting of the backplates: one HDRI was used for image based lighting and one VRayLight was used to simulate the sun. I didn't use the VRaySun or a directional light (which are better in a daylight condition) because the shadows generated from the VRayLight were softer and more appropriate for this lighting situation.

Both the lights were set to invisible, since I didn't want them to interfere with my HDRI for the reflections.

One easy method to match the HDRI with the backplates and then the sun to the HDRI is to assign that HDRI to a huge sphere in the scene. Then in the camera view toggle the visibility of the background and rotate the HDRI to match it. Then you have the position and a rough rotation for the sun too. I used the HDRI rotation and the sun position as a guideline, then I tried to move it a little bit to get better reflections and lighting.

How the backplate and the lights were aligned to the HDRI map in 3ds Max.

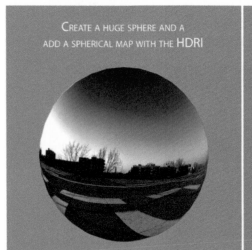
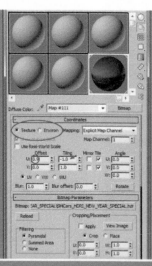
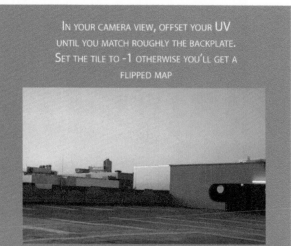
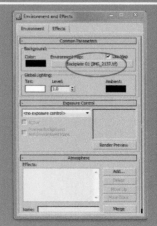
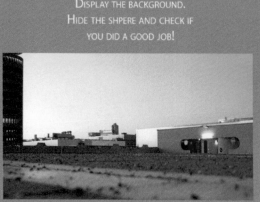
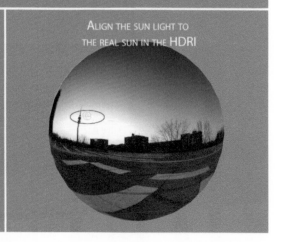

Extracting the information from the original image in
Photoshop and using it in 3ds Max.

Lights and render settings. Gamma 1.8 was used
instead of 2.2 (linear workflow).

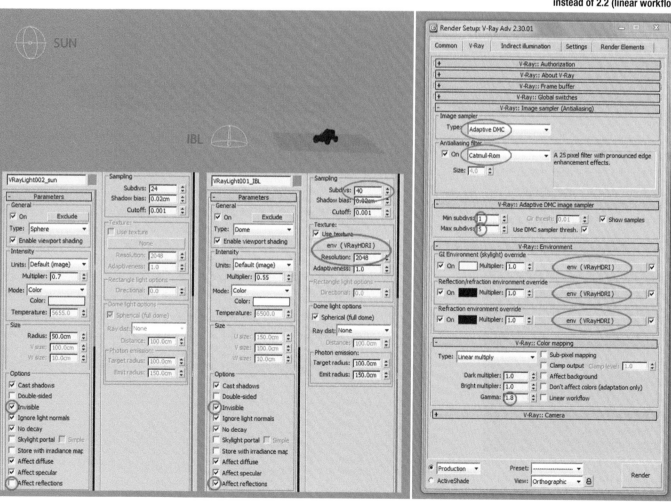

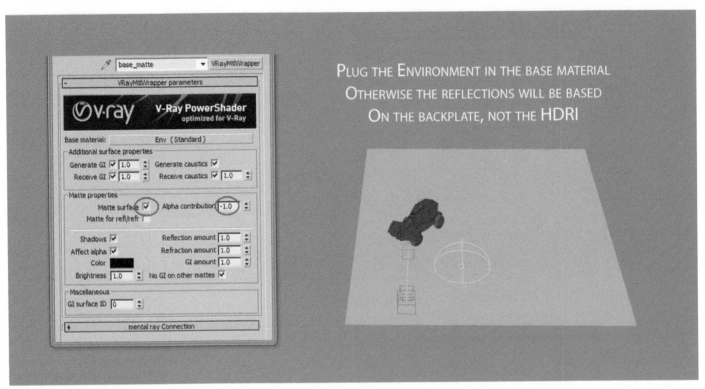

PLUG THE ENVIRONMENT IN THE BASE MATERIAL
OTHERWISE THE REFLECTIONS WILL BE BASED
ON THE BACKPLATE, NOT THE HDRI

The VrayMtlWrapper allowed me to project the shadows on an invisible plane aligned to the floor of the backplate.

After all, the image has to look nice, it doesn't matter if it's not 100 per cent accurate. I used V-Ray Physical Cameras. Since my backplates were raw photos, I could match the lens, aperture, f-stop and so on, which made my life way easier. Plus, since I had more than one camera, I tweaked the cameras' values rather than the lights for each render. To project the shadows of the APC on the Tarmac, I created a plane and assigned a VRayMtlWrapper to it.

TOP TIP – LINEAR WORKFLOW

V-Ray has its own panel with LUT settings that override 3ds Max ones at render time. It's in the render panel, under the Colour Mapping tab. I don't use Gamma 2.2 for the linear workflow. Dark areas come too bright, even for day-time exteriors like this one. I tend to keep it at 1.8, it gives a better contrast to the renders.

MAKING RENDER PASSES

In an early stage of the work process, once I decided the backplate and placed the APC, I did a paint-over in Photoshop on a clay render. That helped me to try different ideas and prepare a reference sketch for my following renders.

When I was happy with my sketch, I properly retouched the backplates in Photoshop to match my early concept sketch. Mainly this was about removing structures and details that could distract the attention from the APC or make it harder to read the silhouette. Then I added details to help give the proper mood. The sky was extremely important in setting the mood as well, so I spent some time finding a replacement.

Then, at the end of the process, I split my final renders into a few passes. This time all the fine tuning work on the vehicle was achieved with the shaders, so the passes were mainly masks to separate the elements for the final composition.

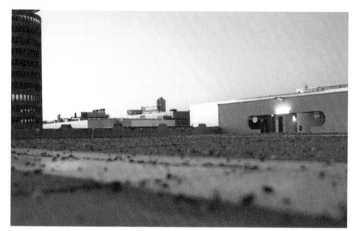

Here's the original backplate before adding the
model and painting the sky.

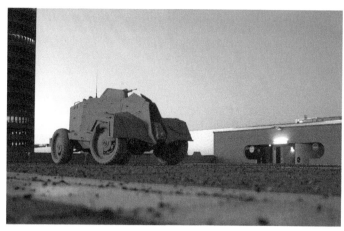

A clay render to test the angle of the lighting, plus
minor retouching of the backplate.

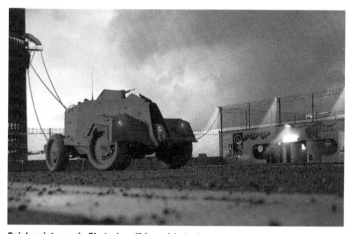

Quick paint-over in Photoshop (2 hours) to test
the final composition and colour correction.

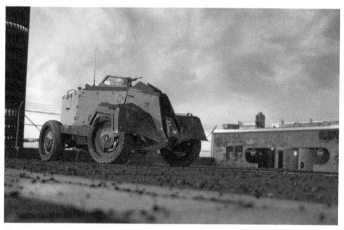

Final render before post production of colour correction,
cropping, vignetting and chromatic aberration.

Then all the passes were composited together. There was some minor
colour correction of the various elements to make them fit together,
and a few small lens flares were added to the headlights and the glass.
The final touches were aimed at making the image look more like a
photo, so a bit of vignetting and colour aberration were added. I tried
not to exaggerate any effect, because in a good composition, all the
elements must blend together harmoniously.

TOP TIP – MULTIPLE RENDER SETUPS

When I work with a scene that will produce
more than one still image, I create an
animation: I set keys for the position of the
cameras and the subject, position and values
of the lights, rotations of the HDR map, even
shader values if needed, and so on. It allows
me to maintain only one scene with all the
renders set up.

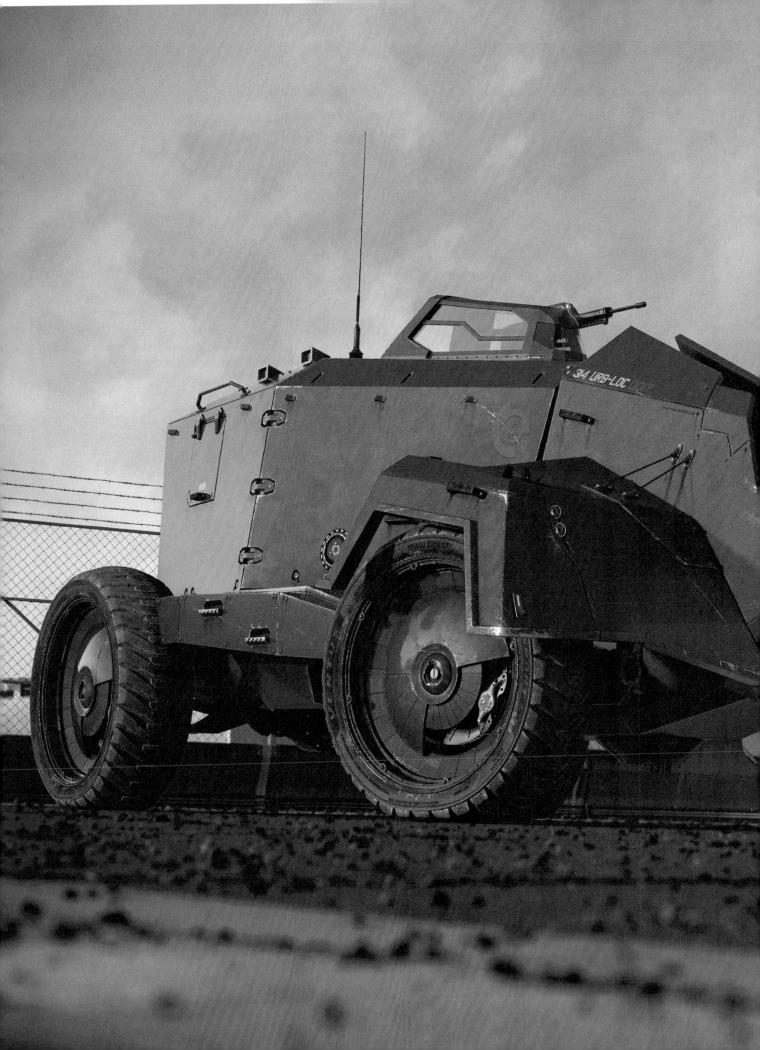

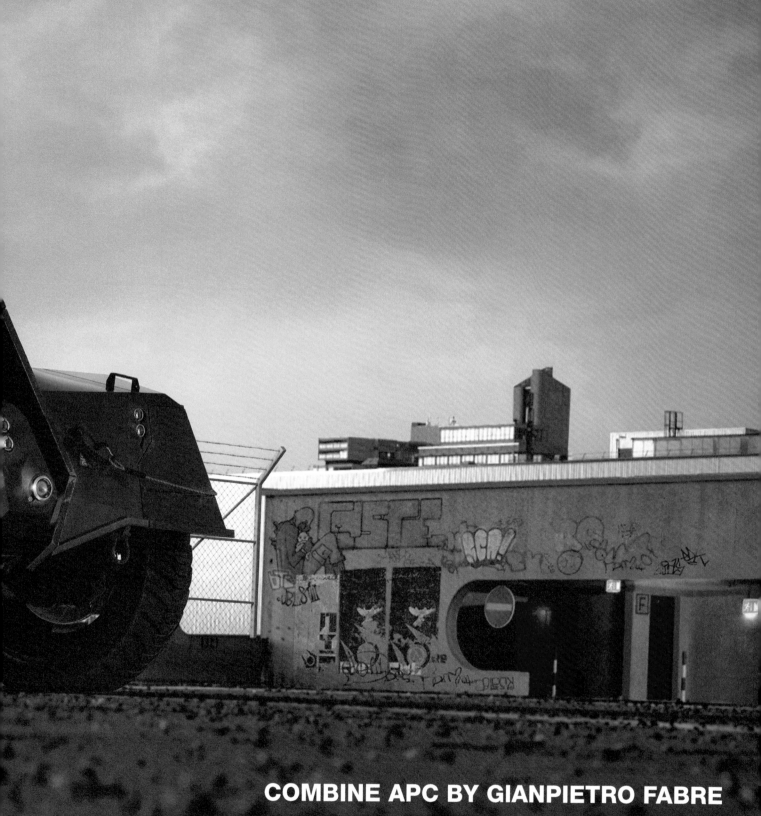

COMBINE APC BY GIANPIETRO FABRE

 3DS MAX, V-RAY, PHOTOSHOP

 3.5 HOURS

"I wanted to draw a dynamic heavy tank which serves more as a mobile home than military equipment. So there is washing on the line, tied to the large gun. The background and effects like the dust and smoke were painted in afterwards using Photoshop."

PROJECT	TANK!
SOFTWARE USED	CINEMA4D, PHOTOSHOP
RENDERING TIME	ABOUT 23 HOURS
ARTIST	FLORIAN RENNER
COUNTRY	MUNICH, GERMANY

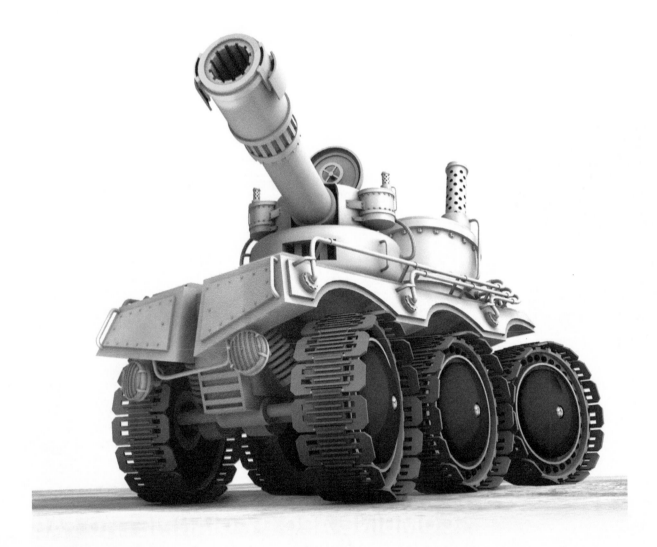

The basic tank model without any of the extra detail which was added using Photoshop.

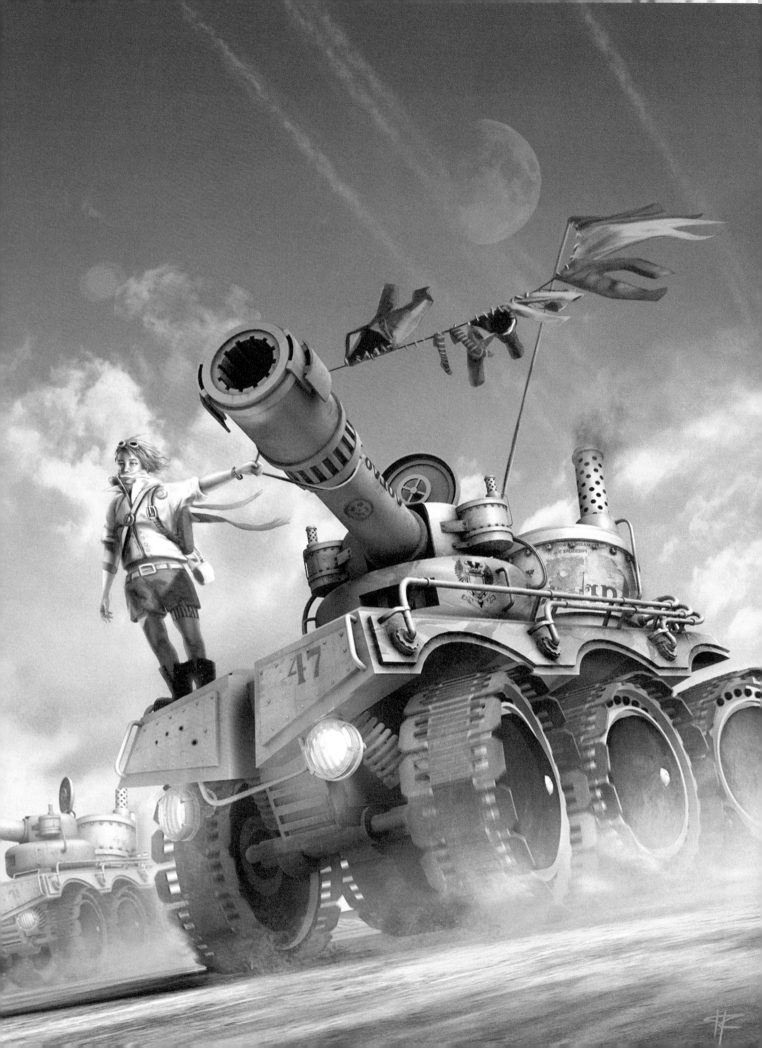

The clay render of the tank in position and with as much detail as possible added.

> The main idea was to create an optimised model of an Abrams MBT tank adapted for real time animation but with as much detail as possible. First I made a high-poly version of the tank. After that I made the low-poly version and baked details on from the high-poly version. I used ZBrush for ground sculpturing, retopology and baking.

Alternative view of the tank, this time from the back showing the rear details.

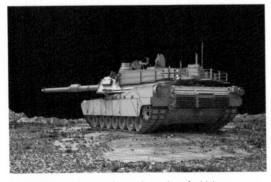

The resulting tank was a low-poly version of a high res model and could be used as a game asset.

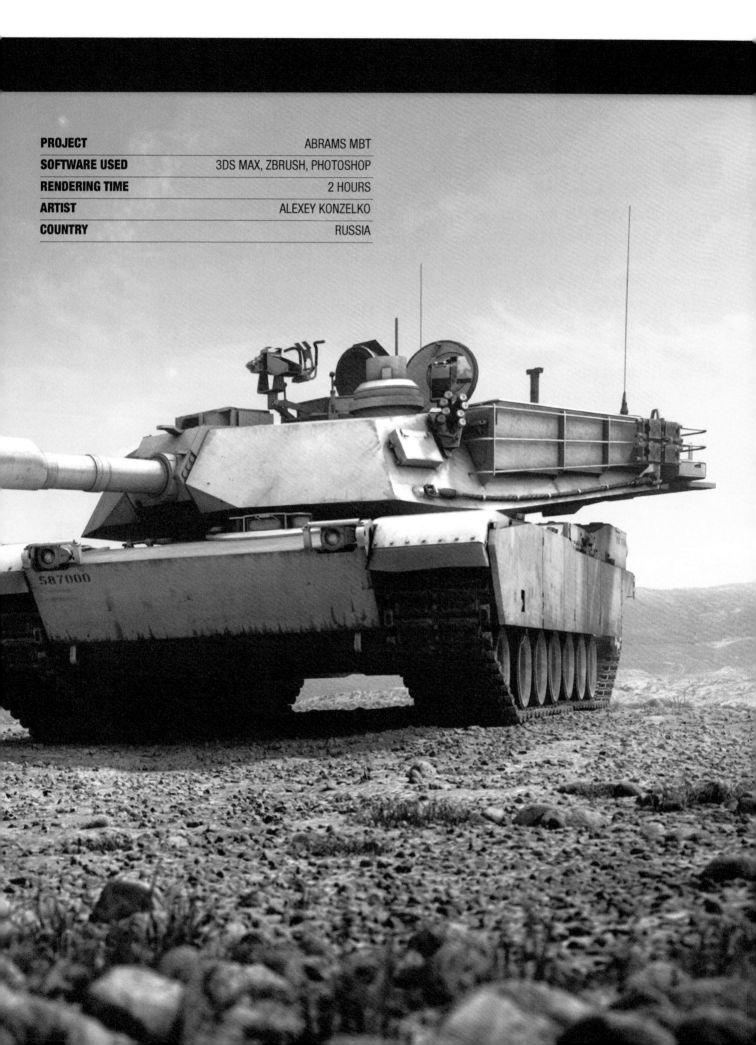

PROJECT	ABRAMS MBT
SOFTWARE USED	3DS MAX, ZBRUSH, PHOTOSHOP
RENDERING TIME	2 HOURS
ARTIST	ALEXEY KONZELKO
COUNTRY	RUSSIA

"This work was done to test my skills using the Maya and Mari software packages. It was not a commercial project. Making textures in Mari was an interesting and new experience for me. The model had four parts including the turret, wheels, tracks and body. All parts had four texture channels like color, specular, bump, reflection with a resolution 8196 x 8196. The model was created in Maya and rendered with mentalray."

PROJECT	PZKPFW VI TIGER
SOFTWARE USED	MAYA, MARI, MENTALRAY
RENDERING TIME	23 MIN.
ARTIST	VITALII MISIUTIN
COUNTRY	UKRAINE

Alternative views of the tank without the background.

Modelling the tank in Maya. It had four basic elements that then fitted together.

Creating the node network
for the material shaders.

The texture was painted on using
Mari before the final image was
rendered with mentalray.

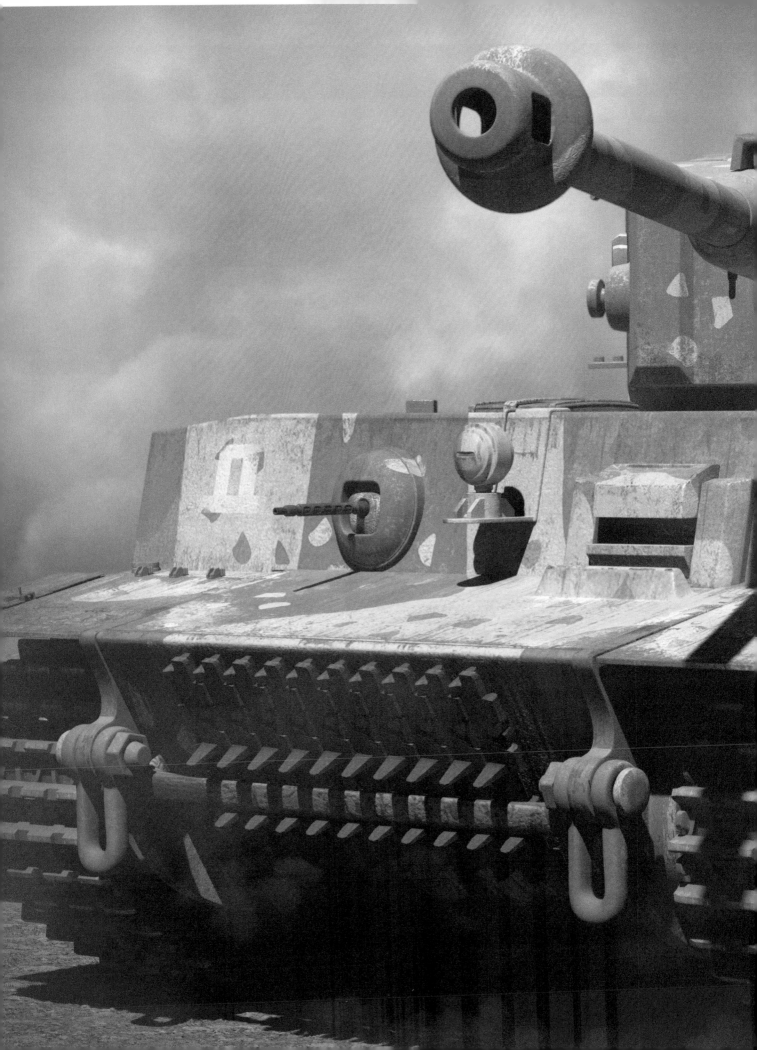

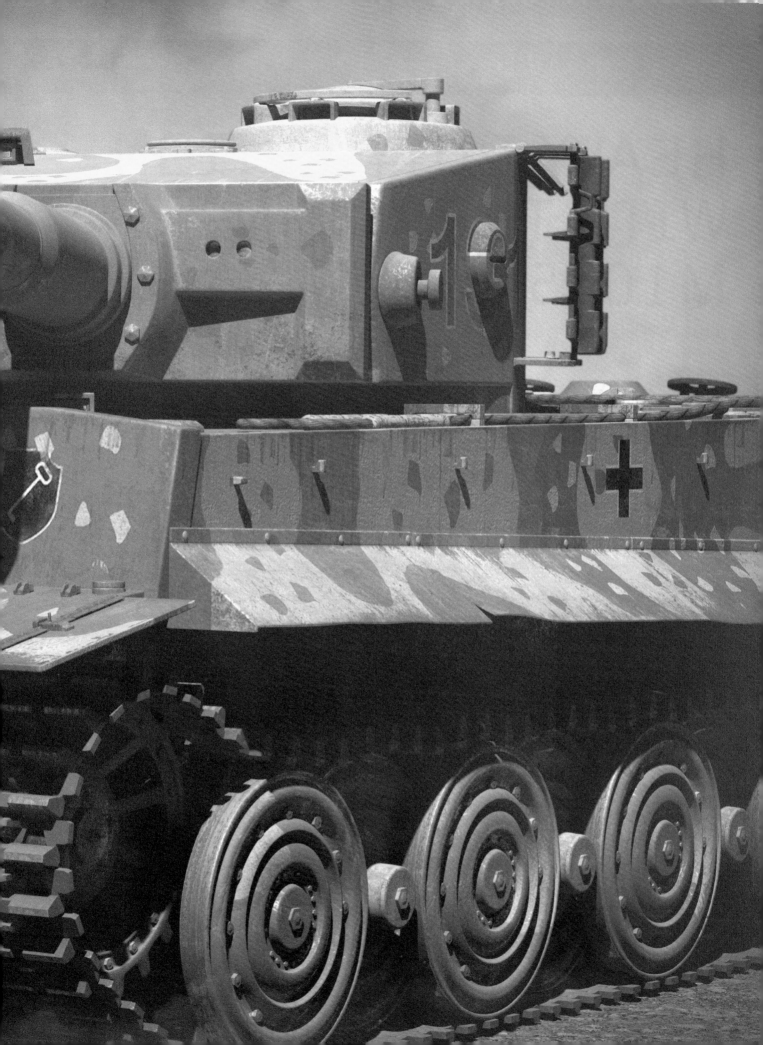

HEAVY DUTY ACTION WITH THE HEMMT-M1075

Gurmukh Bhasin reveals the processes behind creating and compositing a military lifting stalwart

ORIGINS OF DEVELOPMENT

This project began as a class assignment for an advanced hard surface Maya modelling course with Max Dayan at the Gnomon School of Visual Effects. The primary objective was to model a real world vehicle. I chose the HEMTT-M1075 as I had seen this vehicle many times and was incredibly captivated by the unique design. This is the Heavy Expanded Mobility Tactical Truck and comes in various configurations including fuel tank, crane, tractor, transporter and wrecker! It is rapidly deployable and designed to operate in all conditions. It's the backbone of the US Army logistics and supply. The base polygon model was completed in the duration of the course, and I had this sitting on my hard drive for a few months before finally deciding that it deserved a fully processed render. I created the render to practice techniques utilising a linear workflow in Mental Ray to better my photorealistic rendering skills.

I typically start my projects by collecting tons of reference images, and this render was no different. Since this is a real world vehicle the aim of this project was to model it as accurately as possible. I have found that the best online resource for military vehicle references is www.primeportal.net. They have many high-resolution photos of virtually every military vehicle out there. A tip to consider when modelling a realistic vehicle is to set up your parameters as real world units so you know you are getting the sizes and proportions right for all the parts.

PROJECT	HEMTT-M1075
SOFTWARE USED	MAYA 2014, MENTAL RAY, PHOTOSHOP CS6
RENDERING TIME	APPROX 3 HOURS
ARTIST	GURMUKH BHASIN
COUNTRY	USA

The M1075 in action. You get a good idea of the scale and power of the machine from this photo.

HEMTT-M1075 – final image.

The front end which has a towing eye, blackout lights and toughened glass for the cabin.

MODELLING IN MAYA

The modelling for this project was all done in Maya 2014. The project was started by creating a very basic blocking model with as little detail as possible to ensure that the part relations and proportions were correctly assembled. Next the vehicle was built in detail, constructing it as I would have done if I were assembling a model in real life. The base and undercarriage were modelled first and then the details were added to the parts in the back of the truck. From previous modelling efforts I reasoned that these would be the most difficult to figure out and I like to save the easiest parts for last.

TOP TIP
– SPOTTING MISTAKES

For personal projects I post my progress on Facebook as much as possible. It is always a good idea to have a second pair of eyes on your project because others will find mistakes or things that don't fit right with the image that you may have missed.

The base blocking model, constructed to get the proportions right at the start.

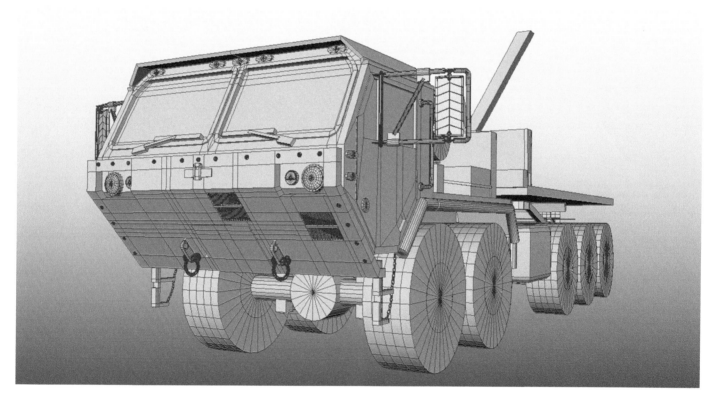

The base and carriage were modelled first before adding the rest of the structure over the top.

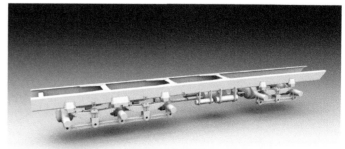

A close up of the back of the truck featuring the more complex design and parts which were done first.

An occlusion render of the back of the vehicle showing how the crane was built into the structure.

Wireframe views of the completed model with all the fine detail added and scaled correctly.

All the parts were modelled, starting with as primitive a shape as possible. Then the detail was built up adding edge loops where hard edges were required, toggling between the smooth mesh preview by pressing 1 and 3 to check the meshes. Finally, the modelling of the front end and detailed parts were finished, just leaving the least complex elements to be added at the end.

A good way to check your model is by toggling a blinn material over your geometry from time to time. This allows you to see wobbles in your geometry and helps you notice if a vertex is pulled out of place.

Occlusion renders of the completed truck which was then ready for texture and material work.

TEXTURE WORKFLOW

When creating the final render I decided not to texture the model in 3D. Instead I wanted to create a series of render passes, which would then be composited in Photoshop to create the final image. I knew the vehicle was going to be rendered with a linear workflow using Mental Ray and the mia_material_x materials plus the physical sun and sky. When clicking on the mia_material_x preset there are several different material setup options, which can be edited to your personal preferences. This was used to set up all the different materials that would be used for the final render with rubber for the tyres, glass for the windows and so on. Materials for dust and metal/rust render passes were also created. These passes were used to create render layers to be applied in the compositing phase of the final image in Photoshop.

Setting up the material preset to use correct materials for the components then adding dust and dirt.

THE LIGHTING SYSTEM

The lighting setup is relatively simple as it uses Mental Ray with the physical sun and sky. I like to add at least one secondary diffuse bounce in my final gather settings. It adds one more light bounce pass to the renders and bounces more of the colours around in the scene helping blend the various elements of composition together and making the final pass look more realistic, vivid and cohesive.

MAKING MULTIPLE RENDER PASSES

This project was created to practice rendering with a linear workflow in Mental Ray. While I personally am still in the process of developing my own technique on how to create the setup for a linear workflow, if you do a basic web search for "rendering with a linear workflow in Maya" you can find a plethora of great tutorials. A number of different render passes for the various elements were created to be composited together in Photoshop for the final image.

To start with, a base beauty pass was created with the basic materials. A familiar "military green" colour for the paint was selected as I really like this colour. It strongly represents the military look and feel that was aimed for at the start. Additionally, it had a nice contrast with the dust and metal passes when composited together. The second pass was the dust pass which was the entire model covered in a dust material. This pass was going to be completely masked out in Photoshop and then re-introduced by painting on the mask to reveal the dust underneath.

Next up was a metal/rust pass that was to be used in the same manner as the dust pass. Then an occlusion pass was created to enhance the ambient shadows, placed on top of all the layers and blended with the Multiply layer mode in Photoshop.

The material ID passes were created for quick selection of the different materials in Photoshop. I like to only use red, green and blue for the material IDs. That way you already have the selections in the RGB channels and it makes for a quicker selection process.

The various settings for physical sun and sky and final gather when using Mental Ray.

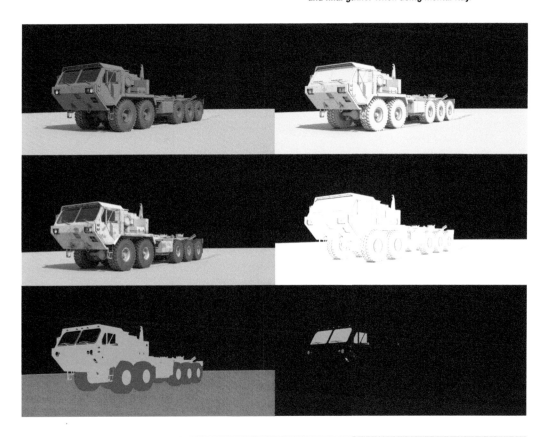

The various render passes, including beauty and materials, to be edited together in Photoshop.

COMPOSITING THE LAYERS

Before starting to composite the various layers, online image banks were searched to find a suitable high-resolution background image. For the heavy duty truck a neutral desert scene that could be used to place the vehicle renders into was ideal. The image was made freely available under the Wikipedia Creative Commons Attribution-Share Alike 3.0 Unported license so could be used without payment or accreditation in the final image. The background image was adjusted so it composed nicely with the truck render. The mountains were moved around and a few more were added to make it visually more interesting without becoming too distracting or fantasy-like.

The background image of the Amargosa Desert was available to use for free.

Some mountains were added and existing ones moved around to improve the background.

At this point, the base beauty render was added over the background and placed where it best fitted in the scene. Next, the rendered ground was masked over to shape the road and a dirt texture was overlaid to give it detail. The dust pass was then placed over the base beauty pass and masked out completely. The mask was then painted on to reveal the dust in specific areas. The same process was followed for the metal/rust pass to add a more realistic finish to the metal. The layers were then compiled together in the scene before progressing on to the final retouching element.

The base beauty pass render added to the manipulated background scenery.

The road was shaped by masking part of the render off and dirt was overlaid on top.

The base beauty pass without any additional dust and dirt layers which were added next.

The dust and dirt layer gave the render a much more realistic feel.

The base render with added rust and wear and tear in the metal so it didn't look new.

To finish the image, flying dust clouds were painted over the background behind the vehicle to add some depth, wash out some of the detail and help to highlight the silhouette. Dust clouds were also added over the back of the vehicle to help blend it into the scene and bring the illusion of some sense of movement to the scene. Then a Hue and Saturation adjustment layer was added in Photoshop to change the colours a little. Brightness and Contrast adjustment layers were added to make the highlights and shadows pop a little more and a cyan photo filter was overlaid on the whole image to tie everything together to get the final image.

The final composited image before any extra dust was added and image adjustments made.

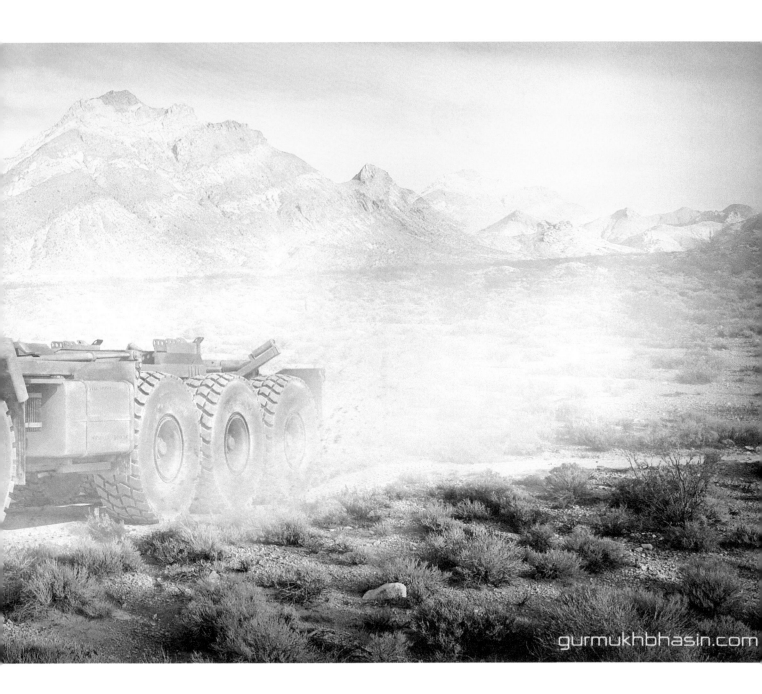

gurmukhbhasin.com

HEMMT M1075 BY GURMUKH BHASIN

 MAYA 2014, MENTAL RAY, PHOTOSHOP CS6

 APPROX 3 HOURS

"This is the USS Saucy which I modelled from scratch using Hexagon. It was then placed in a Vue scene so the rolling waves would be easier to generate. Post production was used to give the image a time-worn, 1940s style."

PROJECT	ESCORT
SOFTWARE USED	VUE 11 COMPLETE, COREL DRAW 11, HDRI DARKROOM, FILTERFORGE
RENDERING TIME	8 HOURS
ARTIST	REINER JORDAN
COUNTRY	GERMANY

The objects were placed in Vue. After that the perspective was set and the atmosphere loaded and edited.

The Illumination was adjusted and a final fine tuning took place in the shadow editor.

The quality was set in the render options. Finally the picture was rendered using final quality settings.

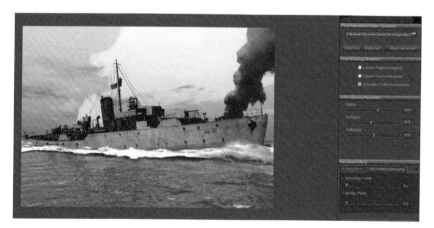

Corel Photo-Paint was used to add details such as the sea foam by using motion blur.

To create as much contrast as possible, an HDRI effect was generated in Darkroom 5.

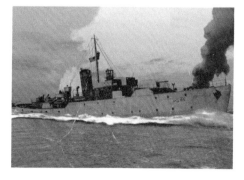

In FilterForge the filter Old Photo was used to create a 1940s style with toning and scratches.

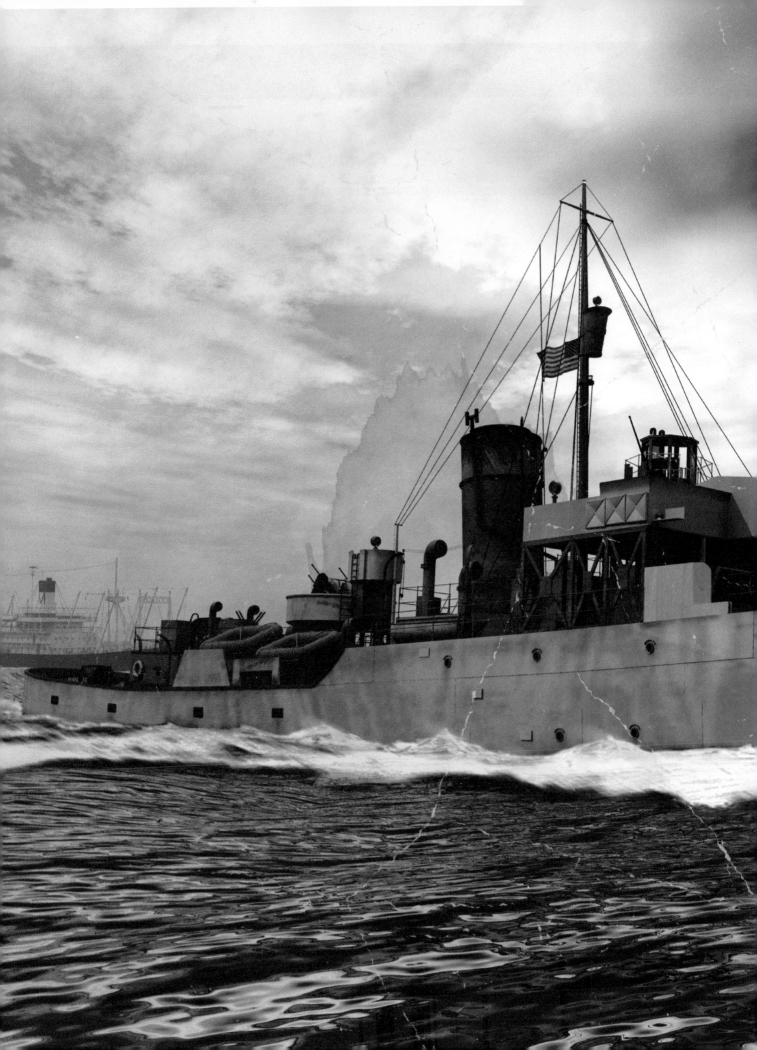

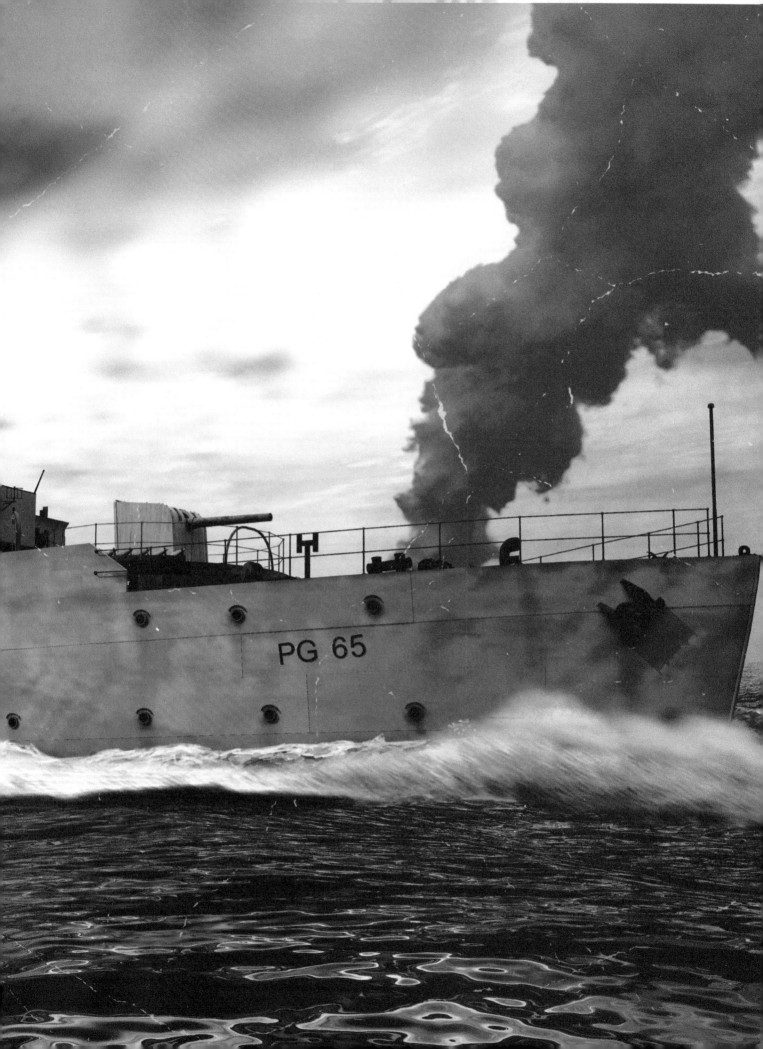

> This project was based on the illustration of the great artist Denis Zilber. It shows a little ship, full of character and defiance, with the name associated with those pirate movies, alongside a massive tank, which dwarfs it.

PROJECT	BLACK PEARL
SOFTWARE USED	MAYA, V-RAY, PHOTOSHOP
RENDERING TIME	APPROX. 3 HOURS
ARTIST	ALEXANDRE TREVISAN
COUNTRY	BRAZIL

Showing the textures of the boat inside the Maya interface.

Combining the various elements for the shader for the boat.

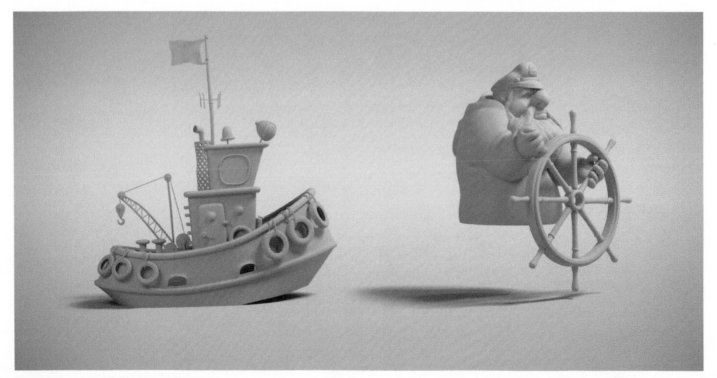

Completed modelling of the boat and the captain in the window.

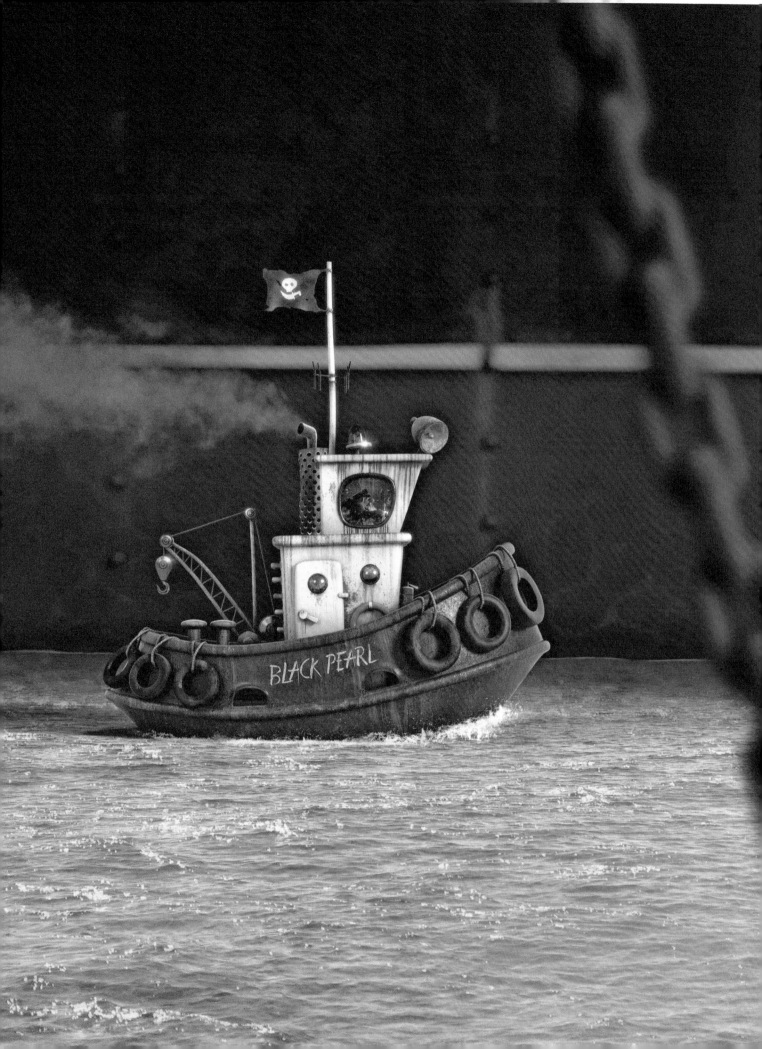

❝ I just wanted to take a look at creating a futuristic seaplane in Vue . This was my first attempt at creating the Osprey Mk1 using metablobs and Boolean intersections. I imagined that it had to have that boat-show shiny and sleek shape. If you have ever dropped your car keys down a drain, then you know how this guy feels. **❞**

Here all the final elements were being positioned before rendering. I find it easy in Vue to organise the objects in layers.

Finally setting up the camera angle so the scene was ready to render.

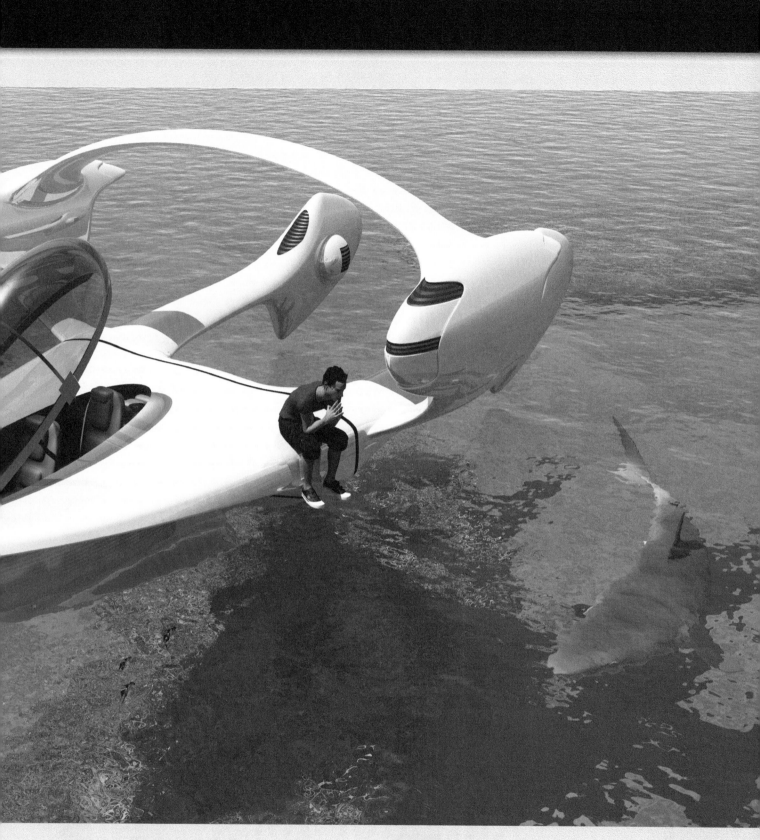

PROJECT	THE LOST KEYS
SOFTWARE USED	VUE 11 COMPLETE, POSER
RENDERING TIME	2–3 HOURS
ARTIST	TERRY M ALLITT
COUNTRY	UNITED KINGDOM

LOST AT SEA

Don Webster explains how he modelled and rendered
an American Civil War submarine

HOW THE STORY BEGAN

This started out as my first modelling project in Modo as
my oldest son, who teaches modelling and animation at
VaTech, introduced me to the program and pushed me to
start creating my own assets. The effort was based on the
continuing research from NOAA on the Civil War vessel, its
initial construction in France and refitting in the US. Since
research kept updating the interior, the initial composition
plan was for an exterior view of the sinking of the vessel
during a storm off Cape Hatteras as she was being towed.

The interior was updated as new information became
available and except for the removal of the original
propulsion paddles, had little effect on the hull itself. The
detailing was always based on what would be desired for
interior shots, as I was always interested in what conditions
would have been like for those who worked inside her
cramped quarters.

A 40" framed giclee canvas print of the Loss of the Alligator
resides at the Graveyard of the Atlantic at Hatteras, part of
the North Carolina Maritime Museum System.

Loss of the USS Alligator – final image

The initial NOAA poster provided the first real information necessary to model the exterior.

"I propose to you a new arm of war, as formidable as it is economical.
Submarine navigation, which has been sometimes attempted, but as
all know without results, owing to want of suitable opportunities, is
now a problematical thing no more."
 –Brutus de Villeroi in a letter to President Lincoln, 1862

Alligator 1863

Digital model by C. L. Veit, Navy & Marine Living History Association, 19 October 2005.

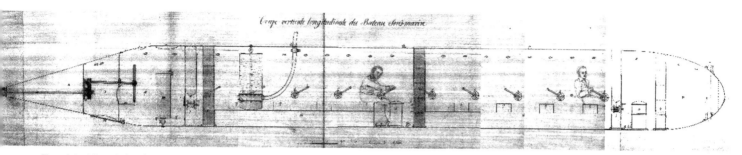

The original French drawings were of little help on both the exterior and interior, but did give an idea of the paddle rowing system.

PROJECT	LOSS OF THE USS ALLIGATOR, CIVIL WAR UNION SUBMARINE
SOFTWARE USED	MODO, VUE INFINITE, PHOTOSHOP
RENDERING TIME	ABOUT 30 HOURS
ARTIST	DON WEBSTER
COUNTRY	USA

A later poster provided all the necessary information to model the interior. The time span for the information was a number of years.

STEP 1
MODELLING THE TUBE

Modelling the hull was a simple process for a new modeller in that it is basically a tube with closed ends. I was intrigued with the idea of hull plates, bolts and rivets, always with the image of what the interior would be like, damp, semi-rusty, dark with beams of light coming into its small portholes.

STEP 2
VERTICAL CUTS

The exterior polygon shell was given a thickness which then allowed for vertical cuts to the interior mesh to form ribs. These small polygon ribbons that now circled the hull were extruded, edges bevelled and made ready for rivets that would protrude through both inner and outer hulls.

STEP 3
ADDING RIVETS

While the rivets could just have been a texture map, knowing that there would be interior views that were at extreme wide angles and point lights that should cast shadows from all these rivets, I decided to model a simple rivet that I could duplicate. A single ring of rivets was created then duplicated for the ribs and repeat duplicated at each rib location. An extra set was created and selected rivets deleted to create the hull plate rivets and the duplicate move-down process repeated.

STEP 4
CONNING BUBBLE AND PORTHOLES

There were a lot of openings in the hull that required selecting both the interior and exterior polygons and creating a circular polygon cutting template that was repeated along the length of the hull. This required changing the working plane to that of the polygon surface that was most in-line with the portholes which needed to cut. While in this new working plane, the porthole mechanics and glass windows were modelled and moved into place and again, duplicated and moved to each opening location.

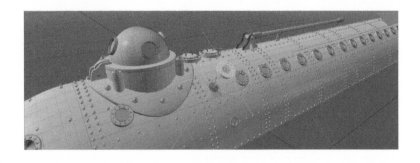

STEP 5
INTERIOR DETAILS, PUMPS AND SEATS

With the latest poster from NOAA, modelling the interior was rather straightforward with simple box and cylinder shapes. The floor was simply a matter of selecting the appropriate polygon edges of one interior wall side and bridging it to the other side. It simply connects the edge of one mesh to that of another. Modo's tube tool made simple work of the crank handles, and as always, edges are relieved where necessary.

STEP 6
WORKING THE INTERIOR

With the complexity of the interior, it would be difficult to pose figures inside using Poser as well as positioning other items that would have been available and used at the time such as lateens, apples and personal items. The outer hull could have been made invisible, but I elected to have a two-part hull that could be opened.

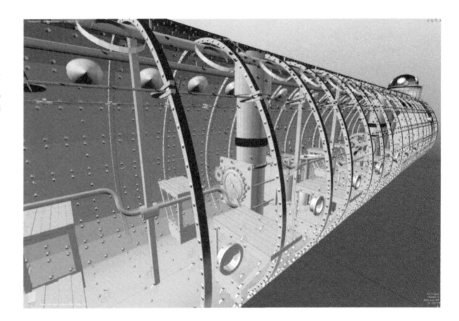

STEP 7
DIVIDING A HULL

Dividing the hull into an upper and lower half was a simple matter of locating an existing polygon division that runs horizontally along the entire model, selecting all the polygons above it and making it into a separate mesh group. As an asset developer, this also provided a great way to show off the interior for those interested in including it in their collection of modelling assets.

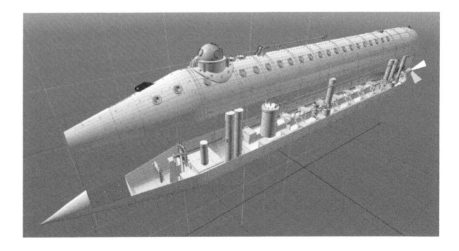

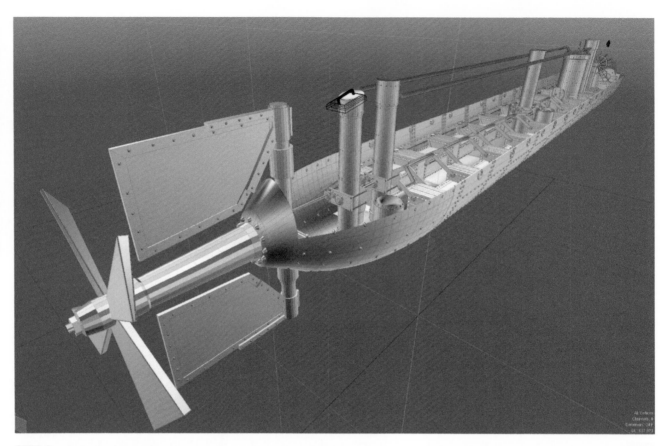

STEP 8
INTRIGUED BY THE POSSIBILITIES

Before moving on to texturing, I took some time to think about what it must have been like to have a number of men in a tube around 5 ft 7 inches tall with little light; the wetness, sounds, and fear of battle while being under the water. I think we forget that many people in past centuries did not swim.

STEP 9
TAGGING MECHANICAL ITEMS

Regardless of whether I use UVs or procedural materials, I colour-assign each mesh that I want to have a particular texture. In Modo, one has to do this to be able to then create a UV file in the system. In Vue this allows easy selection of a mesh, or part of a mesh to assign a procedural material.

CHOICE OF SOFTWARE

While Modo is a great renderer, I tend to render in Vue since I create models for that community and customers like to see what their purchases will look like in their application of choice. I also lean towards Vue as I prefer its material system, especially glass, water and metal. While Vue is a landscape application, the world environment and atmospherics make it the perfect electronic diorama for creating my scenes.

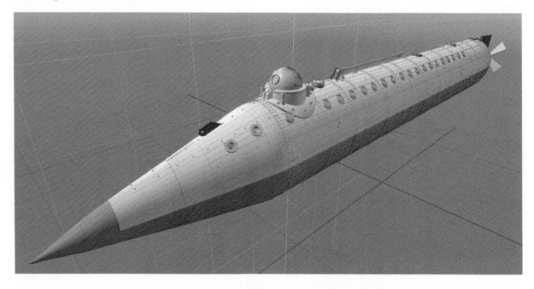

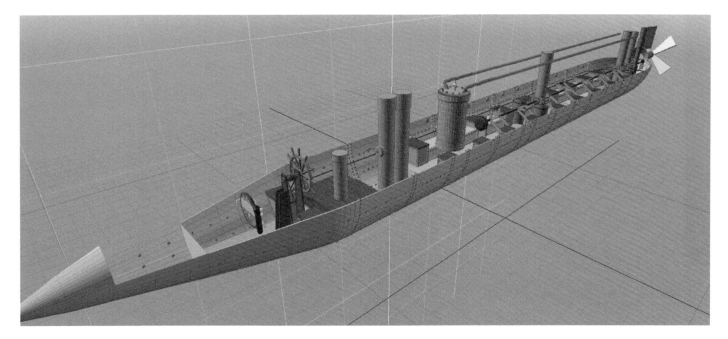

STEP 10
ADVANTAGES OF UV AND MATERIAL PRESETS

Metals in Vue are procedural and provide a seamless omni-directional pattern that works well for items like chrome, brass, anything without a directional pattern to it like plate lines. Since procedurals do not work for things like wood objects where the material pattern needs to orient itself to the individual directions of the mesh, UVs are used for the wood bench seats. Doing the development of this model I tried both UV and Procedural texturing for the inner hull to check out plate lines for the walls. With a model that is primarily all metal, with the same look, the colour tagging allows for a better overview of all of one's mesh elements.

STEP 11
MODO UVS

Modo has a number of UV projections to use. I tend to use their simpler projections and use the atlas projection for my needs. Here individual poly edges were selected and straightened out to eliminate distortion of the image map.

STEP 12
APPLYING MATERIALS IN VUE

With individual items tagged with colour, it's easy to select an item and apply a procedural material in Vue. A material was created using two different metals with the ability to alter the proportions of each. For a Civil War sub that would have been made of basically a few different metals at best, Vue's ability to create a unique material and then create variations of it worked extremely well.

STEP 13
MATERIAL CREATION

Selecting just one of the two materials from the blend above, two different materials were blended together to further alter the look and create a custom metal, which was then saved as a procedural material for future use in other projects. This material optimization includes the ability to adjust the bump and, where two materials are used, distribution based on orientation so that Material 1 appears at the lower heights of an object. A cylinder can be chrome at top and slowly blend into rust towards the bottom.

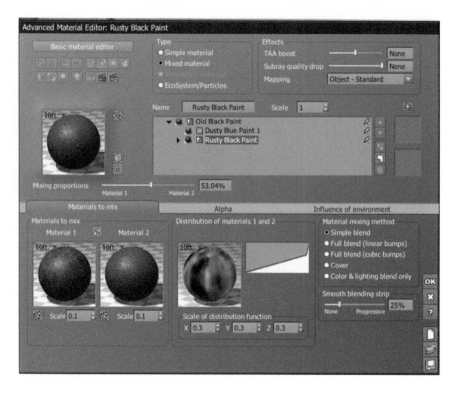

STEP 14
CREATING OCEAN STORM WAVES

I often see people trying to create seas with a single mesh, but for a storm state, a close POV and two large objects, and to have the most options for control, I elected to create a little over half a dozen terrains which could then be resized, rotated and stretched. As the images show, it would be very difficult to create such a stormy sea with a single mesh.

STEP 15
BEHIND CAMERA

A non-perspective view from behind the camera shows how dramatically the terrains needed to be raised to achieve the effects wanted. Creating this type of orientation with a single mesh would have required a lot of work and remodelling.

STEP 16
RIGHT SIDE OF CAMERA

This right side view shows how the terrains were actually lifted for effect so that they are leaning at a steep angle.

STEP 17
TOP VIEW

This top view shows just how widely spread the larger terrains were and how overlapping the smaller terrains were near the submarine to provide the wave action desired. Again, doing this with one mesh would have required going back into Modo to create a specific terrain through modelling, and then being restricted when placing the objects back on it in Vue.

STEP 18
CHANGING TERRAINS TO WATER

Vue provides a number of water procedurals which, like metal and all their other materials, allows for unlimited customisation. Here I kept it simple and used a default polluted water preset. As the image was rendered in Vue it was possible to adjust these material presets with ease if necessary.

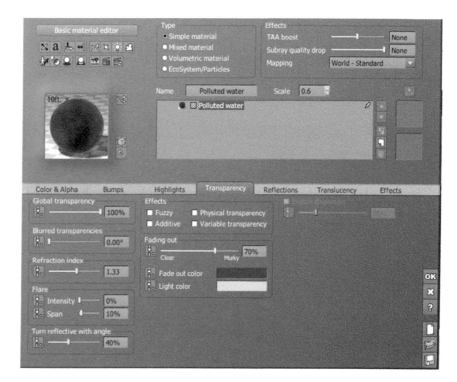

STEP 19
THE TOWING SHIP

The Alligator was being towed to an upcoming engagement when it was lost during the storm off Cape Hatteras. I needed a steam ship of the period to represent the actual one. Since it was going to be visually lost and merely a shadow in the storm, I used a purchased asset, the Patrick Henry, and removed the paddle wheels in Modo.

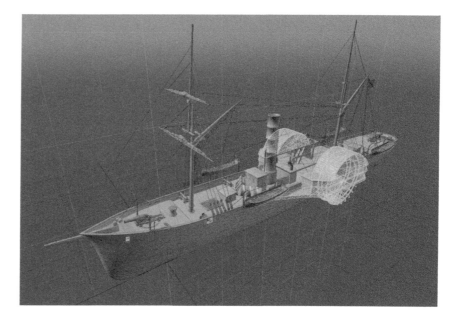

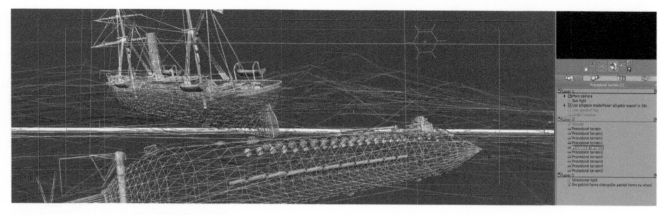

STEP 20
PLACING ELEMENTS IN A TROUBLED SEA

With a high poly count, I switched to wireframe and began placing both vessels in the arrangement of terrains. This stage amounts to a trial and error approach of moving all the elements around as camera angles and perspectives were changed. Coming to a final point of view, the terrains were adjusted to create swells and spillovers for a truly stormy sea.

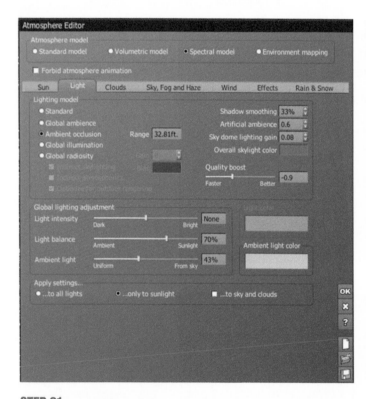

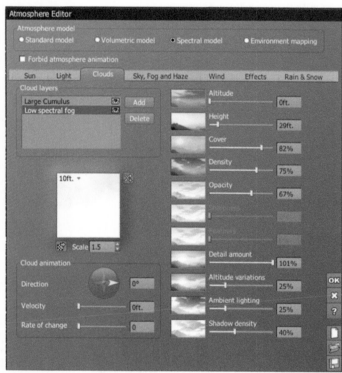

STEP 21
CREATING AN ATMOSPHERE

For what would be a dark, stormy scene, a simple atmosphere preset was selected and the sun was moved to the lower right. The main colour, as well as the ambient light colour, were all low key and dull in nature to add to the storm effect.

STEP 22
CLOUDED, FOG COVERED SKY

Low spectral fog and large cumulus clouds darken the scene and cover most of the visible sky leaving just a peek of the sun for possible light rays. A dramatic, if not particularly realistic, effect.

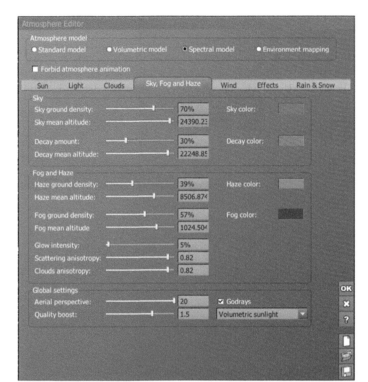

STEP 23
FOGGY BOTTOM
While the two vessels were not that far apart, fog was an important part of both darkening the scene and fading away the distance to isolate the viewer with the foreground event.

STEP 24
TEST SPOT RENDER
It's worth doing a lot of test renders, trying out different POVs and lighting situations as well as different atmospheres. Here I was concerned with the placement of the terrains, their water procedural look, and coverage of the sub itself by a wave.

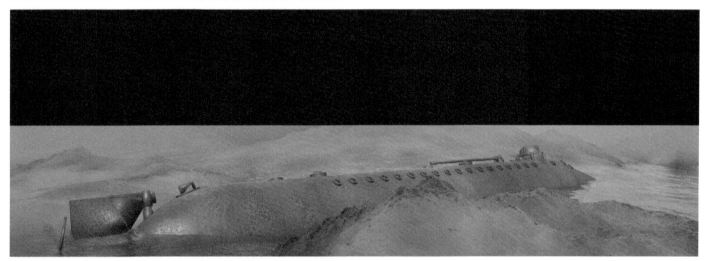

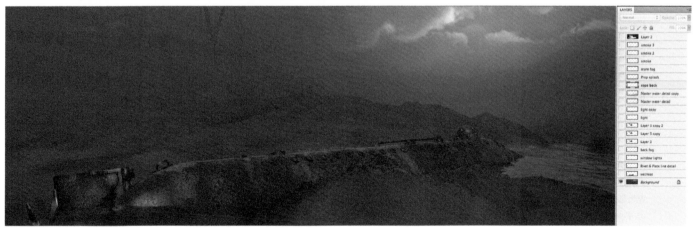

STEP 25
ADJUSTMENTS AND INITIAL RENDERS
Doing a number of draft renders and then final renders after a series of small adjustments in fog, lighting and water procedurals, a final image started to take shape. Once a final scene was reached, the desired size and pixel count were set. In this case it was for a final image measuring 40 x 14 inches at 300 dpi.

STEP 26
MASKING DEPTH

With the high resolution render finished both a tiff of the render as well as an alpha of the scene were saved so the sky and vessels could be isolated against the sea, making the post production work easier. In some scenes it's also worth saving a Z-depth mask to use in Photoshop for depth-of-field adjustments.

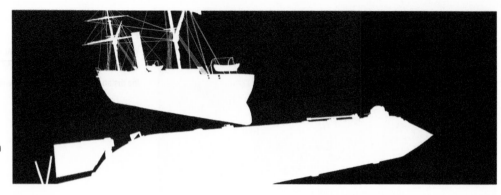

STEP 27
ISOLATING THE SKY

By having the sky isolated it was easy to make adjustments to it as well as being able to composite other possible 2D textures and even sky effects.

STEP 28
POST WORK IN PHOTOSHOP

With the render and masks in place in Photoshop, colour and contrast adjustments were made, adding in sun rays and sea spray to each layer. This was a time consuming but exciting time as it brought the image to life. With so many layers, there were a huge number of possibilities in what could be achieved. In this case I wanted to create a strong feeling of motion with the sea spray. Each spray was done with photo brushes, rotated and resized to match the effect required in a particular area.

STEP 29
ALTERNATIVE INTERIOR SCENE
Sometime after finishing the exterior scene, I went back and started working on an interior scene; that dark, damp, lateen lit cave of a working machine. This shows much of the working and how narrow the space was.

STEP 30
ADDING A CREW
The project was then finally finished by adding a crew and producing another alternative render. As you can see there was very little room to move around and actually no room to stand upright.

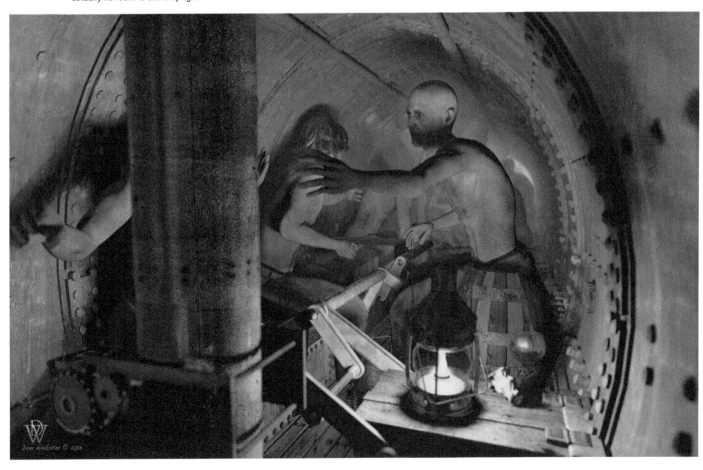

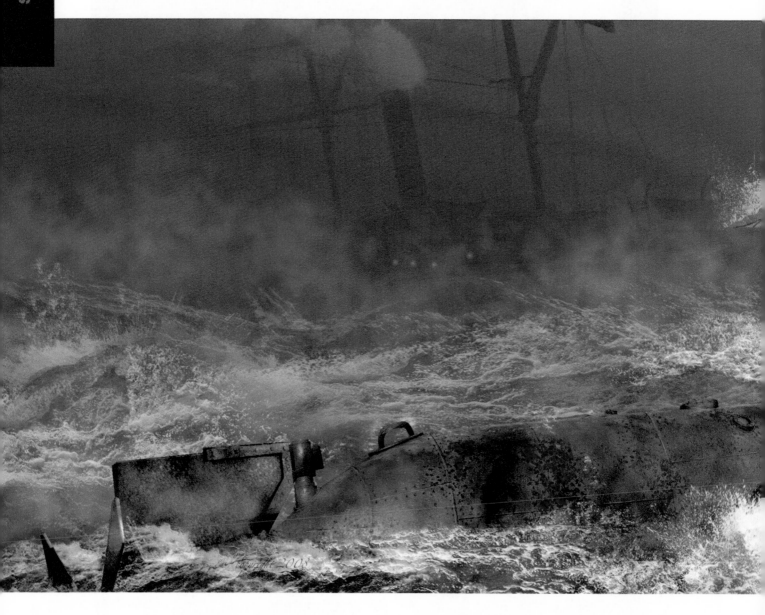

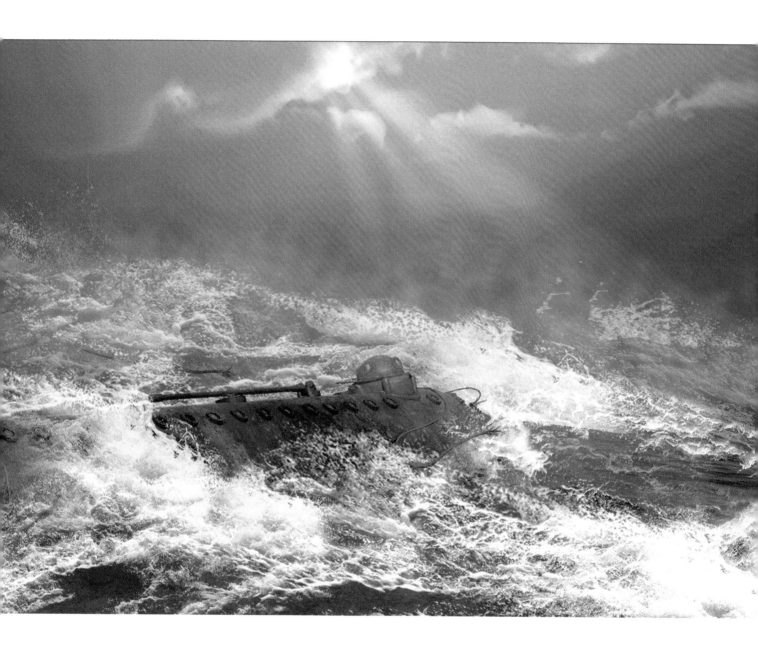

LOST AT SEA BY DON WEBSTER

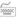 MODO, VUE INFINITE, PHOTOSHOP

 ABOUT 30 HOURS

St Pancras station is probably one of the most iconic of all the Victorian London terminus stations. Beneath its impressive and huge spanned roof built of iron and glass sits the recently outfitted Flying Duchess, waiting to take her maiden voyage across the roof tops of Victorian London. The Duchess is an experimental upside-down locomotive, built to travel over London, diminishing the need to build huge railway cuttings or embankments that will displace much of London's inhabitants.

PROJECT	THE FLYING DUCHESS
SOFTWARE USED	3DS MAX, PHOTOSHOP
RENDERING TIME	4 HOURS
ARTIST	WOKO (ROB WATKINS)
COUNTRY	UNITED KINGDOM

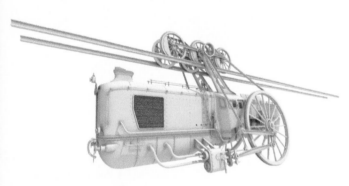

Shot of the engine along with the complex wheel system for overhead travel.

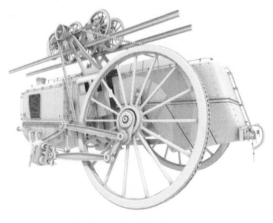

The giant wheel and gears that drive the engine along the tracks.

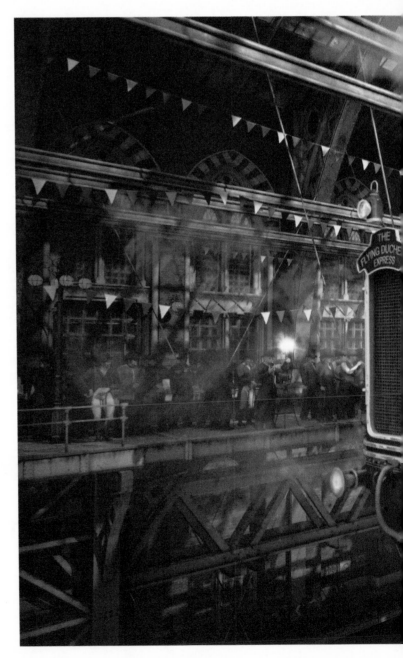

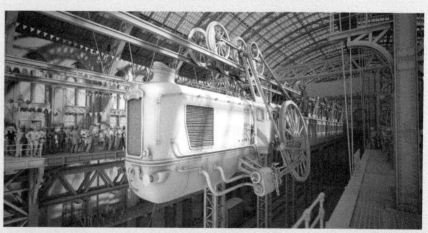

Ambient occlusion render showing the model in the Victorian setting.

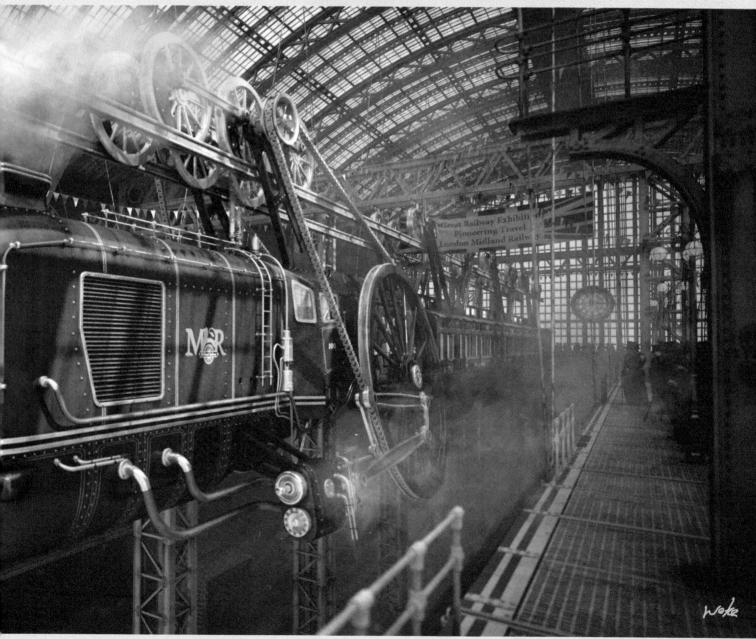

❝ The Golden age of steam locomotives in Britain for me was during the 1920s and 1930s when all the smaller railway companies had been amalgamated into four large companies. It was then that the chief mechanical engineers of these four big railway companies competed fiercely against each other for speed and prestige in the design of their new locomotives. Here I have tried to imagine what it would have been like if the chief mechanical engineer of the London Midland Scottish, Sir William Stanier, had experimented with a different type of rail transport. **❞**

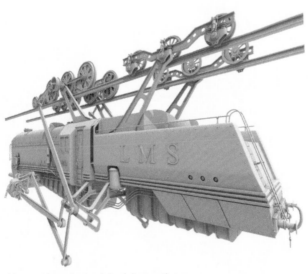

Here we have the hush-hush locomotive number 92200 in a shed awaiting trials.

PROJECT	THE FLYING DUCHESS
SOFTWARE USED	3DS MAX, PHOTOSHOP
RENDERING TIME	4 HOURS
ARTIST	WOKO (ROB WATKINS)
COUNTRY	UNITED KINGDOM

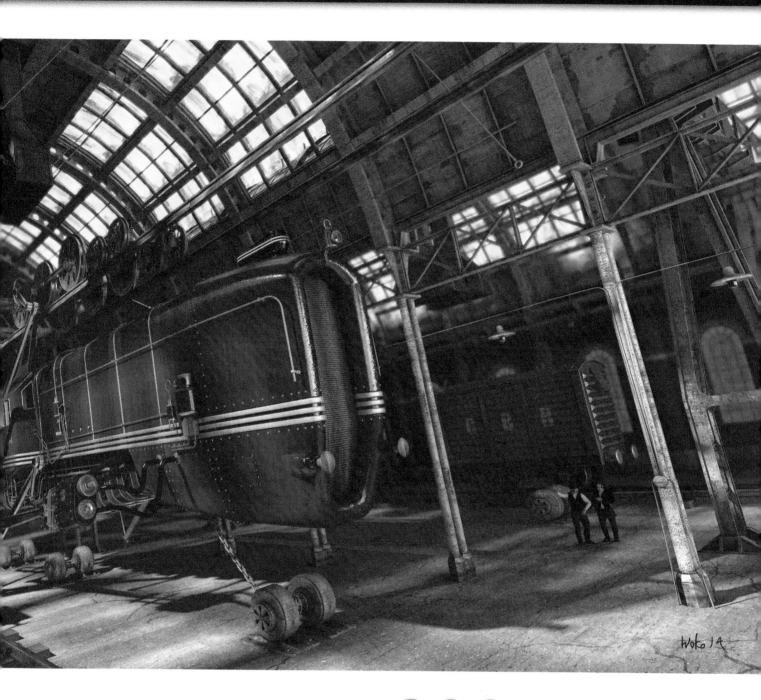

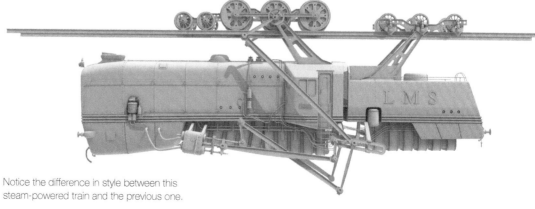

Notice the difference in style between this steam-powered train and the previous one.

The story starts like this: A few days ago, two unidentified vessels laid down their anchors in our harbour. No one knows who they are or where they come from. What exactly is their purpose? The scene was done in Maya and rendered with V-Ray. I actually did this for a lighting study, but it took longer than expected to build the whole environment, just to get the look and feel right. Nonetheless, I still think it was a valuable experience, and it can be considered one of the first stepping stones to reach where I am now.

PROJECT	ENEMIES OR ALLIES
SOFTWARE USED	AUTODESK MAYA 2013, ADOBE AFTER EFFECTS, ADOBE PHOTOSHOP
RENDERING TIME	2 HOURS
ARTIST	RICHARD JUSUF
COUNTRY	INDONESIA

As it's an exterior scene with fog, a directional light with very soft shadows and a skylight dome was used.

A V-Ray blend material was used for most of the object and a V-Ray two-sided material for the sail, because it was translucent.

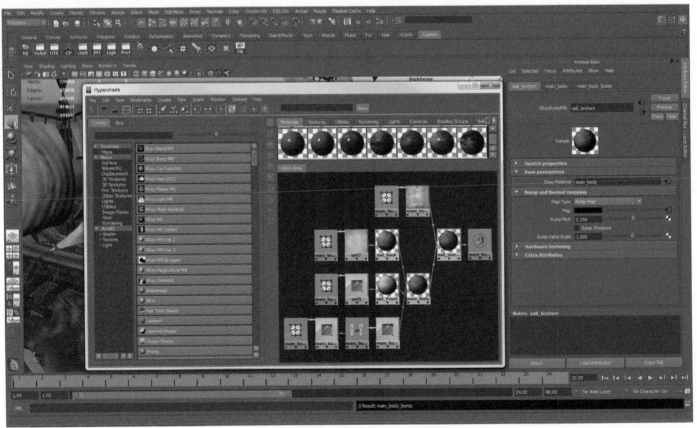

For the render settings, GI texture and V-Ray environment fog were used to create the foggy atmosphere, even though it increased the render time.

The basic shapes for the ship were created using operations and tools such as bevel, extrude and insert edge loop.

After Effects was used for the first step of post production as it has better tools for colour correction with EXR formats.

The After Effects output can be seen in this image, where there was quite a bit of colour correction compared to the raw render.

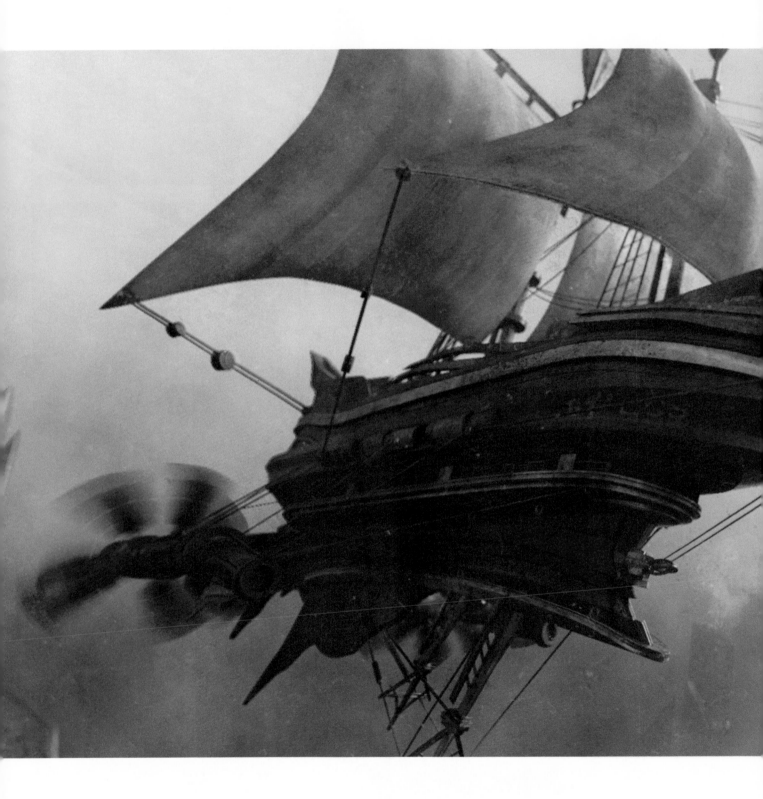

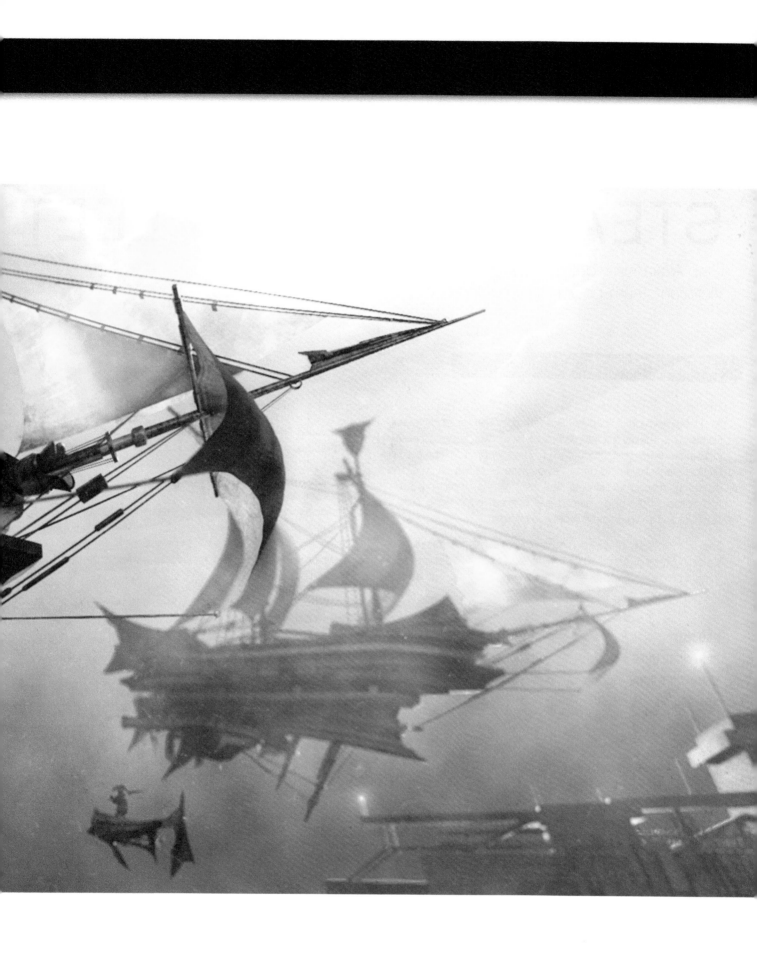

CREATING A STEAMPUNK AIR FLEET

Gleb Alexandrov details how he fused gothic architecture with Victorian steam-powered technology.

GOTHIC INSPIRATIONS

This render won the first prize in a competition called Her Majesty's Air Fleet, held on a popular Russian computer graphics portal, Render.ru. It was my first serious project, which was done completely in Blender (plus post production in Photoshop). The competition provided real stimulus to using various aspects of Blender including modelling, making UV layouts, texturing, lighting, rendering layers and passes, optimising viewport performance, establishing project structure and so on, to make a detailed picture.

The main themes of the competition were epic, steampunk and Victorian England. After struggling with a concept, the decision was made to create huge steel zeppelins flying into a Gothic cathedral of epic proportions.

PROJECT	HER MAJESTY'S ZEPPELINS
SOFTWARE USED	BLENDER, CYCLES, PHOTOSHOP
RENDERING TIME	4 DAYS TOTAL
ARTIST	GLEB ALEXANDROV
COUNTRY	BELARUS

**Her Majesty's Zeppelins
– final image**

I also developed a back story for the image:

In 1880 young Nikola Tesla proved the existence of the Ether and created a machine capable of using rotating magnetic fields to create the lift force to move vehicles upwards. Tesla believed that the technology was the common heritage of mankind, thus he sent packages with the detailed description of the technology and all the instructions for the production of an Ethereal engine to governments of all the major world powers. The British Empire, wanting to establish the status of not only the greatest sea power, but also the greatest air power, managed to build shipyards and was the first to create a fleet of armoured airships in them.

Invulnerable to anti-aircraft fire, carrying heavy armour, well-armed and manoeuvrable, the airships of Her Majesty's Air Fleet started to terrify enemies of the Empire.

I began the process by trying to come up with a composition that showed the initial blurred image of zeppelins flying through the archway. Right away I was trying to formalise this image on paper. I came up with an open environment, light and shadow play, the Gothic cathedral with ribs on the arches, the dark spots of the ships on a light background of the sky.

St. Vitus Cathedral in Prague served as a starting point for the sketch. This epic structure contains rhythm, movement, contrast in its forms. It inspired me a lot during the sketching phase. After sketching out the tonal values of the arcade and also a heavy blob of a zeppelin, I opened Blender and prepared to start modelling. The ship concepts were reworked at least three times. Nevertheless, all three versions were shaped like a zeppelin as I stubbornly refused to depart from steampunk concept. The first version of the ship was a funny fish with a harpoon and a soft belly.

Then came the idea to do something like an air locomotive assembled from parts of terrestrial trains. But this idea did not work. The third version was the final one, a zeppelin with a rotating magnetic field. I also thought about chrono-engines and how they would distort time and gravity.

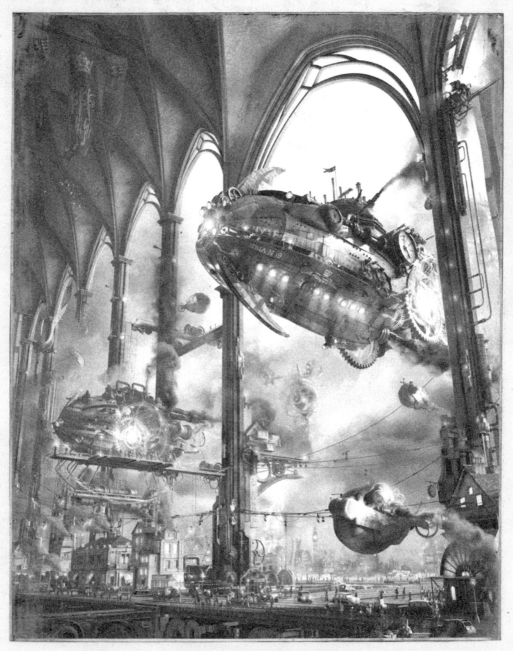

No. 2977.

THE ILLUSTRATED
LONDON NEWS

VOL. 108

VOL. XXIX.—No. 1300.
Copyright, 1885, by HARPER & BROTHERS.

LONDON, SUNDAY, SEPTEMBER 1, 1885.

TEN CENTS A COPY.
$4.00 PER YEAR, IN ADVANCE.

HER MAJESTY'S AIR FLEET ARRIVAL. - Photo by Mr. Bean - [See Page 9.]

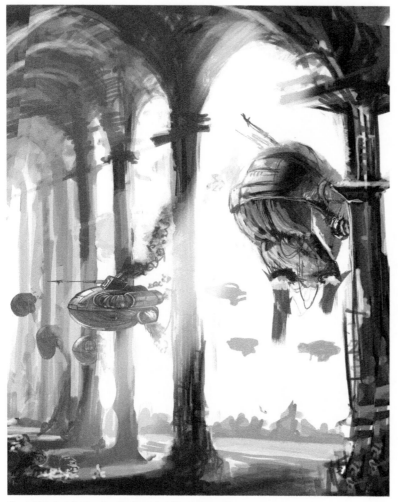

The initial sketch showing the layout of the scene and the contrast of dark and light areas.

The structure of St Vitus Cathedral in Prague provided the inspiration for the shape of the cathedral.

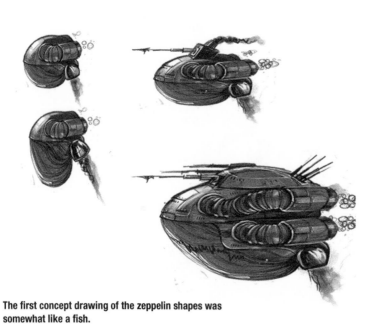

The first concept drawing of the zeppelin shapes was somewhat like a fish.

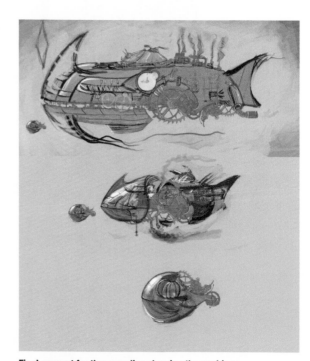

Final concept for the zeppelins showing the workings as they generate the anti-gravity field.

CONSTRUCTING THE SCENE

During the modelling phase, I realised, once again, the importance of the DRY principle – Don't Repeat Yourself. There wasn't much time to complete the render and there was a lot of work to be done from blocking the scene to detailing and so on. Thus, I tried to use every possibility to optimise the workflow, to make it more efficient and fluent. For example, I've used such time-savers as the group instance, mirror modifier, procedural materials. Also, I copied objects and pasted them in other places, rotated and scaled.

Needless to say, with a tight deadline logic sometimes had to go out of the window so there are, for example, gears floating in the air without any anti-gravity. Humans and machines, for sure, demanded more polish too.

As mentioned, during the arcade modelling group instances were used extensively. In other words, changes to an original group propagated to all instances. For example, when mechanisms were added to the source group, they appeared in every child group. This saved a huge amount of time.

TOP TIP – PROJECT STRUCTURE

I find it really easy to underestimate the meaning of organised folder structure and then to lose track of the project. Thus, it's highly advisable to create some sort of structure that will protect the project from chaos and entropy. Moreover, it's cool to give files descriptive names: scene_zeppelins__01, tex_metal_rusty_02, ps_compose_final and so on.

Use group instances; any changes to the source group will be propagated to the child groups automatically.

At first, the camera was positioned high in the air. Later on, it was positioned roughly at eye level to enhance the feeling of a huge environment. In addition to that, tiny figures were placed here and there for scale reference. Meanwhile, mechanisms were modelled according to the references for steam engines, locomotives, clock mechanisms, cranes.

Later on I decided to add a pit in the foreground, to make things look more technological. Once it was done, I thought that it would be cool to make the entire cathedral float on an anti-gravitational engine. But soon this idea was left behind because I wanted the scene to be closer to London street life. Once again, already modelled elements were transformed and re-used.

TOP TIP – WORKFLOW STAGES

Personally, I can rarely move consistently from sketching to modelling, from modelling to texturing and so on. If a scene is full of objects, there comes a time when separation on stages becomes meaningless. When it happens, it becomes easier to think of groups and layers rather than stages. This is partly due to the fact that all the components of the scene interact with each other in a complex way. For example, if we move the light the specular highlight on materials changes, if we add a model we introduce a shadow. If the colour of the texture on the columns is tweaked the ship is being lit differently by secondary global illumination bounces. In turn, all of the above influence the render setup.

Some of the mechanical references used when creating the machinery.

Taking things like the wheels and cogs from one model and adding them to another.

Here one architectural feature has been rotated 90 degrees in order to be re-used.

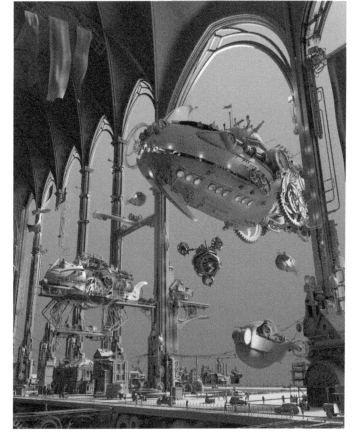

This flat render shows the setting of the camera angle so that it was looking up at the ships attacking.

When the basis of the scene was done, the detailing phase began. The column, and also the symmetry, was broken, then lanterns, spotlights, lamps and elevators were created. Then fencing, scaffolding, pipes, clocks, wires, dam, embankment and so on, were added.

The fins on the front of the ship were added to break up the phallic shape and enhance the silhouette. Later, they came in handy when I was looking for a place for markings. Moreover, it was funny to imagine zeppelins as fishes or submarines in a surreal air–water world.

To determine the function of each ship and identify it as belonging to Her Majesty's Navy, special details were added. The flagship got bomb doors, guns, heavy armour (the gears are protected by a magnetic field), extra anti-gravitational engines to manoeuvre and the spotlights.

Adding details down on the street level with cars and lamp posts.

VIEWPORT ACCELERATION WITH DISPLAY TOOLS

Display Tools are plug-in tools to make setting up the viewports in Blender much easier. They are made by Jordi Vall-llovera Medina or JordiArt. Let's take a look at some of the most useful functions.

Fast Navigate – during navigation viewport switches to bounding box mode.

Double Sided off – mass disables the property "double-sided lighting" on selected objects. This setting alone makes the viewport much more responsive. Without it the viewport begins to feel slower on approximately 1 m polygons, and goes completely slow on 2 m, on my GeForce 550m. With double-sided off it feels smooth on 5–7 million polys.

Another crucial setting for viewport acceleration is VBO (Vertex Buffer Objects), which is found in System Settings. Also, Subsurf modifier on top of modifier stack ignores VBO, therefore, we can add an empty modifier (simple deform with zero value) on top of the stack to override this behaviour.

Now there are buses, little steampunk cars and lots of people wandering around.

Fine details were added to the docking area to make it more mechanical.

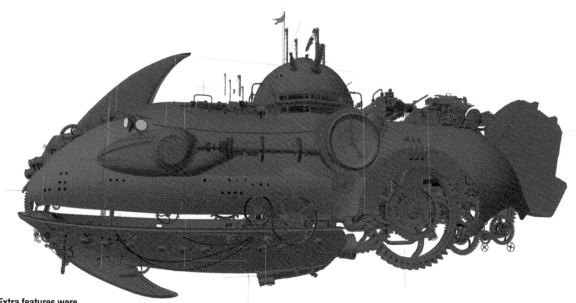

Extra features were
added to the flagship to
make it distinctive from
the other zeppelins.

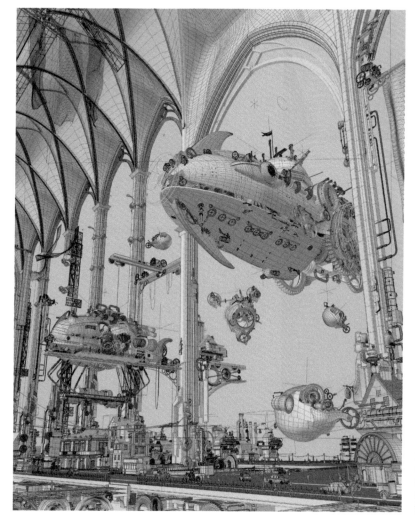

The completed
wireframe of the scene
showing all the ships
and cathedral in the
foreground.

UV MAPPING AND BOX PROJECTIONS

The flagman zeppelin was unwrapped manually by marking seams, unwrapping UV islands and trying to reduce distortion. After that, an ambient occlusion map was baked in the Blender Internal renderer, to serve as a guide for texture painting.

Finally, the UV layout was exported from Blender to Gimp and the texture was painted and composed from various photo sources and creative commons textures. All in all, it was a task of going back and forth between Blender and Gimp and watching if everything was alright with detail placement and overall look of the texture.

This was the process for the main zeppelin, every other one was unwrapped mainly through fast methods including smart UV projection, box mapping and projection from view. UV islands were obtained during the unwrap phase and were located on the texture of the main flagship.

After laying out the base of the texture, the details were added. The tactical designator, HMA, stands for Her Majesty's Air Fleet. Also used was the winged badge of Royal Flying Corps.

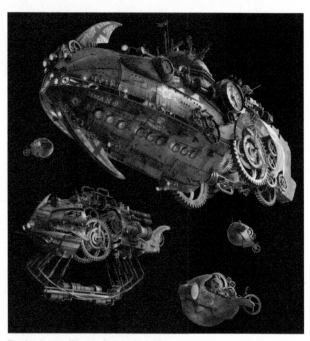

The lead zeppelin showing the insignia
and details along the body.

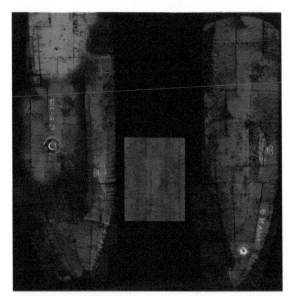

An ambient occlusion map was baked in
the internal renderer to use as a guide.

The lovely rusty texture for the
main ship in the fleet.

During this process I often used the generative mapping type instead of UV, and box projection instead of flat. It's a pretty fast way to go without UV unwrapping the model. Box projection means that the texture is projected from each side of the box shape, and then all the projections are blended to hide the seams. As a consequence of this type of procedural materials, seamless textures should be used.

A seamless
texture used for
box projection as
this was much
faster than UV
unwrapping.

CREATING THE LIGHTING

The lighting was set at the very beginning and since then the base has not changed much. The main light sources were the sun and the HDRI map. The purpose of the sun lamp was to create sharp separation between the exterior-lit areas and the shadowed geometry, because a HDRI map alone creates softer shadows and ambient lighting.

While processing the HDRI, I was trying to tint one side of the sphere with cool tones and the opposite side with warm. The dome was highlighted separately to achieve rhythmical light and shadow. I was constantly adding omni lights in the scene to illuminate specific details and accentuate the colours.

The smoke trails were simulated in Blender then added on top of the composition. Emitter smoke density was animated from zero till one (0–80 frames) to avoid creating just one big smoke puff. Also, the smoke was blown away by the wind.

I tried to render clouds for the background using Nick Keeline's impressive add-on called Cloud Generator. During the tests I realised that the results were going to be great for mixing with the main background in small doses. The problem was that it was taking too long and on this project, time was of the essence with the deadline looming.

Some of the various types of smoke stacks created using the emitter in Blender.

The lighting setup with lots and lots of little omni lights to pick out particular details.

Here's the animation in action showing the smoke path spreading out and being dispersed by the wind.

A cloud test that was used for a little of the background but started to take up too much time.

RENDERING AND POST-PROCESSING

When rendering, I separated the scene onto a number of layers including the cathedral, buildings, zeppelins, people, light sources, details and background. I also created some render passes for ambient occlusion, Z-depth (or mist) and diffuse direct.

This all had to be rendered with the CPU, because my video card refused to handle 10 million triangles. On average, the level of noise in the picture was getting satisfactory after 500–1000 samples. Although the layer with an arcade demanded 4,000 samples because of the small omni lights.

For ships, buildings and the arcade an ambient occlusion pass was mixed with an RGB pass using Multiply layer blend mode. Later on an aerial perspective was added with the help of the Z-depth pass. The background was a painted/collaged backdrop where I tried to achieve the atmosphere of an approaching storm. The city with Big Ben in the background, a symbol of Englishness, was used to serve as a reference to London.

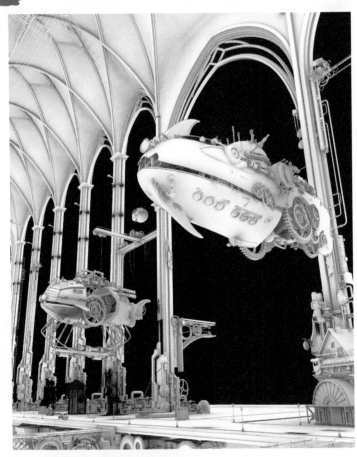

An ambient occlusion pass from the render engine showing the foreground action.

A stormy sky that was composited into the background. It features some symbols of the Empire like Big Ben.

The render settings in Blender showing it using the CPU for the heavy rendering work.

Once all the layers were composited a vignette effect was added and colour correction applied to all parts. The colour palette range was driven by complementary colours with shades of cool blue and warm orange-brown. With some minor touching up and final tweaking of the various layers, the image was completed.

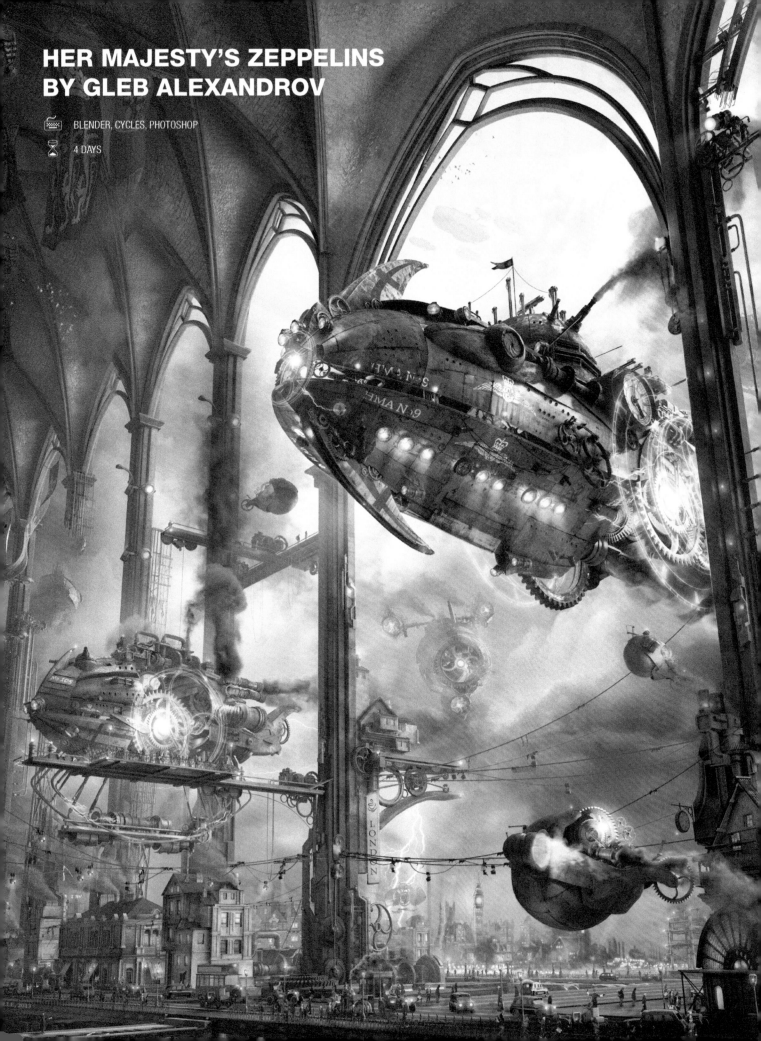

HER MAJESTY'S ZEPPELINS
BY GLEB ALEXANDROV

BLENDER, CYCLES, PHOTOSHOP

4 DAYS

SCULPTING A GLAMOROUS ANDROID

James Suret explains how he created a sexy robot character using ZBrush and Photoshop

IDEAS IN DEVELOPMENT

The aim of this project was to create a glamorous female android character. The character would be posed facing away from the camera, similar to shots seen in fashion and style magazines. This meant the back of the character needed to have some interesting features. The spine would be one of the main features of the character and I initially wanted to add some robotic wings. I wanted to create and style the hair using the Fibermesh feature and groom brushes in ZBrush. Previously, I had only used small amounts of Fibermesh so I was looking forward to creating a long hair style and learning from the experience. This project was also a good challenge because I had been focusing on creating 3D creatures recently and I needed to add some diversity to my portfolio.

The type of fashion model pose that the android character was going to emulate, but a little sexier.

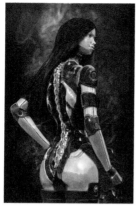

Nova-25 – final image.

PROJECT	NOVA-25
SOFTWARE USED	ZBRUSH, PHOTOSHOP
RENDERING TIME	APPROX 1 HOUR
ARTIST	JAMES SURET
COUNTRY	UNITED KINGDOM

STEP 1
PREPARING THE BASE MESH

For this character I decided to start from a base mesh rather than using ZSpheres to speed the process up. It was good to have an accurate anatomical base to make the character believable. I downloaded this base mesh for free from www.zbrushcentral.com. The first thing I did was to enable symmetry and change the proportions in order to give her a slender and idealistic feminine look.

STEP 2
ROUGH BLOCK-IN OF FEATURES

Now the base was ready I had to decide on the main features of the character. At this point I wasn't entirely sure what the armour or skin would be made of or how it could be separated up into panels and materials. Using the Clay and Claytubes brushes I scooped out cavities for the robotic spine and neck and then started to build up the shoulder panels.

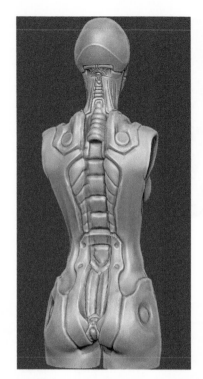

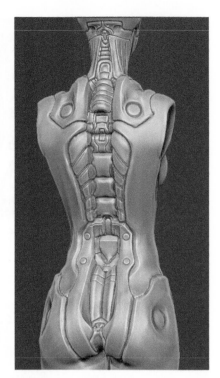

STEP 3
FURTHER BLOCKING-IN
OF SHAPES

I started to section up parts of the suit using the Damien Standard (DS) brush and polished the surfaces with the Flatten and Smooth brushes. Also, I cut out some holes using the Clay brush that could potentially be used for detailing. From the start I knew the character would be facing away from the camera so I saved some time by barely detailing the front of the body.

STEP 4
ADDING SEPARATION
BETWEEN FORMS

Next, parts of the body were cut up into areas using the DS and Claytubes brushes. The metal frame section was defined at the bottom and the shapes down the cavity where the spine would go. Then the metallic area was slightly polished with the Smooth brush to give a hint of the material it could be made from.

STEP 5
ADDING INITIAL
DETAILS

After using Dynamesh the mesh was now at about one million points. This enabled me to add finer detail and edges to the central area of the back. The Pinch brush was used to create sharper edges and then the Flatten and Hpolish brushes to tidy them up.

STEP 6
CREATING THE SPINE

I decided to create the robotic spine using an InsertMesh and the curves feature. Starting with a basic cylinder for the vertebra, using the move brush the main shapes were pulled out. Then mainly using the DS brush, the form was sculpted to resemble a human vertebra whilst adding some embellishments.

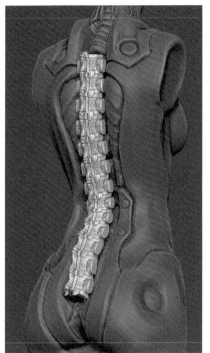

STEP 7
DETAILING THE SPINE VERTEBRAE

Now that I had the basic shape of the vertebra, I defined more details using the DS brush and polished with the Flatten and Hpolish brushes. Some InsertMesh shapes were added that could be used as lights and polygroups were added to section the materials up. Finally, using some InsertMeshes of screws some mechanical details were added to the piece.

STEP 8
INSERTING THE SPINE

When the vertebra was completed it was turned into an InsertMesh and Curve mode was enabled. Then the rough shape and length of the spine over the back of the character were drawn out. Next, I turned the snap option off for Curve mode so that I could tweak the position of the spine in order to make it look like it fitted properly into the spine cavity.

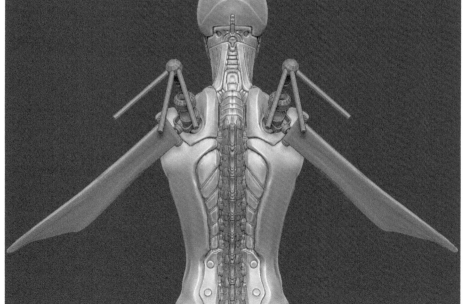

STEP 9
EXPERIMENTING WITH THE WINGS

I initially wanted to add robotic wings to this character so I started kit bashing by adding InsertMesh shapes to create a form that I could then sculpt on top of. However, as I had already decided on the angle of the camera and the size of the final render I realised that the wings would obscure too much of the character so I removed them.

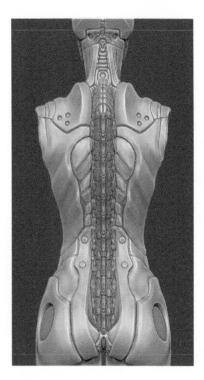

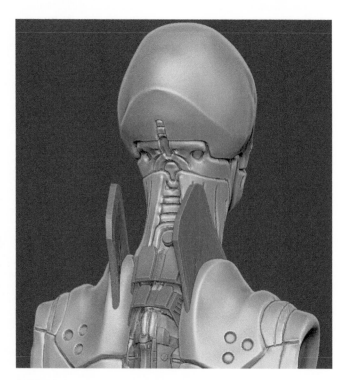

STEP 10
ADDING FURTHER DETAIL AND SEPARATION

Now that the spine was in place, the top and bottom of the body was modified to better accommodate it. Then using the DS brush separation lines on the shoulder and waist were created. Next, using the Clay brush some smooth cavities along the upper body were carved out to resemble ribs.

STEP 11
EXPERIMENTING WITH INSERTMESHES

At this stage I experimented further with InsertMesh shapes to build up some interesting additions to the neck and shoulders. However, I decided the model didn't need the extra details in that area and it was better to keep it sleek and simple.

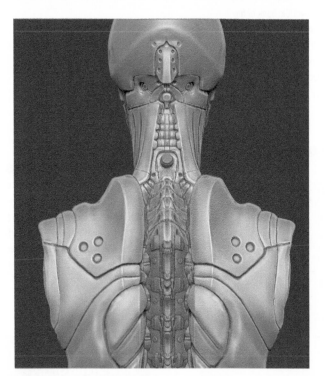

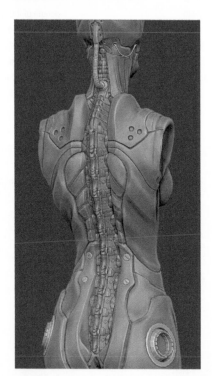

STEP 12
DETAILING THE NECK AND HEAD

The polygon count of the mesh was increased to about 4 million points. This meant I could then start adding fine detail to the back of the neck and head.

STEP 13
ADDING DETAILS WITH INSERTMESHES

Now that I had sculpted the fine details I started inserting more screws and wires to give the character a robotic look. A tube was added to the back of the neck but I wasn't sure if this would be hidden by the hair. However, it's good to put as much detail and as many features in as possible just in case you want to show them later.

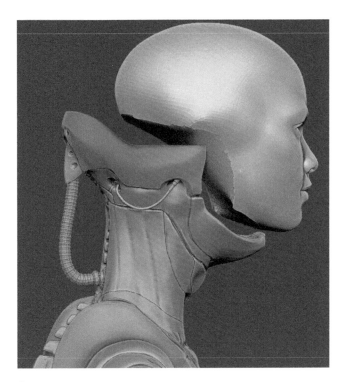

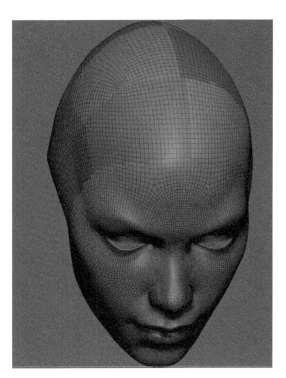

STEP 14
ADDING THE HEAD

To add the head the original base mesh was re-opened and the face cut out using the Lasso selection tool. The hidden geometry was deleted then the face was inserted into the project as a subtool and the Transpose tool was used to fit it inside the neck of the suit.

STEP 15
CREATING MASKS FOR THE HAIR

When creating long hairstyles using Fibermesh in ZBrush it is very important to create Polygroups so that you can control the shape of the hair. Symmetry was turned off then a section of the scalp was masked out and turned into a Polygroup. Then this process was repeated for the rest of the scalp.

TOP TIP – CREATING HAIRSTYLES

When creating long hairstyles I recommend creating Polygroups of the scalp before generating the Fibermesh, then set Auto Masking to "Mask By Polygroups" 100 per cent. Now you can brush and move segments of the hair one at a time to create complex hairstyles.

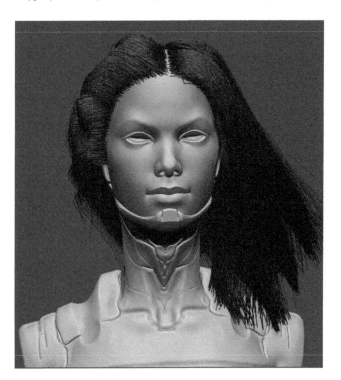

STEP 16
GENERATING THE HAIR

Next, the Fibermesh was created using one of the default templates (Fibers142) with gravity set to -1 so that it was easy to see the length of the hair. The coverage was set to 30 per cent, the Max Fibers to 18 and the Length to 1000. This then created a separate subtool for the generated hair which included the Polygroups previously created.

STEP 17
STYLING THE HAIR

The brush option Mask By Polygroup was set to 100. This meant I could brush sections of the hair using the Polygroups I had already created without interfering with the rest of the hair. Using the GroomHairBall brush, I pulled down one section at a time and then using the GroomHairLong brush the windswept look of the hair was created.

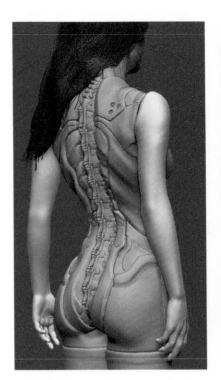

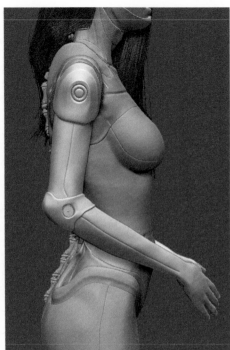

**TOP TIP
– SOFT MASKING**

When posing organic characters you usually need to create smooth bends, for example, the elbow or knee. Rather than masking the area and clicking on it several times to soften the mask you can hold down the Ctrl key and lower the RGB opacity.

STEP 18
ADDING THE ARMS

At this point the hair was taking shape and I was pleased with how the body looked. The original base mesh was opened again and the arms were sectioned off using the Lasso selection tool and then inserted into the project as a subtool. The arms were smoothed out slightly to look more like armour rather than skin and then shaping of the shoulders started.

STEP 19
ADDING DETAIL TO THE ARMS

The arms needed detailing to match the style of the body. To do this the Claytubes and Flatten brushes were used to pull out some basic shapes around the shoulders and elbows for padding and armour. At this point I wasn't sure whether to leave the hands looking completely human or robotic.

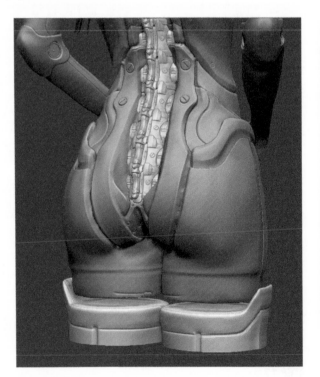

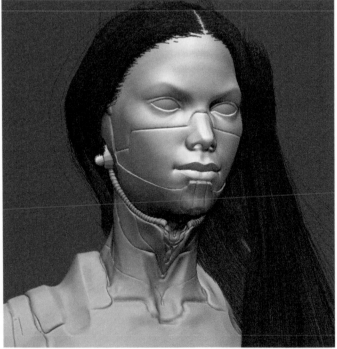

STEP 20
ADDING THE STOCKINGS

I hadn't worked on the legs yet so I decided to add some sexiness to the character by creating futuristic armoured stockings. A basic cylinder shape was inserted, the mesh was divided and using the Claytubes and Flatten brushes the tops of the stockings were created and the seam was cut out with the DS brush.

STEP 21
DETAILING THE FACE

The character now looked like a good mix of human and android so I decided to only add small changes to the face. A separation line was created with the DS brush and the Pinch brush used to tighten it up. Then the face was smoothed out to make it look slightly fake rather than actual flesh.

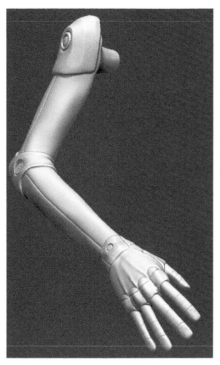

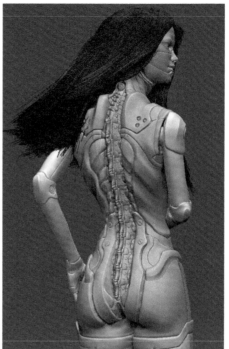

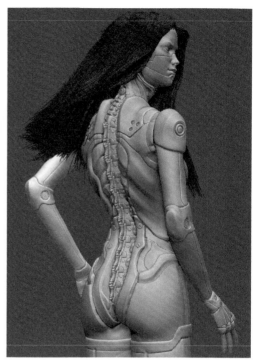

STEP 22
CREATING THE HANDS

To create the hands the fingers were cut off and the hand details were sculpted. Then a finger was sculpted from a basic cylinder. The finger was duplicated four times and then they were all moved into place on the hand before being resized slightly.

STEP 23
INITIAL POSE

Next, using Soft masking and the Transpose tool the arms were moved into place. In the initial pose I was going to show the character with her arms wrapped around her body and looking away to the side.

STEP 24
CHANGING THE POSE

I reconsidered the pose after doing a test render, I felt it was rather weak and made the character look too fragile. The character was repositioned so that it was more dynamic and the pose suggested movement.

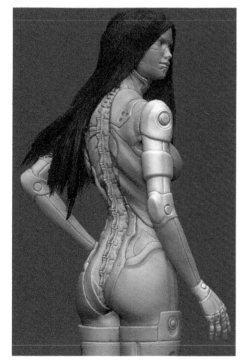

STEP 25
REFINING DETAILS

Now with everything in place I looked over the entire character and added more details to the hands, shoulders and stocking tops. Additionally, the hair was brushed further to tidy it up and also pulled down over the character to create the illusion of gravity.

STEP 26
ADDING MATERIALS

With the sculpting and pose completed parts of the body were masked out and some materials were added to those areas to section up the armour. To the white outer areas of the body a matte material was added and to the rest of the sections black and red metallic materials were added. A skin material was also added to the face.

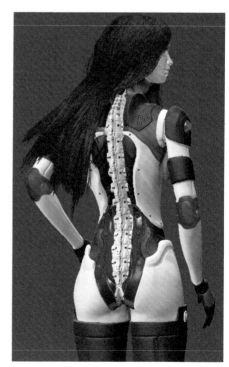

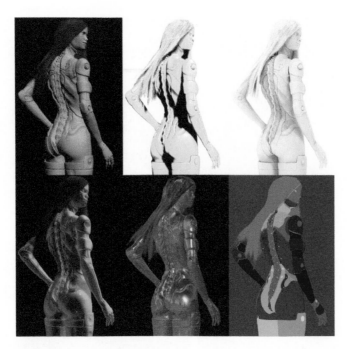

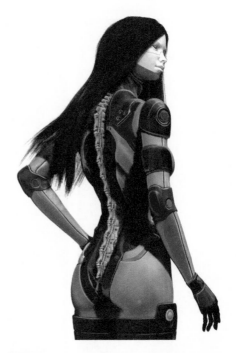

STEP 27
CREATING THE RENDERS

A basic render was created without shadows to use as the base layer in Photoshop. Then the light placement was moved to create shading across the back and this was rendered. The individual parts of the armour were selected, filled with different flat coloured material and rendered to use as a mask. Also, several renders were created using different materials so that I had options when compositing.

STEP 28
LAYERS AND COMPOSITING IN PHOTOSHOP

Next, the renders were opened in Photoshop. I started with the basic render then added the shadow and ambient occlusion layers, inserting the silhouette mask and material masks layers on top. Some of the extra material renders were experimented with, changing the layer modes until I was happy with the lighting and colours.

TOP TIP – SCULPTING STRAIGHT LINES

It's often necessary to cut out straight lines in the mesh, for example, seams on clothing or panels on metal. To achieve this you can hold down the mouse and then hold down the Shift key and drag the mouse, the mouse cursor will then snap to a straight line.

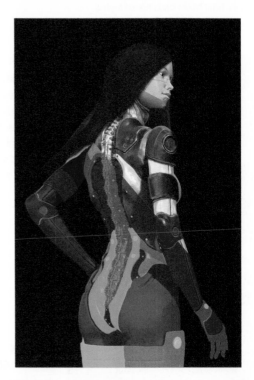

STEP 29
CREATING THE BACKGROUND

The abstract background was then painted using a few custom brushes and blurring the image to create a colourful smoky backdrop. Using a large soft brush the shadow and light were painted to help focus the eye on the centre of the image. Finally, a layer of noise was added to emulate the way light scatters into the distance.

STEP 30
ADDING TEXTURE AND EFFECTS

To add realism a scratched metal texture was added and using the mask the excess texture was deleted. This process was then repeated with skin texture for the face and painting on the eyes and eyebrows. Finally, the red glows were painted on a new layer using a soft round brush set to Multiply. Also, the specular shine was added coming from the edges of the metal.

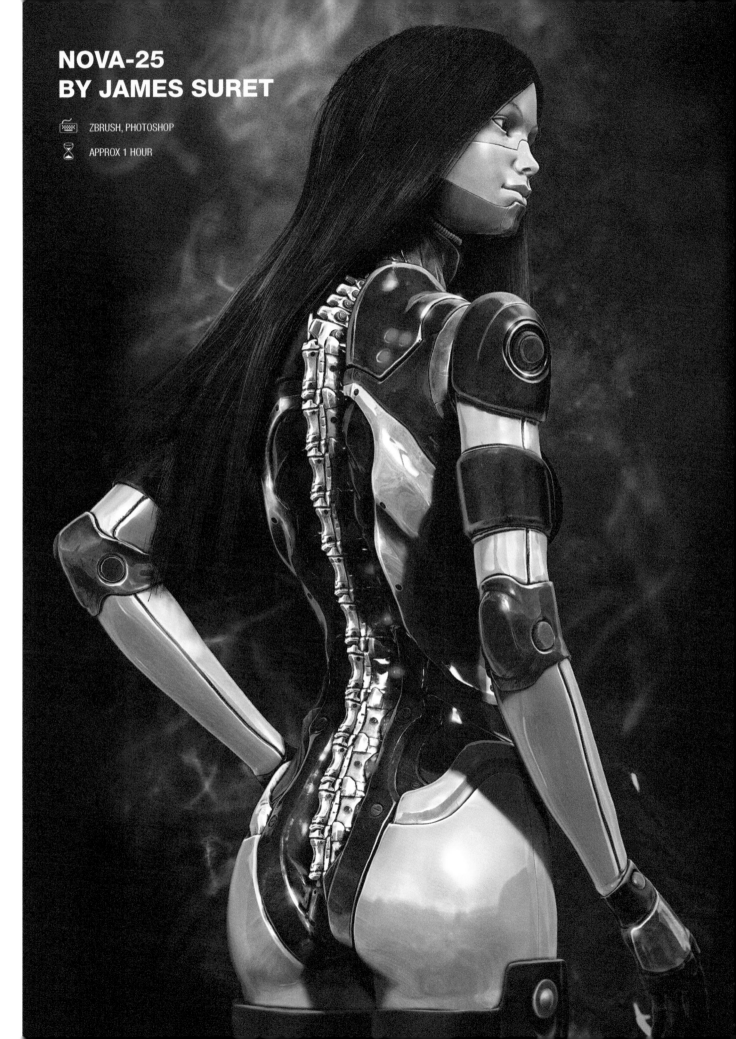

NOVA-25
BY JAMES SURET

ZBRUSH, PHOTOSHOP

APPROX 1 HOUR

" The project concerned a robot avatar, who is a motorcycle rider on a larger vehicle. The vehicles of the AEG27 (Advance Engine Gear) range are from a not too distant future. The pilots will control the remote robot avatar and the teams will fight for the championship title of CERN 05. Being a designer I thought a lot about the aesthetics and functionality of every component. The front wheel has holes that allow air to enter the turbine, the rear wheels are free of the hub. The design of the robot is minimalist with the frame and the engine being the high technology elements, but the plates are just aesthetic to mimic the muscles of a person. AEG27 other vehicles are visible in my personal portfolio on Behance. "

PROJECT	ROBOT AVATAR CERN 05
SOFTWARE USED	RHINOCEROS 4, KEYSHOT 4, ADOBE PHOTOSHOP CS3
RENDERING TIME	7 HOURS OUT OF TOTAL OF 110 HOURS
ARTIST	LUIGI MEMOLA
COUNTRY	ITALY

All the various layers of the completed model from within the Rhinoceros interface.

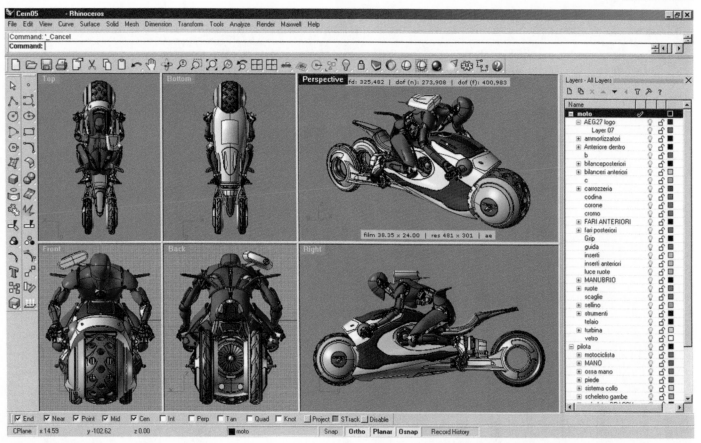

The model imported into KeyShot for rendering. An HDRI lighting system is being applied.

The actual race for the robot avatar in progress where a human controls the machine.

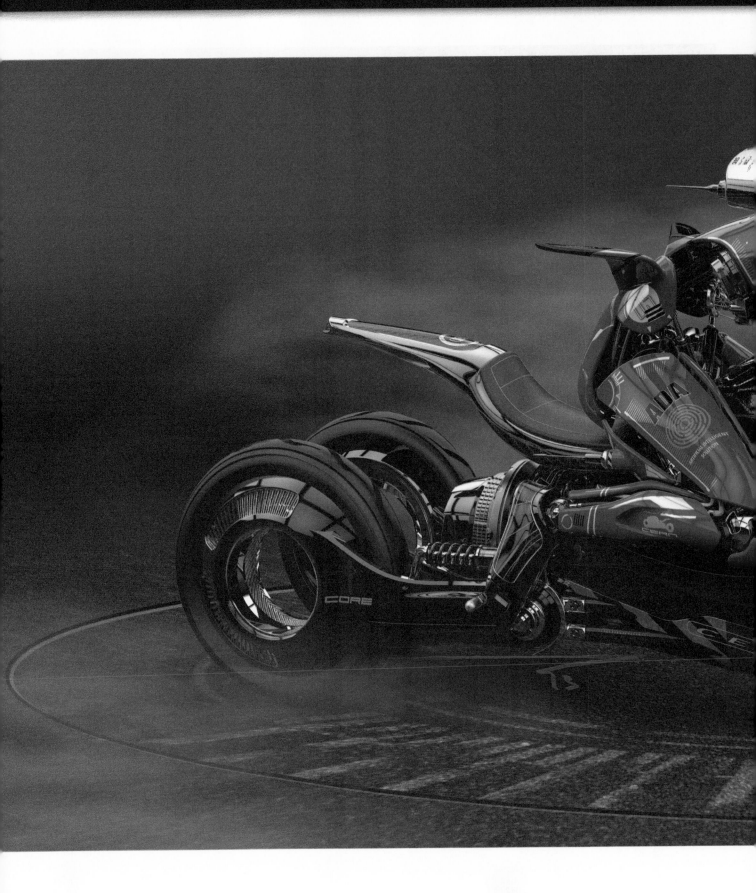

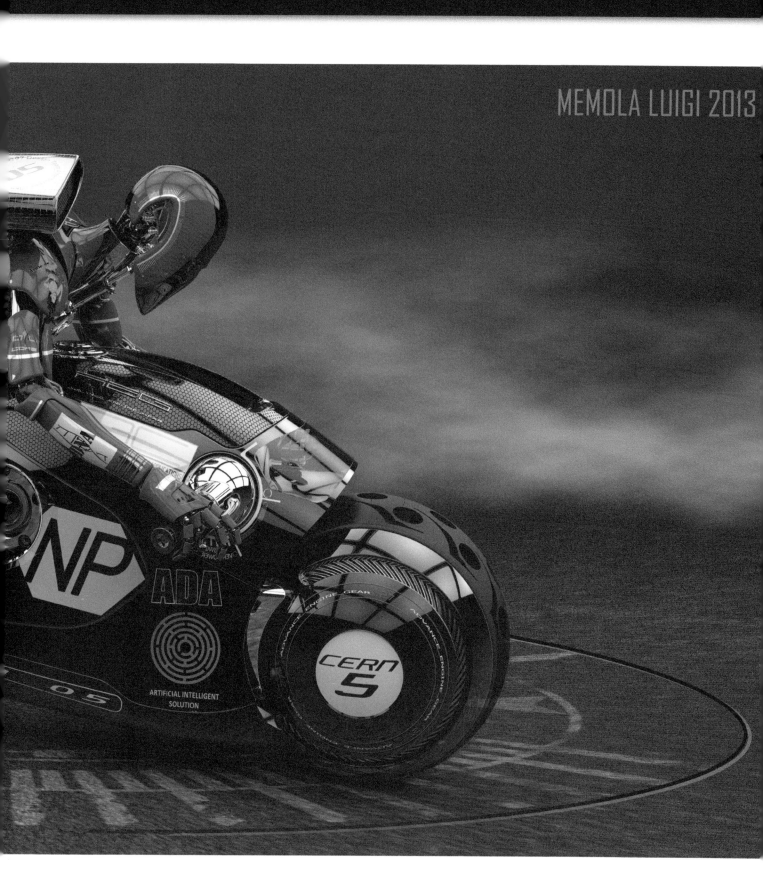

" The image was made as part of a series of pieces depicting derelict or broken machines/ships in sci-fi environments. The 3D model was from an older project that I decided to re-use for this. It was modelled and rendered in Lightwave 3D then painted over in Photoshop to complete the image with more of an artistic look rather than a clean render. "

PROJECT	REBUILD
SOFTWARE USED	LIGHTWAVE 3D PHOTOSHOP
RENDERING TIME	N/A
ARTIST	NEIL MACCORMACK
COUNTRY	SWITZERLAND

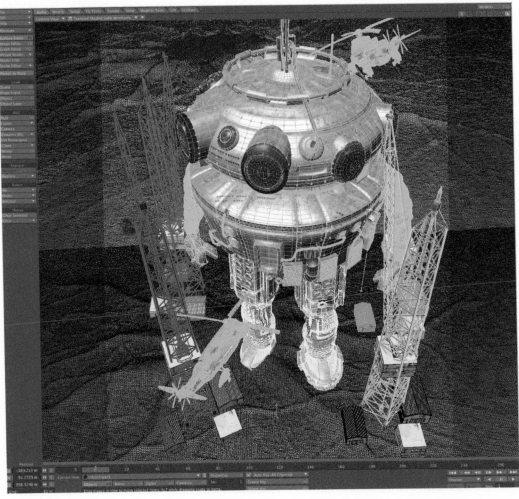

Creating the supporting elements of cranes and helicopters that are working on the giant robot vehicle.

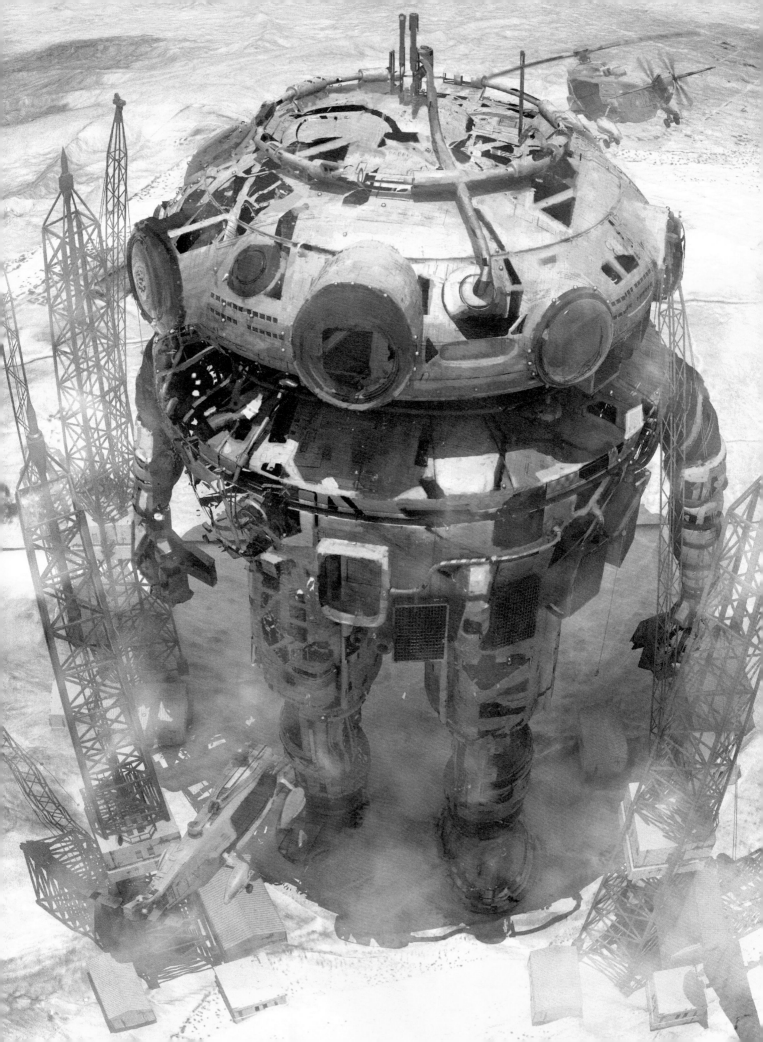

> This was a personal project where I created a series of military-grade robots. This one is an assault robot, hence it has two large weapons on the ends of its arms. The lighting of the eyes was to give it that contemporary shining/futuristic lighting look that you get in movies.

PROJECT	CAPTAIN-TE
SOFTWARE USED	ZBRUSH, MODO, KEYSHOT
RENDERING TIME	APPROXIMATELY 120 MINS
ARTIST	RAFAEL AMARANTE
COUNTRY	BRASIL

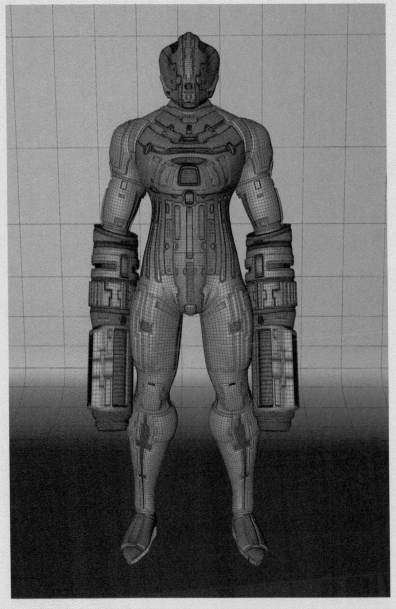

The robot was modelled in Modo as it is one of the better 3D packages for hard surface modelling.

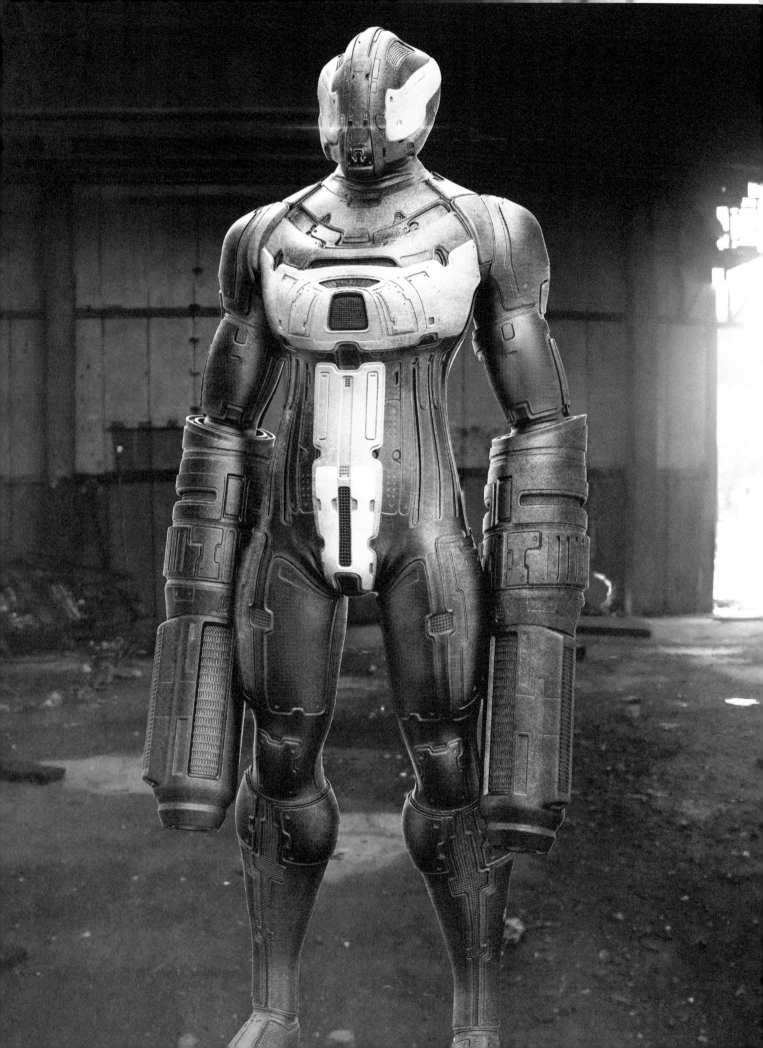

66 I was taking part in a hard-surface modelling workshop with Pedro Toledo and needed a model to use. I had always loved this robot design, originally sketched by my friend, Thiago Almeida. 99

PROJECT	ROBOT
SOFTWARE USED	3DS MAX 2012, ZBRUSH, MUDBOX, TOPOGUN, UVLAYOUT AND V-RAY
RENDERING TIME	2 HOURS
ARTIST	VICTOR HUGO DIAS DE SOUSA
COUNTRY	BRASIL

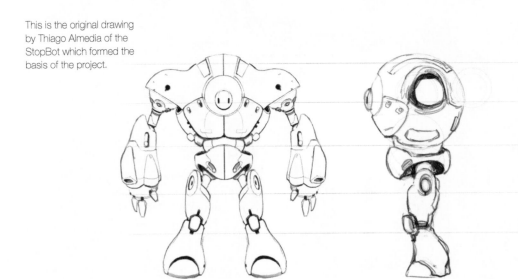

This is the original drawing by Thiago Almedia of the StopBot which formed the basis of the project.

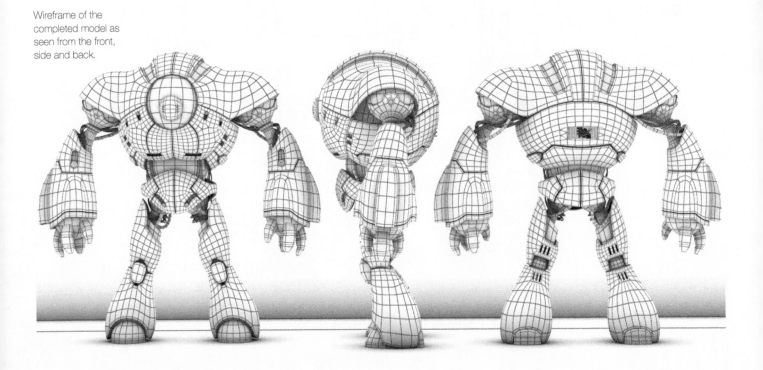

Wireframe of the completed model as seen from the front, side and back.

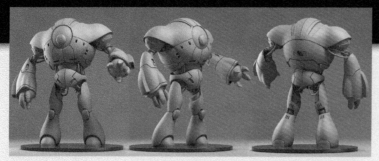

The robot on a turntable to showcase the model.
This is a clay render without any textures.

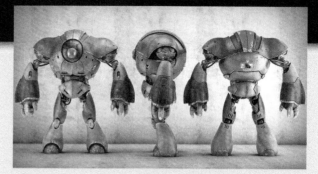

Same turntable view of each side of the bot,
but now with the textures in place.

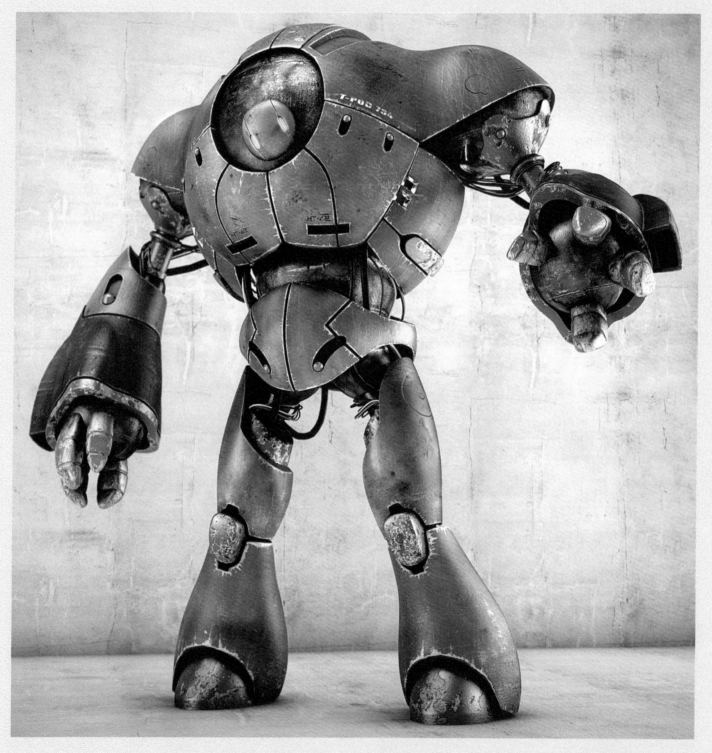

> The aim for this project was to create a robotic alien character and render it in a realistic way. I initially sculpted this as a complete character with a feminine look but later decided to focus on making a more detailed bust rather than whole character. To do this I replaced the chest/neck and also made it more masculine. I wanted to make use of the ZBrush insert mesh feature as I hadn't used it much before this. I added lots of screws and panels from the insert mesh library that came with ZBrush which adds to the realism of the character.

PROJECT	ALIEN CYBORG
SOFTWARE USED	ZBRUSH, PHOTOSHOP
RENDERING TIME	APPROXIMATELY 35 HOURS INCLUDING SCULPTING
ARTIST	JAMES SURET
COUNTRY	UNITED KINGDOM

Sculpting the basic shapes of the character using the Move and Clay brushes. Also creating some separation between panels/sections of the armour.

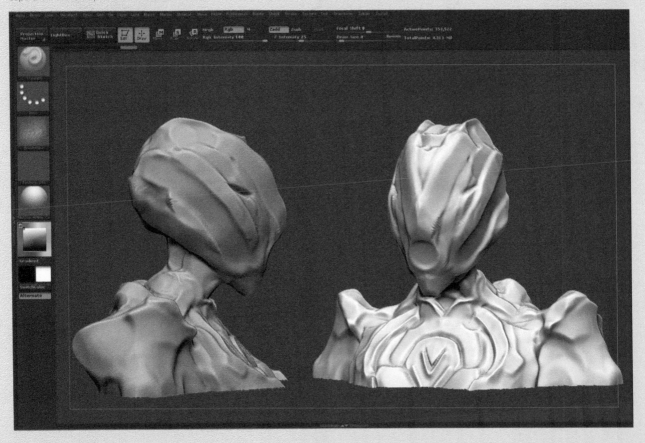

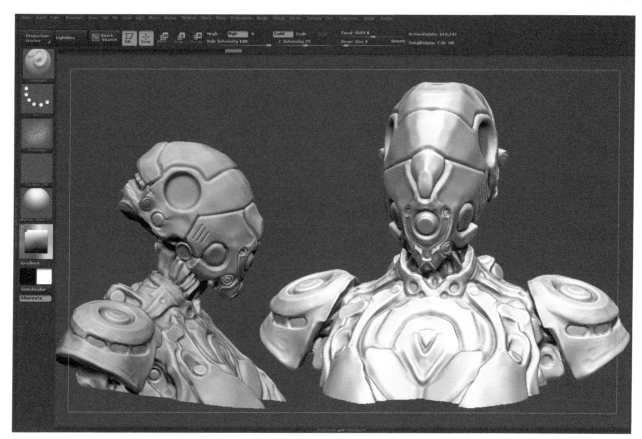

Having increased the density of the mesh I then added more detail whilst leaving some parts bare in order to add insert mesh objects later.

Further refinement of the features of the bust – I polished some of the surfaces as well as added insert mesh objects such as screws and vents.

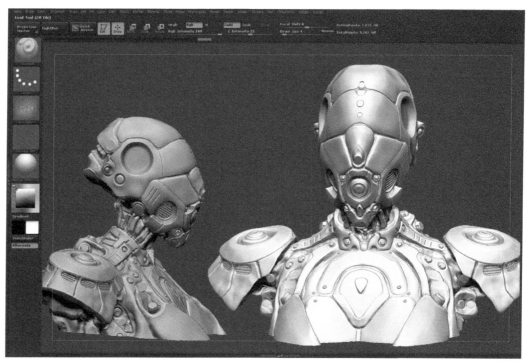

I re-created the chest/neck to look more alien and masculine. I also added more insert mesh objects and polished the metal surfaces using the Flatten and Polish brushes.

Several layers were rendered out including ambient occlusion, shadow, reflection and specular lighting. In Photoshop I then painted skin and metal textures on top.

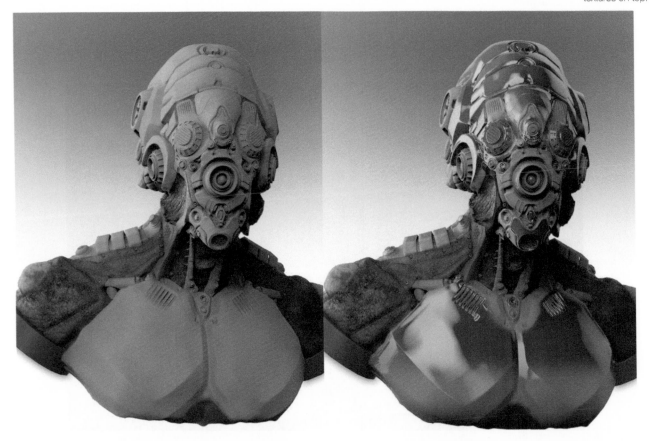

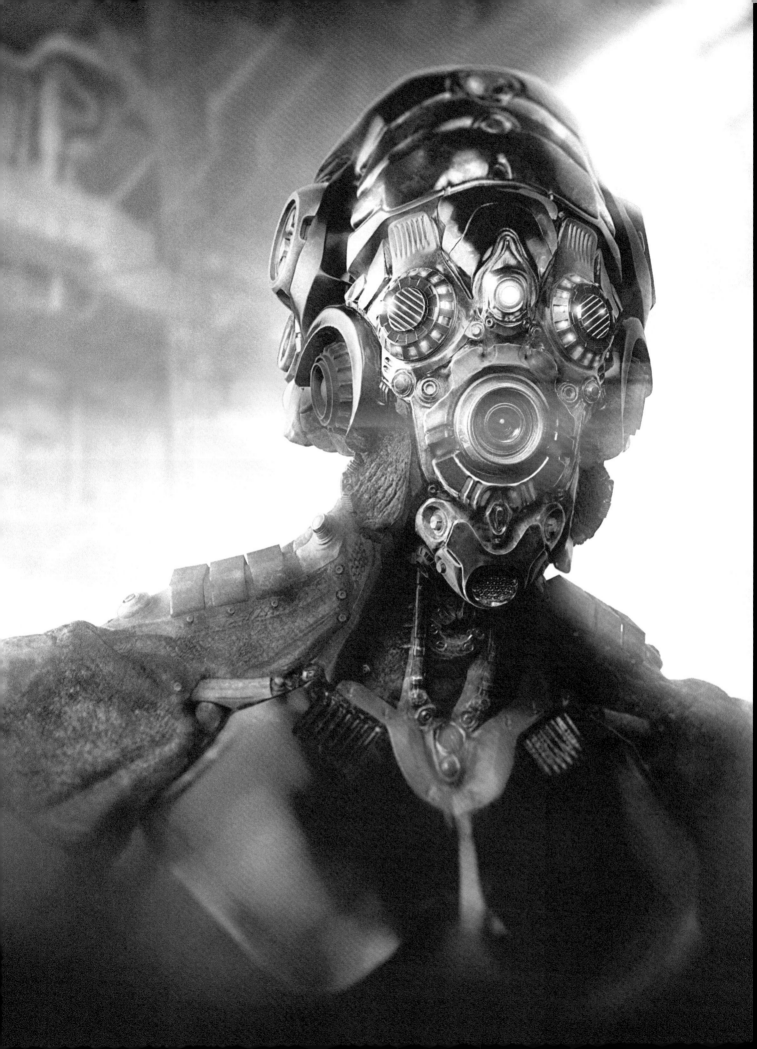

MIXING NATURE AND ROBOTICS

Christopher Parnian explains how he fused two styles together to create a robot with organic stylings

MECHANICAL DESIGN DEAS

I created this robot character for a challenge where the guideline was creating a robot or a vehicle by taking inspiration from a creature or nature. I chose a Queen Bee as the inspiration for my character. When creating something we usually look at the physical appearance or the distinct characteristics to get some idea of what to use in the CG design, but in this case I considered more its personality and instinctive behaviours. These included concepts such as being hard working, defending of the hive and protecting itself against enemies by stinging. I often search the Internet for photos of things like machines, mechanical industry, animals, and insects. I also check out artworks of other artists to see what kind of inferences and references they are using. For the robotic Queen Bee, the whole purpose was to bring the somewhat tedious nature of mechanical industry objects to life. This meant creating a robot with a combination of mechanical elements and beautiful fashion models.

These are a bunch of images that I have collected for inspiration, from fashion models to machinery and bees.

A close-up shot of the head of the final rendered image.

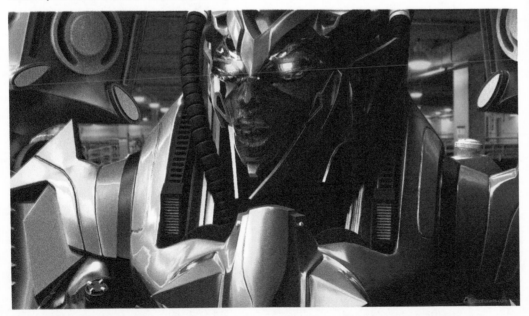

Queen Bee – final image

PROJECT	QUEEN BEE
SOFTWARE USED	3DS MAX, ZBRUSH, XSI SOFTIMAGE, MENTAL RAY, PHOTOSHOP
RENDERING TIME	6 WEEKS TOTAL
ARTIST	CHRISTOPHER PARNIAN
COUNTRY	IRAN

SCULPTING THE MESH

The process started by modelling a generic body or blockout, in 3ds Max. I didn't draw any preliminary sketches because I wanted to jump into the design right away with the sculpting stage. The base mesh of the body was built using a poly-by-poly modelling technique. This means that the mesh was built by basically extruding edges from existing polygons, after which the new points are moved to form the required shape and so on. The overall shape and surface were kept pretty clean so they could be pushed drastically in ZBrush later.

The base mesh had more than enough detail to get started so it was then imported into ZBrush and the Move brush was used to change the proportions and develop some interesting shapes. At this point I didn't care too much about stretched geometry. Once I got some interesting shapes I imported the mesh back into 3ds Max and added more edge loops in areas that had become too stretched. The basic premise behind a clean sculpt is to keep your polygons in as many quads as possible. Figure 1 shows the earliest low-poly concept model, which gives you an idea about the overall shapes that were sculpted using the Move, Standard and Inflate brushes.

The mesh was divided four to five times, just to make sure that there was enough geometry for the small, crisp details. At this point I started to concern myself with the surface. Piece by piece the shapes were carefully formed, starting with large areas and going down to the small ones. At the same time I kept looking at different kinds of reference images, just to keep myself inspired. I wanted to keep the overall profile simple and easy to read, but add a unique sci-fi aspect to the details.

Switching from Zadd to Zsub mode makes the alpha affect the surface in the opposite way. I especially like combining this approach with the new brush features in the latest version of ZBrush. It's so much fun to just experiment and explore different ideas. Sometimes I saved different versions and then worked on the one with the best design after the sculpting base mesh was completed. Resurface modelling methods were used to build the low poly model that could be imported into XSI SoftImage for more detailing.

The early low-poly model which was being shaped and sculpted.

Trying different expressions to see which would work best for the overall effect.

The Standard, Inflate and Move brushes were used to add details to the mesh.

Basic block outline from 3ds Max that was imported into ZBrush.

Assembling various
components to go with
the main body of the
model.

**TOP TIP
– KEEP IT QUAD**

The basic premise behind a clean
sculpt is to keep your polygons
in as many quads as possible.
This avoids the model becoming
stretched and too low resolution
in places.

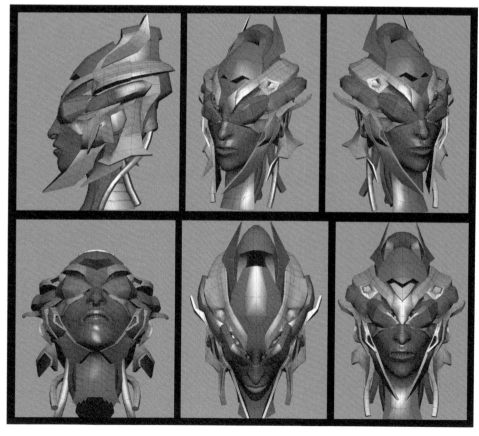

Rotating through the
various views of the
head to show the
structure.

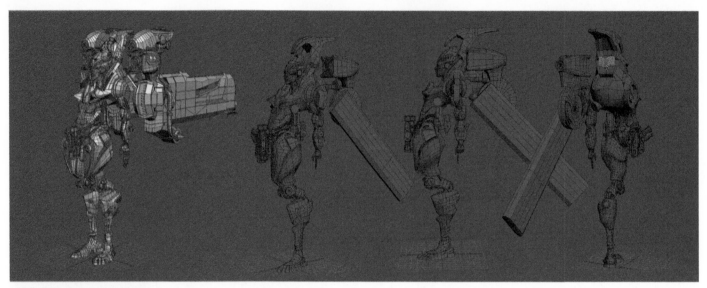

At this stage, the work in progress shows that almost all of the details have been completed.

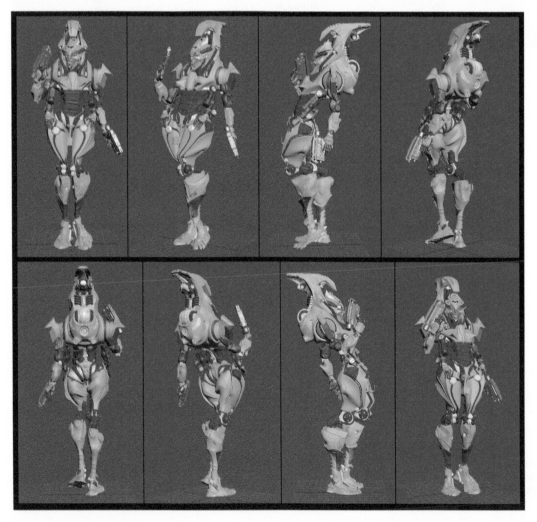

The final model on a turntable where all the details and features have been created.

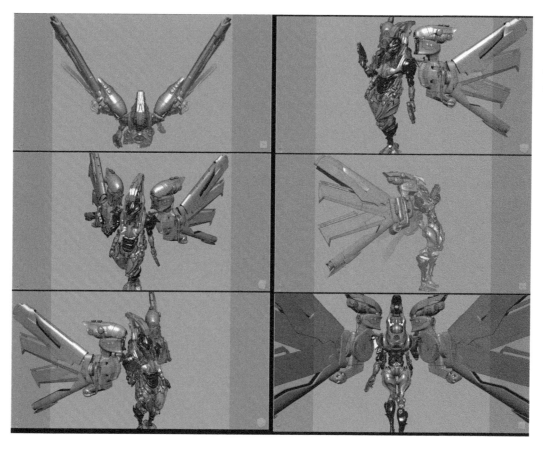

The wings and aerial propulsion system for the model is shown from various angles.

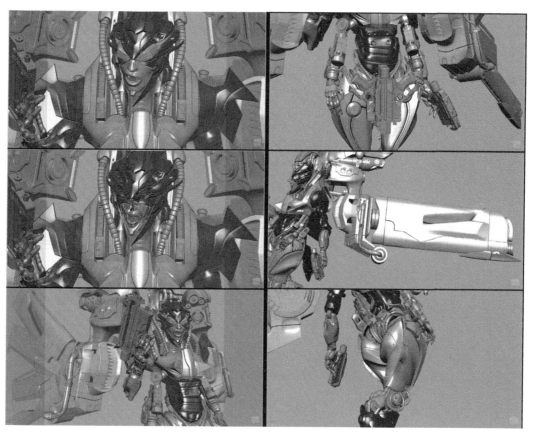

Close up shots showing hands, mouth, weapons, and the hydraulic system for the legs.

CHOOSING MATERIALS

The Mental Ray Arch and Design material system was used for this project, as they are very good at portraying metal materials. The Arch and Design materials have some good preset settings with which to create all sorts of realistic materials and are an excellent starting point from which to create your own custom set-ups. An HDR image in the reflection map slot was also used, which helped greatly in achieving realistic metals instead of relying only on the environment reflections. The Arch and Design materials dramatically increased the render times, but the end results are usually much more natural so it's worth putting up with.

Material assignment in Mental Ray. The Arch and Design group is invaluable for creating realistic materials.

More materials including those for the glass elements and the metal of the hand guns.

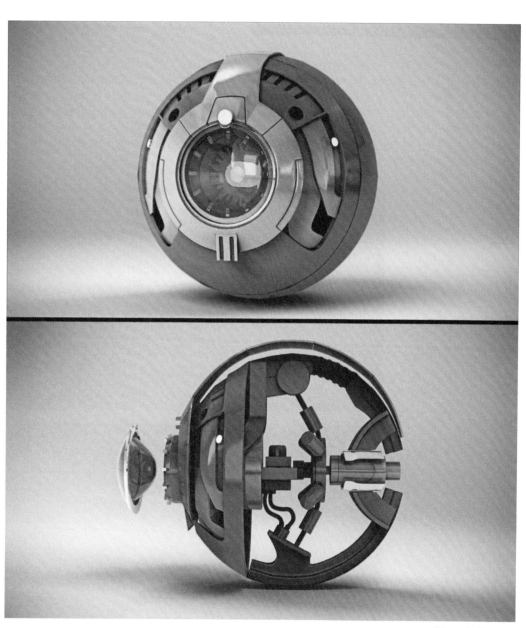

The eyeball system with glass and metal materials assigned for a realistic render.

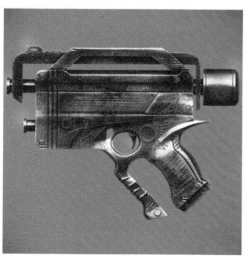

One of the electro-magnetic hand guns used by the Queen Bee figure.

LIGHTING GROUPS

The trick with lighting is to keep it simple whenever possible. With this in mind, only three groups of lights were used and each one has two lights for the whole scene. Also I used mr Sky Portal lights as this produced the smooth shadows I wanted. Figure 2 shows the entire lighting rig, consisting of six lights in three groups. The groups consisted of one key light as the main light source and two fill lights to add reflections and reduce shadow areas.

After some render tests it became apparent that there was a problem with the far left of the image being too dark. To resolve this the locations of the lights were changed and further test renders were produced until it came up with a satisfactory result. Producing a clay render of the figure allowed me to check for any modelling or lighting issues without being distracted by textures or materials.

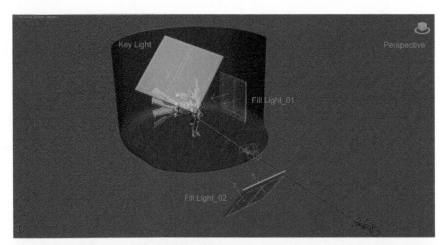

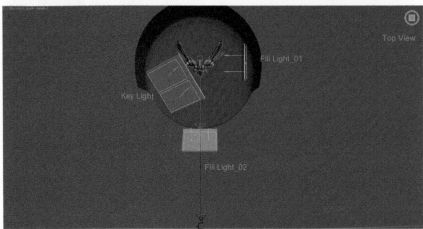

The lighting group setup from a variety of angles showing the use of key and fill lights.

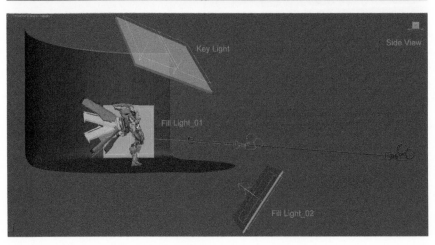

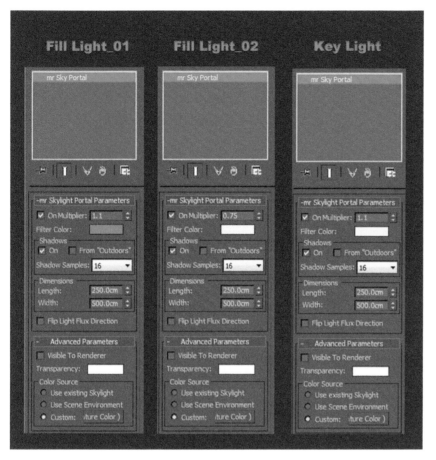

The settings for the three sets of lights shows the slight colour being used as the main light filter.

TOP TIP – HDRI LIGHTING

Using an HDRI image in the reflection map slot helped greatly in achieving realistic metals instead of relying only on the environment reflections.

This is a clay render, just showing the lighting, so any problems with the model could be seen.

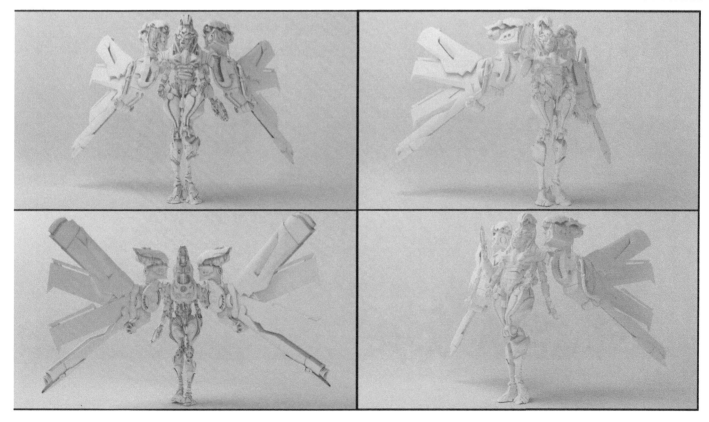

RENDERING THE ROBOT

As some of the materials were quite heavy and took a long time to render, the render tests were set to a very low quality. This is always good practice and will speed up the workflow because the last thing you want to be doing is waiting around for test renders when making small adjustments. The default Draft settings were used for the tests and the image resolution was kept small to help keep it rendering quickly.

Once happy with the render and when the lighting looked reasonable, I moved on to a larger render. This render had slightly increased settings such as Bounce and Final Gather rays cast to improve the quality. The important things were to limit the depth of reflections for the ray tracer.

The render setup, with ray tracing limits highlighted, for using the Mental Ray rendering engine.

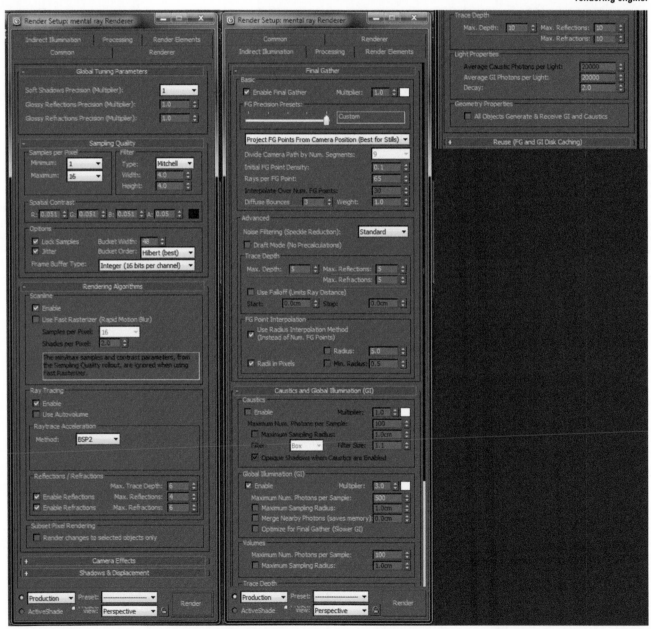

An HDRI map was used to create a more rounded lighting solution while the colour temperature was set to 5200K.

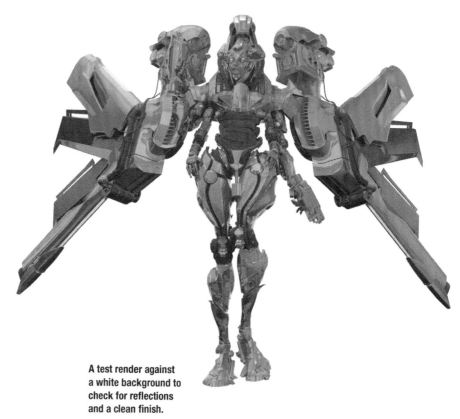

A test render against a white background to check for reflections and a clean finish.

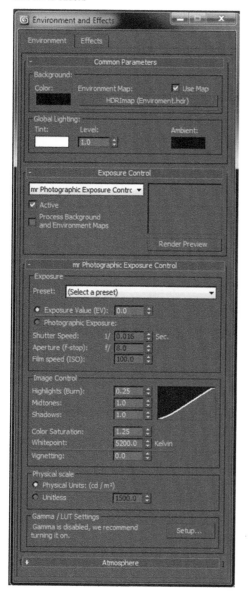

A final test render with the colour background, before increasing the quality for the final render.

TOP TIP
– TEST RENDERS

When using detailed and high resolution textures, even preview renders can take a long time to churn out. Reduce this time by lowering the resolution to the smallest size at which you can still see the details and set the quality settings in the render engine as low as possible.

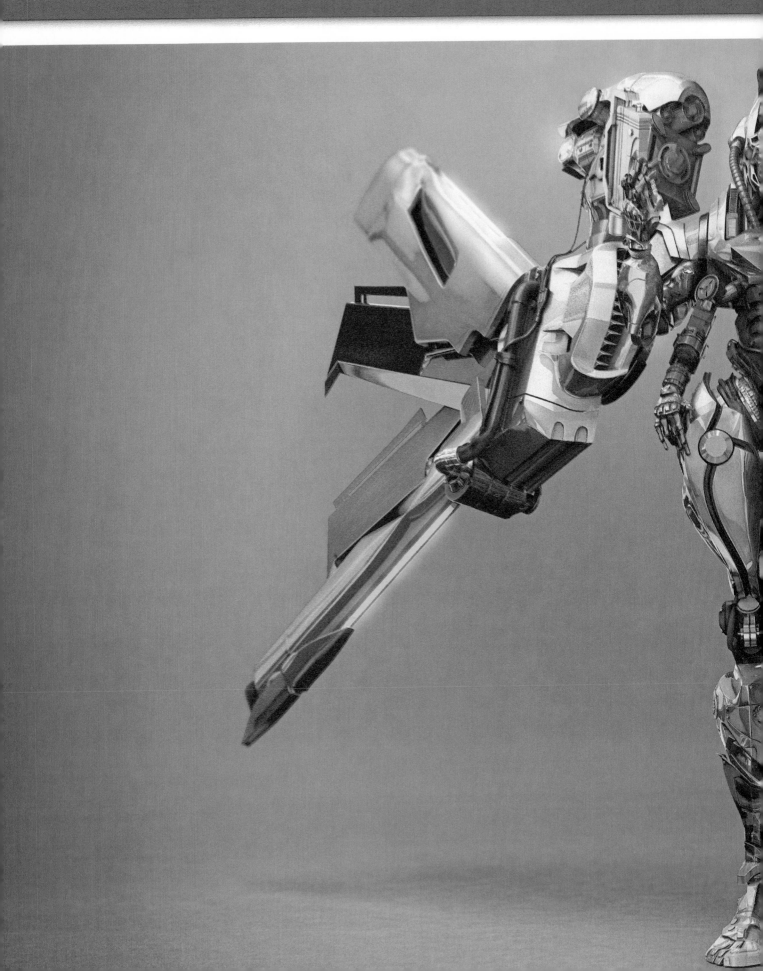

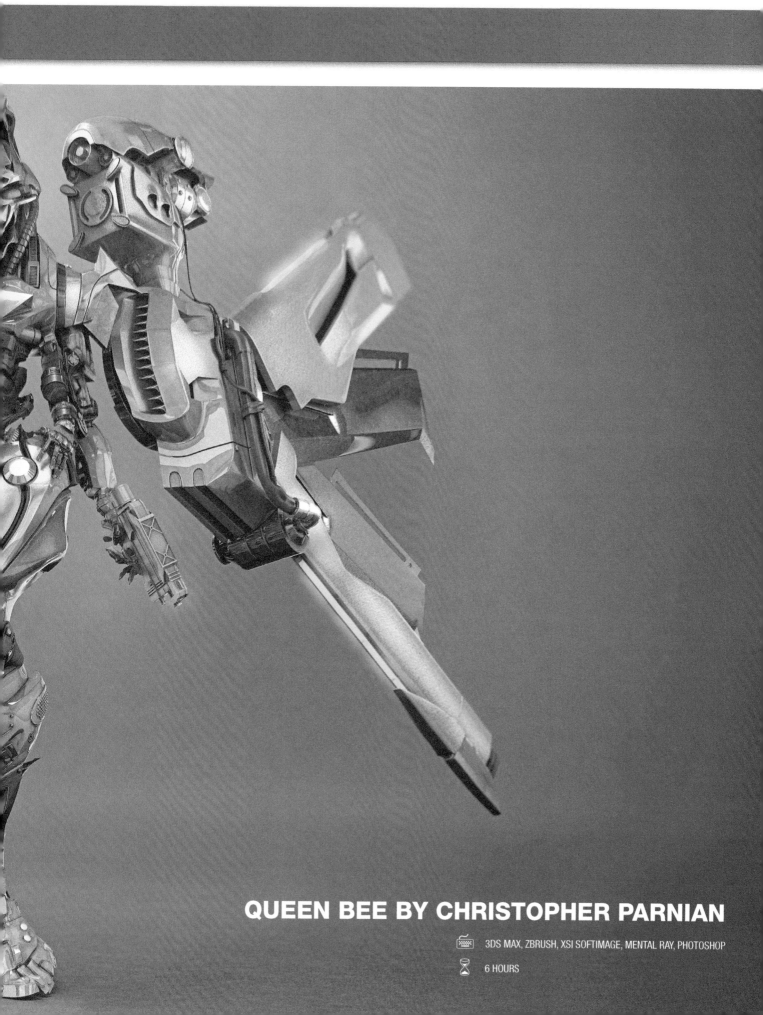

QUEEN BEE BY CHRISTOPHER PARNIAN

3DS MAX, ZBRUSH, XSI SOFTIMAGE, MENTAL RAY, PHOTOSHOP

6 HOURS

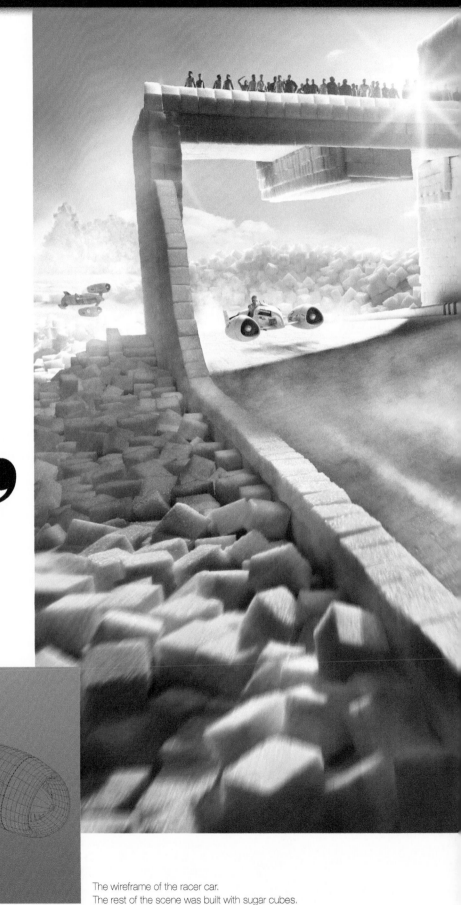

" The Racer A was developed by American artist Doug Chiang. He loves old race cars, so he simply took an old Autounion Bergrennwagen and switched the front and bottom end. I loved it the moment I saw it, so I decided to make it a special image using 3D, photography and sugar. The racing course itself is built of sugar cubes, we ended up using 46 pounds of sugar, because it reminded us of a snowy and icy landscape. The racer was created in CINEMA4D while the pilot was photographed – it was my assistant at the time, Johannes. We showed the image to Doug who liked what we had done with the concept. **"**

The wireframe of the racer car.
The rest of the scene was built with sugar cubes.

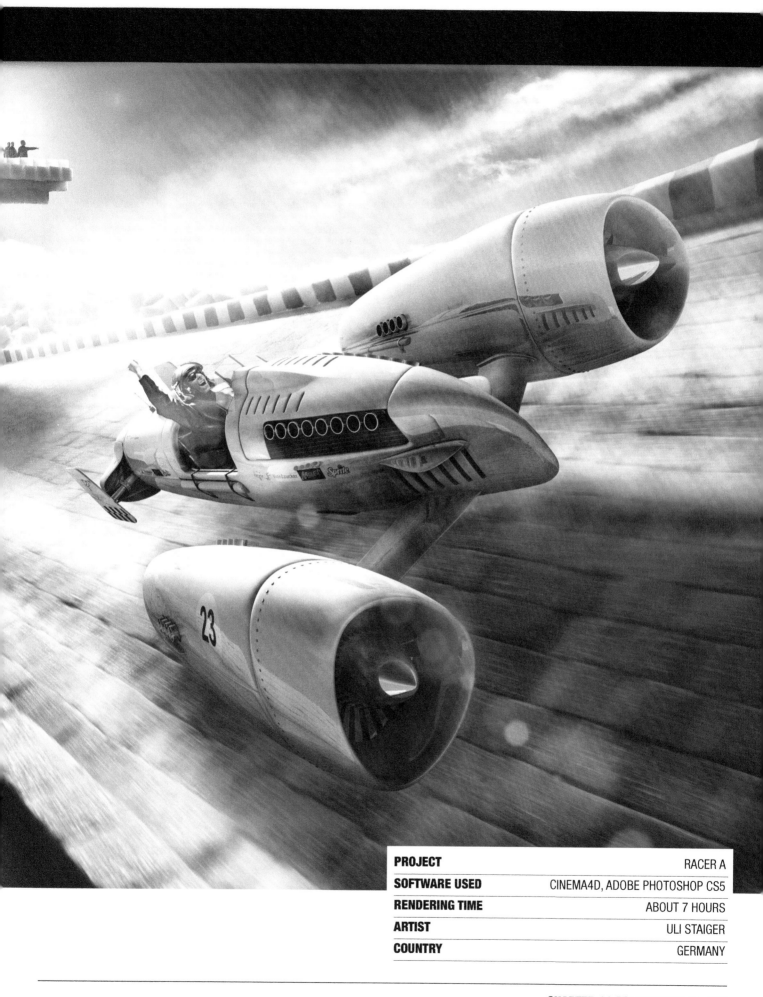

PROJECT	RACER A
SOFTWARE USED	CINEMA4D, ADOBE PHOTOSHOP CS5
RENDERING TIME	ABOUT 7 HOURS
ARTIST	ULI STAIGER
COUNTRY	GERMANY

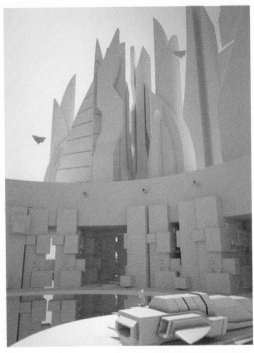

After some sketches I made this base 3D concept which shows the layout of the city.

PROJECT	CRATER CITY
SOFTWARE USED	3DS MAX, V-RAY, PHOTOSHOP
RENDERING TIME	3–4 HOURS
ARTIST	MACIEJ DRABIK
COUNTRY	POLAND

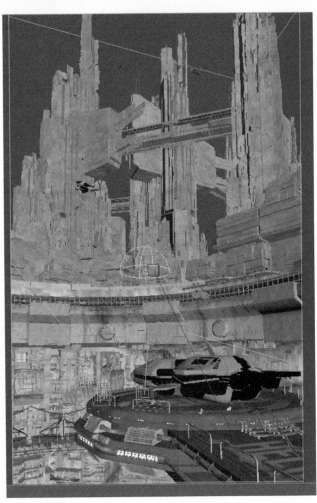

This is the final scene from inside 3ds Max, showing the completed model and lighting.

❝ I always want to create sci-fi environments that are somehow reflecting my vision of the future but also carry impressions of current events. In the comic book INCAL you can find futuristic cities that contain many levels and, as you can imagine, the lowest are for the poor and highest for the aristocracy. That was my main inspiration. Another inspiration was the beautiful works of Stefan Morrell. ❞

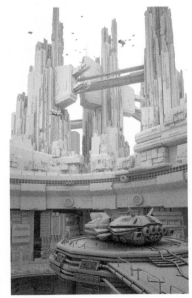

A clear model, or ambient occlusion pass, to show off the structure.

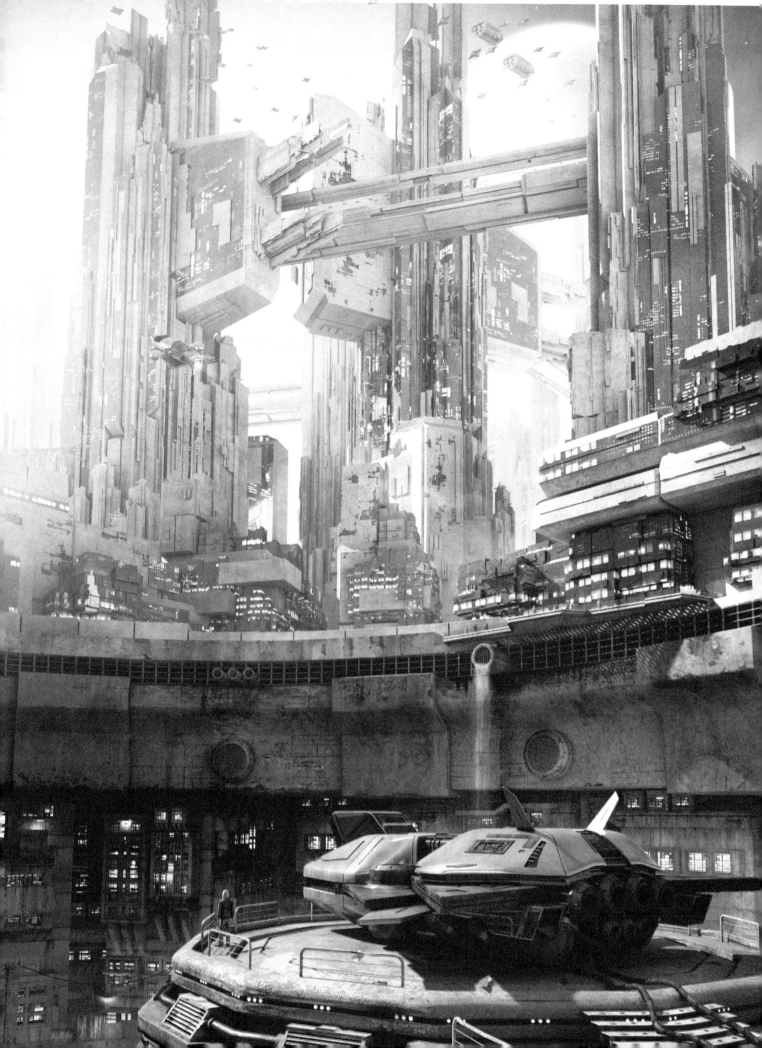

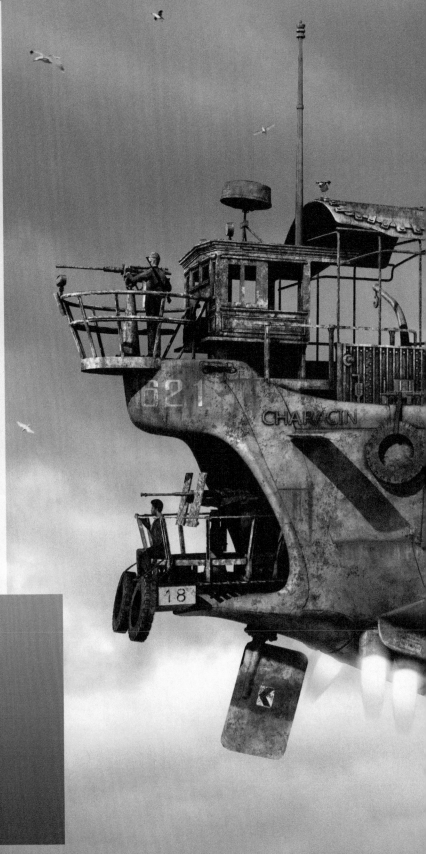

" This work is a 3D concept that I made for my personal portfolio, inspired by the amazing concept work of Ian McQue, http://mcqueconcept.blogspot.com and http://ian_mcque.cghub.com. In order to achieve the specific style of the concept that uses old junkyard pieces as building blocks, I used several parts from different 3D library models. They were then assembled together along with other parts made from scratch, to construct my concept ship. For the rendering in Softimage, I used multiple passes of colour information, shadows, speculars for the actual ship, the crew members and the seagulls. The final compositing was done in Photoshop, where I used the rendered passes, along with quite a few layer masks, heavily altered photographic bits from free online galleries and also some hand painting, to produce the final image. **"**

The airship concept being put together from third party models and custom-made elements.

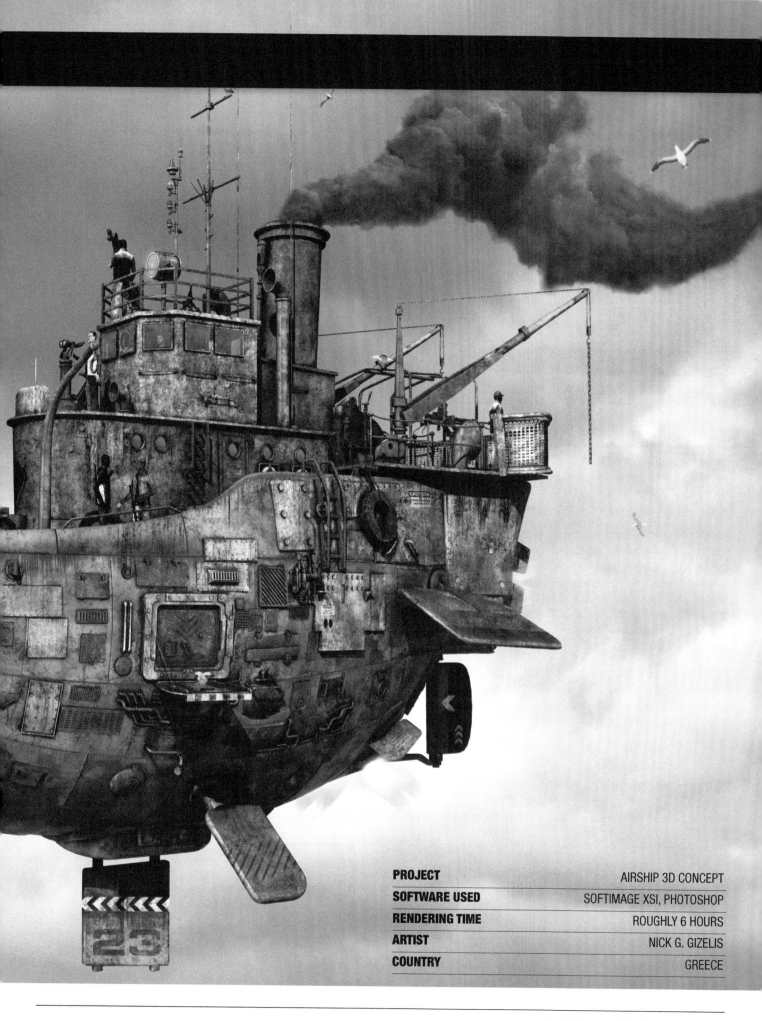

PROJECT	AIRSHIP 3D CONCEPT
SOFTWARE USED	SOFTIMAGE XSI, PHOTOSHOP
RENDERING TIME	ROUGHLY 6 HOURS
ARTIST	NICK G. GIZELIS
COUNTRY	GREECE

POST-APOCALYPTIC WARFARE

Michael Tshernjajew explains how he created a Mad Max-style fighting machine from the near-future

SETTING THE SCENE

This image is one of a series of ten that I wanted to make for personal use.

They were all to be set in a post-apocalyptical world. Usually I model cars and trucks from the former USSR and modify them so they fit into the world-theme that is being created. For this image I modelled the original GAZ66 truck first, including every little detail because I was not sure at the time that I wanted to make a Mad Max version out of it.

Finally I decided to build the post-apocalyptical version, with some modifications like guns, exhausts, cables and stuff like that. For the background I wanted to create a pile of trash, which is actually a wall that guards a base behind. The truck itself was part of that wall defence, more like a mobile watchtower, which could be moved. The scene takes place somewhere in a very hot region, under an old highway bridge, as the wall and base are coming under attack. That's why the gunfire is happening.

I didn't make any sketches of this piece, I just collected reference images via Google Search for blueprints of the original truck as well as some photographs. For the scene itself I had something in my mind as to how it should look.

**Outpost 2031
– final image.**

PROJECT	OUTPOST 2031
SOFTWARE USED	CINEMA4D, V-RAY FOR C4D, PHOTOSHOP
RENDERING TIME	5 HOURS
ARTIST	MICHAEL TSCHERNJAJEW
COUNTRY	GERMANY

The actual truck itself. My version would change this by adding weaponry and remodelling it.

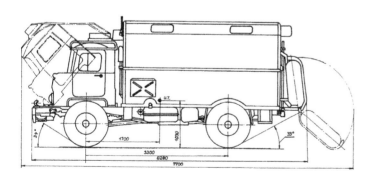

The blueprints for an old Soviet truck that was going to be the basis for the creation.

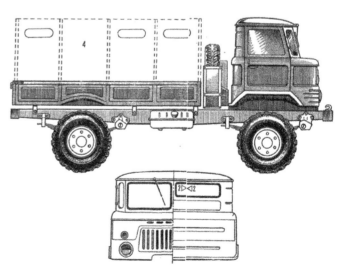

MODELLING THE TRUCK

I used polygon modelling within CINEMA4D to create the truck. For some parts I used C4D's Nurbs tools to create windows, lights and features like that. It's faster and more accurate and for the image it is not important how you created it. I started with the hood and checked everything against the reference images and blueprints, which are very handy in such projects.

Next was the easiest part of the truck, the back cabin, as this was a really simple object being just made out of a box object. When modelling, I always render nearly every step just check how the model will look like under render circumstances with light and shadow.

After the basic shape of the cabin was done I added all the detail elements like rivets, bolts and windows. I decided to make the rivets out of real objects, rather than paint them, because it would look better in the end. I used a symmetry object to make it quicker though.

Next thing I had to do was to model an undercarriage which was done in a very simple and basic fashion because you can't see it, it's just there to support everything else.

After that was done I tackled the wheels. They were made out of cylinder objects which were subdivided and then formed out properly. I cut off some of the polygons and used them as extra geometry for dirt spots. Once the wheels were complete they were positioned to show what the basic shape of the truck would look like.

The next step was the front including the cabin where the driver sits. This piece was actually the most time consuming because it is the most important part of the vehicle. So I started with the driver's door which was also made out of a box object and then later was smoothed with a subdivision surface. From one reference image I found on Wikipedia I decided to add some interesting details on the roof. As work progressed on the front end I decided to model in some details at the same time, like lights for example.

This was the first step in making the truck. I always start with the easiest part, so in this case it's the cabin.

Wireframe of the details being added to the hood to make it look more interesting.

A quick render to check how the shape was progressing. After each modelling stage this was done.

Close up of the hood with the complex details, checking for any faults.

After I made the wheels I positioned them for the first time to make sure the basic shape worked.

Almost done with the hood but still adding details like rivets, bolts, lights and features like that.

Next up were the bumpers and these varied from the blueprints because I wanted to create a custom look for them. They were formed out of a shape which I thought would look cool enough. That was it for the basic shape. For the post-apocalyptical version I needed to add some weaponry, grunge and to modify some parts.

I went through the process of adding and deleting features. The first thing I made were some more bumpers. In this case they came out of an old project and were part of a metal fence, so just like in real I added that part to the truck. I covered the windows with plates and made cage-like objects to guard the wheels. A ladder to reach the top of the cabin was added and then up there I created the anti-aircraft gun. This was made very quickly and is a really simple model as I wanted to focus on the truck.

I kept on adding more and more features, and deleting others, to take the model from a Soviet era truck to that near-future, sci-fi post-apocalypse version. Again nearly every step involved a quick render to check the results, after I was pleased with modelling.

The background of the image consisted of parts from old projects I decided to recycle and arrange for this scene, except for the bridge, which I had to build especially.

The transmission underneath has been added along with some extra details on the doors.

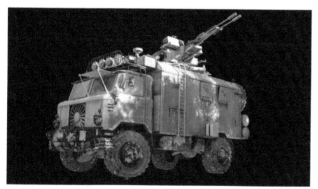

The very basic shape of the bridge without any of the dangling debris.

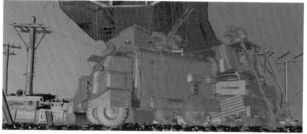

Basic arrangement of the scene with the bridge and the details in the background.

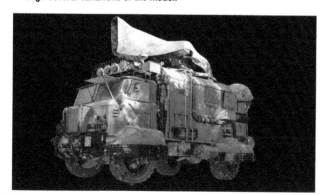

In the stage of adding and deleting stuff to the model, I went through several variations of the model.

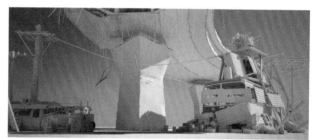

The entire scene with the armoured truck in it, in wireframe view.

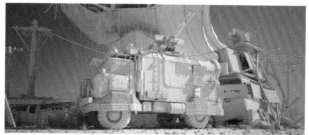

This version has a large covering for the gun, but it does start to look like a carpet so it was ditched.

A clay render of the whole scene so that the lighting could be used.

DIRTY TEXTURES AND DESERT PHOTOS

As mentioned earlier, originally it wasn't the plan to create a scene like this with the GAZ66 model. So, I initially textured it like the real model. I wanted to make it look really dirty as though it had been driving down a muddy road. The wheels were tackled first which were unwrapped properly and then a wheel texture was applied to the skin wall. Some real dirt was added to the surface and this worked well in the final render.

I went over the basic colour of the truck and created a simple shader with a slight glossiness and almost no reflection. As I did not want to unwrap all of the parts I decided to add the dirt and used-look textures as separated, layered textures. This meant making a few dripping, rust, dust and dirt textures which were modified within CINEMA4D and

stacked onto the specific parts. This was a very smart technique because I was able to move the stacked dirt on the model where I wanted without going back to Photoshop and change the whole UV map.

A lot of tests were run just to make sure the shaders would look cool enough. After I had a pleasing result the colour was changed from green to the rust-like colour seen on the model in the final image.

To make it more interesting I used Paul Everett's Grunge Shader plug-in but after testing it out, it was a little too grungy so I decided to make a mixture out of the Grunge Shader, the rendered version, and the one without.

Applying textures and shaders for
the first time on the model.

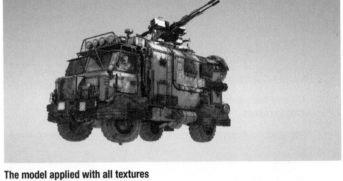

The model applied with all textures
and Paul Everett's grunge shader. It
worked fine, but in this case it was a
bit too much.

Then rendering it to see how those
textures looked when the lighting
was applied.

The two versions of the
textures mixed together
produced a more
pleasing result.

For the ground a simple dry desert photograph from cgtextures was used. That's where most of the other textures were from.

The ground plants, which were distributed with Surface Spread had the Surface Spread Grass Shader plus Clone Shader on them, so there was slight variation in the colour from one patch of grass to another. The trash in the background had some rust shaders on it which came out of my own database. Finally, a UV map was created for the bridge.

Adding some used old metal rust shaders to the pile of trash in the background.

USING THE SUNLIGHT

The lighting of this scene is not really complex as it used a V-Ray sun with a V-Ray sky, as well as an area light with a HDRI in it. It was really simple but it produced great and natural lighting. The default attributes of the sun were mainly kept but the Turbidity number was changed from 3 to 7 and the colour of the sun/sky system was made a little more of a warmer colour.

The sun added great shadows to the scene and the HDRI made it better by lightening them out. In this way you don't have disturbingly dark places and also get some nice reflections on significant shiny parts. What's important when using a sunlight, is the angle of the sun entering the scene. It affects the shadows, colour, nearly everything in the scene. So, it's important that you figure out what is the best angle for your scene.

In this image a very directional angle, which was not too sharp, was used so there were short shadows that didn't cover too much. As I wanted to make the environment quite dusty I first tried out VRayFog, but this resulted in very long render times, so I decided to do that in the post work instead.

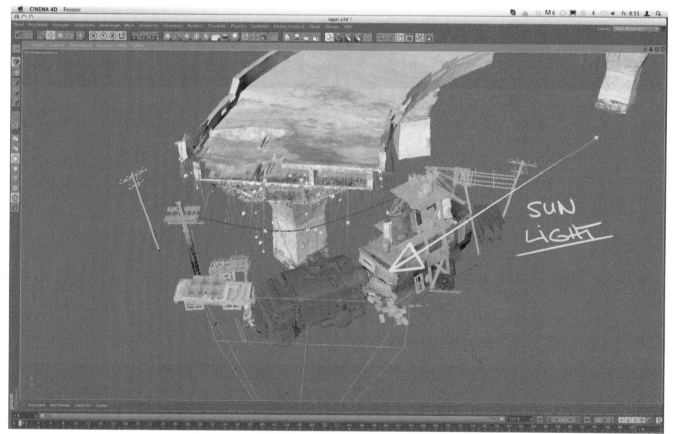

The basic scene with the lighting featuring sun light/directional light coming from the right.

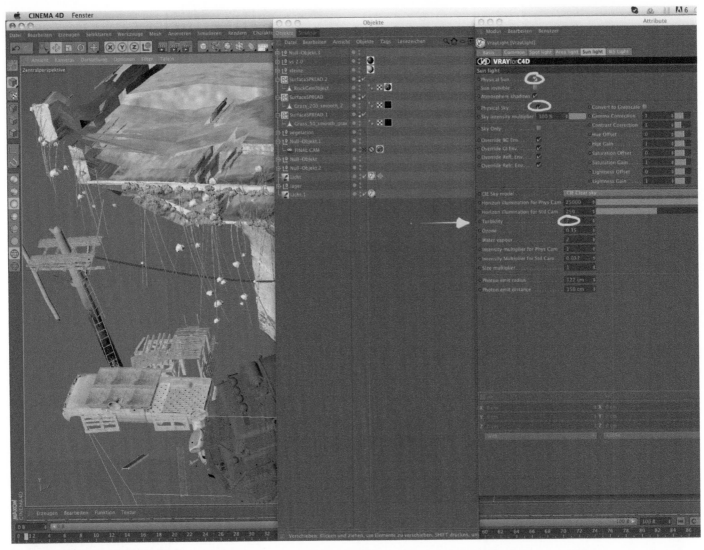

These were the sun/sky attributes, which
shows that they really used the default
attributes, except for the Turbidity.

Showing the angle
of the sunlight, and
the short shadows,
compared to the
rest of the scene.

MAIN RENDERING OPTIONS

For rendering I used VRayforC4D, which is my main render engine. For this image I used some of CINEMA's advanced render capabilities as well. To have better control over the final image the backgound and truck were rendered separately from each other. So, the background was rendered first with the truck invisible, but casting shadows, reflections and so on. Then the truck was rendered without the scene being visible.

For the render settings within VRayforC4D I used the most common Irradiance Map/Lightcache method. This produces great results.

Important for the scene was colour mapping and in this case I decided to use a "Reinhard" colour mapping with default attributes. Normally I use exponential colour mapping, but in this case Reinhard worked better.

For anti-aliasing an adaptive dmc without filtering and a dmc threshold were both used to get a nice clean result.

The colour mapping attributes where a Reinhard with default attributes was used.

The GI attributes with Irradiance/Lightcache which was mostly using default settings too.

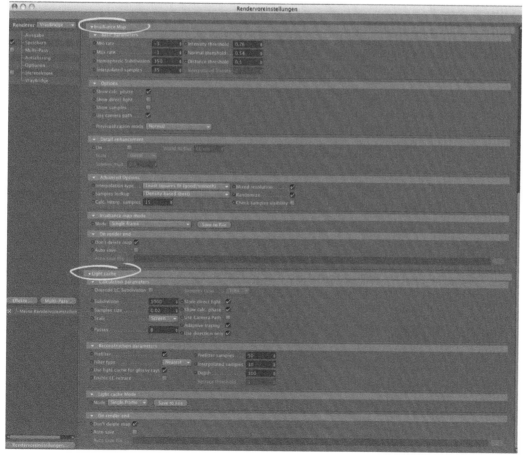

As I wanted to make a slight depth-of-field effect, I used CINEMA4D's Z-buffer render pass so that it would be possible to make the effect later in Photoshop. Also, an ambient occlusion pass was created to get a little more contrast in the end.

CINEMA4D's Z-depth pass rendered out for compositing later in Photoshop.

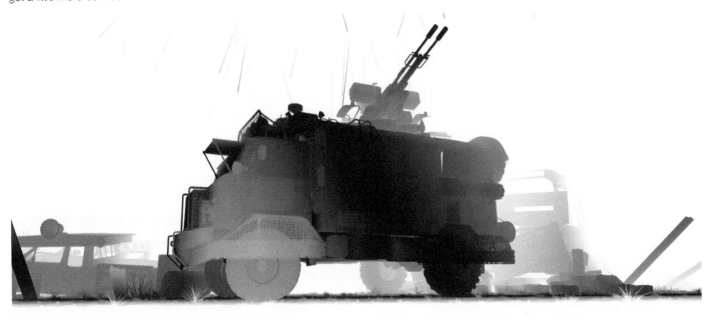

FINAL COMPOSITION

Composing was done in Photoshop where there were layers for the background, the truck, as well as some fog layers and a sky, which was composed in the background sky.

Almost everything was done with just an alpha channel and a Z-pass, which was rendered out with CINEMA4D renderer. A few smoke plumes were drawn on with the Photoshop brush and the Z-pass was used to fit them in. A second smoke layer with an inverted colour for the back of the background was created. There were two renders of

the truck, as mentioned before, that were then merged together. A soft brush eraser was used on some places of the grunge shader image so it looked like the truck was even more dirty and used, but more randomly.

For the gunfire, some images from web searches were cut out and placed on the scene. A colour ramp was added in Photoshop, over the entire image that made it look a bit faded out. In the end a scan of some dust particles was added on the final image.

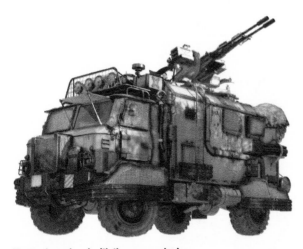

The truck rendered with the grunge shader which was a bit too severe.

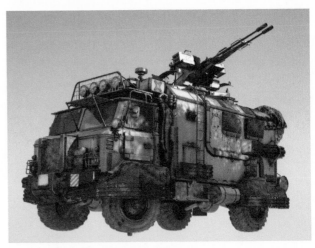

Then rendered again without grunge shader so the two could be combined.

The dust pass with the help
of the Z-pass which was
rendered out.

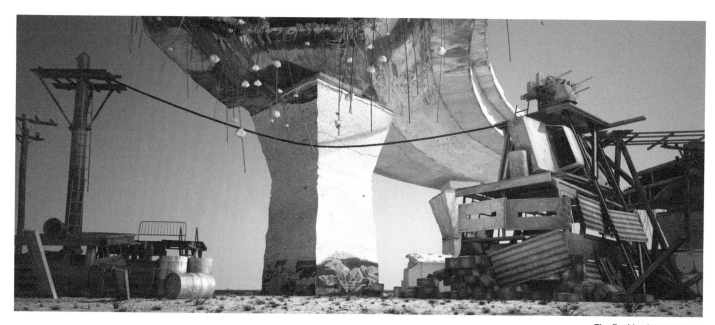

The final background pass
without any Photoshop work
carried out on it.

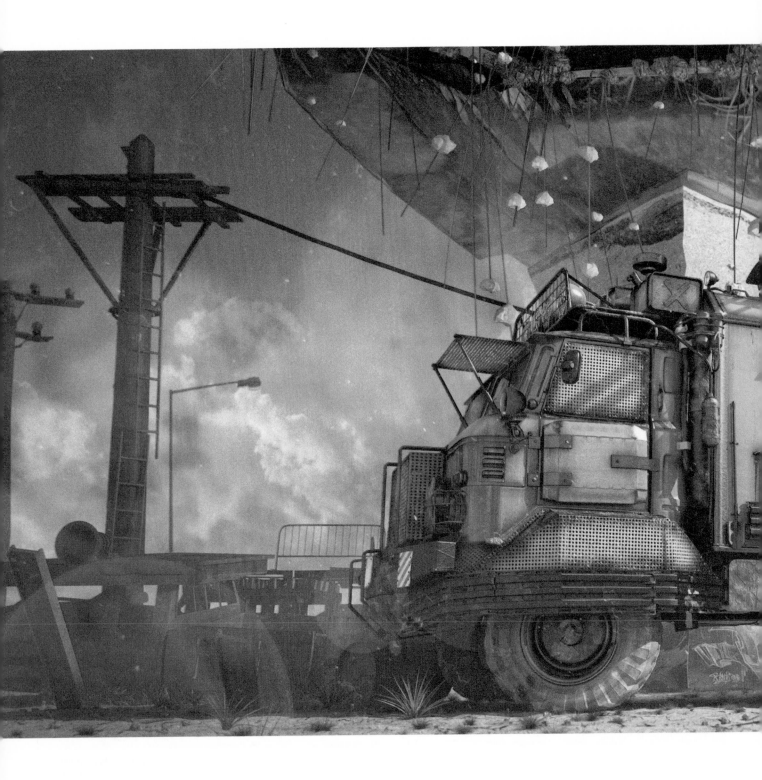

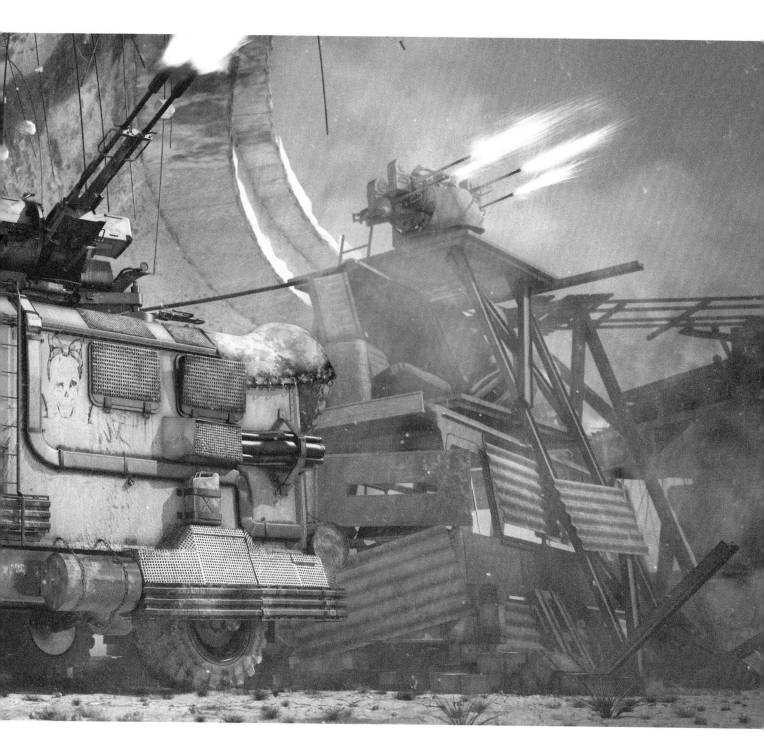

OUTPOST 2031 BY MICHAEL TSCHERNJAJEW

 CINEMA4D, VRAY FOR C4D, PHOTOSHOP

 5 HOURS

" For a long time I wanted to create a poster for my kids. To create something dreamy and fascinating, full of little things to discover. Something that could possibly push their pure minds to some direction in the future. To invent, build and explore. "

PROJECT	ROOFTOPS, ROCKETS AND ADVENTURES BEYOND
SOFTWARE USED	3DS MAX 2012, V-RAY 2.3, PHOTOSHOP
RENDERING TIME	RENDERED OVER NETWORK
ARTIST	MAREK DENKO
COUNTRY	SLOVAK REPUBLIC

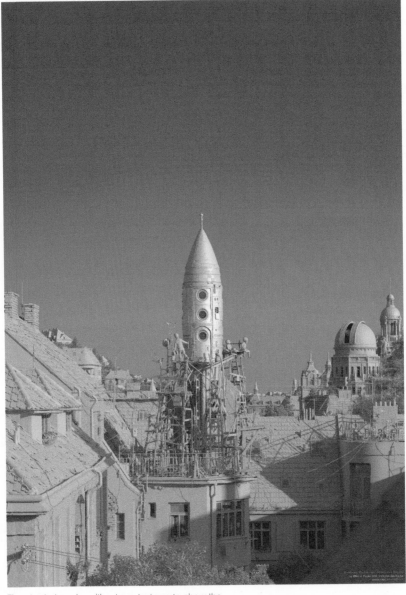

The shaded render without any textures to show the model in the foreground against the painted scenery.

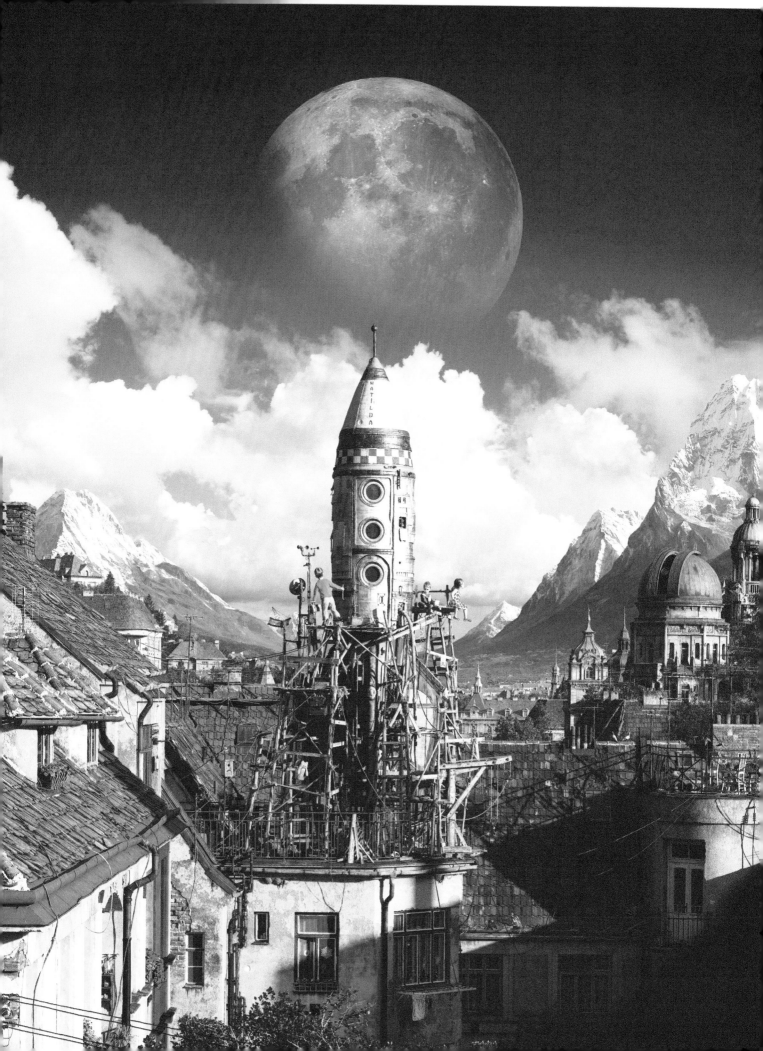

> This is a spaceship concept and layout design I did for the short film Audacia (http://www.imdb.com/title/tt2304493/). The director wanted a very big ship that sits over the city like in the movie District 9. For the ship design, I tried to mix up forms and volumes to depict a spacecraft that can go underwater as well as fly, hence the turtle-shaped final design.

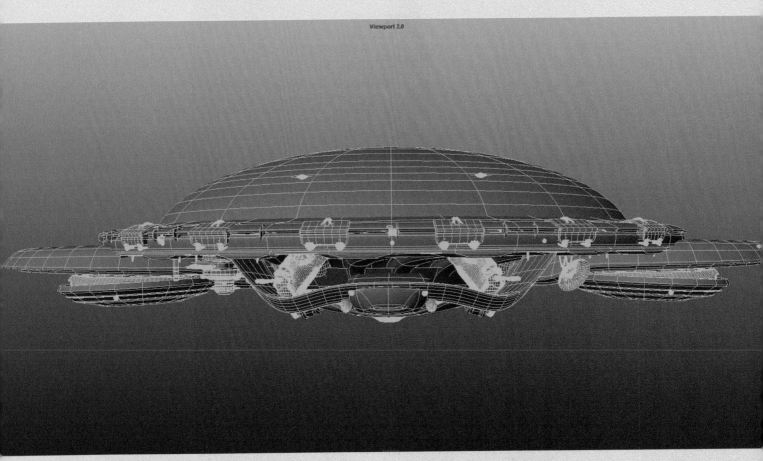

Viewport 2.0

Maya viewport showing a frontal
view of the ship's wireframe.
Work in progress.

PROJECT	SPACESHIP OVER MADRID
SOFTWARE USED	AUTODESK MAYA, ADOBE PHOTOSHOP
RENDERING TIME	UNKNOWN
ARTIST	FRAN SAA
COUNTRY	SPAIN

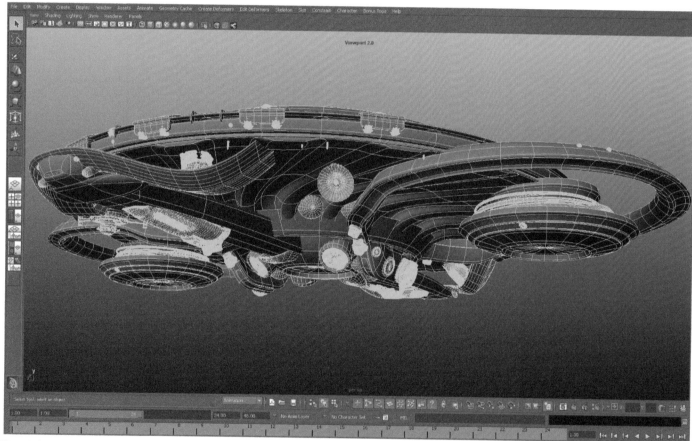

The wireframe of the ship, as seen from below, while it was still developing.

Post production tweaks in Photoshop with the image almost ready to be published.

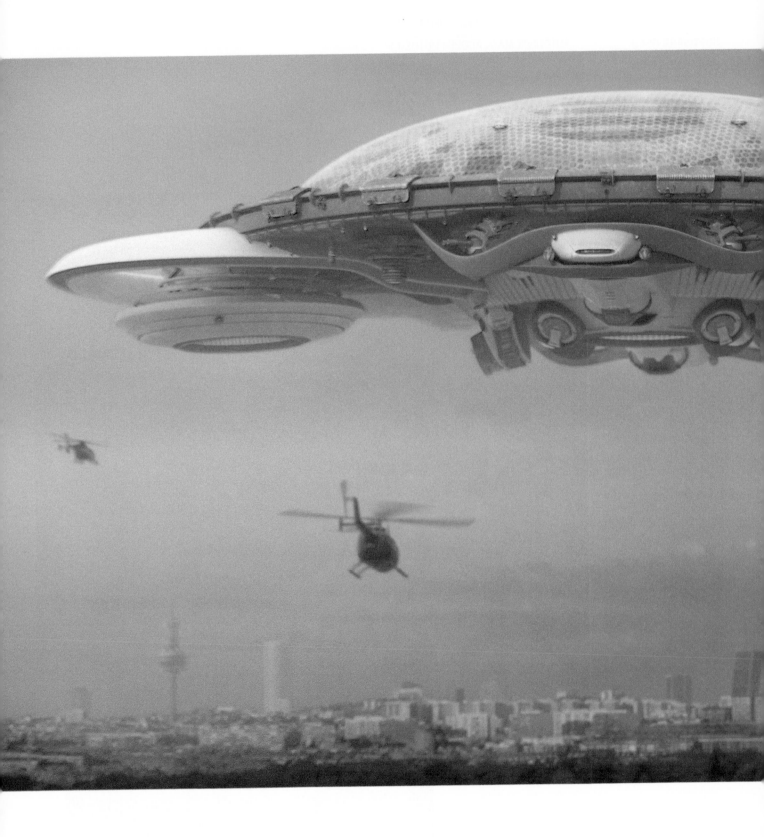

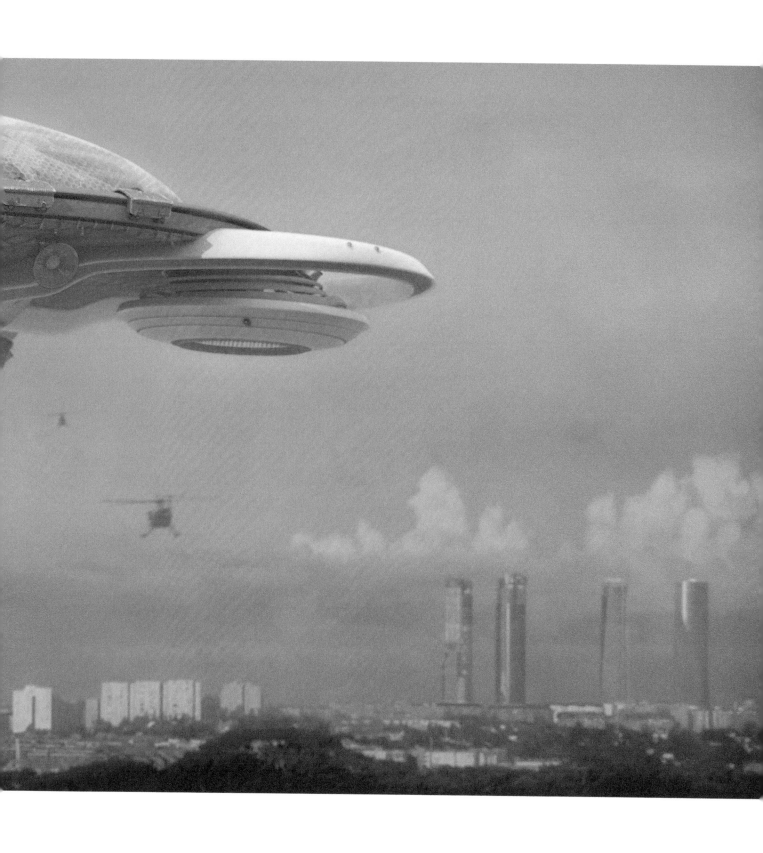

> **❝** The basic story is that of a control-vessel spaceship which is about to dock on a mining colony on an asteroid. I started with a short concept where I just put the general elements together. During the past year I had already created a huge library of 2D and 3D assets and some of them were used in this project. **❞**

PROJECT	MINING COLONY
SOFTWARE USED	3DS MAX 2010, PHOTOSHOP CS3
RENDERING TIME	ABOUT 10 HOURS
ARTIST	ALEXANDER PREUSS
COUNTRY	GERMANY

The background image without any of the models added.

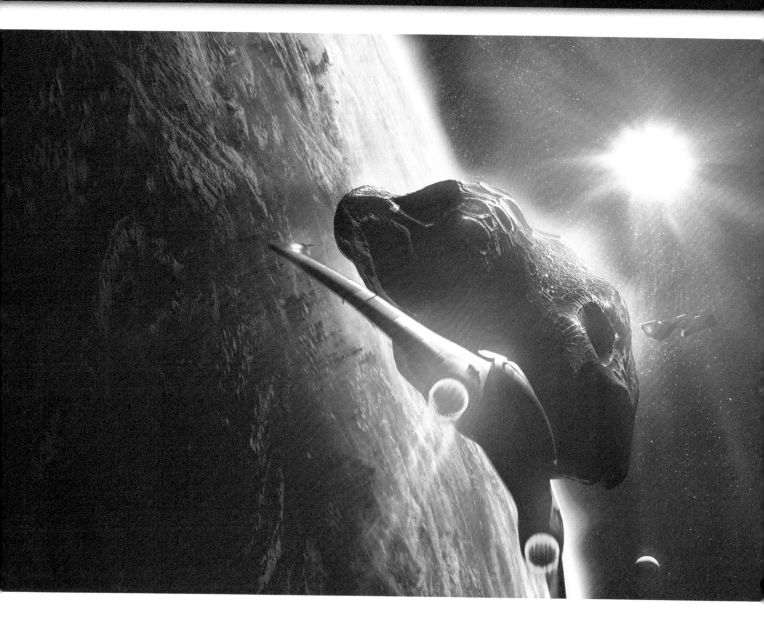

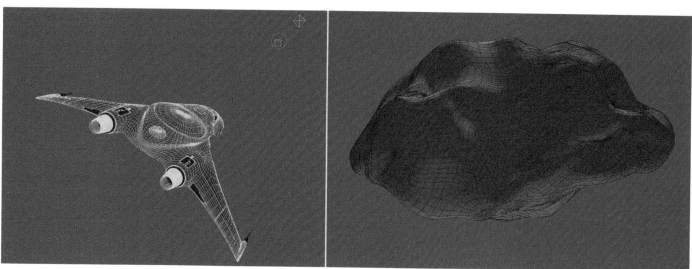

Some of the assets which had already been created during the year.

" The image was done to complete a series of two previous artworks themed on sci-fi terminals into space. I figured out that a massive terminal under the shape of an ULCC (Ultra Large Cargo Carrier) oil tanker would look pretty cool with a sci-fi spirit and background scene. While a space battle is taking place, the biggest cargo in space is there to refuel and refill the troops and spaceships at war. That's the back story. **"**

PROJECT	THE REFILLER CARGO TERMINAL
SOFTWARE USED	3DS MAX 10 AND PHOTOSHOP CS3
RENDERING TIME	10 MINUTES
ARTIST	SEBASTIEN HUE
COUNTRY	FRANCE

Modelling the various shapes for the surface detail of the cargo terminal.

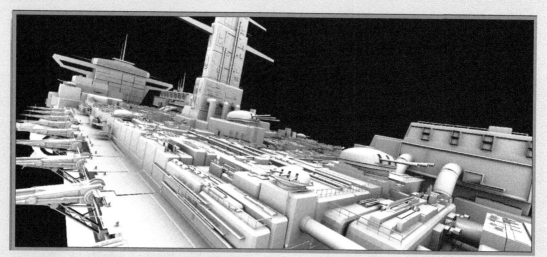

Checking out the lighting across
the station to ensure there were
no flaws in the model.

Adding textures now to
give it an oily and used
appearance, even on
the gun turrets.

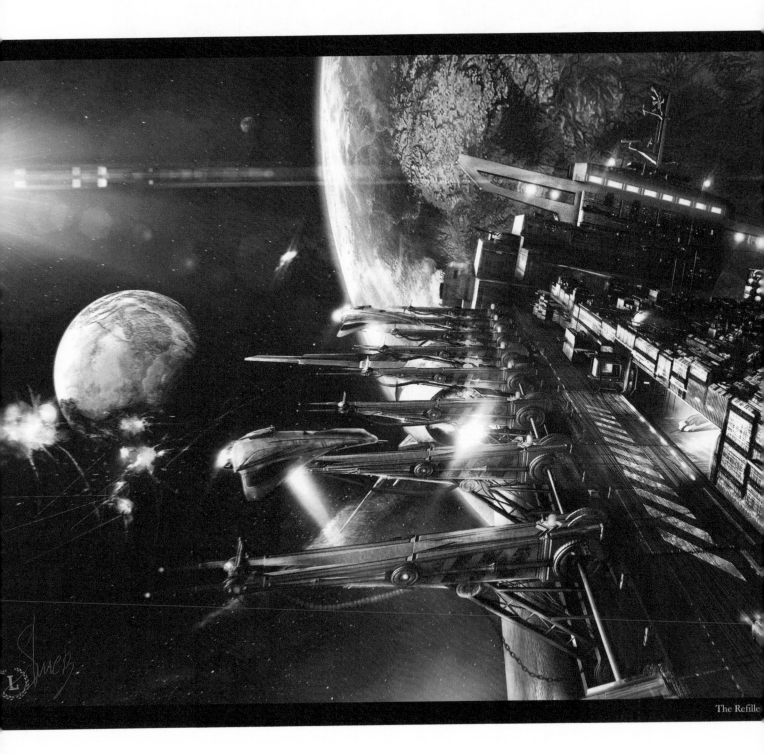

The Refille

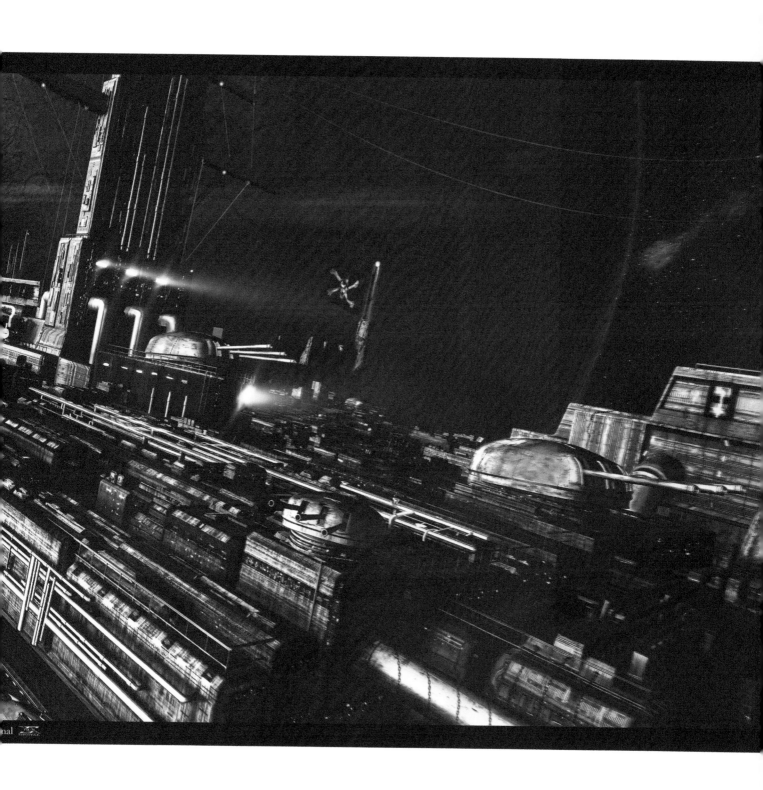

CREATING A HEAVILY ARMOURED SPACESHIP

Don Webster explains how he modelled and posed a massive scene based around a spaceship hangar.

SCI-FI MOVIE INFLUENCES

Like most creative people, outside influences often redirect my modelling and composition efforts. Looking forward to the release of the movie Prometheus, I realized that I never do space art or models, even though I have been moved by films like Blade Runner and more recently Avatar. Such realization often pushes me into a new direction to take on a challenge to understand both the themes necessary as well as the technical aspects of doing it. Here I had a challenge, and a desire, to do something a bit different from the current look in both visual composition and in the mechanical look of the 3D hardware, vehicles, spacecraft, etc.

I started out knowing that I wanted a massive scale to everything, more grit than shine and, as far as the main spacecraft, something that looked more organic with probes and feelers rather than windows, and large domes which, in a way, were large eyes. The final requirement was to model something that was not at all symmetrical. While basic structure on anything like this needs to be symmetrical, there was no reason for much of the exterior elements to follow suit.

I have never been one to sketch out what I am thinking. I work out in my mind the basic items I want for a composition, which in this case would be a mother ship. From there I would see what developed. In this case a gantry landing system and some type of transport.

PROJECT	NIGHT OPERATIONS
SOFTWARE USED	MODO 6.01, POSER PRO 12, VUE INFINITE 2014, PHOTOSHOP CS5
RENDERING TIME	6.7 HOURS
ARTIST	DON WEBSTER
COUNTRY	USA

Night Operations – final image.

STEP 1
LARGE SHIP DESIGN THEME

My design was to be based on crustaceans, sea life that had
flexible armour, arms and tentacles. I didn't just want light
probes like in Close Encounters, but projections that had
secondary arms and feelers at angles to the main arm, looking
as though they were reaching out.

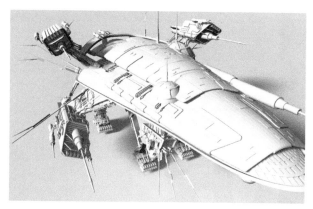

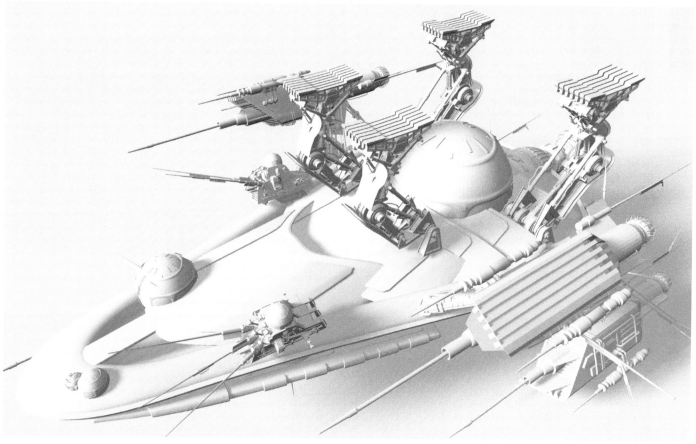

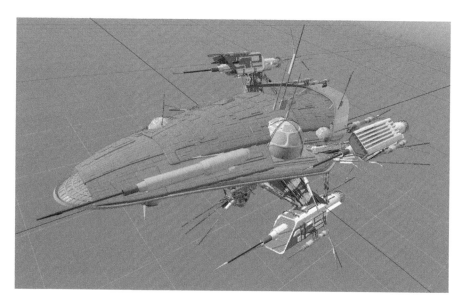

STEP 2
COLOUR TAGGING FOR
VUE PROCEDURAL TEXTURES

Since there would be some elements that were duplicates
I colour tagged, or UV'd, them, then duplicated them to
save time. Here the engine and support arms were mirror
duplicated for the four positions. UV'd texture mapping
in Modo provided many of the textures, but some of the
smaller items and especially the domes benefitted from Vue's
procedural materials.

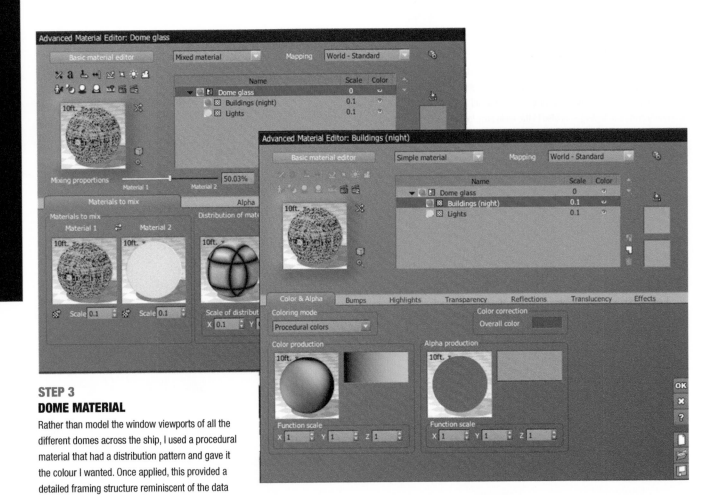

STEP 3
DOME MATERIAL

Rather than model the window viewports of all the different domes across the ship, I used a procedural material that had a distribution pattern and gave it the colour I wanted. Once applied, this provided a detailed framing structure reminiscent of the data structure visuals in the movie, The Matrix.

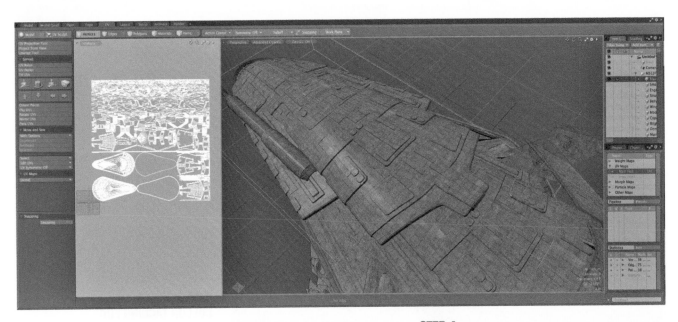

STEP 4
HULL UV

Modo has a very easy UV system and where possible I keep it in their Atlas projection. Here Modo has cut up the selected structure and laid out the main top and bottom surfaces for a horizontal alignment. The smaller elements are just too small to worry about, even for some of the close ups. Scaling is all that is necessary.

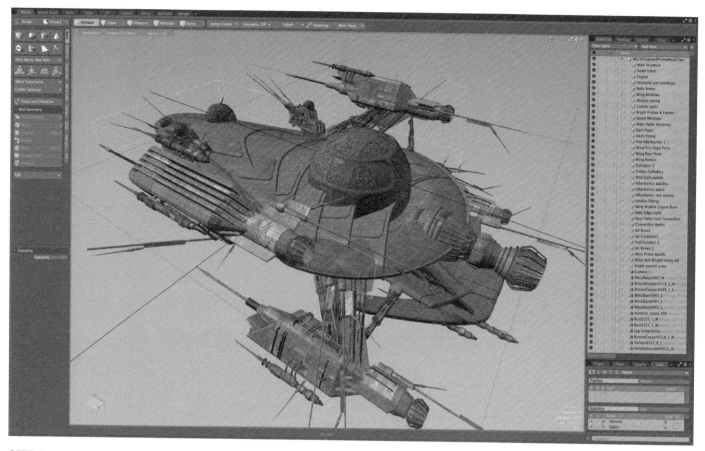

STEP 5
HULL TEXTURING

Main surfaces textures were run throughout the individual object meshes to check everything out before saving and exporting as obj format files, which I then used in Vue. It also allowed me to check structures that need to be further divided up for UV or colour tagging for even more material diversity.

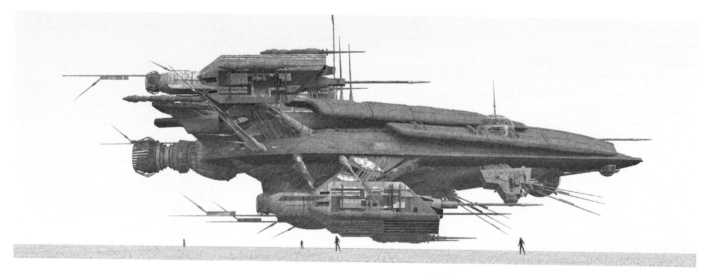

STEP 6
AN INFLUENCING VIEW

Importing the obj into Vue and taking a quick side view look, I imported a few Poser based obj figures and played with the scale. Intrigued with the size and look, I decided that I liked the potential of a composition that shows figures like this in a ground related view. The problem was that it wasn't just going to float there.

STEP 7
TEXTURING LANDING LEGS

What was needed was a massive landing gear system to support such a structure. This became the fun part of the project with lots of hydraulics, pistons, cables and heavy feet. While the two shields were UV'd in Modo, the rest used Vue's procedural materials.

STEP 8
BENEFITS OF VUE'S PROCEDURAL MATERIALS

I found that one of the main benefits of Vue with an object like this was the procedural materials and the ability to quickly and interactively mix to create just the metal look that I want. I could have a vertical piston start out at its highest points clean and then evolve to a greasier chrome at lower levels.

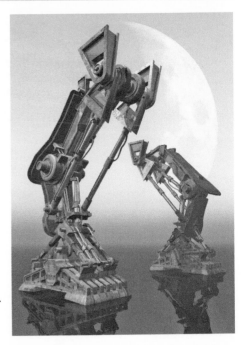

STEP 9
WORKING GEAR

Having achieved the results I wanted with the landing gear, I had to accept that I wasn't able, nor really wanted, to go back and incorporate it into the main ship for any inflight operations. Cheating really, I just told myself that should I do a flight composition, I would simply leave them out.

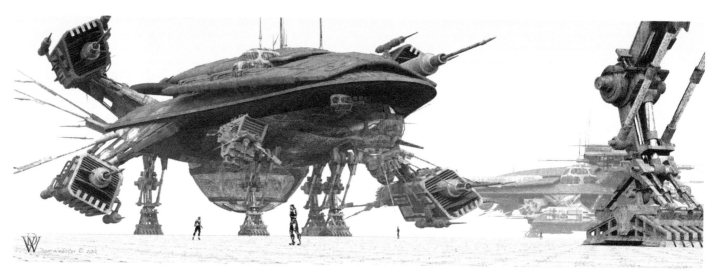

STEP 10
FORMING AN IDEA

Positioning several duplicates of the ship and the landing gear, to include one gear in the foreground along with the figures, I sensed a possible final composition. The background could have been some troubled sky, a distant planet but I decided that this might be too distracting, yet I wanted some type of texture in the background.

STEP 11
LAUNCHING TOWERS

My decision was to make a gantry or launch pad facility that would be appropriate and yet be nothing more than the texture pattern of horizontal, vertical and diagonal polygons. Looking at any of the gantries from our space programme, the structure was easy to make and build up by duplicating simple box structures.

STEP 12
TEXTURED ELEMENTS

A simple, one-texture UV in Modo Atlas projection and with all elements aligned in a horizontal, packing the gantry, was just what I wanted. Should I have needed to bring it out more in the composition I could easily have added lights to both the spires and the interior and let the shadows do the rest.

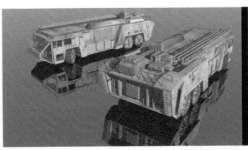

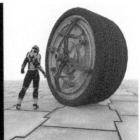

STEP 13
A TRANSPORTER

With these two models positioned, it seemed only natural that some type of transport would be necessary. I decided on something not unlike what we have today as emergency vehicles at our airports. Large enough to carry workers while still having flame-fighting hose systems and pumps on the roof plus emergency lighting floods and a wheel/ tire system to carry such a large vehicle.

STEP 14
WHAT SIZE

From the rear the model was quite large compared to a human, and you can see this in the ladders. But from the front I decided to make it look more in scale with a figure and felt that if I needed to keep the large scale it would show a two-level cockpit cabin.

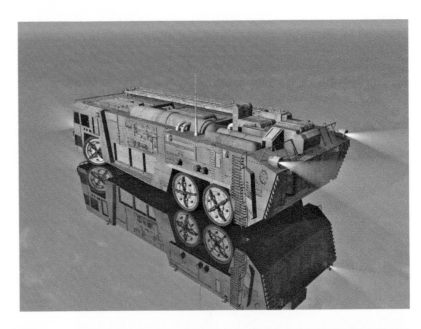

STEP 15
TEXTURING A TRANSPORT

I also decided that I liked the firefighting and emergency equipment of today and the vehicle would be in better shape, and looked after, in the atmosphere of far-away planets While weathered, it still remained a viable transporter and emergency vehicle with fire extension piping and tanks on the roof.

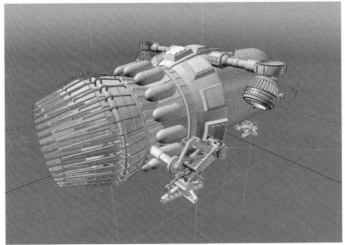

STEP 16
NEED A SMALLER RECON SPEEDSTER

After considering ground transportation and distant travel spacecraft, what about those short trips and recon patrols? I decided to make a small, one-person craft that was basically a glass dome with a big engine. Happy with my landing gear, I took elements from it for the small craft tri-landing gear. The engine was made up of elements from the main ship.

STEP 17
INSECT-LIKE WITH A BIG MOTOR

Knowing that this would be something that I wanted to have in flight in future work, I developed the gear in a folded up position, modelled the hatch open and closed and provided a step up system. Happy with the look and the potential for close ups, I jumped into modelling a seating position with monitors for a pilot control system.

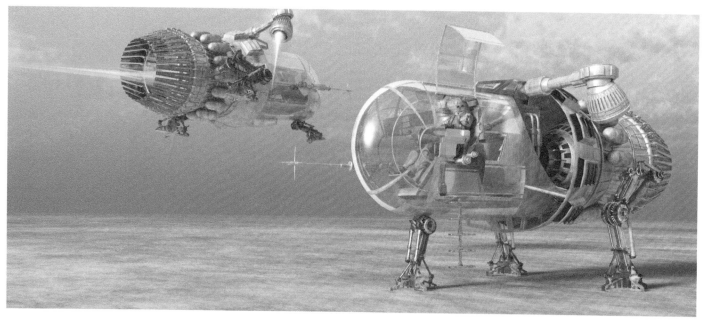

STEP 18
DID I GO OVERBOARD?

With a figure in the seat and taking advantage of the wonderful metal procedurals of Vue, I think I might have gotten carried away as I took a bit of a side-step in developing this one model. Playing around with POV from inside the cockpit I started to envision scenes from inside, looking out at the main ship. Then I decided to save that for another day.

STEP 19
JUST COULDN'T WALK AWAY

One thing that stopped that side journey was the fact that such a wide view to capture a small cockpit would also distance the main landing pad scene. Also, which one would be the main focus? Well, this was a problem to solve for another day, but intriguing anyway.

STEP 20
HUMAN FIGURES FOR SCALE

While I need figures and even a few cyborgs for the composition, I did not take a lot of time working this out in PoserPro. A single female figure was duplicated and repositioned to group together in a pairing of three and I had what I needed as they would be very small figures on the canvas.

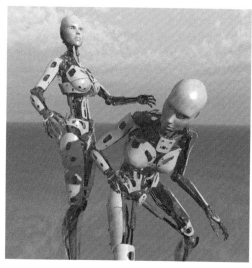

STEP 21
CYBORG MODELS

The cyborgs were another PoserPro asset that I did decide to make a bit more posed since I wanted to make them much taller than the humans. I've had some friends tell me that it wasn't appropriate to have them larger, but I thought that with vehicles as large as this, mechanics would need to be larger and stronger to be useful. There was a cyborg leaning over as it listened to a group of humans in discussion.

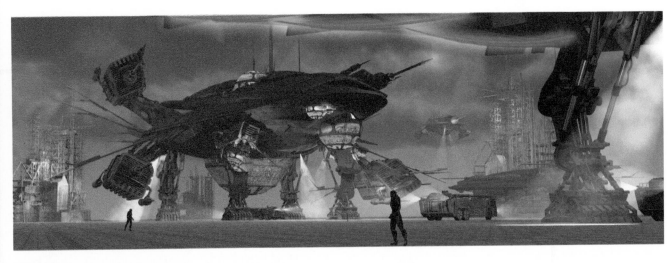

STEP 22
INITIAL LAYOUT RENDER

While the composition was incomplete, a test render showed me that the basic framing was okay, but there was no, one focal point of interest. Also the glowing red underbelly lights of the main foreground ship were distracting. The gantries were too small and well defined with lights.

STEP 23
CHANGING COMPOSITION

In this side view you can see that I have moved both gantries, and also changed their sizes, disregarding world scale. In my camera view I simply moved, scaled and positioned the POV I wanted regardless. I changed some of the textures, like the glowing red strip lights, and added all the figures and the Recon Speedster.

STEP 24
PREVIEW RENDERS

Even with the confusion of all the light sources, the composition was looking better and the focus was on the main ship. It was time for a full render. I already knew that this would take about 6–7 hours at 4800 px wide size. I print my own Giclee canvas prints, usually at 40 inches wide, and some have taken as long as 67 hours.

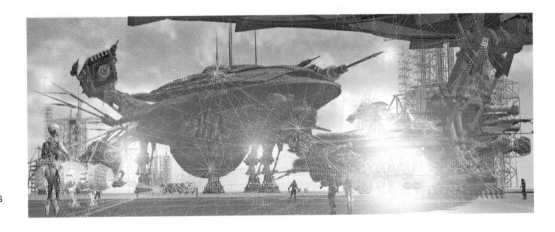

STEP 25
MASTER RENDER WITHOUT RELIGHTING

With 56 lights, this render might have been surprising, but my process was to just position lights and do all the lighting in Vue's relighting Post panel. The render complete, I saved as a tiff and then saved the atmospherics mask as a separate tiff file. I then stacked the colour image into the Vue system for retrieval later if required.

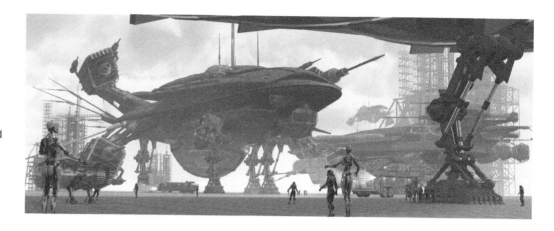

STEP 26
USING A SKY MASK

Saving the sky mask allowed me to make changes to it independently of the rest of the image. I often adjusted it, as well as added additional 2D elements to my background sky.

STEP 27
RELIGHTING THE SCENE

Relighting is one of the joys of Vue. It allowed me to place any number of potential light sources in the composition adding to the overall composition potential of any given work down the road. Once rendered, I could then go into a dark scene as it were and start turning on these lights as a lighting director would on a sound stage.

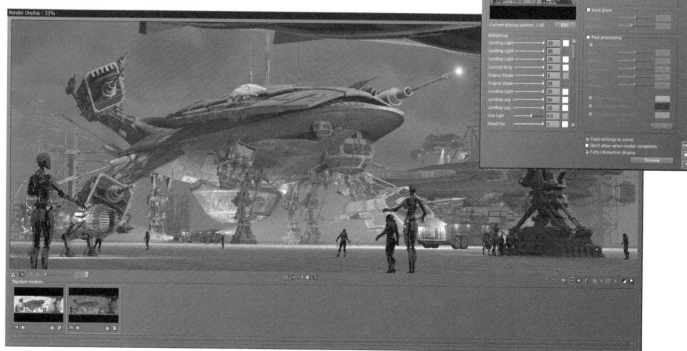

STEP 28
ADJUSTING THE SKY

With the relighting adjusted as desired and a full version saved in a Vue stack that I could come back to, I moved over to Photoshop where I imported the colour tiff and the mask, and then used the mask to cut out the sky into another layer. I made additional further contrast and selective colour changes.

STEP 29
RE-RENDER SELECTED ELEMENTS

Wanting the landing gear and figures in the foreground to stand out a bit more, I went back to Vue and did a selective object render of those elements and saved it as a tiff, which was then added to the Photoshop layers. This also allowed me to do a few paint things to the image behind these elements.

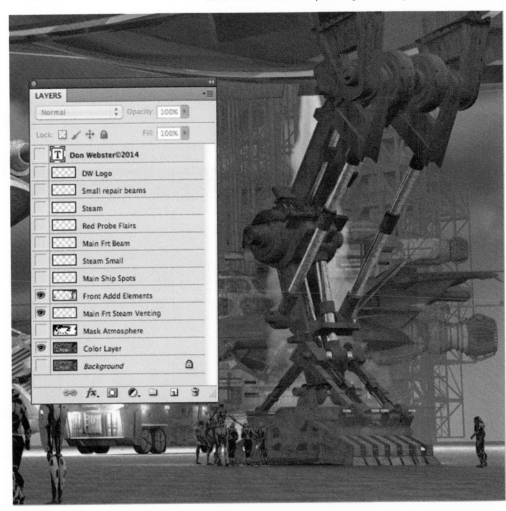

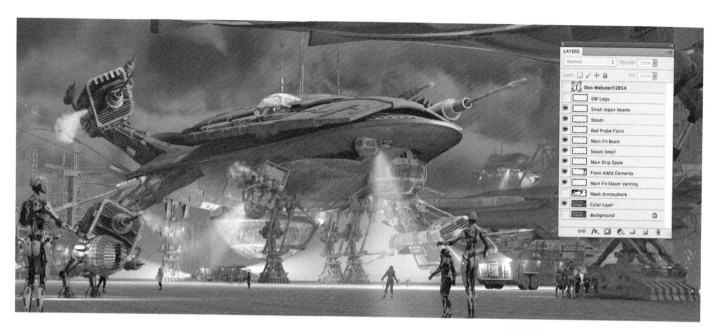

STEP 30
PHOTOSHOP ADJUSTMENTS

Using Photoshop steam and light-beam brushes, I was able to scale, add and adjust each in their own individual layer where necessary. The overall look was the one I wanted, with the main focus on the mother ship, framed and showing the large scale of the objects against the human-world scale.

THE ADVANTAGE

I cannot say enough about the advantages that Vue's latest offering provides by having the ability to relight a scene after the render. Returning to a stacked render, the look of a scene can be changed beyond even just day or night to match whatever mood or highlight was required. A simple change of POV is all that is needed to develop a new look.

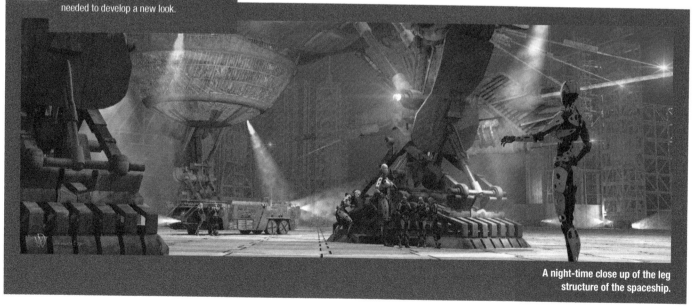

A night-time close up of the leg structure of the spaceship.

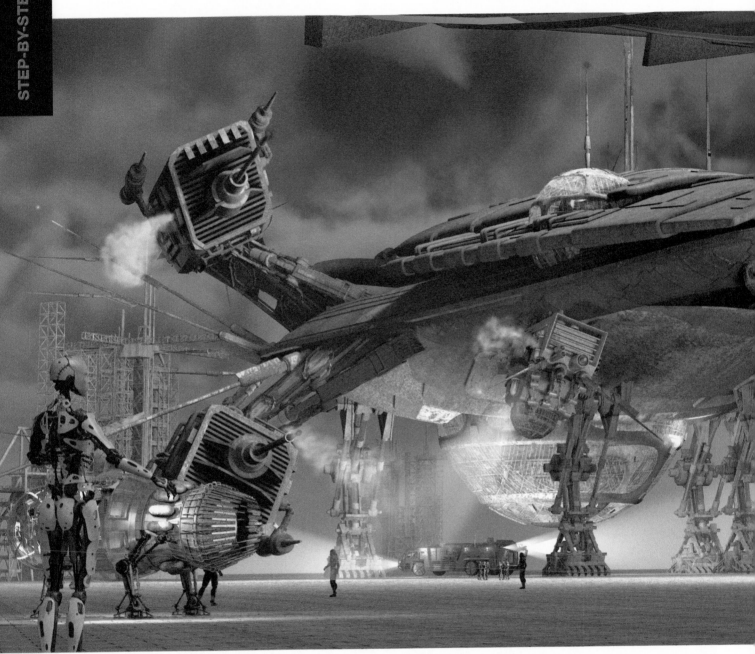

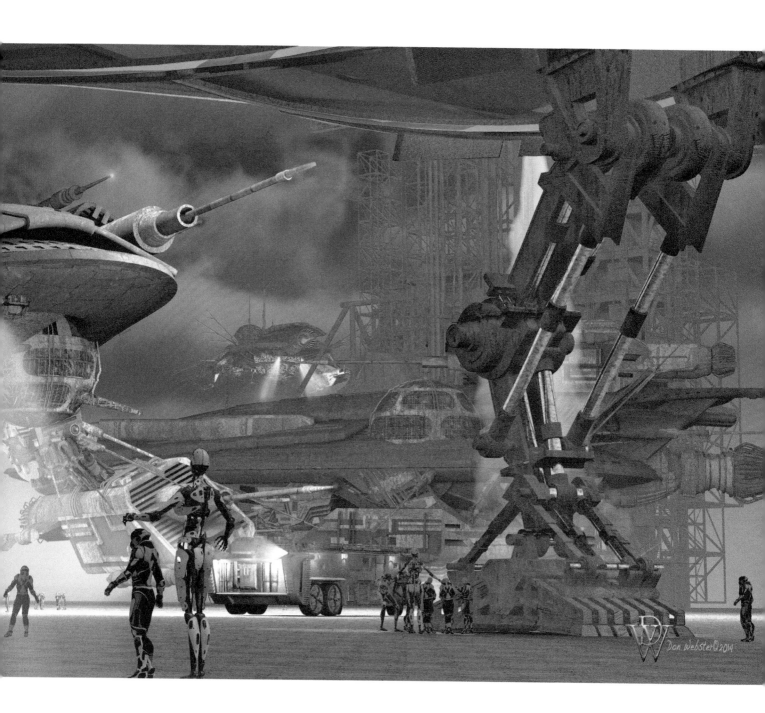

NIGHT OPERATIONS BY DON WEBSTER

 MODO 6.01, POSER PRO 12, VUE INFINITE 2014, PHOTOSHOP CS5

 6.7 HOURS

SECTION 3: POST PRODUCTION EDITING

Whether you use Photoshop or After Effects to composite various render passes, have different layers so you can add specific effects, or just use the post production process to improve the final image, the image straight out of the render engine is rarely the final result. In this chapter we take a look at some of the processes worth looking at as post production options, starting with adding speed to the image. Then there's a discussion on reducing the amount of depth-of-field and throwing in some old-school film effects to make it look less digital. Finally, there are practical considerations of image resolution and colour profile appropriate for the target platform and end use.

USING SPEED

Make your images more dynamic by adding a sense of motion

Although software packages like Maya include shutter speed as part of the camera settings, for the most part, unless you are creating an animation, this doesn't have the effect on the image that shutter speed does in photography. For a start, the image is completely static, no matter where you put the camera or what settings you use. In reality, taking images of aeroplanes or any moving ground-based vehicle uses the shutter speed to decide what the final image will look like. There are two basic methods of capturing a moving object against the background. The first is to use a fast enough shutter speed so that the scene appears to be completely still. This is, in effect, what you get when you render an image. In airborne photography, the camera is usually fixed to another plane and is moving at a similar speed to the target. The result then is that the other aircraft appears sharp and in focus but the background is blurred because it is moving underneath. You can also do this in car photography by having the camera mounted on another car to take the shot, but car photos are usually created using the second technique outlined further on. To create this first style in a 3D image is easy, especially if the aircraft and the background are rendered on separate layers. You can then simply use motion blur on the background while leaving the vehicle static.

The other way of creating motion in the image relates to car photography, but it is applicable to any moving ground vehicle. In photography it's called a tracking or panning shot where the camera focuses on the vehicle as it passes, or to be specific, it's pre-focussed on the area where the car will pass through. A longer shutter speed than normal is used and as the car passes in front of the camera, the camera is panned with it, maintaining focus on the same point on the car throughout the slightly longer exposure. It's a tricky technique to get right but the end result is that the background is blurred, the car remains mainly in focus but the wheels, because they are rotating throughout the exposure, are also blurred. If you are going to replicate this technique, then again, rendering on separate layers makes life a lot easier. So then, as well as using motion blur on the background, a radial blur needs to be used on the wheels. Also, it should be noted that, usually, not all of the car remains in focus. It's important to get the front to stay in as much focus as possible, so the back end can often have a slight blur as well.

ADD MOTION BLUR

Above: here the three steampunk ships were rendered on a separate layer from the background to make it easier to add motion.

The background used directional
motion blue while the ships had a small
amount of movement added to their
rear ends.

The final image looks much more
dynamic with a definite sense of
movement and speed.

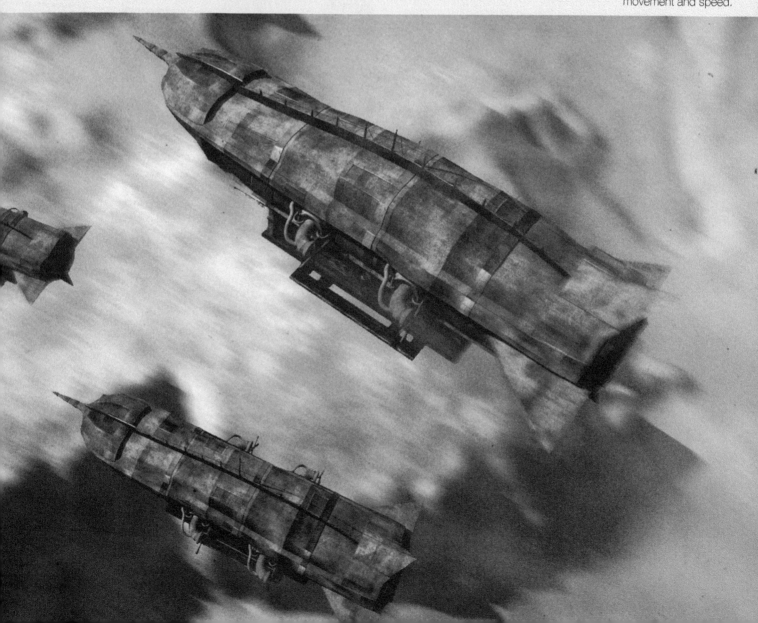

EFFECTS OF DEPTH

How you depict the amount of depth in a scene determines what the viewer focuses on.

Depth-of-field was discussed in the pre-viz section and having considered the effects of using it, you should have chosen your camera lens accordingly. However, there are times when you might want to look at an older image and see what it would look like with a shallow depth-of-field, without having to spend the time rendering it out again, if you can actually find the scene files. Or, you might want to render an image with plenty of d-o-f but have the option for a quick and easy post production process to blur the background. The other consideration is that you might not actually like the Bokeh effect – the blurred background – that the software lens produces and doing it in software might give a better or more pleasing result. So the question then becomes one of what is the easiest and quickest way to create a shallow d-o-f, as a post production process.

The easiest way to do it is to also output a Z-depth layer or map when rendering the image. As the scene is obviously 3D, the Z-depth can be used as a mask in photo editing software. Apply a blur of your choice and use the mask to limit where the blur effect appears. Obviously there's one shortcoming to this. The depth map goes from front to back and isn't a depth-of-field map where something in the foreground can be just as out of focus as something in the background. As long as your machine is in the foreground though, this is a quick way of achieving shallow d-o-f. Otherwise you're faced with either using multiple rendered layers of different parts of the scene, or, if it's all one image, then marking out objects and placing them on separate layers or using lots of masks. On a complex image it will undoubtedly be easier and quicker to just go back and render it again with a different camera lens setting – assuming you still have the scene file of course.

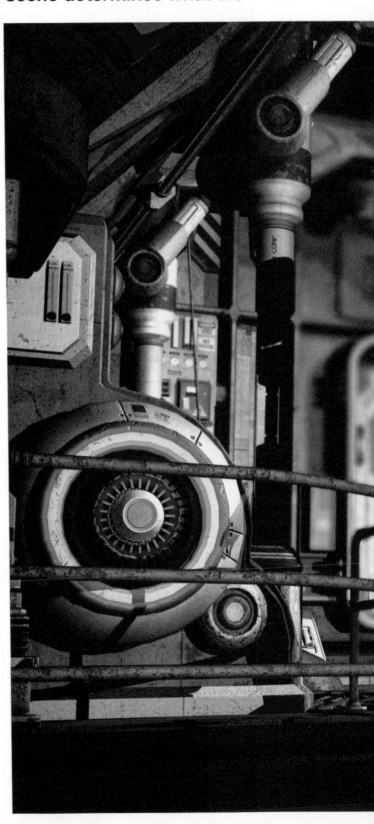

Here Topaz Labs Lens Effects was used to create a depth map for a Bokeh filter that was then applied to the finished image. The original image was sharp all the way to the back.

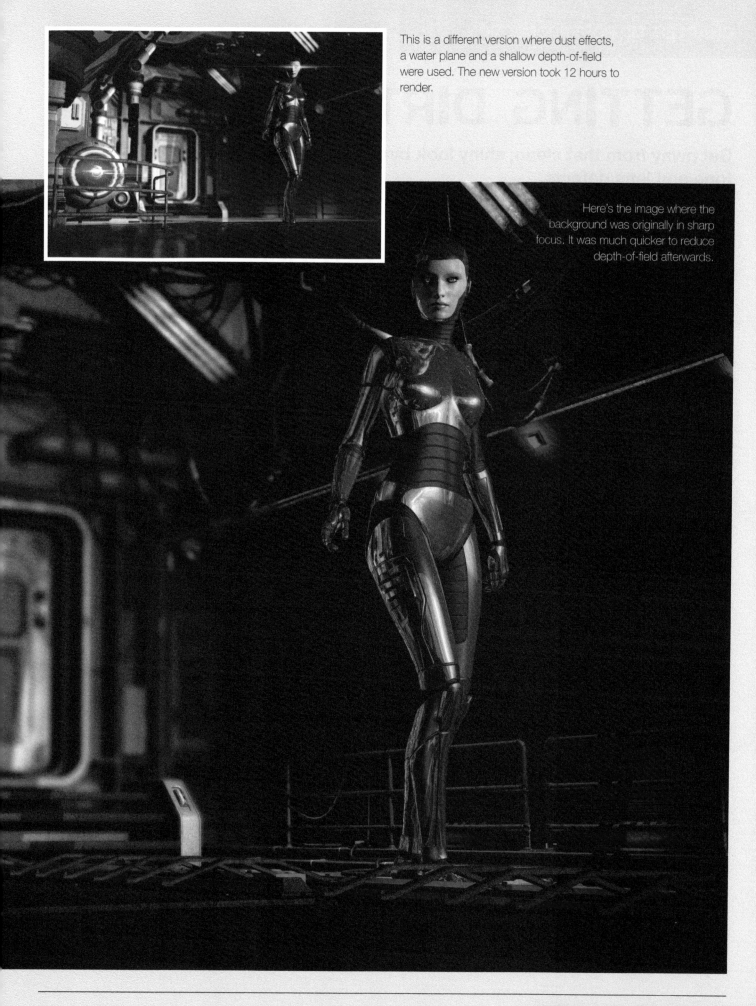

This is a different version where dust effects, a water plane and a shallow depth-of-field were used. The new version took 12 hours to render.

Here's the image where the background was originally in sharp focus. It was much quicker to reduce depth-of-field afterwards.

GETTING DIRTY

Get away from that clean, shiny look by adding grunge, grain, colour tone and lens defects

It's one of those curious contradictions that as digital photography has increased exponentially in quality and treats effects such as chromatic aberration as something to be eliminated, the aim in CG is to make the final image less clean and obviously artificial. One of those tricks includes adding chromatic aberration on the final image using something like After Effects. This does miss one point though. Traditionally, chromatic aberration has been a lens defect, but what is often prescribed as that flaw in images from digital cameras is actually a shortcoming in processing the image in the transition from very dark to very light areas. So, adding that effect to images doesn't make them more film-like, it makes them more digital, albeit, more photographic. There are plenty of other effects though, that make an image less CG looking: lens flares, vignettes, light leaks, grain, chemical stains and grunge effects for things like water damage, cracking and scratches.

Obviously, textures should be handled at the building stage but there's nothing wrong with adding a little extra dirt where it's needed. The easiest way of doing it is on separate layers but if you're coming to a pre-existing image and deciding that a more grungy version would be interesting, then painting them on in Photoshop is the way to go. Filters are a quick and easy post production effect, though it's harder to be precise, even with layer masks.

Aside from obvious dirt, damage and grunge there's also colour toning to consider where images can be given particular styles or a popular retro flavour. For more commercial images or animation sequences then professional colour grading is the order of the day. Either way, adding a colour style to the image will give it significant impact and a less just-rendered look.

LOOKING AT THE OPTIONS

Here are some of the various effects available in Alien Skin's Exposure 5 for adding colour, grain and defects like light leak and lens distortion.

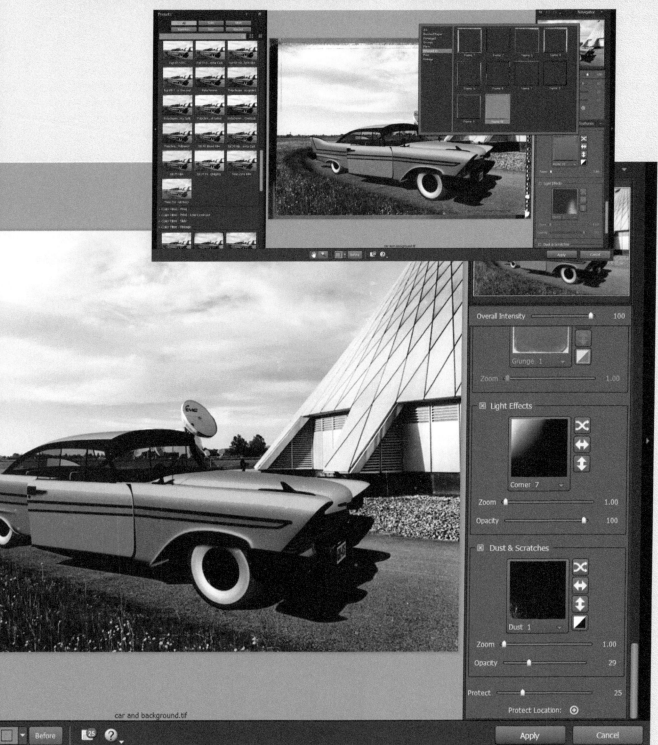

car and background.tif

Before

Overall Intensity 100

Grunge 1

Zoom 1.00

Light Effects

Corner 7

Zoom 1.00
Opacity 100

Dust & Scratches

Dust 1

Zoom 1.00
Opacity 29
Protect 25
Protect Location:

Apply Cancel

GETTING THE RIGHT SIZE FOR YOUR RENDER

The target media for your image dictates what resolution you render it in initially and whether any changes will be subsequently required

The resolution of an image – literally how many pixels go into it – determines both the level of detail, where and how large it can be used, and, correspondingly, how long it takes to create. The end market for the image determines what you are going to need in terms of resolution because if you are only creating images for your website, then there's no need to tie your computer resources up rendering an image that can be printed at A3, 300 dpi. If it's for the web then 1024 x 768 pixels is a reasonable size, though if it's for use as a full screen background, or for an animated feature then you're talking about 1280 x 720px or 1920 x 1080px.

The highest resolutions are needed when you turn to print projects that include magazines, books and posters. These typically print the image using a print density of 300 dpi, which is dots per inch. Note that 300 dpi is not an image resolution in itself, and on its own is meaningless. An image 300 x 300 px could be printed 1 inch square and it would still be 300 dpi, whereas if a client asked for an image sized 10" x 7" at 300 dpi then it would need to be rendered at 3000 x 2100 pc.

The problems with larger resolutions for print are computer resources and the time it takes. The larger the scene, the better the graphics card needs to be to display it without slowing down and the more RAM is required to process it during the render. Typically, the first time you'll find out that you don't have enough system RAM is when the software crashes after chugging away for 10 hours. For those reasons, if you don't need it to be super-sized, then there's little point in trying to render it at that size. However, if you do, then ensure the computer can handle it.

Going up or down in size

There are two occasions when you need to change the image size after it's been rendered. The easy one is when you have a hi-res version, but you need a lo-res one for a website. No problem there but, bear in mind, reducing the size will make the resulting image softer.

On the flip side, if you need a larger image than what you have but your computer can't take it or you just don't have the time to re-render, then you need specialist interpolation software. In a pinch, Photoshop CC has decent image enlarging facilities, but the older versions don't. Instead look to apps and Photoshop plug-ins such as Blow Up from Alien Skin, Perfect Resize from OnOne Software and PhotoZoom Pro 5 from BenVista for example. Ensure that your starting image is always an uncompressed or lossless compressed format like a TIFF

to get the best quality during resizing. These plug-ins are much better at creating smooth lines rather than avoiding jagged edges but the more you increase the image size, the less convincing the result becomes. Depending on who and what the final image is for, really determines how much you can get away with.

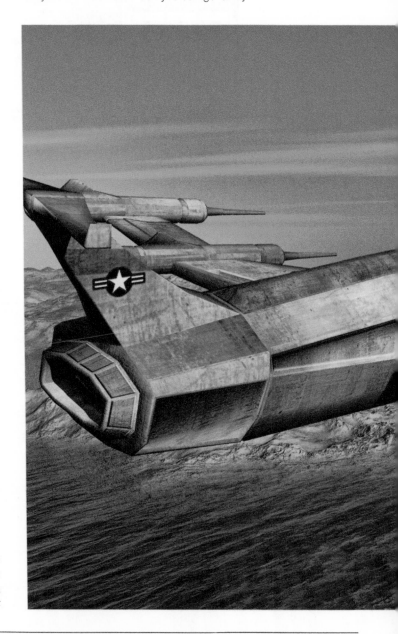

Here Perfect Resize was used to increase the resolution up to 5334 x 3000 px while maintaining a high level of detail.

The image, having been increased in size by 50 per cent, still features relatively smooth edges.

SELECTING COLOUR PROFILES

Whether it's for print or screen, the choice of colour profile plays an important role in how your images are displayed.

While there are a number of different colour profiles, there are only really two and their sub-categories that you need to worry about. They are RGB and CMYK. RGB is an additive colour model where the displaying device adds red, green and blue colours together to create the finished spectrum. One of the issues with RGB is that it is dependent upon the device displaying it, and all devices render colour differently unless they have been colour calibrated first. For the 3D creator though, RGB tends to be the main platform for colour profiling.

There are a number of different versions of RGB, mainly for medical, scientific and technical sources. The two main ones for your consideration are sRGB and AdobeRGB. The former is used by web pages so even if your image is saved as AdobeRGB, only the colours in the sRGB spectrum will be displayed on the Internet. AdobeRGB has a wider colour gamut than sRGB, which is to say it has a greater range of colours. Both models only have a finite number of colours they can display in a typical 8-bit file though, so in some cases you can find that an AdobeRGB image with very fine colour graduation across a wide spectrum suffers from banding, or gamut compression. Conversely, the sRGB image faced with colours outside its gamut may just render them all as the nearest colour, known as gamut clipping, so you end up with blocky colour in places. In reality, it's rare that this happens, but it's worth noting that if your image features a very wide range of colours, AdobeRGB is probably better and if it has fine colour graduation, then sRGB is better. All of which is a moot point if it's going to be displayed on the web because, as mentioned, it will only render the sRGB colours anyway.

The alternative to RGB is CMYK which is a subtractive colour model consisting of Cyan, Magenta, Yellow and Key. This is used for print, such as for this book and magazines. The problem for 3D artists is that CMYK has a much smaller colour gamut than any version of RGB, specifically in the bright or neon colour bands. Usually this isn't a problem if your 3D machine is out on the road or in a sky scene, but urban or sci-fi scenes with lots of bright colour and neon lights can be markedly affected when the image is converted to CMYK for printing. What was previously bright and glowing can suddenly become very flat. You can't get back those colours and the only recourse is to increase the contrast and saturation. That's why, if your image is destined for print, it's better that you convert it to CMYK yourself first, so that you can control what it looks like, rather than leaving it to the art editor or printing service who will just convert it and not make any adjustments.

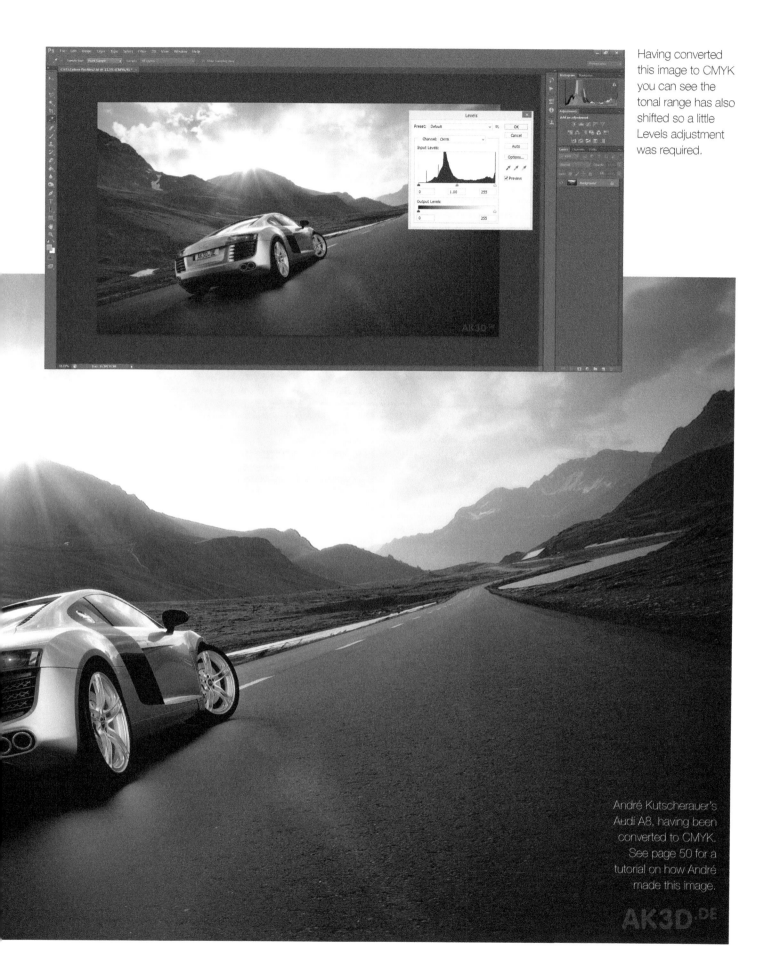

Having converted this image to CMYK you can see the tonal range has also shifted so a little Levels adjustment was required.

André Kutscherauer's Audi A8, having been converted to CMYK. See page 50 for a tutorial on how André made this image.

APPENDIX – RESOURCES

Some handy places for information, free models and help

Digital Mayhem: 3D Landscapes
www.focalpress.com/cw/evans. The companion website for this book where you will find tutorials, downloads and links to the work of some of the exceptionally talented contributors to this book.

CG Society
www.cgsociety.org. The number one website for professional artists with features, jobs, galleries and forums.

Cornucopia 3D
www.cornucopia3D.com. From the makers of Vue, the website offers help and advice on the forums, galleries to showcase your work and a world of models, plants, atmospheres and lighting set ups to purchase.

Renderosity
www.renderosity.com. Site for enthusiasts with plenty of galleries for showcasing work and also free and paid-for models to populate your scenes with.

3D Total
www.3dtotal.com. Free tutorials and textures, galleries and forums.

Evermotion
www.evermotion.org. Portfolios, articles and an extensive model shop.

TurboSquid
www.turbosquid.com. Leading site for paid-for models to use in your renders.

Free models
www.3dmodelfree.com. Plenty of free models to download.

YouTube
www.youtube.com. There are hundreds of how-to-do videos on YouTube for all the popular makes of 3D software.

Autodesk
www.autodesk.com and www.autodesk.co.uk. Website for the biggest name in 3D with support for 3ds Max, Maya and SoftImage.

Maxon
www.maxon.net. Outstanding software in CINEMA4D, used extensively across Europe. Galleries, stories and tutorials.

Chaos Group
www.chaosgroup.com. Creators of one of the best rendering engines available in V-Ray.

Blender
www.blender.org. Home of the free, open source 3D software.

DAZ3D
www.daz3d.com. Creators of DAZ Studio – a free package and a great way to get started. Also features an extensive shop for props and models, mainly people, but some machines and sci-fi environments.

ACKNOWLEDGEMENTS

Producing a book is a long, and at times tortuous, process that relies on the goodwill and contribution of a lot of people to make it happen. As the author, I'd like to thank Caitlin Murphy at Focal Press, the publisher of this book, for managing the editorial process through choppy waters.

Everyone who contributed to the content deserves a big thank you for their efforts, particularly those who supplied the tutorials. So, extra plaudits to:

Michael Hirsch

André Kutscherauer

Marcel Haladej

Nicholas McElmury

Andrea Lazzarotti

Omer Messler

Gianpietro Fabre

Gurmukh Bhasin

Gleb Alexandrov

James Suret

Christopher Parnian

Michael Tschernjajew

And especially Don Webster, who supplied not one, but two tutorials, when the original submission fell through at the very last minute. Many thanks for that Don.

Duncan Evans

Printed and bound by CPI Group (UK) Ltd, Croydon, CR0 4YY

21/10/2024

01777094-0020